THE TIMES BRITAIN FROM ABOVE

Published by Times Books

An imprint of HarperCollins Publishers
Westerhill Road
Bishopbriggs
Glasgow G64 2QT
www.harpercollins.co.uk

First Edition 2014

A catalogue record for this book is available from the British Library

ISBN 978 0 00 752581 2

10 9 8 7 6 5 4 3 2 1

Printed in China by South China Printing Co Ltd

If you would like to comment on any aspect of this book, please contact us at the above address or online.

www.timesatlas.com

e-mail: timesatlases@harpercollins.co.uk

facebook.com/thetimesatlas

@TimesAtlas

The world's most authoritative atlases
www.timesatlas.com

THE TIMES

BRITAIN from ABOVE

CONTENTS

INTRODUCTION

No matter how well you know Britain, to see it from the air is to view the country anew. It becomes clear how much time we spend scurrying along familiar paths with our heads down, barely looking over the hedgerows. Gain altitude and your vista expands to the horizon. Roads shrink to ribbons, a foothill unfolds into a mountain range, and every point of the compass is a new world to explore.

To fly is to spy. Unnoticed by the people on the ground you can peer over a neighbour's fence and see what their garden is really like. Most of us will never be invited to Buckingham Palace but our aerial camera gives us a peek into Her Majesty's back garden. It clearly shows that what we think of as the front of the Palace was a tacked-on afterthought at the back of the original building.

Britain has changed more in the century that aeronauts have been observing it than in any other. Much has gone. Towns have gobbled up the surrounding green space and belched out shopping centres and black tarmac. Cities have doubled, tripled, in size until they have swallowed each other up. Heavy industry has dwindled and hundreds of factories, foundries and mines have closed.

However, development can be a force for good, too. At Penallta in Wales a spoil heap has become a sculpture. Where smoke-blackened cranes winched tobacco bales from ships in Bristol docks, workers now relax in waterfront cafés. Hundreds of miles of branch line may have disappeared courtesy of Dr Beeching, but now many tracks are coming back. The Borders Railway is reconnecting Galashiels with Edinburgh. The brilliantly engineered Falkirk Wheel is the ultimate symbol of canal regeneration.

Change is everywhere, even in the oldest places. The squat bulk of the New Bodleian Library, built in 1940, shoulders itself a space amid Oxford's delicate college spires. The megaliths at Stonehenge may not have moved for centuries, but each season dresses the landscape afresh and totally changes its character. At Caerleon, a twentieth century archaeological dig has actually taken the landscape back to Roman times. Geological wonders allow us to see even further into the past: the caldera on Ardnamurchan is the stump of a volcano that last erupted 55 million years ago.

There is so much beauty to be discovered, so close to home. There are some views here that will stop you in your tracks with their wildness – can that really be Britain? It can, it is, and that surprise thrills the heart.

As you look down on our country in these pages, we hope you see new facets to Shakespeare's 'precious stone set in the silver sea' that will make you love it even more.

LOCATOR MAP

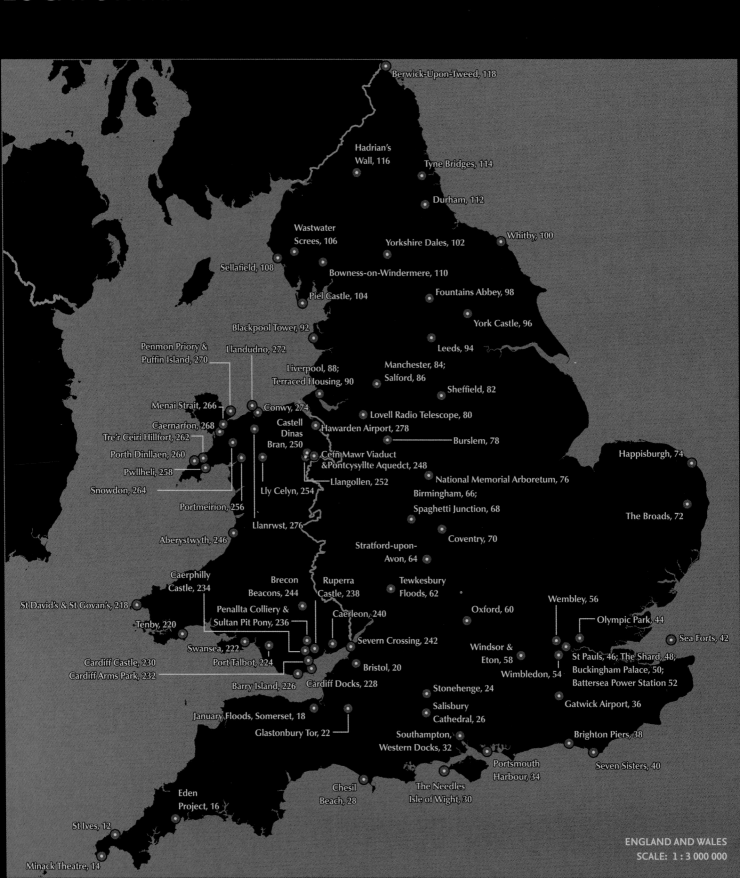

Berwick-Upon-Tweed, 118

Hadrian's Wall, 116

Tyne Bridges, 114

Durham, 112

Wastwater Screes, 106

Yorkshire Dales, 102

Whitby, 100

Sellafield, 108

Bowness-on-Windermere, 110

Fountains Abbey, 98

Piel Castle, 104

York Castle, 96

Blackpool Tower, 92

Leeds, 94

Penmon Priory & Puffin Island, 270

Llandudno, 272

Liverpool, 88; Terraced Housing, 90

Manchester, 84; Salford, 86

Sheffield, 82

Menai Strait, 266

Conwy, 274

Castell Dinas Bran, 250

Lovell Radio Telescope, 80

Caernarfon, 268

Hawarden Airport, 278

Burslem, 78

Tre'r Ceiri Hillfort, 262

Happisburgh, 74

Porth Dinllaen, 260

Cefn Mawr Viaduct &Pontcysyllte Aquedct, 248

National Memorial Arboretum, 76

Pwllheli, 258

Llangollen, 252

Birmingham, 66; Spaghetti Junction, 68

The Broads, 72

Snowdon, 264

Lly Celyn, 254

Portmeirion, 256

Coventry, 70

Llanrwst, 276

Aberystwyth, 246

Stratford-upon-Avon, 64

Caerphilly Castle, 234

Brecon Beacons, 244

Ruperra Castle, 238

Tewkesbury Floods, 62

Wembley, 56

St David's & St Govan's, 218

Penallta Colliery & Sultan Pit Pony, 236

Caerleon, 240

Oxford, 60

Olympic Park, 44

Tenby, 220

Sea Forts, 42

Swansea, 222

Severn Crossing, 242

Windsor & Eton, 58

St Pauls, 46; The Shard, 48; Buckingham Palace, 50; Battersea Power Station 52

Cardiff Castle, 230

Port Talbot, 224

Bristol, 20

Cardiff Arms Park, 232

Wimbledon, 54

Barry Island, 226

Cardiff Docks, 228

Stonehenge, 24

Gatwick Airport, 36

January Floods, Somerset, 18

Salisbury Cathedral, 26

Brighton Piers, 38

Glastonbury Tor, 22

Southampton, Western Docks, 32

Portsmouth Harbour, 34

Seven Sisters, 40

Eden Project, 16

Chesil Beach, 28

The Needles Isle of Wight, 30

St Ives, 12

Minack Theatre, 14

ENGLAND AND WALES
SCALE: 1 : 3 000 000

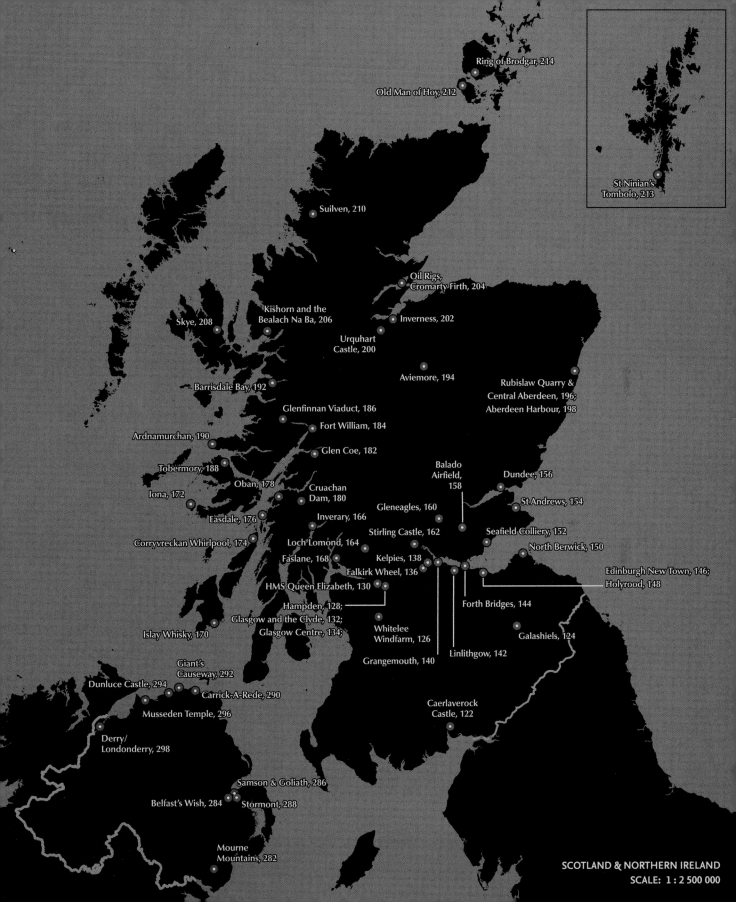

Ring of Brodgar, 214

Old Man of Hoy, 212

St Ninian's
Tombolo, 213

Suilven, 210

Oil Rigs,
Cromarty Firth, 204

Kishorn and the
Bealach Na Ba, 206

Inverness, 202

Skye, 208

Urquhart
Castle, 200

Aviemore, 194

Rubislaw Quarry &
Central Aberdeen, 196;
Aberdeen Harbour, 198

Barrisdale Bay, 192

Glenfinnan Viaduct, 186

Fort William, 184

Ardnamurchan, 190

Glen Coe, 182

Balado
Airfield,
158

Dundee, 156

Tobermory, 188

Oban, 178

Cruachan
Dam, 180

Gleneagles, 160

St Andrews, 154

Iona, 172

Inverary, 166

Seafield Colliery, 152

Easdale, 176

Stirling Castle, 162

Corryvreckan Whirlpool, 174

Loch Lomond, 164

North Berwick, 150

Faslane, 168

Kelpies, 138

Edinburgh New Town, 146;
Holyrood, 148

Falkirk Wheel, 136

HMS Queen Elizabeth, 130

Forth Bridges, 144

Islay Whisky, 170

Hampden, 128;

Linlithgow, 142

Glasgow and the Clyde, 132;
Glasgow Centre, 134;

Whitelee
Windfarm, 126

Galashiels, 124

Giant's
Causeway, 292

Grangemouth, 140

Dunluce Castle, 294

Carrick-A-Rede, 290

Caerlaverock
Castle, 122

Musseden Temple, 296

Derry/
Londonderry, 298

Samson & Goliath, 286

Belfast's Wish, 284

Stormont, 288

Mourne
Mountains, 282

SCOTLAND & NORTHERN IRELAND
SCALE: 1 : 2 500 000

ENGLAND

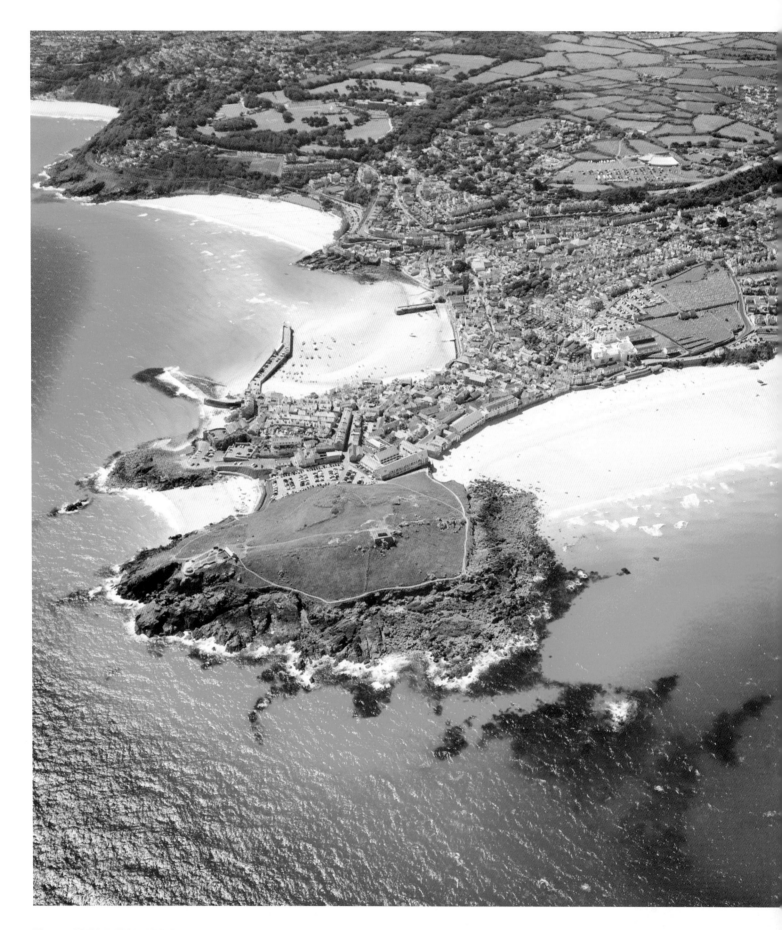

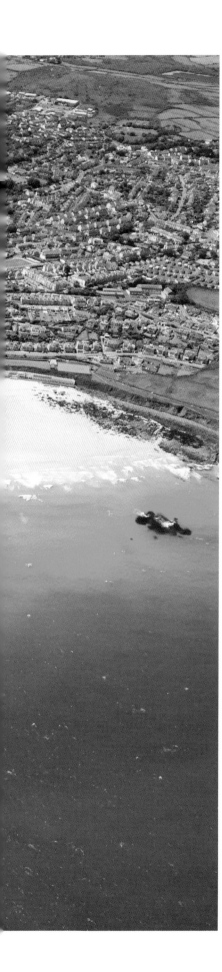

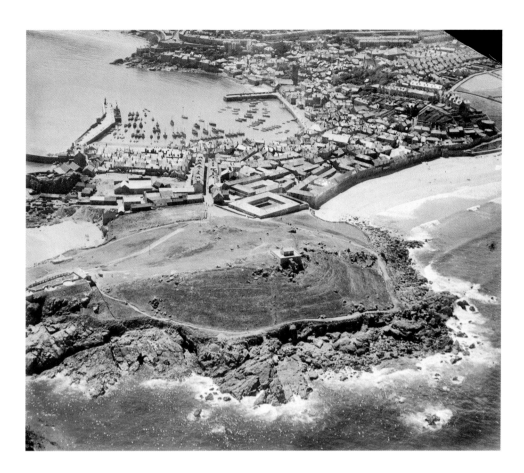

ST IVES
1928 and 2008

Turquoise waters studded with golden beaches adorn St Ives like a jewelled necklace. Today it is primarily a holiday destination, but for most of its human history it has been a fishing port. The Sloop Inn, which still serves thirsty seafarers on the wharf is said to date to 1312.

The 1928 photograph shows many large fishing vessels moored in the harbour. Although the industry has declined since then, there are still many local fishermen making a living from the sea. Huge shoals of mackerel swim by from May to October and cod, haddock, squid and crab are still found in these rich waters.

St Ives' natural rocky haven was given added security by a pier in the late eighteenth century, designed by engineering maestro John Smeaton (the man who coined the term 'civil engineer'). Smeaton's pier was later extended, which is why the lighthouse today occupies an odd position halfway along it.

The clear light, warm climate and natural beauty of the town have long attracted artists to St Ives. Turner sketched here in 1811 and the completion of the rail link in 1887 made it popular with Victorian painters, including James Whistler and Walter Sickert. In the years between the two world wars, St Ives was almost as famous an artistic colony as Paris. The potter Bernard Leach set up his studio in St Ives in 1920, and in 1939 the painter Ben Nicholson and his wife, the modernist sculptor Barbara Hepworth, settled here. The town's artistic status was recognised by the opening of the Tate St Ives gallery in 1993.

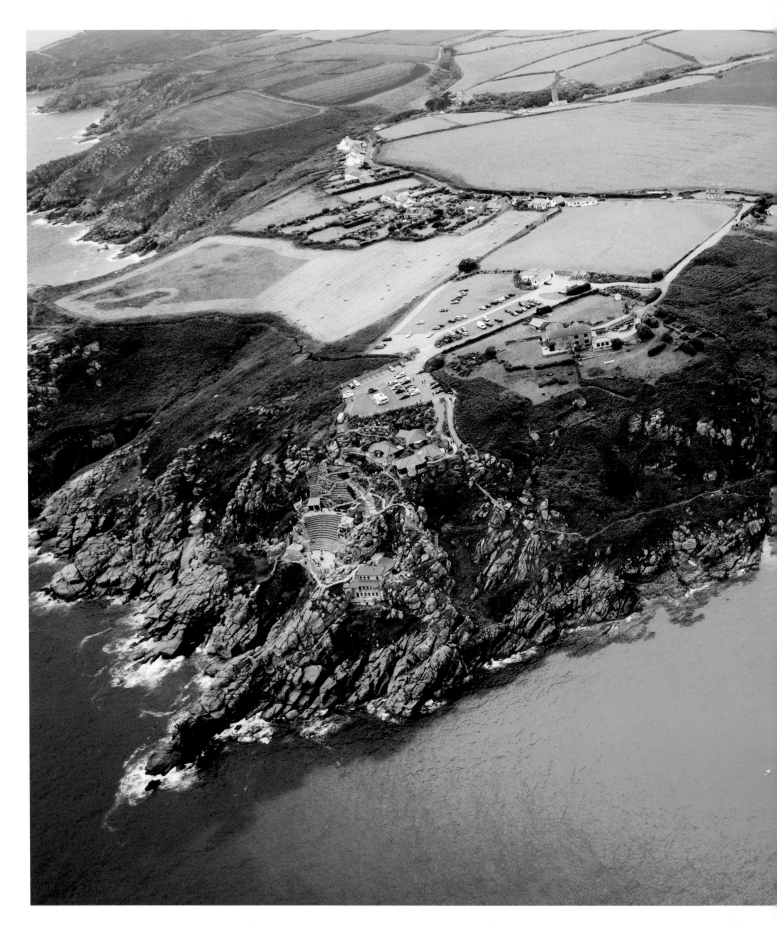

MINACK THEATRE
2012

In a setting as naturally dramatic as the theatre at Delphi in Greece, the Minack Theatre perches on the cliffs above the Atlantic breakers. Here the cries of gulls often echo the shouts of the actors, the sea creates a moving backdrop and the Cornish weather has been known to add its own tempestuous special effects.

This spectacular theatrical dream was a lifetime's work for Rowena Cade. In 1930 the local group of players had staged Shakespeare's A Midsummer Night's Dream in a nearby meadow. Miss Cade thought a cliff-top spot opposite her garden would make a tremendous location for their next production. With her gardener, she hauled a few planks and stones down from the house and up from the beach to make a basic terrace and a few seats. In 1932, The Tempest debuted at the precipitous Minack theatre, lit by batteries and car headlights, to great success.

Every winter for the rest of her life, Miss Cade risked her neck to make the theatre a little bit better. Dressing rooms were added in 1955, built with beams from a Spanish freighter wrecked on the rocks below. A car park, visitor centre and coffee shop followed as the theatre's fame grew. Today, companies come from around the UK and overseas to perform in this al fresco arena.

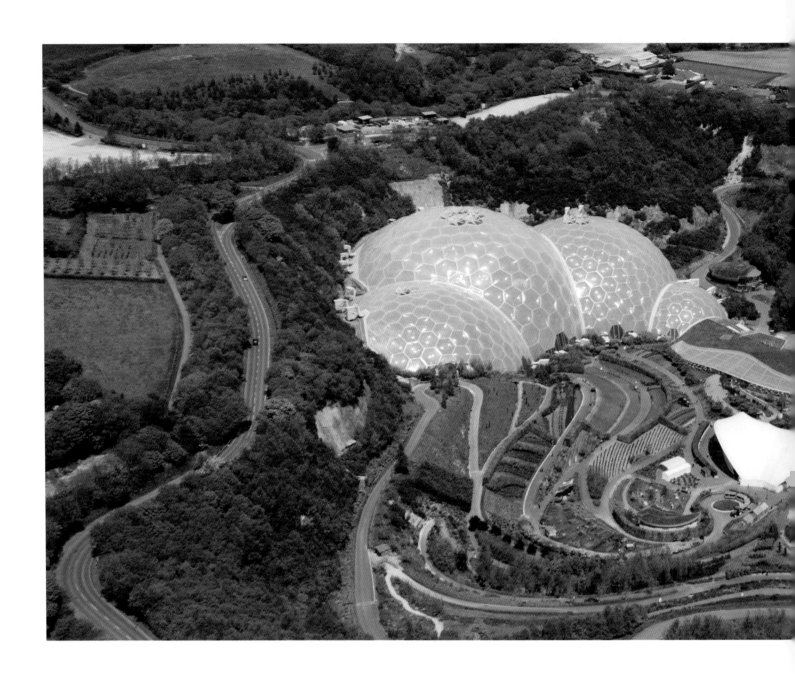

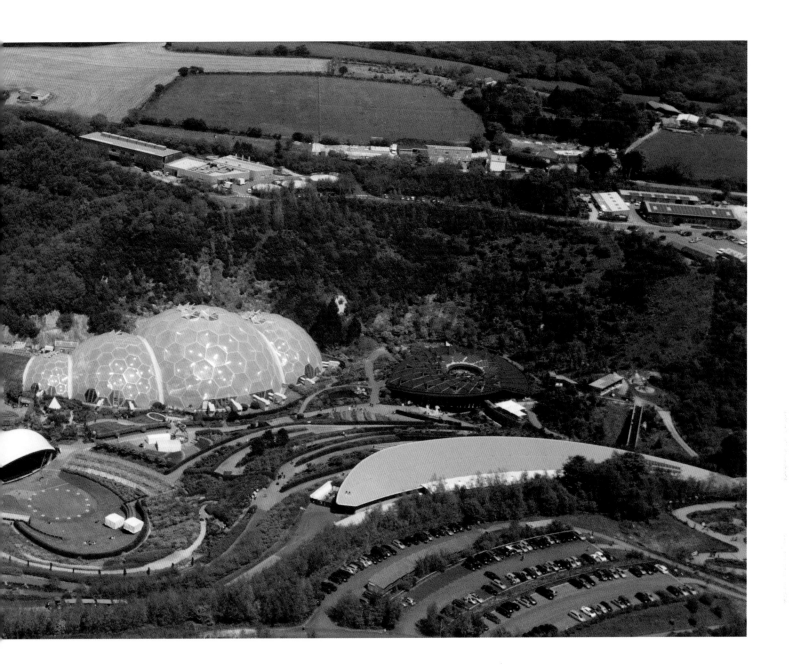

EDEN PROJECT
2013

China clay has been mined in Cornwall since the eighteenth century. Once a massive industry, it still employs over 2,000 people at several pits. When reserves at the Bodelva pit were exhausted after 160 years of mining, the site was abandoned. After a brief role as an alien planet in the TV series of the Hitchhiker's Guide to the Galaxy, the 60 m (220 ft) hole in the ground was transformed into the Eden Project, a unique environmental and educational centre.

Over three years a total of 1.8 million tonnes of rock and earth were shifted and £86.5 million was spent before the venture opened in 2001. Drawing more than 1 million visitors a year, the Eden Project is now one of the country's most popular attractions.

There are two huge biomes, where thousands of exotic plant species thrive under self-supporting geodesic domes built of hundreds of inflated plastic cells. Covering an area equivalent to two and a half football pitches, the Tropical Biome is the world's largest greenhouse. It measures 50m (160 ft) high, by 110 m (360 ft) wide and 240 m (790 ft) long. All rain that falls on the shell is recycled inside, with streams, waterfalls and misters replicating rainforest conditions. The temperature is kept between 18–35°C, perfect for banana trees, giant bamboo, coffee and rubber plants. Exotic butterflies have been introduced to help pollinate the flowers.

The smaller Mediterranean Biome recreates the hot, dry summers and warm, wet winters of temperate areas where vines and olive trees feel at home.

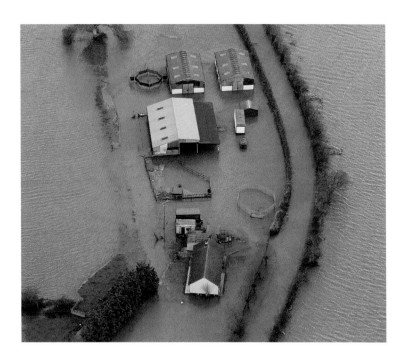

JANUARY FLOODS, SOMERSET
2014

More rain fell in southern Britain in January 2014 than in any winter month for 250 years. The Radcliffe Meteorological Station at Oxford University has been making daily recordings since 1767 and it measured a total of 146.9 mm (5.78 in) of rain in January, smashing the previous record of 138.7 mm (5.46 in) in 1852. This new record is also three times the monthly average over the last two and a half centuries.

Furthermore, the rainfall figures for the 45-day period from 18 December were the highest of any such period in the Radcliffe Station's records. The total of 231.3 mm (9.11 in) swamped the total from 1 December 1914 of 209.4 mm (8.24 in).

The exceptional rainfall resulted from what was essentially a storm factory over the Atlantic Ocean. Here, cold polar air was meeting warm, tropical air to create a string of unstable weather systems that were then guided across Britain by a strong jet stream.

With many southern counties already saturated from a wet autumn, the winter flood waters simply had nowhere to go and many parts of the country were inundated. The Somerset Levels were particularly badly affected, with scenes like this lasting for several weeks.

The same weather systems also brought gales and storm waves to many coastal areas. The main railway line to the south-west suffered a spectacular breach when the sea wall was washed away at Dawlish on the south Devon coast. There were several major cliff falls, including at Happisburgh in Norfolk and at Birling Gap in East Sussex, as heavy seas undercut steep slopes and the waves claimed a few more metres of England.

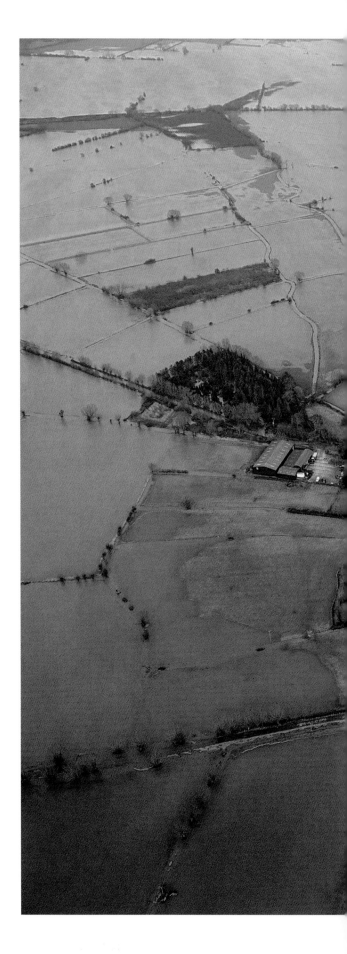

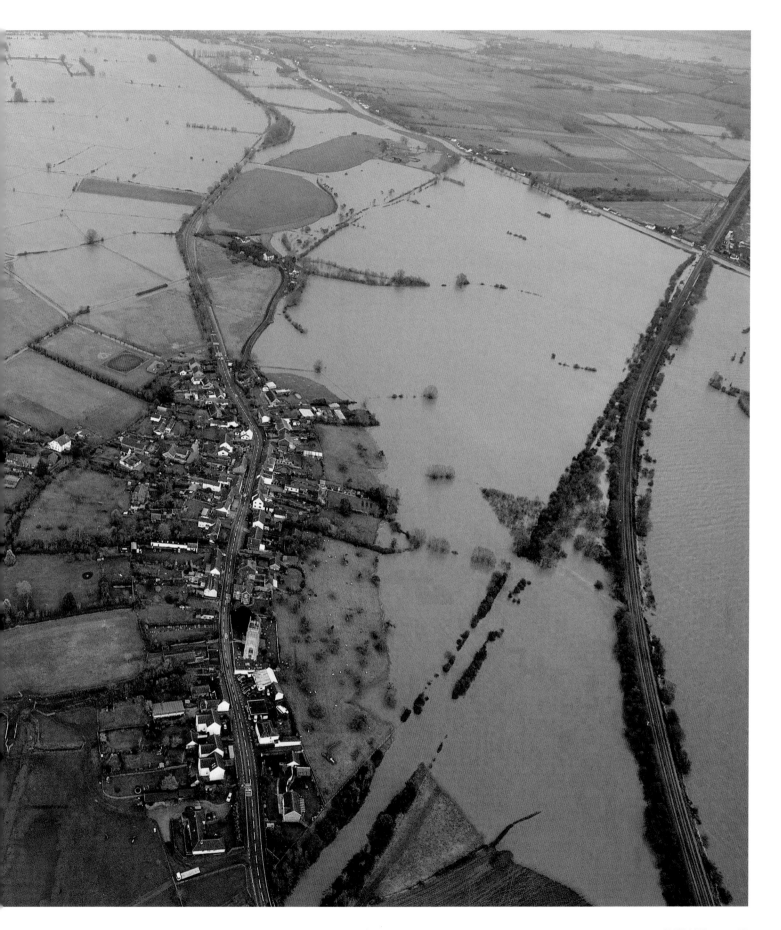

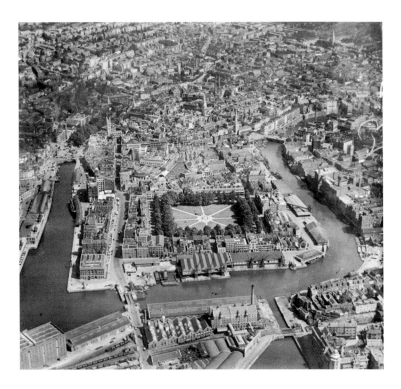

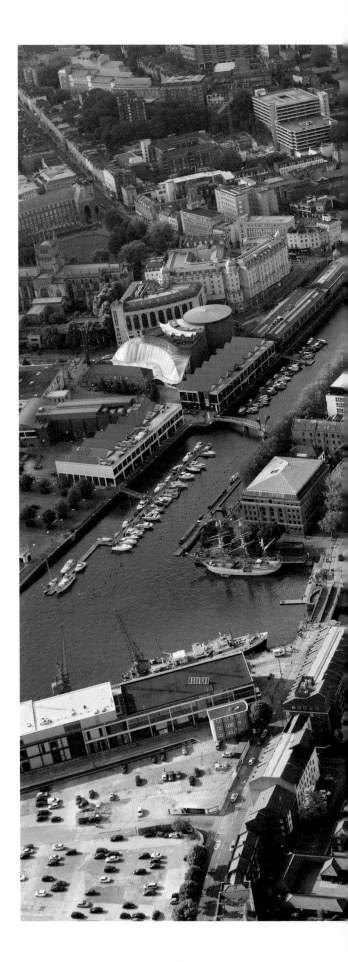

BRISTOL
1930 and 2014

There has been a harbour at Bristol since the thirteenth century, but it was in 1809 that it took on its more familiar form. The River Avon is easily navigable at high tide but is a mere muddy channel at low tide. Ships would be stranded in the harbour for unloading – vessels able to take the strain of a stranding on the mud were 'shipshape and Bristol fashion'.

So the tidal River Avon was diverted round the centre of the city and locks were built to create a Floating Harbour on the old river. Bristol flourished as a hub of import, export, shipbuilding and manufacturing activities.

However, as ships grew too large for the river's bends, and new docks were built 5 km (3 miles) downstream at Avonmouth, Bristol Harbour's days were numbered. The last ship was built here in 1977.

Some of the changes can be seen by comparing these photographs. Queen Square is an unchanged area of greenery, but since the 1930 picture was taken the warehouses, shipyards and dock buildings lining the Floating Harbour have been replaced or developed into offices, restaurants and housing. The harbour itself is now mainly used by leisure craft.

At the bottom left of the old photo are the dock buildings of Prince's Wharf, now preserved as part of the M Shed museum. A section of the Bristol Harbour Railway still runs west from here, but at the centre bottom of the old photo, the line can be seen continuing east over the channel running to Bathurst Basin.

The Grove, which lies in front of Queen Square in the photographs, was a densely packed street of warehouses on both sides. Now its waterfront is open and tree-lined. The large warehouse at its far left corner still stands, but is now the Arnolfini Gallery.

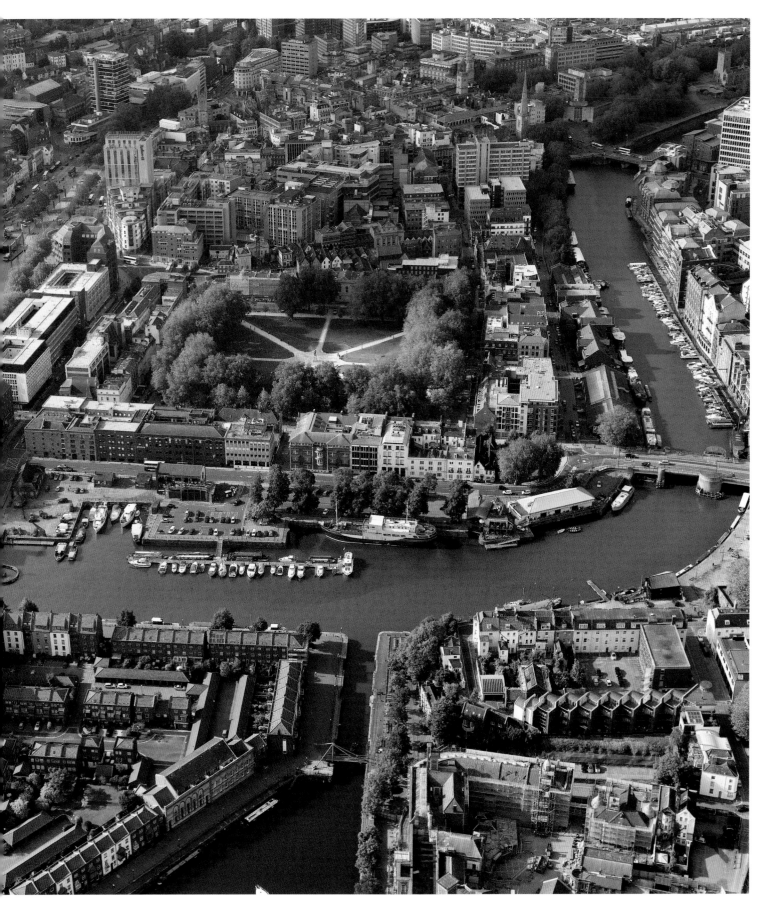

GLASTONBURY TOR
1946 and 2008

When the mists rise from the River Brue and envelop all but the steep terraced summit of Glastonbury Tor, it's easy to see why it is known as 'The Isle of Avalon'. Legend holds that Avalon was where King Arthur's sword Excalibur was forged, and where he came to die. Local monks reported finding his and Queen Guinevere's neatly labelled coffins here in 1191. Glastonbury Tor is also a possible location of the Holy Grail. The formation of the mound's seven terraces has yet to be fully explained.

St Michael's church was built atop the tor by monks of nearby Glastonbury Abbey. All but the tower was demolished in 1539, following the dissolution of the monasteries.

The tower has been cared for by the National Trust since 1933, but was in urgent need of repair when this picture was taken in 1946. Ground movement as well as erosion by wind and water were revealing cracks in the foundations of the tower. These were repaired and new paths were laid to minimise wear by the increasing number of visitors. In recent years the masonry has been carefully restored and the parapet rebuilt.

Glastonbury lies at the edge of the Somerset Levels, a wide vale of grassland, marsh and peat moor. Today this has a comprehensive drainage network, but severe annual flooding forced its Anglo-Saxon settlers to abandon the lands at the onset of winter. The area was then known as *Sumorsaete*, meaning 'land of the summer people', which today has become 'Somerset'.

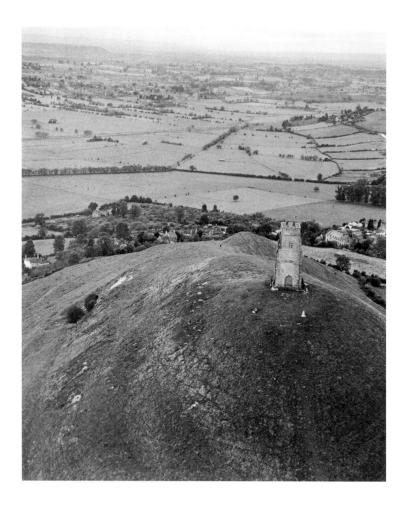

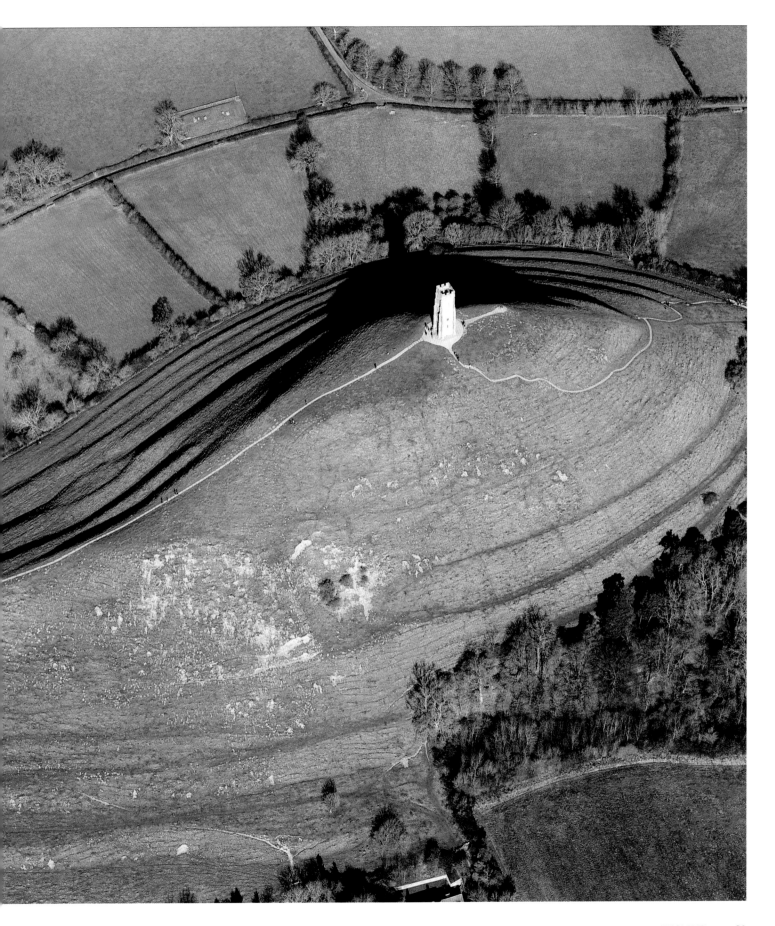

STONEHENGE

Was it a burial site, a place of healing, a status display, an astronomical calendar, a shrine, or perhaps all these things and more? The fact that the true purpose of Stonehenge is unkown only adds to its allure.

Archaeologists are reasonably certain that it first took form as a ditch, dug out by hand using deer antlers, with the chalk spoil piled up as an inner and outer bank, in about 3100 BC. Remains show that this monument was used as a cremation ground for several hundred years.

Then, in 2600 BC, a spectacular transformation began. The surrounding downs are littered with sarsens – hard sandstone blocks – and seventy-five of these were dragged here and skilfully dressed. Using pits and levers, a circle of thirty upright stones was created, each one standing 4.1 m (13 ft) and weighing 25 tonnes. This circle was capped with thirty lintels, secured with mortise and tenon joints. Within that circle fifteen even larger stones, up to 9.1 m (30 ft) high and weighing up to 50 tonnes, were arranged as five trilithons. Construction took around 200 years.

Bluestones were added to the site a few hundred years later. These came from the Preseli Hills in southwest Wales 240 km (150 miles) away, and were either dropped here by a glacier or hauled by human effort.

Until 1977 it was possible to walk freely around the stones, but access is now allowed only at the equinoxes and solstices. From the centre of the stone circle, the sun can be seen to rise above the sloping heel stone on the summer solstice. It's a sacred moment for neo-druids, neo-pagans, Wiccans and a spectacular sight for all visitors.

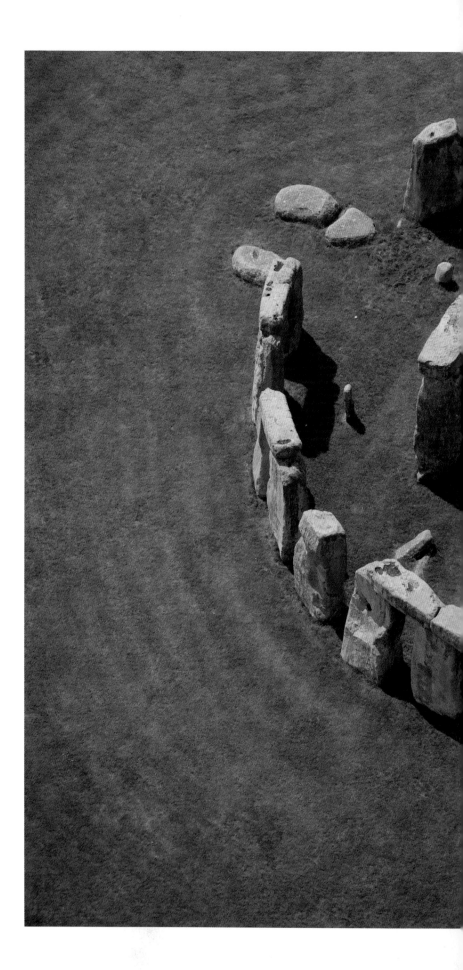

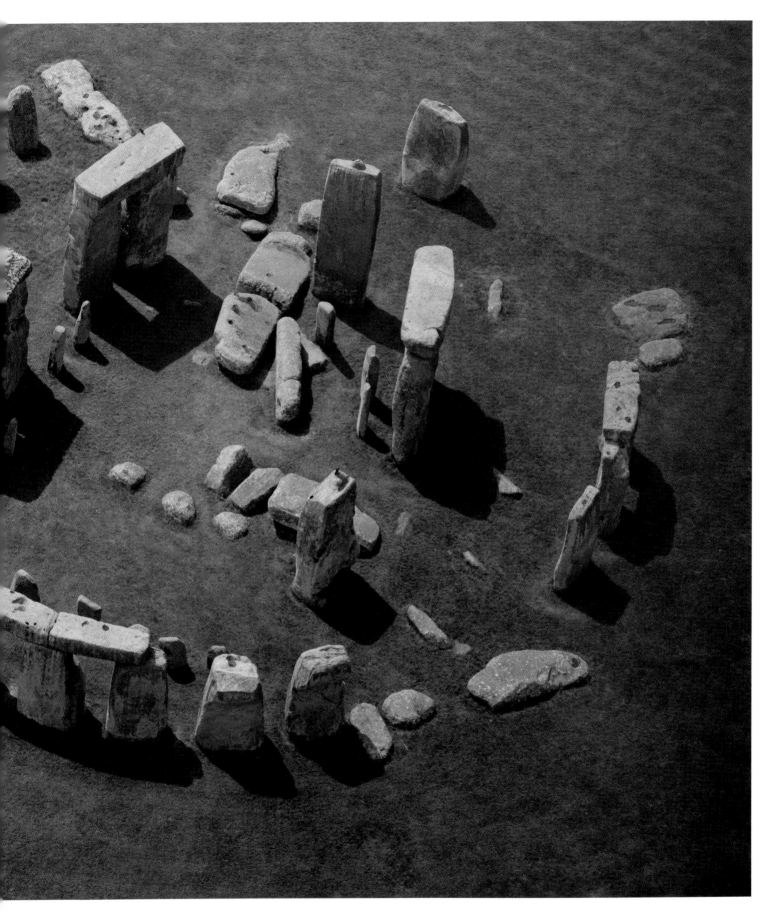

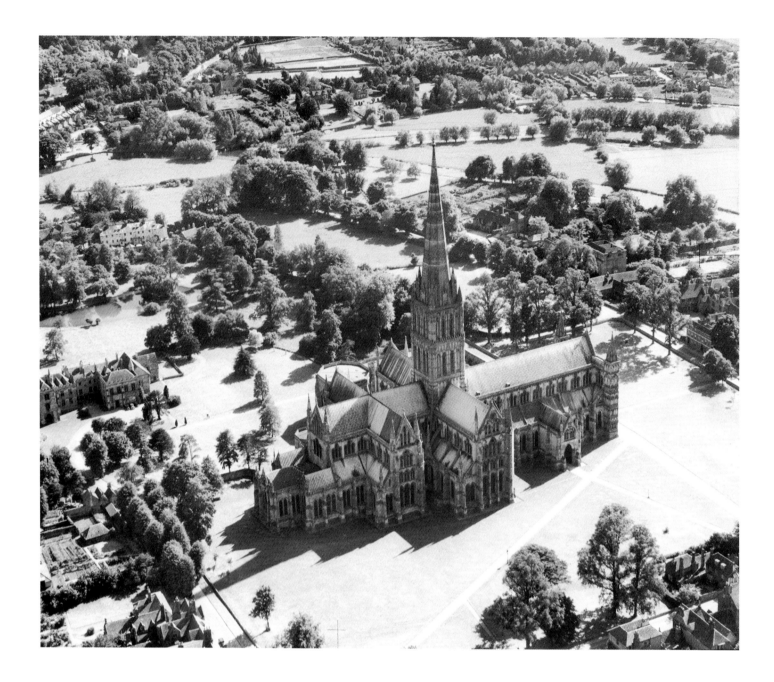

SALISBURY CATHEDRAL
1947 and 2011

It took just 38 years to build Salisbury Cathedral, from 1220 to 1258, which was positively rapid for a project that often took centuries. The swift construction blessed the building with a single style and it remains the finest example of Early English Gothic architecture.

The spire was completed in 1320, and today it is the tallest in Britain, at 123m (404 ft). Although at the time it was shorter than the spire on Lincoln Cathedral, which at 159.7 metres (524 ft) was the tallest building the world.

Cathedral construction was then the cutting edge of building technology, and errors of judgement frequently led to disastrous collapses, as happened at Lincoln.

Considering that Salisbury is built on ground with a high water table and has foundations only 1.2 m (4 ft) deep, it was lucky to escape this fate. Its central crossing columns are now bowed by 25 cm (10 in).

Salisbury also has the largest cloister and the largest cathedral close in Britain, and the world's oldest working clock, which dates from AD 1386. This has no face, instead ringing the hours on a bell. In the cathedral chapter house is the best-preserved of the four original copies of Magna Carta.

Salisbury Cathedral was a favourite subject of painter John Constable, and many of the views he depicted remain almost unchanged 200 years later.

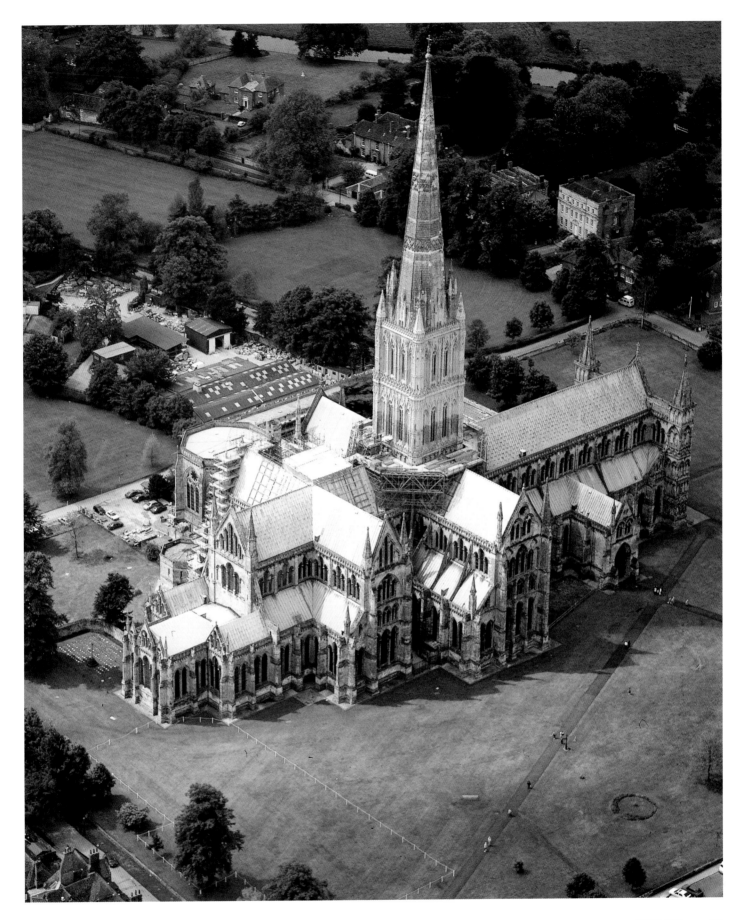

CHESIL BEACH
2010

More geological phenomenon than sandy strand, Chesil Beach Is 29 km (18 miles) long, 200 m (660 ft) wide and up to 15 metres (50 ft) high.

The beach hugs the Dorset coast for several kilometres before curving out into a long, graceful arc that eventually meets the Isle of Portland. Although it looks like a tombolo – a beach running perpendicular to the mainland and linked to an island, formed by wave refraction – it is actually a huge shingle shoal that has 'rolled' landwards. It was pushed into position by rising sea levels at the end of the last ice age 20,000-14,000 years ago. 'Chesil' is from the old English 'ceosil' meaning shingle.

When the beach connected island to mainland, glacial meltwater formed the shallow Fleet lagoon. The Fleet offers ideal conditions for many species of birds and a swannery was established in the eleventh century to give local monks a ready source of meat. Abbotsbury Swannery still thrives today, and is the world's only managed colony of mute swans.

The beach's individual stones grow from pea-sized at the northwest end to orange-sized at Portland. This was of great help to local smugglers – they were said to know exactly where they were on the beach, even in the darkest of nights, by the size of the shingle. It was the setting for the classic novel *Moonfleet*.

The bouncing bombs used by the Dambusters in the Second World War were first tested at the Fleet and Chesil Beach.

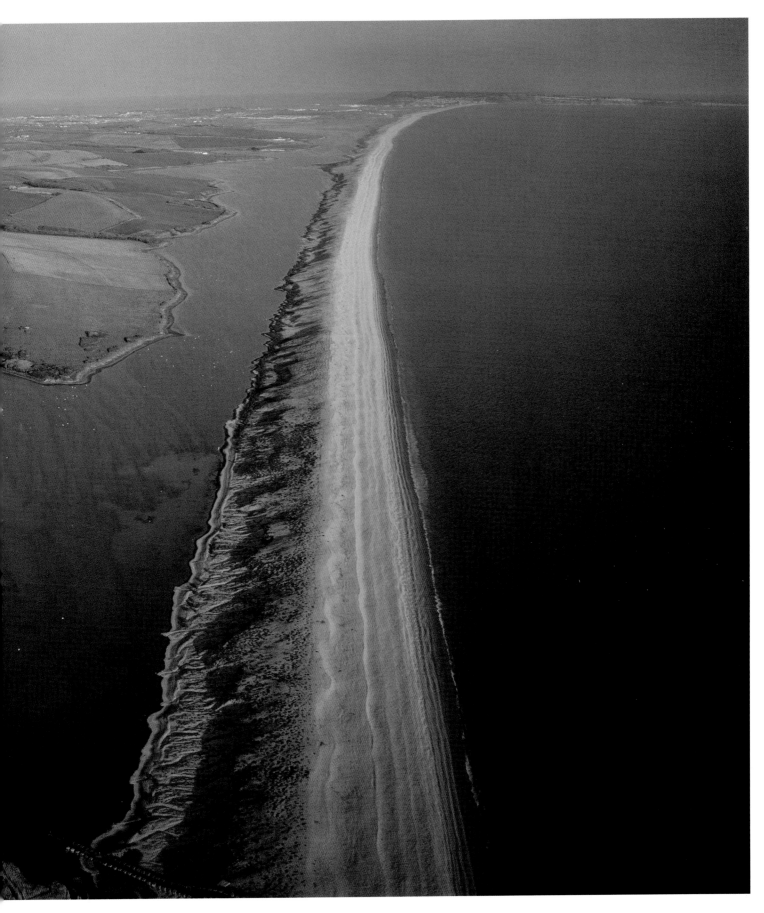

THE NEEDLES, ISLE OF WIGHT
2010

Looking more like serrated teeth than pins, this unique rock formation off the western point of the Isle of Wight has long been known as The Needles. The name comes from the days when a taller, and much more needle-like, stack also stood proud of the waves in the gap between the second and third rocks from the lighthouse. Known as 'Lot's Wife', this was felled by a storm in 1764. The formation is part of a chalk outcrop that runs right through the Isle of Wight then under the sea to the equally spectacular coastline at Lulworth Cove and Durdle Door in Dorset.

There was an artillery battery at The Needles from the 1860s to 1954, and from 1956–71 the cliffs above the rocks were home to an experimental rocket station. Hundreds of people worked locally in building and testing rocket engines for intercontinental ballistic missiles. The site is now owned by the National Trust.

At the end of the stacks is The Needles Lighthouse, which was built in 1859. Its light was manned until 1994.

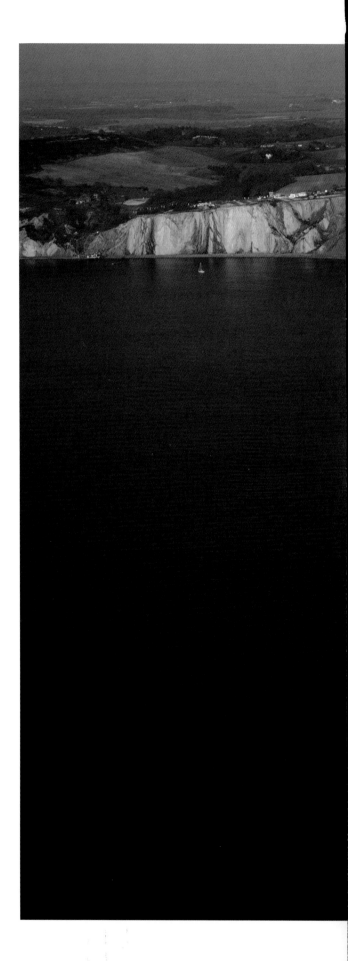

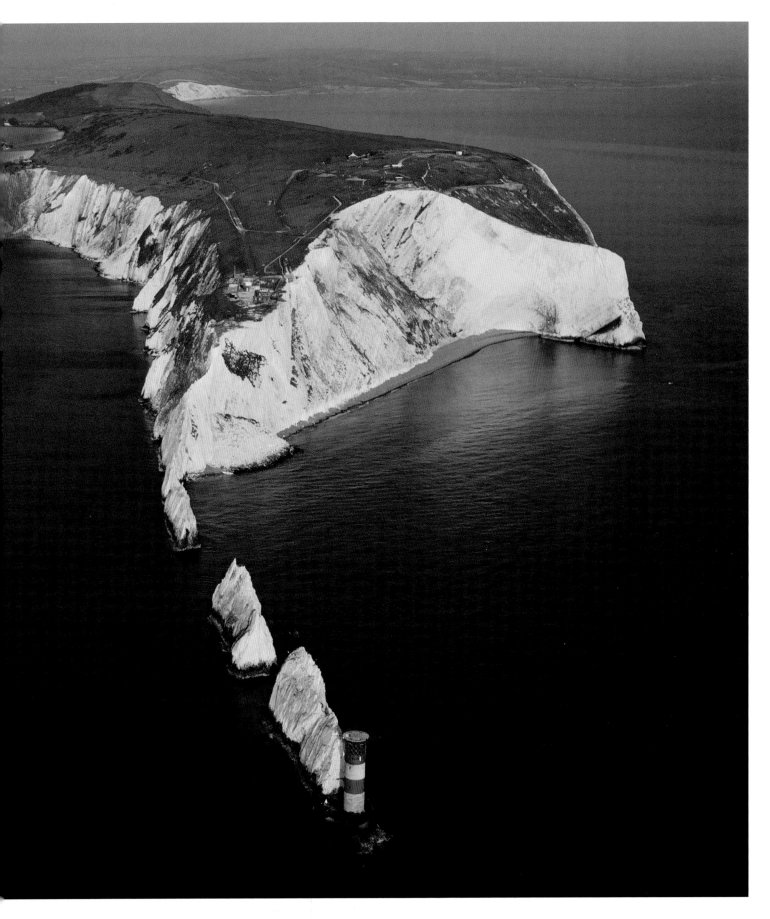

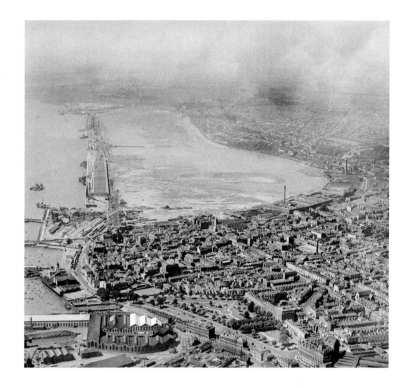

SOUTHAMPTON WESTERN DOCKS
1932 and 2013

One of the largest non-rural reclamation schemes ever carried out in Britain is under way in this 1932 photograph. A 3 km (1.9 miles) dock wall was built sheer across the tidal shallows lying just off Southampton, starting from the east. Progress is clearly visible here: nearest the camera the wall is finished, with tugs tied up and sheds built. Above that the wall is nearing completion, while at the far western end the cofferdam is still in place to allow piles to be driven into the seabed. When the dock was finished, the vast lagoon it created was filled with mud and silt dredged from the shallows outside the wall.

Towards the top of the 1932 image, building work is underway on the King George V graving dock. When it opened the next year this was the largest dry dock in the world, at 366 m (1,200 ft) long, 41 m (135 ft) wide and over 15 m (50 ft) deep, able to safely berth the largest ships afloat, including the *Queen Mary*.

In the 1970s the western docks were developed into a container port, now the second largest in the UK. The port continues to offer a berth for the largest vessels afloat, including the *Queen Mary 2*.

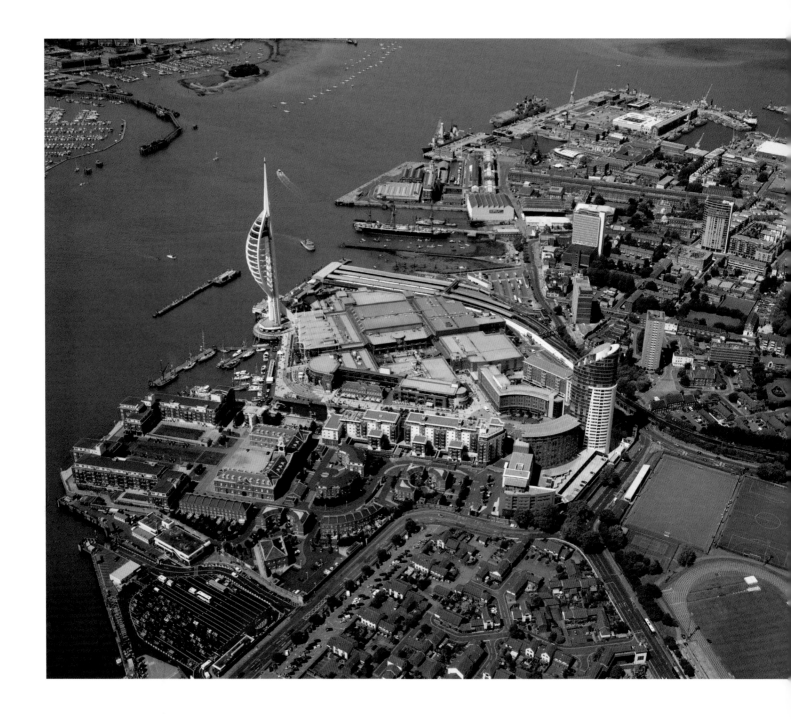

PORTSMOUTH HARBOUR
1947 and 2013

As Britain's only island city, it's no surprise that Portsmouth has been a maritime hub for centuries. Henry VII built the world's first dry dock here in 1495, and Royal Navy ships have long come to the dockyard for repair and restocking, while their sailors enjoyed shore leave in the old city.

In 1787, eleven ships sailed from Portsmouth to establish the first European colony in Australia. Marc Isambard Brunel (father of famed engineer Isambard), established the world's first mass production line here, to make rigging blocks, and at its height Portsmouth's dockyard was the largest industrial site in the world.

The 1947 picture shows the harbour busy with naval vessels and it is still the headquarters for two-thirds of the Royal Navy's surface fleet and the Royal Marine Commandos.

Spinnaker Tower blows like a mighty sail 170 m (560 ft) above Gunwharf Quays, once the place where ships going in for repair in dry dock unloaded their heavy guns – unsupported by water, the keels would have splintered under the full weight of all that ordnance. Today the redeveloped area loads up on shoppers, diners and drinkers.

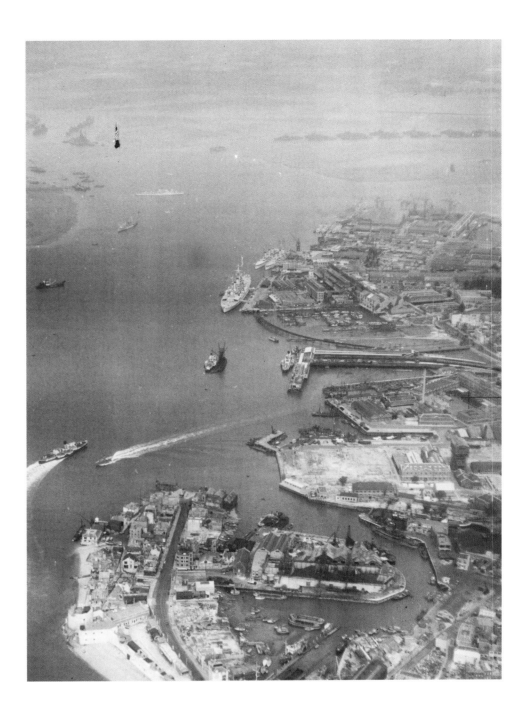

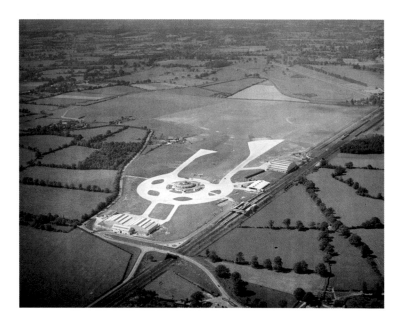

GATWICK AIRPORT
1938 and 2013

This pair of images perfectly illustrates how important air transport has become in just half a century. The grassy plain next to the racecourse at Tinsley Green was used as an aerodrome from the late 1920s, with the local aero club using an old farmhouse as their base. However, after the airstrip was licensed for commercial flights in 1933, development began in earnest.

Three years later a new terminal, The Beehive, was opened and the airport was officially named Gatwick. The Beehive may look quaint in this image, but it was a very modern piece of design. The first circular airport terminal in the world, it had many innovative features, including a tunnel to the railway station, which enabled passengers to journey from London Victoria to their aircraft without going outside. The first scheduled flight left the Beehive on 17 May 1936 for Paris. A ticket cost £4 5s and included first-class rail transfer from London Victoria. The Beehive is still standing, but it now lies outside the main terminal complex and is used as offices.

In 1950 the world's very first air package tour left Gatwick for Corsica. Over the following decades the runway was lengthened four times, and two new terminals built and later expanded.

Today, although it only handles half as many passengers as Heathrow, Gatwick is still the tenth-busiest airport in Europe, with 34.2 million passengers passing through in 2012. It also has the world's busiest single-use runway, with a capacity of fifty-five aircraft movements per hour.

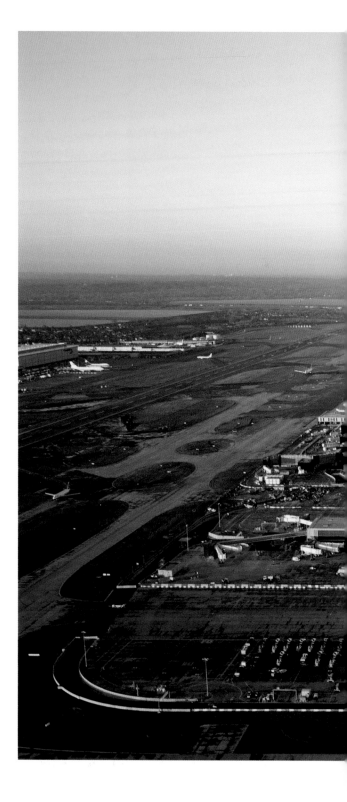

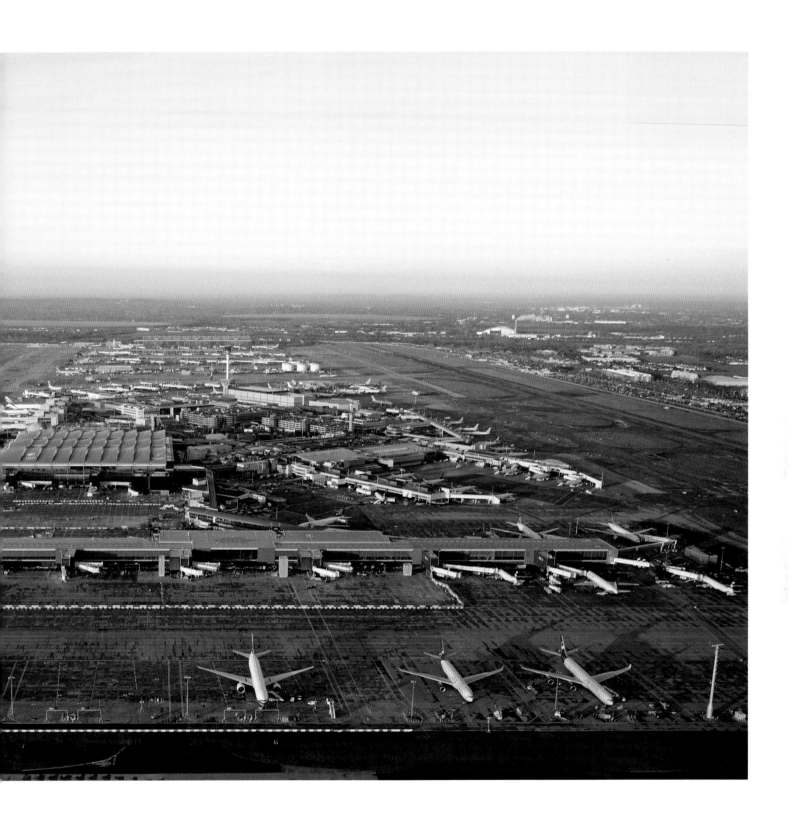

BRIGHTON PIERS
2012

England is the home of the pleasure pier. The first was built at Ryde, on the Isle of Wight, in 1814. The arrival of the railways in the nineteenth century, as well as increasing prosperity and spare time, meant more and more Britons travelled to the seaside. Boats could not reach many potential resorts at low tide, and so piers were built to transfer trippers from ship to shore. They were lined with amusements and often had a theatre that attracted big name entertainers. The boarded walkways also enabled people to promenade by the water no matter how far out the tide went.

There have been at least ninety-nine pleasure piers around Britain's coast; there are fifty-eight still surviving. The longest in the world is at Southend-on-Sea.

It extends for 2.16 km (1.34 miles) into the Thames Estuary and has its own train line running to the pier head.

Brighton has had three piers. The Royal Suspension Pier was built in 1823, and was joined by the West Pier in 1866. The Suspension Pier was demolished and replaced by Palace Pier in 1891.

The West Pier closed in 1975 and subsequently suffered a series of mishaps, being wrecked by storms and gutted by fires. Much of its iron framework still stands, but is cut off from the shore, as can be seen in the bottom left of the image below.

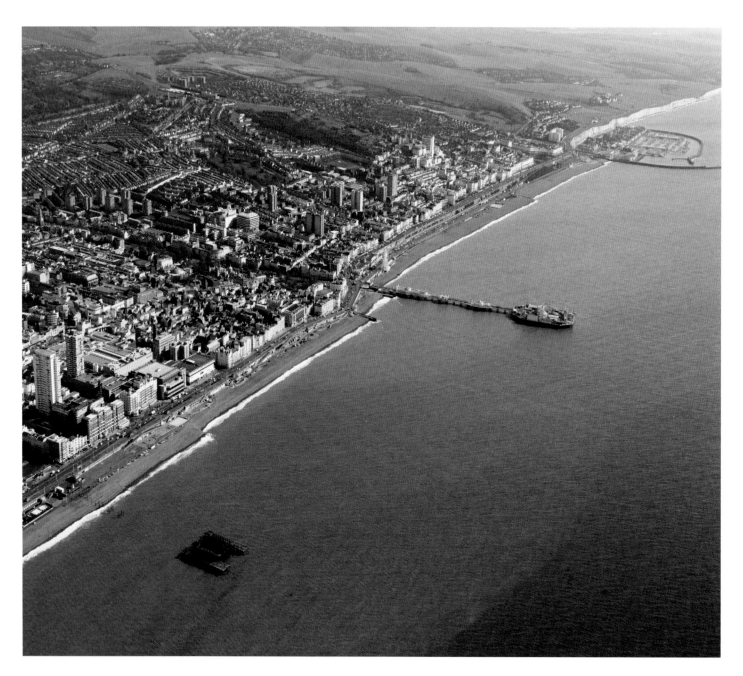

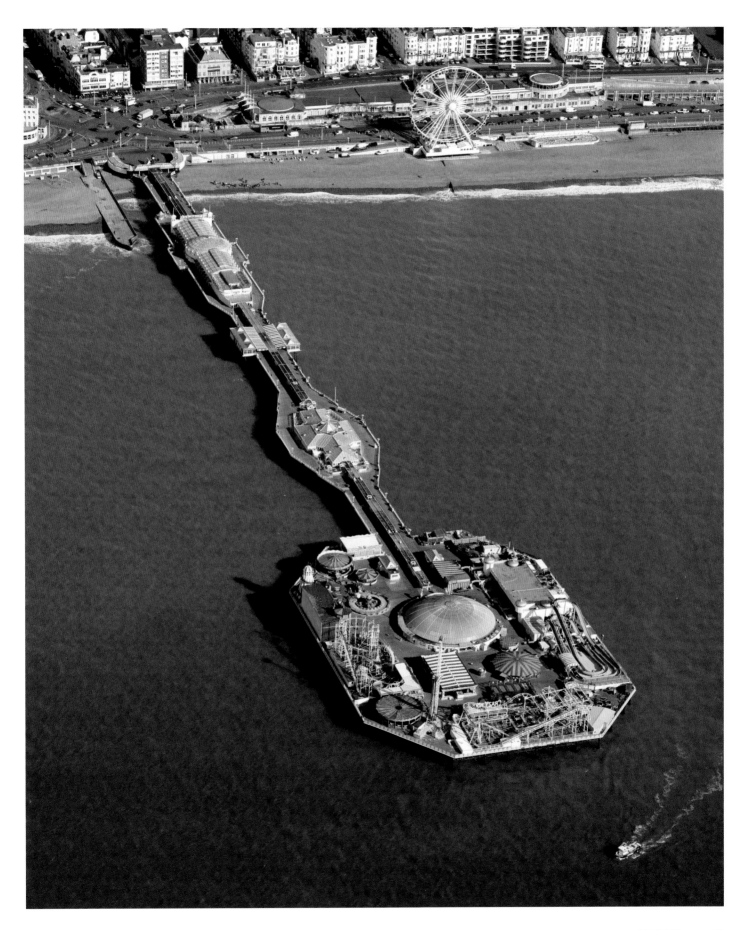

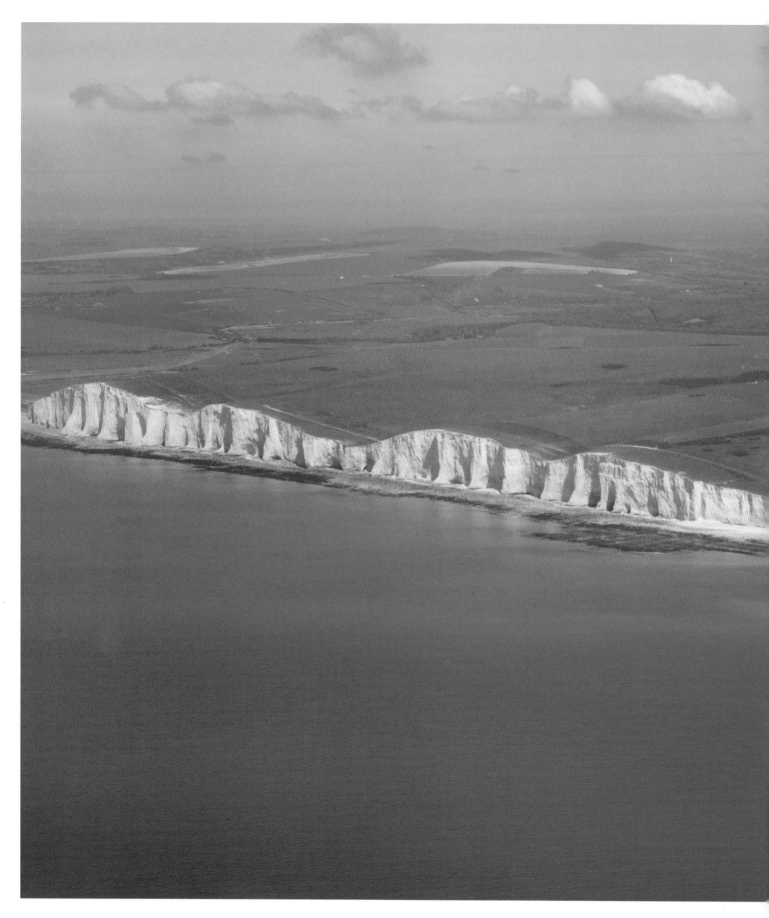

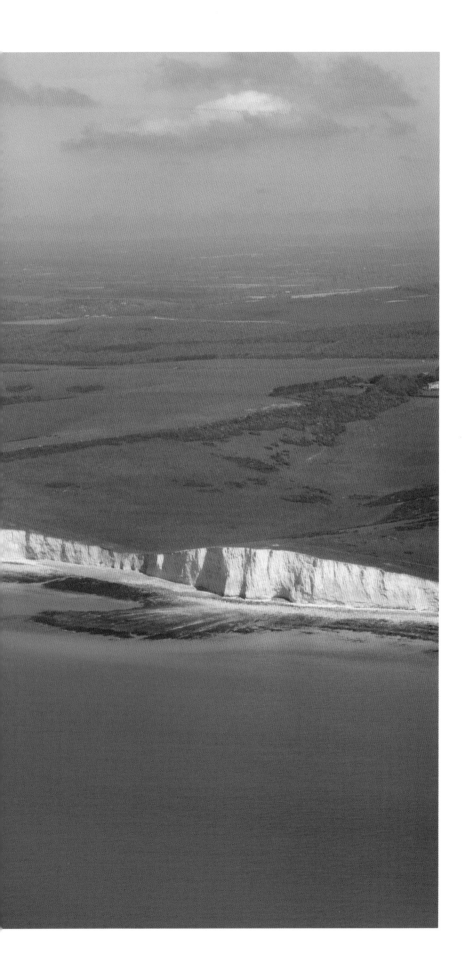

SEVEN SISTERS
2010

From this height the ripples in the land seem within touching distance – it would be easy to run a finger over their neat corrugations. However, the heads of the Seven Sisters stand up to 77 m (253 ft) proud of the waves and stretch for 3 km (1.9 miles) along the Sussex Coast.

For millennia they have presented travellers from Europe with a beautiful but intimidating and highly symbolic sheer cliff as a welcome to our island nation. There are seven rounded hills in this section, but after a small gap there stands Beachy Head, the highest and most famous of all the chalk peaks here, at 164 m (538 ft).

The chalk of the Sisters was formed around 100 million years ago, when the area was under the sea. The chalk then rose and was cut by the sea after the last ice age finished 12,000 years ago. This is still an active landscape, with the waves of the English Channel constantly nibbling at the base of the cliffs to undercut them. Rivers eat notches into the top while wind and rain lash the soft chalk face. The result is that every year the Sisters march backwards into the farmland by 30–40 centimetres. After heavy storms or rough seas major cliff falls are often clearly visible.

Nearby is Cuckmere Haven, which, as the only undeveloped river mouth in Sussex, offers a sanctuary for wildlife. The pristine condition of this area also makes it a popular film and TV location, with the Sisters frequently standing in for the white cliffs of Dover, which, with a large port at their base, are rather less photogenic.

SEA FORTS

Early in the Second World War, a series of sea forts were built in the Thames Estuary. This fort at Red Sand was one of three offshore complexes built by the Army. It was laid out like a shore-based anti-aircraft site: five gun towers with Bofors 40 mm anti-aircraft cannons surrounded a central control tower, with a searchlight tower at the rear. The towers were built at Gravesend and carried out on barges before being lowered onto the seabed by winches.

Four concrete legs supported each steel 'cell', which was self-contained with its own living and sleeping compartments and food and fuel supplies. The inhabitants could travel between the towers on narrow catwalks, which also carried power and fuel lines.

The towers shot down twenty-two enemy aircraft and twenty-five flying bombs. Abandoned after the war, the towers in the busiest shipping lanes were demolished but the others were sealed up, their walkways removed, and left to face the elements. Then, in the 1960s they were hijacked by pirates – of the radio persuasion. Screaming Lord Sutch set up a broadcasting station in one of the forts, however, Legislation in 1967 enabled the Government to shoo the pirates away, but many of the towers still stand today.

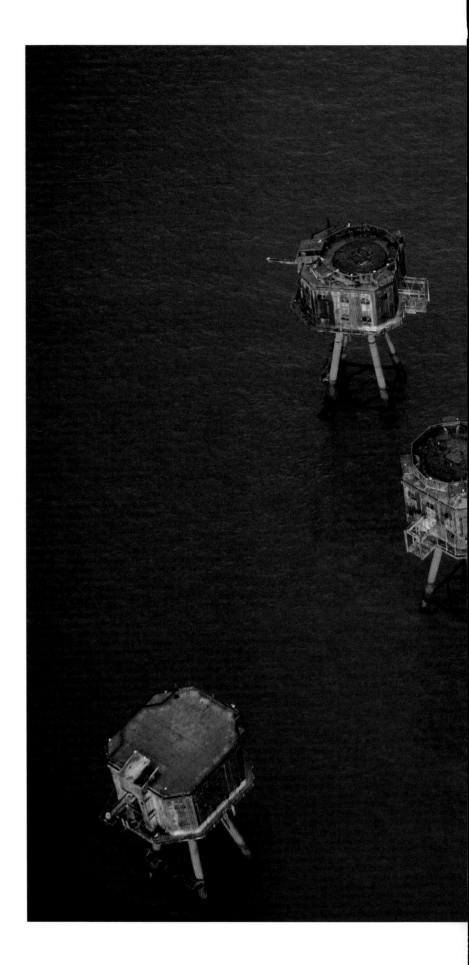

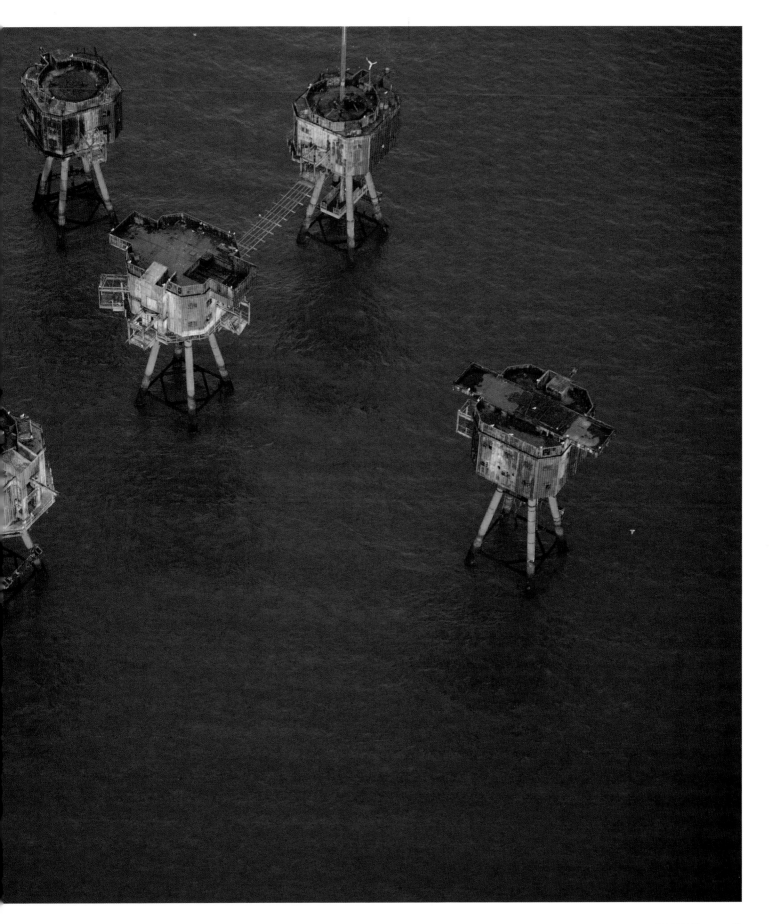

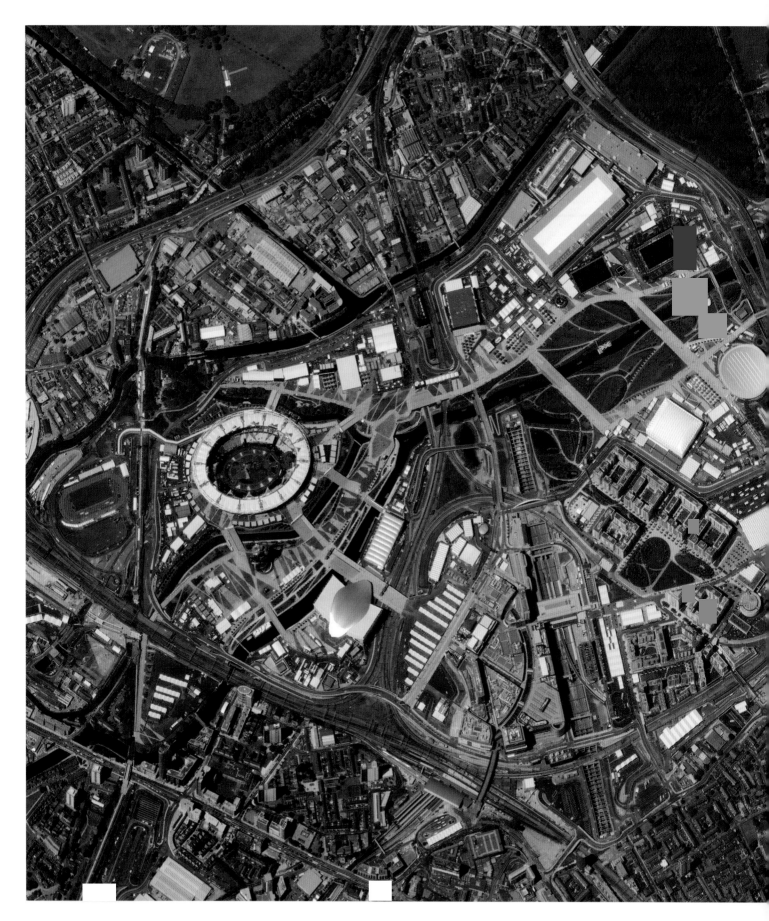

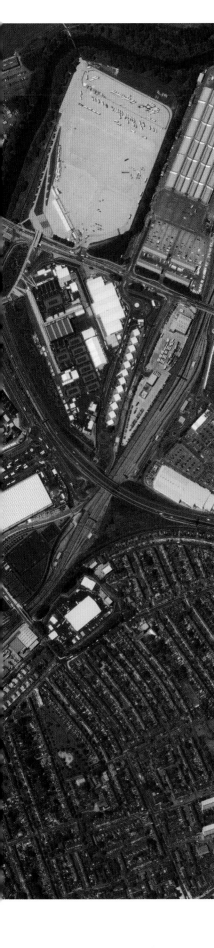

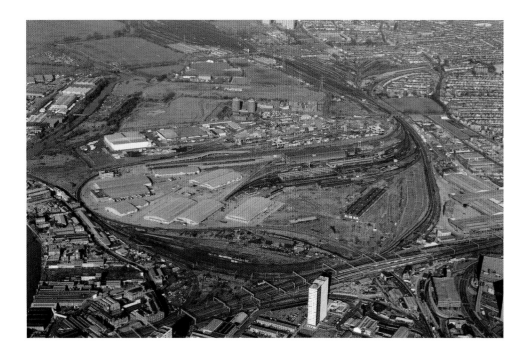

OLYMPIC PARK
1984 and 2012

The 2012 Olympics changed the face of London's east end forever. As the River Lea runs south on its route to the Thames it splits into several channels. These once meandered through medieval fields, but in the eighteenth century they were canalized to power mills and carry freight. Factories, foundries and huge railway works soon covered the whole river corridor.

Industry declined throughout the twentieth century, and by the 1990s the dilapidated canals ran between huge tracts of wasteland. Stratford could boast a 6 m (20 ft) high 'Fridge Mountain' – the biggest collection of discarded white goods in Europe. Then the Olympic clean-up began.

This 1984 photograph, taken from the southeast, shows the cranes, containers, sidings and warehouses of the railyards which formerly occupied much of this site, with industrial buildings along the river and the football pitches of Hackney Marsh in the top left.

The new Stratford International Railway Station is prominent towards the lower centre of the 2012 view. The apartment blocks of the Olympic Village lie just above and to the right of the new station, while Westfield Stratford City, the largest shopping centre in Europe, lies immediately to the left. The Olympic Aquatic Centre is situated on the riverbank farther to the left, with the ribbed roof of the Water Polo Arena just above this. The prominent loop of the old freight line on the 1984 view now carries the Docklands Light Railway, which runs between Westfield Stratford City and the Aquatic Centre/Water Polo Arena buildings in the modern image. The red Orbit sculpture now stands on the cleared strip of land between the two river channels farther to the left, with the Olympic Stadium just above this. The blue hockey pitches with their red pitchside areas are prominent above centre, with the media centre building above.

The £9 billion Olympic investment would appear to be worth it.

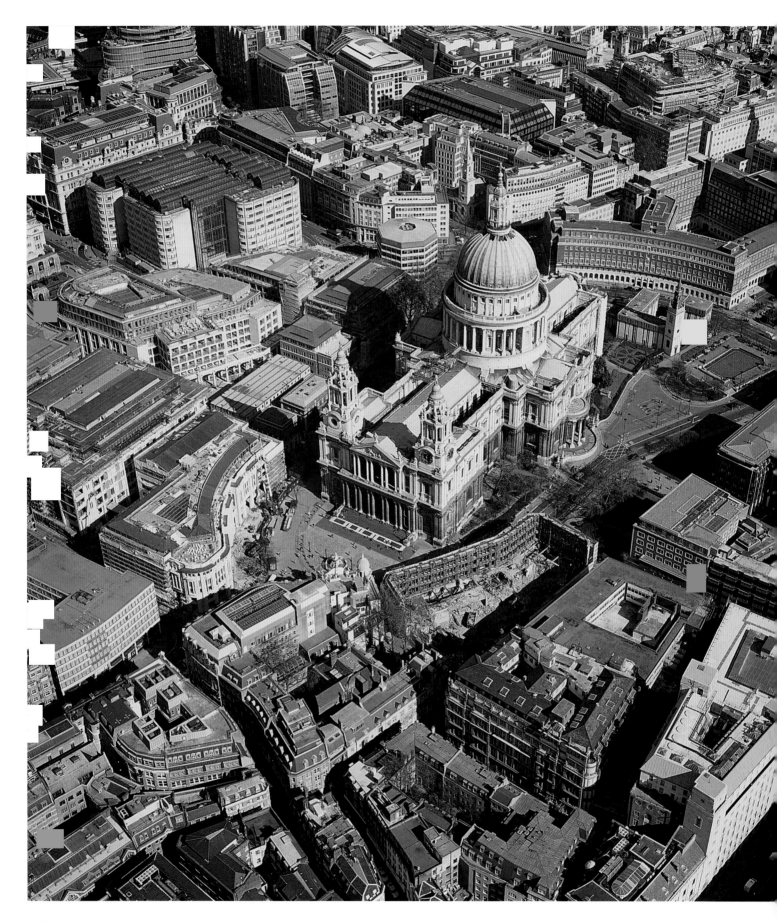

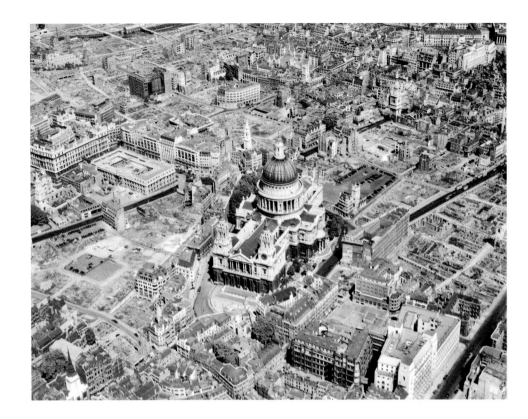

ST PAUL'S CATHEDRAL
1947 and 2014

A cathedral dedicated to St Paul has stood at the highest point in the City of London for more than 1,400 years. Designed by Sir Christopher Wren, the current church is the fourth to stand on the site, rising from the ashes after the Great Fire of London destroyed its predecessor in 1666. It stands 111 m (365 ft) high and was the tallest building in London from 1710 to 1962.

In 1940, it too very nearly succumbed to fire. For seventy-six nights from 7 September, the Luftwaffe unleashed hell from above on the capital in the form of 13,000 tonnes of high explosives and one million incendiaries. A third of the City of London was flattened and 20,000 people killed. Docks, train lines, power stations and gas works were obliterated and half the houses in the capital were damaged.

These photos show just how miraculous St Paul's survival was. This was in part thanks to the St Paul's Watch, a group of 300 volunteers that included the poet Sir John Betjeman. They patrolled the cathedral as the bombs fell, ready to extinguish any incendiaries.

A new generation of office buildings has since sprung up, but in a controlled way. Towers like the Gherkin and Shard can never be built around St Paul's or on eight key lines of sight, protecting its beacon-like profile.

THE SHARD
2013

It may polarize opinion, but the Shard is certainly iconic. At 306 metres (1,004 ft) high, it is the tallest building in the European Union. It stands on the south bank of the Thames by London Bridge station, and replaced a 25-storey office block built in 1975. The pyramidal tower's 87 floors are clad with 11,000 panes of glass, a total surface area of 56,000 sq metres (600,000 sq ft) – the equivalent of eight football pitches.

Architect Renzo Piano was inspired by the slim steeples and spires of eighteenth century London as painted by Canalleto. Ironically, the building's nickname came from criticism of the original design: English Heritage claimed it would be 'a shard of glass through the heart of historic London'. The Shard is mostly owned by the State of Qatar.

In July 2013, six female Greenpeace activists climbed the outside of the Shard from street level to summit to protest about oil drilling in the Arctic. Their ascent took 16 hours.

The Shard is not the tallest structure in Britain; that honour goes to the 330-metre (1,083 ft) transmission tower at Emley Moor.

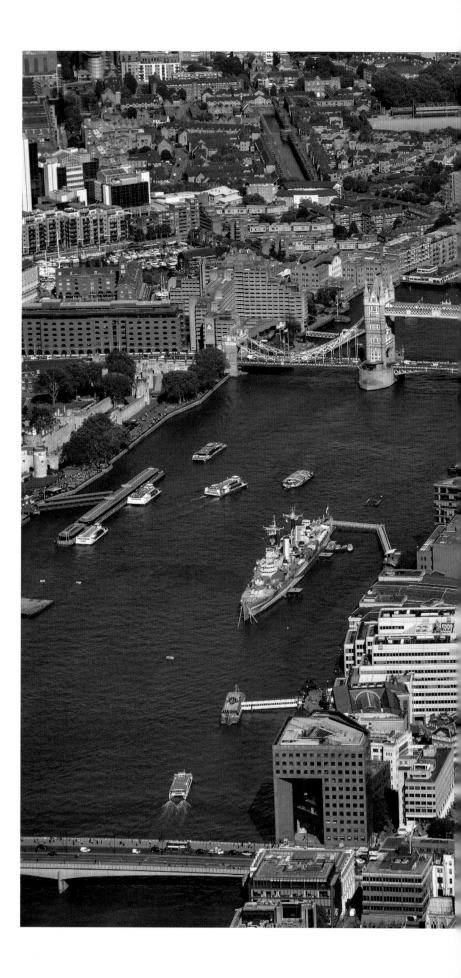

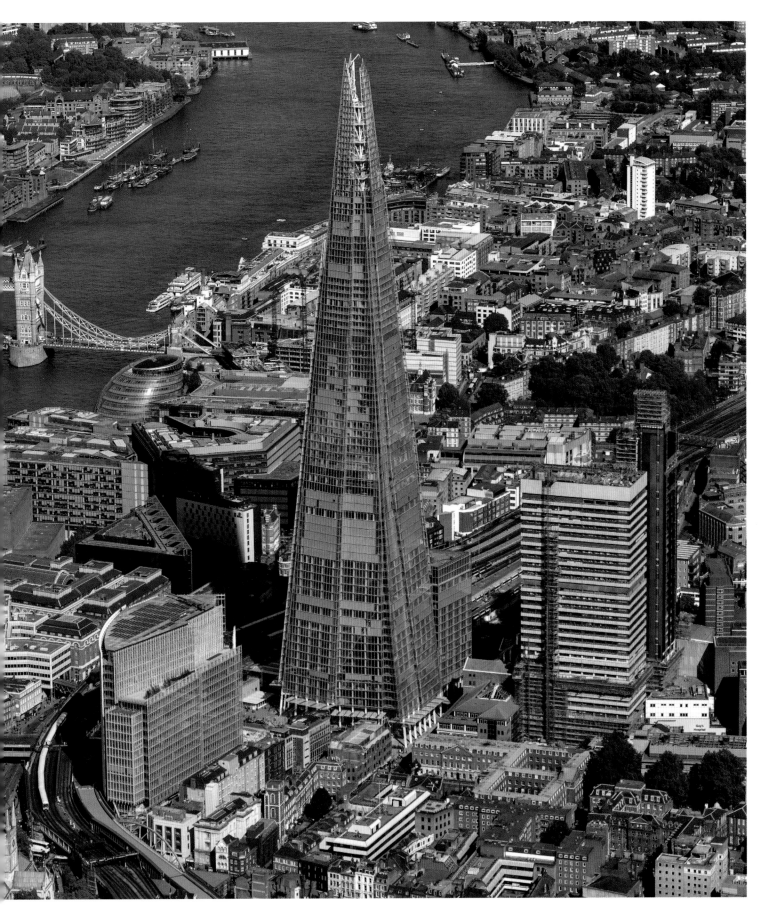

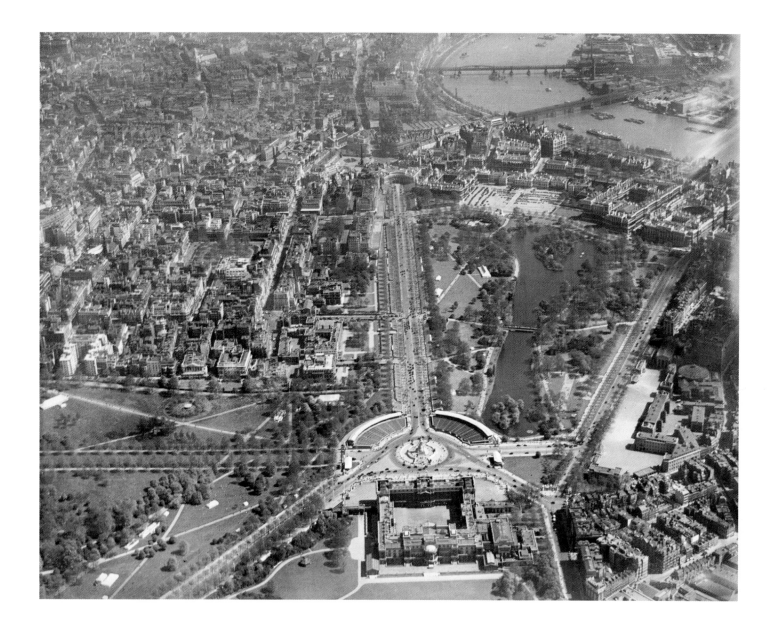

BUCKINGHAM PALACE
1937 and 2012

The front balcony of Buckingham Palace, with the Queen and other royals stepping out to wave to the crowds below, is an iconic British image, however, that famous façade is a relatively new part of the building.

The original house was built in 1703 for the 1st Duke of Buckingham. George III liked the house and bought it in 1761 as a private family retreat close to the official court at St James's Palace. George IV had John Nash double it in size in 1826, adding a suite of State rooms on the garden side and new service wings. Now it formed a palatial U-shaped courtyard. The Marble Arch, built to commemorate the victories at Trafalgar and Waterloo, was its centrepiece.

Queen Victoria found it too small for her growing family, so she had the fourth wing built in 1847 to enclose the quadrangle. This required the removal of Marble Arch, which was placed at its present site near Speaker's Corner.

By 1913 the east front's soft French stone was crumbling; it was refaced with Portland stone and remodelled into its current landmark form. This picture clearly shows the contrast between the French neo-classical design and mellow Bath stone of the west wing and the paler, more modern style of the east front.

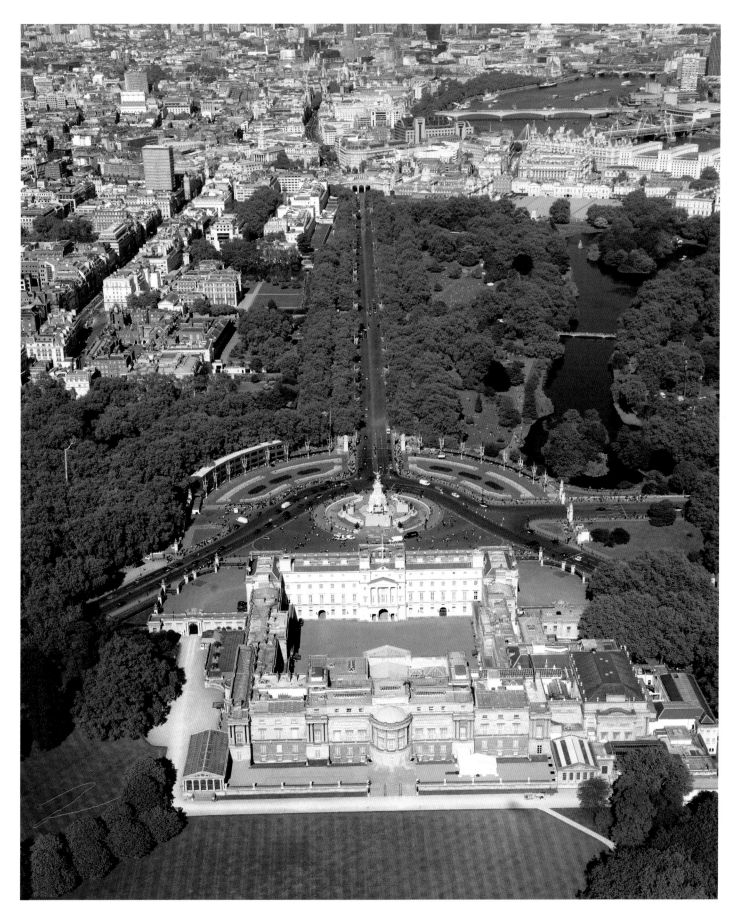

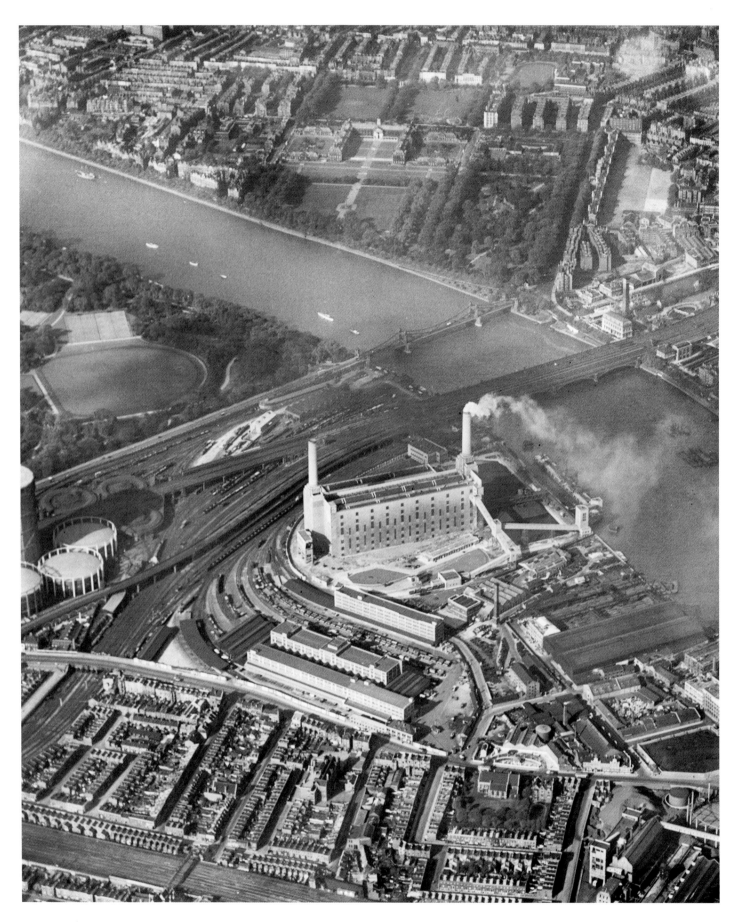

BATTERSEA POWER STATION
1933 and 2011

Battersea Power Station only had two chimneys when it opened in 1933, as seen in this photo. It only achieved its iconic four-chimney layout 20 years later, when the 'B' station was built as a mirror-image of the original 'A' station, and opened in 1953.

The station was deliberately sited in the heart of the metropolis – close to its customers, with the Thames nearby for cooling water and coal barges. When local residents protested about the size and ugliness of the planned building, the power company hired Sir Giles Gilbert Scott, of Liverpool Anglican Cathedral and red telephone box fame, to design the exterior.

Londoners loved the design of his 'brick cathedral', and it became a cultural icon, appearing in films and on the cover of Pink Floyd's 1977 album *Animals*. It was beautiful inside, too: the control room had Art Deco fittings, with Italian marble, polished parquet floors and wrought-iron staircases.

When its 1983 closure was announced, campaigners successfully got the building Grade II listed. The station's roof was removed in the late 1980s, when there were plans to convert the structure into a theme park. Several other development schemes have all fallen through; a current proposal for apartments is scheduled for 2017.

The station is still the largest brick building in Europe.

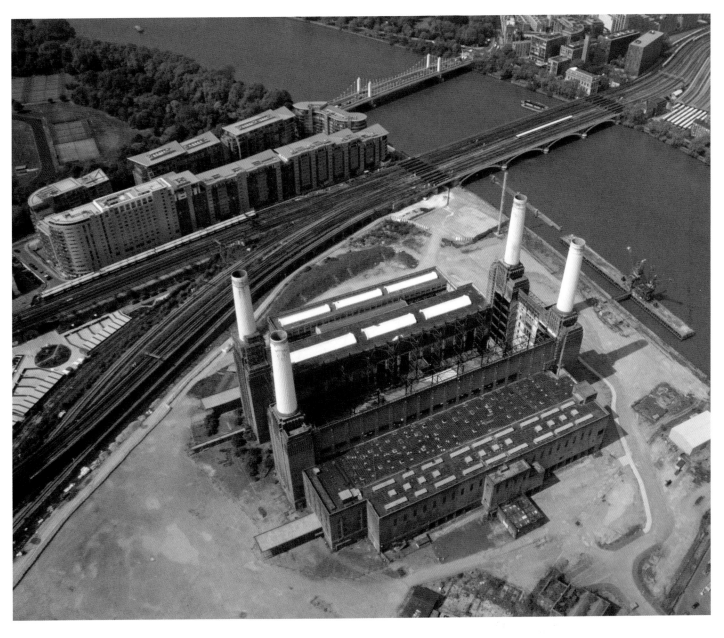

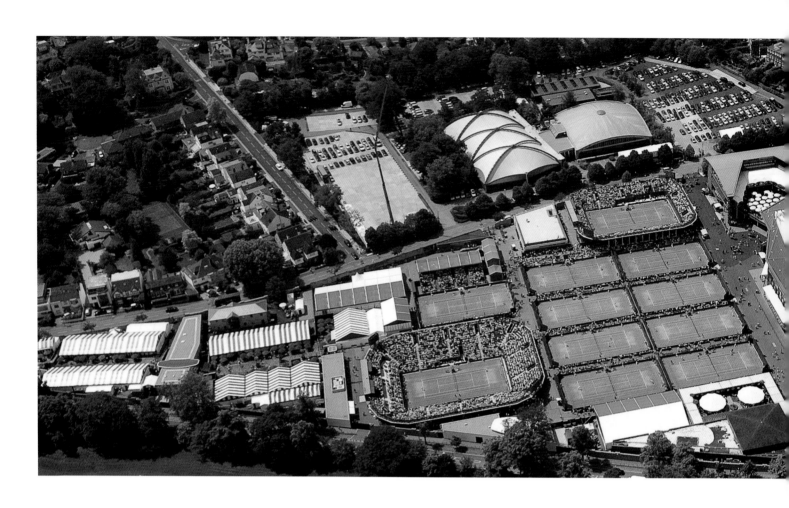

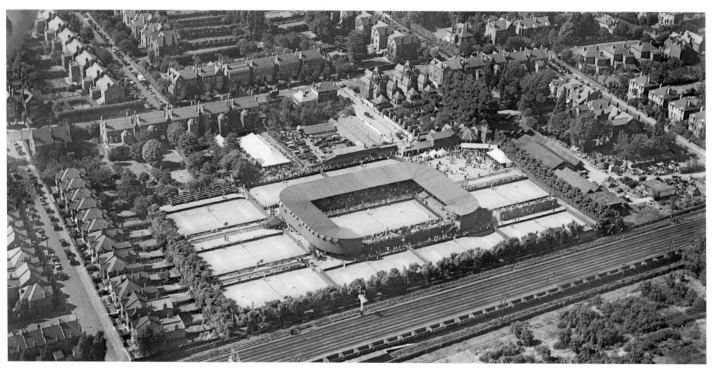

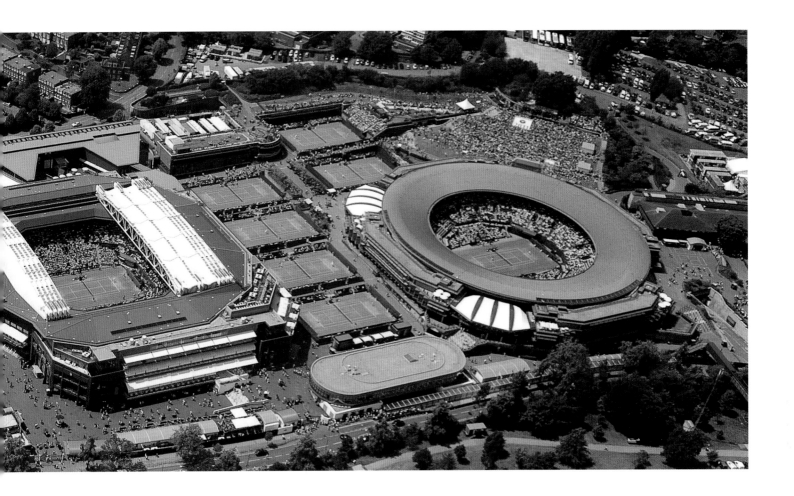

WIMBLEDON
1921 and 2011

Tennis was an afterthought at Wimbledon. The All England Club was founded in 1868 as a croquet club. When lawn tennis was invented a few years later by Major Walter Clopton Wingfield (he gave it the memorable name 'Sphairistike'), a single lawn at the Worple Road grounds was set aside for the game. The first Championships were held in 1877, principally to raise money for a pony-drawn grass roller. The club soon became The All England Croquet and Lawn Tennis Club.

In 1922, swelling spectator numbers forced the club to move to much larger grounds at Church Road. The huge crowds were mostly there to see French sensation Suzanne Lenglen, who played in clinging silk skirts and, no matter how hot the sun, a fur coat.

Wimbledon is the only major championship still played on grass and is the most prestigious. The All England club has nineteen grass courts, most of which are used by club members. Centre court is only used for the Championships. It can hold 15,000 spectators and since 2009 has had a retractable roof to keep out the occasional summer rain. In 2013, Andy Murray became the first British male Champion in seventy-seven years.

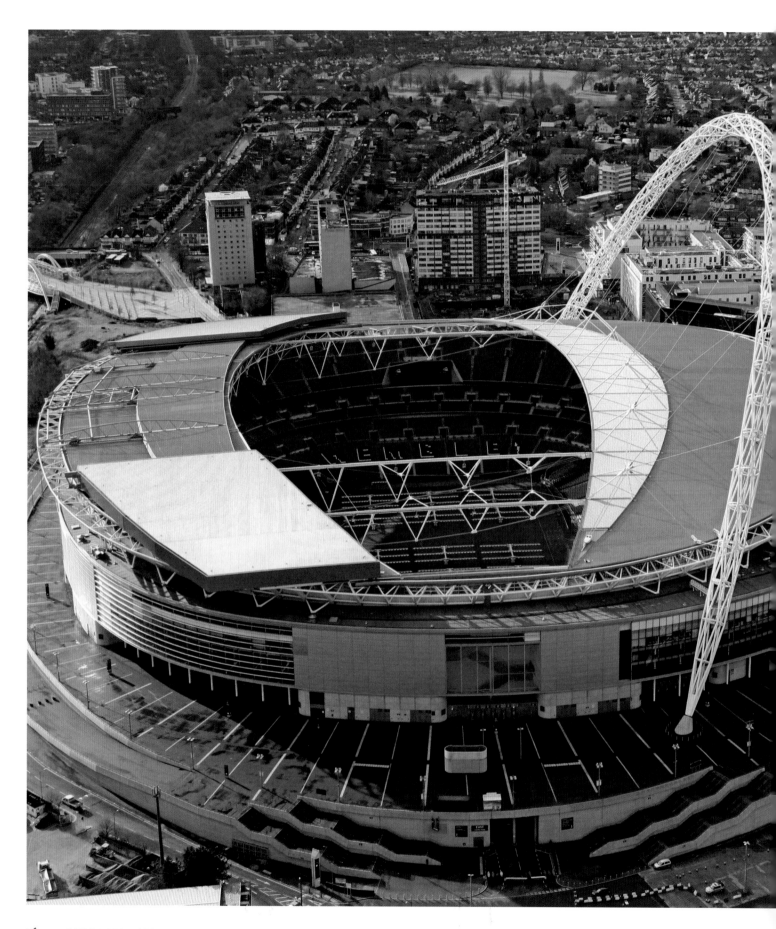

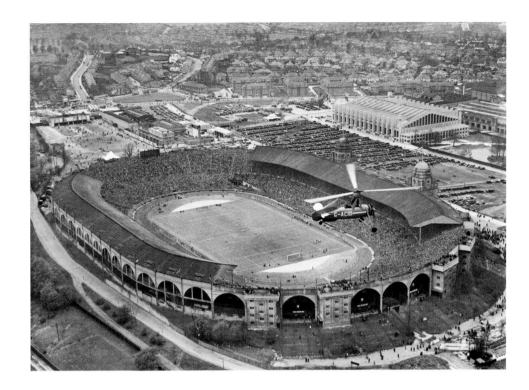

WEMBLEY
1935 and 2012

It's 27 April 1935 and the FA Cup final kicks off at Wembley Stadium. Sheffield Wednesday went on to beat West Bromwich Albion 4–2 in front of 93,204 fans. In the foreground is a Cierva autogyro, flown by Scotland Yard as part of an early experiment in monitoring crowds from the air.

The original Wembley stadium cost £750,000 and was built for the British Empire Exhibition of 1924. It was meant to be demolished at the end of the Exhibition, but was saved at the last minute. Its twin towers became an icon for England before their demolition in 2003. Wembley was the first pitch to be referred to as "Hallowed Turf".

The new Wembley Stadium was built on the site of the old one at a cost of £757 million. It opened in 2007. Its capacity of 90,000 makes it the second largest stadium in Europe, after Camp Nou in Barcelona.

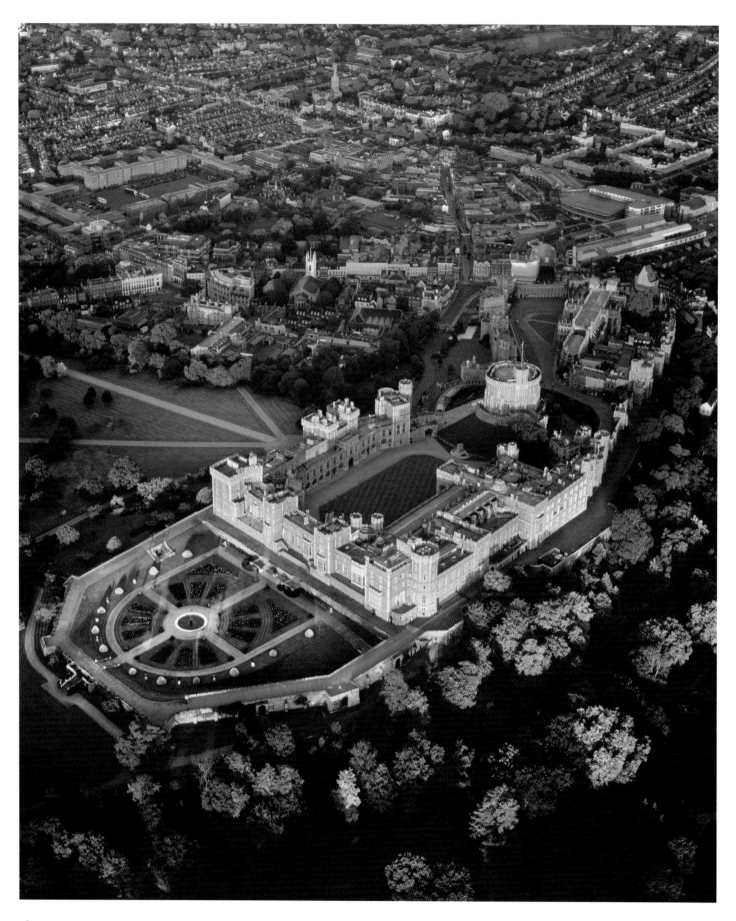

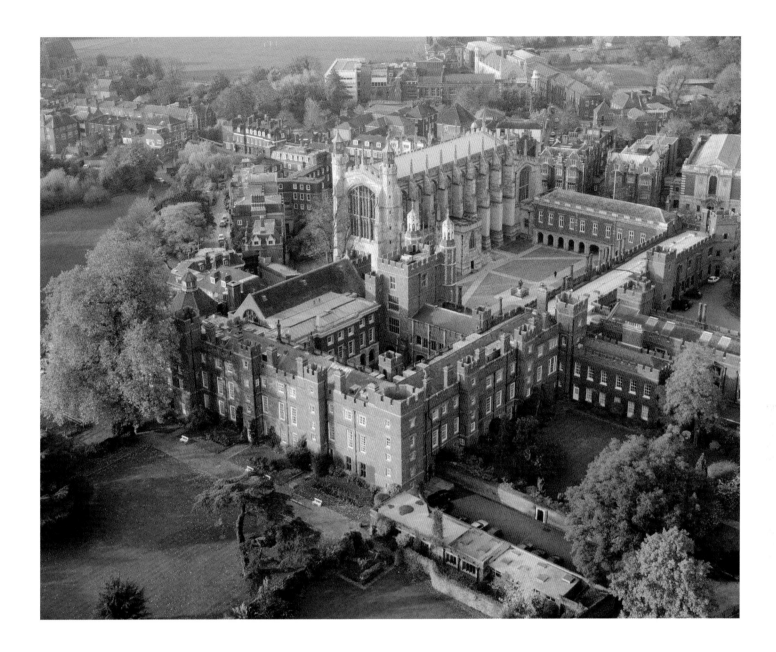

WINDSOR & ETON
2010

Windsor is the oldest inhabited castle in the world, established on this spot by William the Conqueror more than 900 years ago. The enormous twelfth century Round Tower stands on the site of the original motte and bailey, and the castle was extended and frequently rebuilt by successive monarchs. The sumptuous State Apartments date from the nineteenth century. Ten English monarchs are buried inside the fourteenth century St George's Chapel. The castle sprawls over 5 hectares (13 acres), making it also the world's largest inhabited castle. The grounds are equally majestic in scale: the Home Park immediately surrounding the castle covers 200 ha (500 acres), while the Great Park (where Shakespeare set The Merry Wives of Windsor) is even larger at 700 ha (1,800 acres). It was originally the castle's private hunting ground.

Windsor is more than a fortification: it is a royal palace, a venue for state visits, a major tourist attraction, and a museum with priceless works by Rembrandt, van Dyck and da Vinci. With 500 people living and working within the castle, in many ways it functions as a small town. It is also the Queen's favourite weekend bolthole. The castle was gutted by a fire in 1992 that destroyed over 100 rooms – a fifth of the castle area. It was restored and reopened in 1997.

Just across the Thames is Eton College, Britain's most famous public school. Annual fees in 2014 were just under £30,000 for the 1300 boys studying there, but ironically the school was founded by Henry VI in 1440 with the specific aim of giving 70 poor boys a free education. Teachers were recruited from Winchester College, which had been founded a century earlier. Nineteen British Prime Ministers have been educated at Eton.

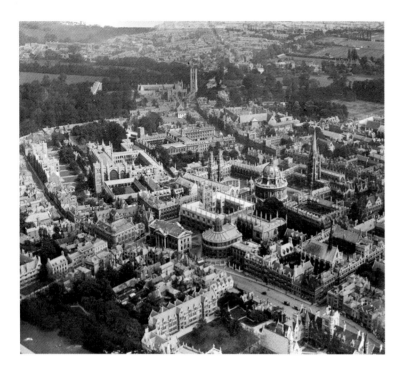

OXFORD

Oxford is the oldest university in the English-speaking world, with a history dating back to at least 1096. With most of its colleges many centuries old, its centre is slow to change. However, this pair of images shows perhaps the largest new addition to the core of the collegiate city.

Easily recognisable in both the 1920 and modern day image is the circular, domed, Radcliffe Camera, which was originally built in 1749 a specialist science library ('camera' is Latin for 'room'). Since 1860 it has been part of the Bodleian library, one of Europe's oldest libraries and the second largest in the UK (after the British Library) with over 11 million items. The Bodleian has been in almost continual expansion since Thomas Bodley refurbished a modest room above the Divinity School and donated a few books in 1602.

The green-roofed quadrangle to the top right of the Radcliffe is the Old Bodleian Library building, completed in 1619. In 1909 the library was expanded downwards, with a massive underground bookstack.

The ramshackle group of houses visible in the 1920 image across Broad Street from the Clarendon was cleared in 1937 for the biggest extension yet. Completed in 1940, the New Bodleian was the work of Sir Giles Gilbert Scott, designer of Battersea Power Station, Liverpool Cathedral and the classic red telephone box.

The building's unusual ziggurat design has 60 per cent of its shelving below ground level. A tunnel under Broad Street connects the old and new buildings with a pedestrian walkway and a book conveyor.

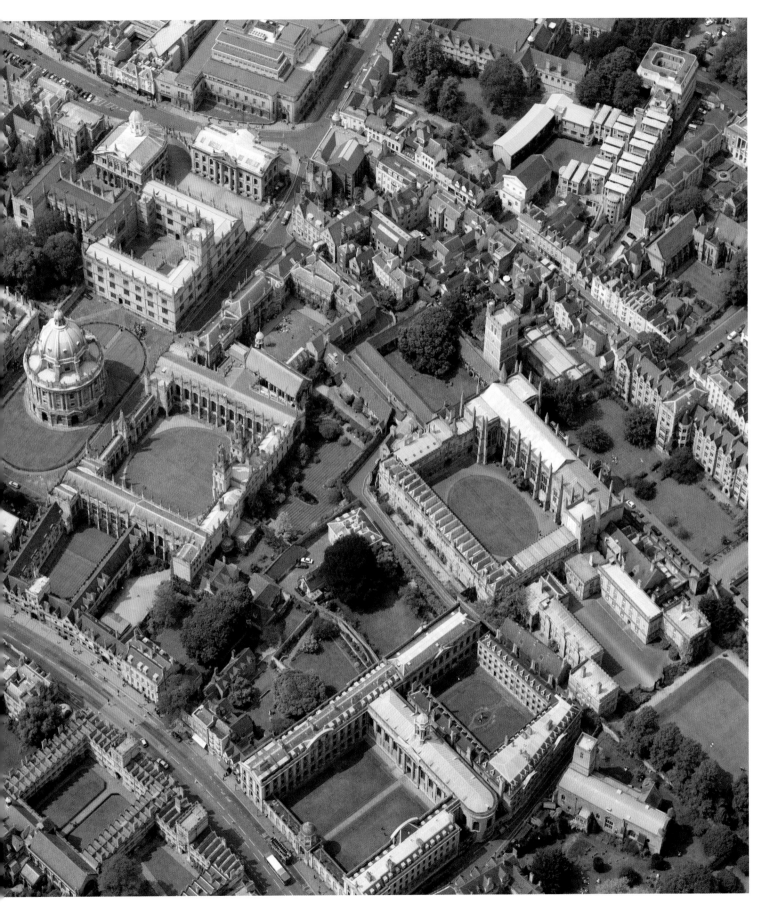

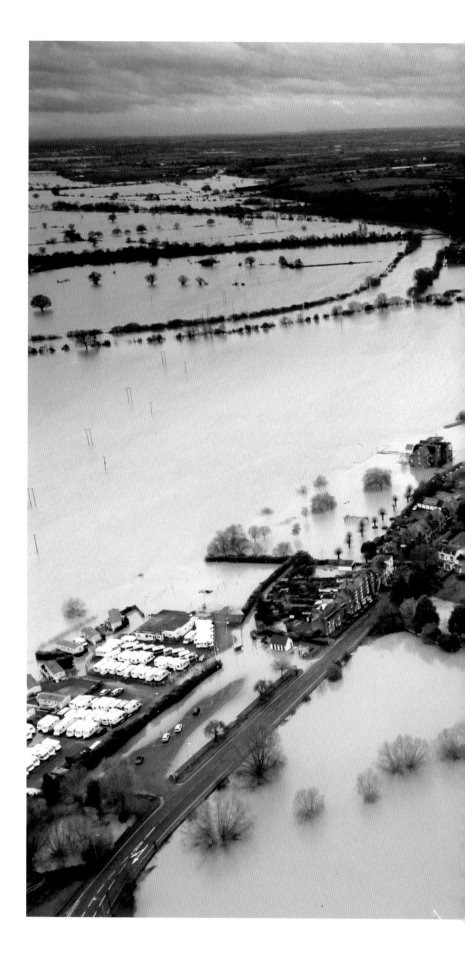

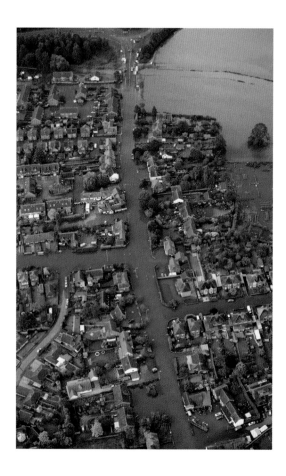

FLOODING, TEWKESBURY
2007 (above) and 2012 (right)

Tewkesbury stands on a crescent-shaped rise just east of where the great Rivers Severn and Avon meet. Surrounded by great swathes of low-lying farmland, it is particularly susceptible to flooding.

This image from November 2012 shows the twelfth century Abbey standing just proud of the flood that followed some of the wettest weather in British history. This masterpiece of Norman architecture is the second largest parish church in Britain. It is built of French stone, which was quarried in Caen and then floated over the English Channel and up the Severn.

The rainfall in June 2007 was 140 mm (5.5 inches), more than double the average. In some places a month's rain fell in 24 hours. The period from May-July was the wettest since records began in 1776. This extraordinary deluge was repeated on a similar scale in 2012 and 2014.

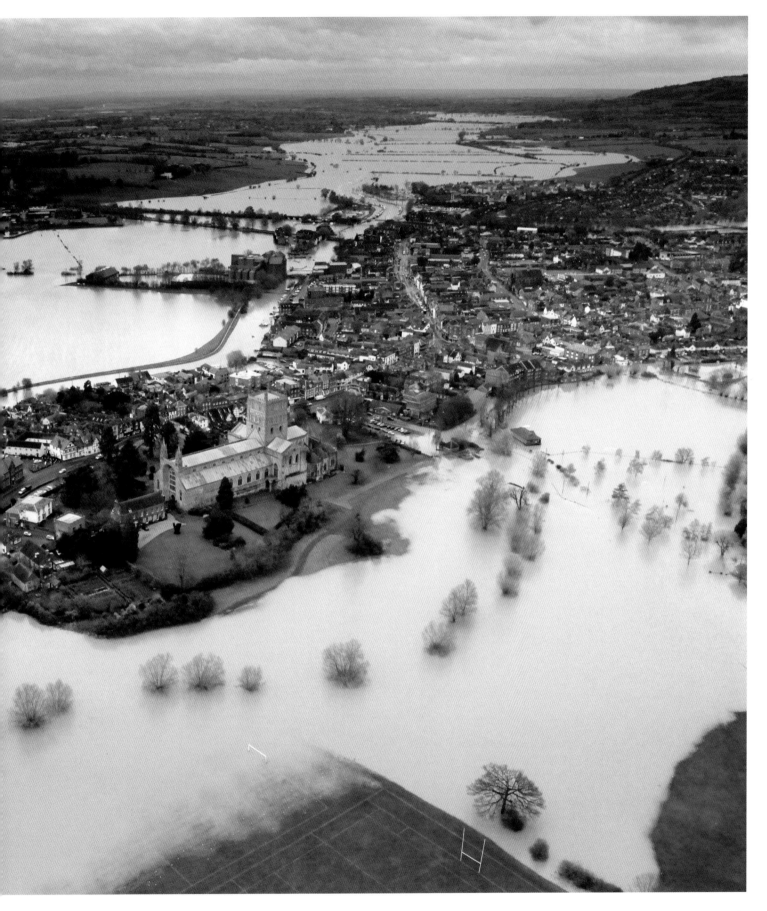

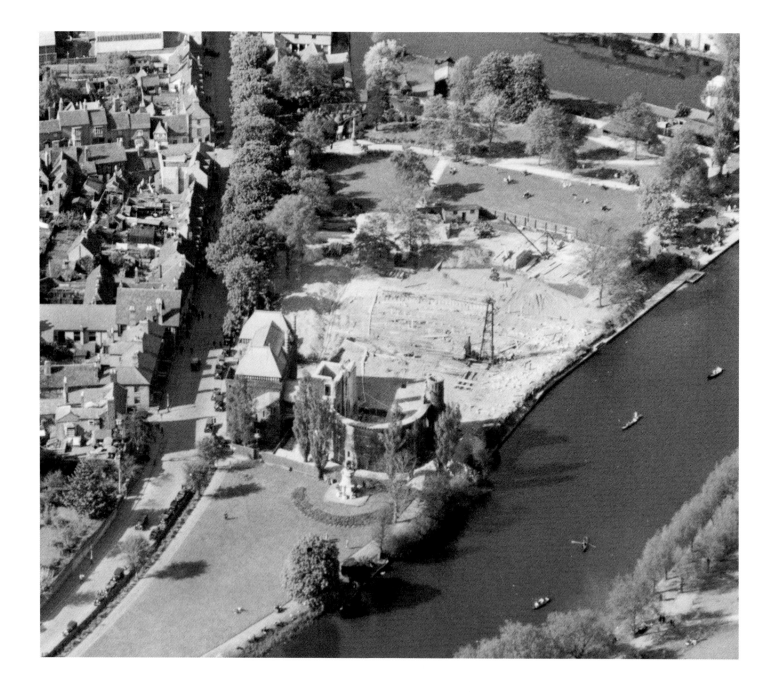

STRATFORD-UPON-AVON
1929 and 2012

A fire consumed the original Victorian gothic Shakespeare Memorial Theatre in Stratford in 1926, just three years before the first photograph was taken. By 1932, the Royal Shakespeare Theatre had risen from the ashes. It was the first major public building in the country to be designed by a female architect – Elisabeth Scott. Its rather functional exterior drew very mixed reviews at the time. Playwright George Bernard Shaw praised it, but the theatre's supposed new musical director, Sir Edward Elgar, was so angry at the building that he refused to enter it.

The new Swan theatre was completed within the remains of the old Memorial Theatre in 1986. In 2007, the Royal Shakespeare Company began a major project to rejuvenate the whole theatre complex. New restaurants, cafes and public spaces were created, and the Royal Shakespeare Theatre was transformed: its grand proscenium arch replaced by a thrust stage auditorium more in keeping with the play-going experience of Shakespeare's day.

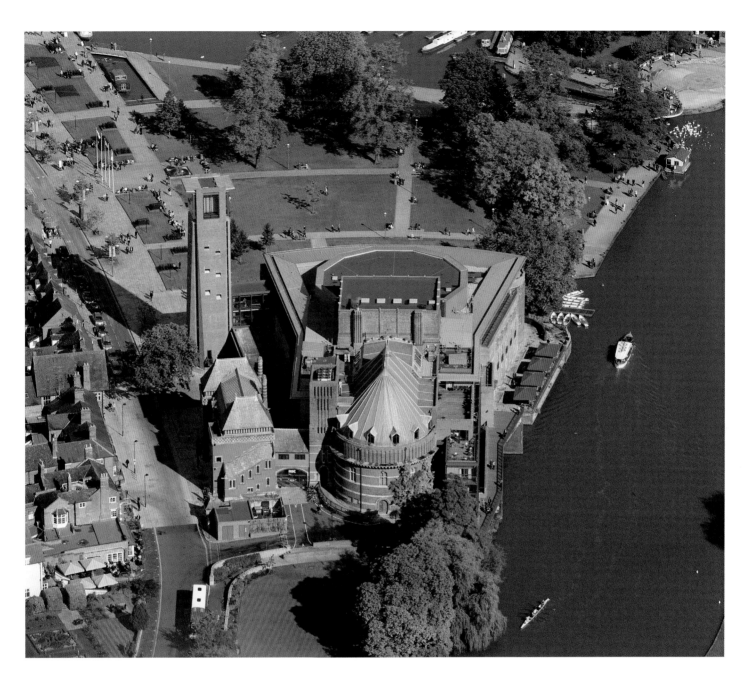

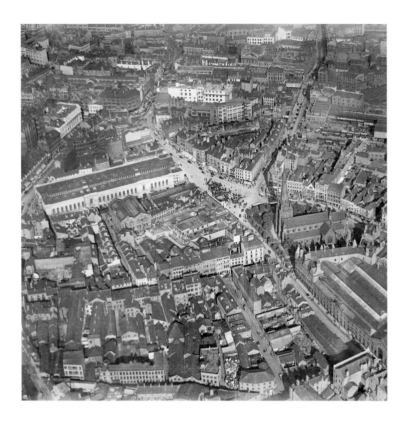

BIRMINGHAM
1931 and 2014

A church has stood on the site of St Martin's in Birmingham since at least 1263, and throughout those centuries it has been surrounded by the hustle and bustle of markets. In the Middle Ages, open-air markets for fish, corn, cloth, spices and cattle grew up around the church. The area became 'the Bull Ring' after a space in the corn market that was used for bullbaiting. In 1835 a covered Market Hall (middle-left in the 1931 photo) opened with the same goal as today's Bullring – to hold retail outlets and to impress visitors. Stretching 111 m (365 ft), it was clad in Bath stone with grand Doric columns flanking its wide entrances, and held 600 market stalls. For a century this mighty building was the hub of daily life in the city, until it was destroyed in 1940 by an incendiary bomb.

In the early 1960s the old markets were demolished and new roads laid out as part of extensive redevelopments. The infamous 1964 Bull Ring Centre was the first indoor city-centre shopping centre in the UK, but its concrete, boxy design was never widely popular. It was redeveloped into the Bullring, which became Britain's busiest shopping centre when it opened, with 36.5 million visitors in 2004.

St Martin's is virtually the only structure visible in both images.

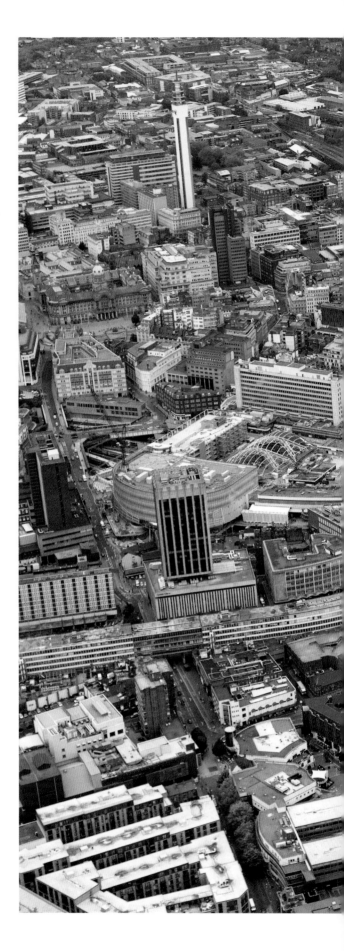

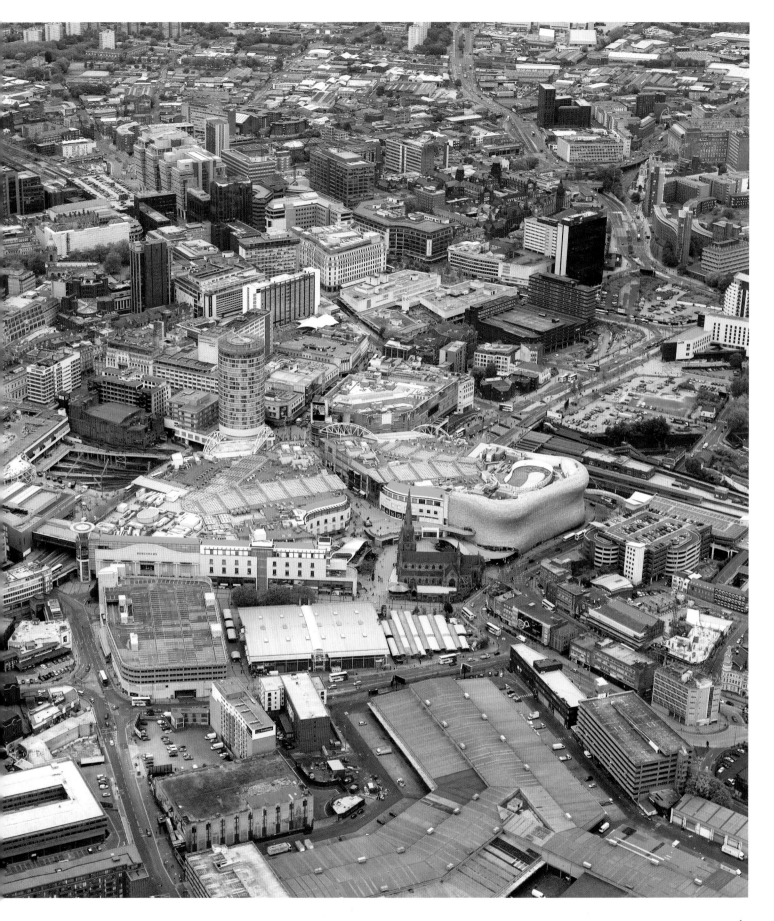

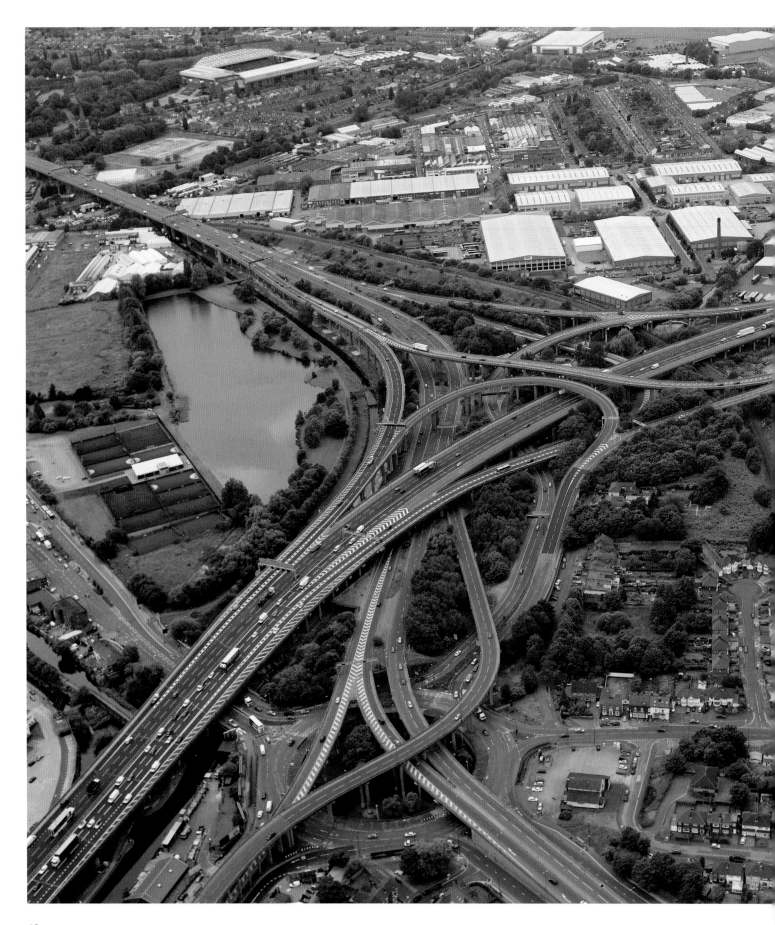

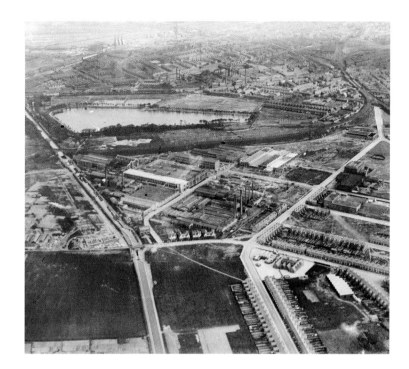

SPAGHETTI JUNCTION
1920 and 2014

Over 200 road interchanges around the world are known as 'Spaghetti Junction' but this is the original. Junction 6 of the M6 was given its nickname in 1965 – seven years before it even opened – by bemused local journalists writing about the plans.

Spaghetti Junction links the motorway with the A38, the Aston Expressway, the A5127 and several unclassified local roads. Its Sunday name is the Gravelly Hill Interchange.

Avoided by drivers, the junction is admired by engineers: it covers 30 acres (12 ha) over five different levels, and hoists the motorway for 21.7 km (13.5 miles) over two railway lines, three canals, and two rivers.

This 1920 photo shows the rows of electrical engineering and other manufacturing works lying to the northwest of the reservoir in Salford Park. The canal that runs from bottom to top left of the picture has working barges on it. The bridge that carries the railway over this canal still exists; it hides in the shadows below a tangle of slip roads.

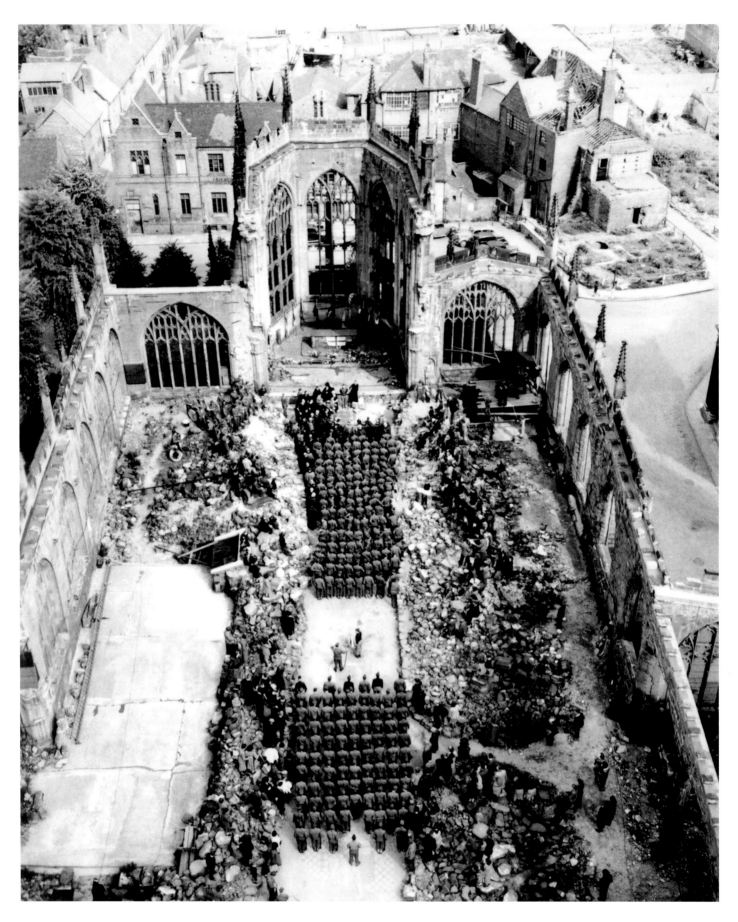

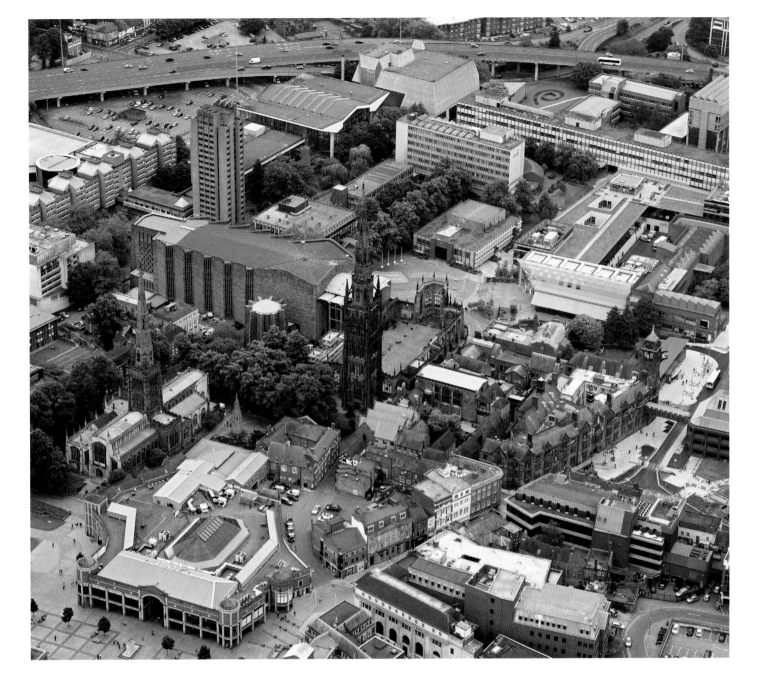

COVENTRY
1945 and 2014

St Michael's Cathedral in Coventry stood for 700 years until the night of 14 November 1940. In a few hours, the Luftwaffe dropped 500 tonnes of high explosive and 36,000 incendiary bombs on the manufacturing city, destroying most of the buildings in the centre, including the medieval cathedral. When the dust settled, only the tower, spire and outer wall were still standing.

This moving photograph, shot as if from the heavens above, shows a Mother's Day service being held in the roofless building. It is 13 May 1945, just a few days after Germany surrendered, and the men attending are wounded US soldiers from nearby convalescent hospitals.

In 1950 a competition was held to choose a design for a new cathedral. The winning proposal, by Basil Spence, was selected from 200 entries. Spence proposed that rather than re-build the old cathedral, the ruins should remain as a garden of remembrance, with a new cathedral built alongside. Today the old shell remains as hallowed ground alongside Spence's modernist building, creating a single church and symbol of reconciliation. Spence was later knighted.

After the destruction of the medieval cathedral in 1940, the Provost had the words 'Father Forgive' inscribed on the wall behind the altar of the ruined building. The 90 m (295 ft) mediaeval spire remains the tallest building in Coventry.

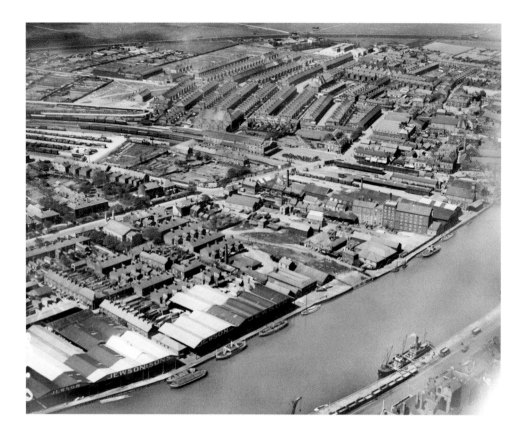

THE BROADS
1928 and 2010

The Broads offer a serene natural landscape for boating and walking – except that this network of navigable rivers and lakes is man-made. There are 200 km (120 miles) of waterways covering 303 sq km (117 sq miles) of Norfolk and Suffolk. They vary from small pools to the huge expanses of open water, but almost all are less than 4 m (13 ft) deep.

Their true nature was unknown until 1965, when it was proved that in the Middle Ages, the area was a vast peat moor. Local monks began hand-cutting the peat and selling it as fuel in Norwich and Great Yarmouth. The business grew rapidly, and the area became a network of diggings – Norwich cathedral alone took 320,000 tonnes of peat a year. Then the sea levels began to rise, and the pits flooded. Many attempts to hold back the waters were made, with dykes and wind-pumps, but Nature won through in the end, creating the reed beds, grazing marshes and wet woodland we see today.

For centuries the Broads formed a vital trading network. Norfolk wherries – wooden vessels with distinctive high-peaked sails – transported cargo through the reeds. The 1928 image shows wherries among the vessels picking up timber from the yard of Jewson & Sons at Great Yarmouth. This chain of builders' merchants was founded in East Anglia in 1836.

The railways made this trade uneconomic in the nineteenth century, and many boat owners converted their craft to service the tourist trade. Today the Broads are Britain's favourite boating holiday destination.

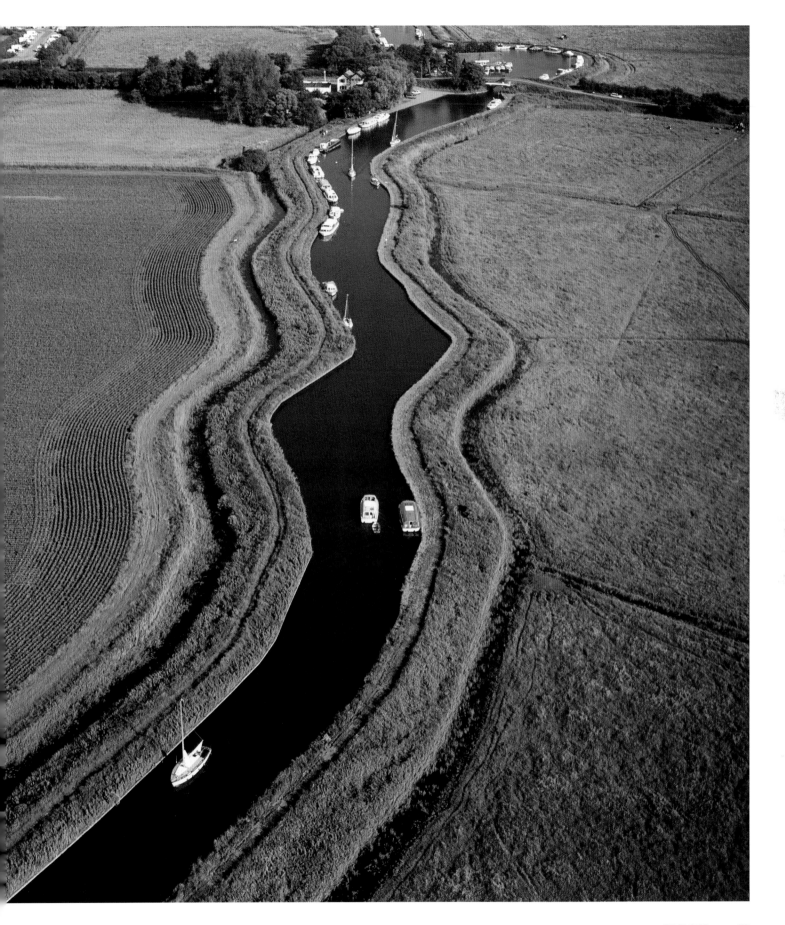

HAPPISBURGH
2008 and 2010

Happisburgh was once a quarter of a mile from the sea; now it's falling into it. When sea level reached its current position, the Norfolk cliffs had been constantly eroding for around 5,000 years. Rainwater running off the land cuts gullies in the weak, sandy cliffs from the top, while waves undercut them from below. These forces combine to cause severe landslides.

Alarmingly, there is evidence that this process is speeding up. Historical records show that from 1600 to 1850, over 250 m (820 ft) of land at Happisburgh crumbled into the waves. Between 2004 and 2007 it retreated 20 m (66 ft). An average of one property disappears forever each year and is clearly demonstrated in these images.

Man-made coastal defences have slowed down the erosion, but these structures themselves are now in disrepair. Sea-level rise and climate change, including increased storminess, may further accelerate the erosion.

Ironically, although Happisburgh is now disappearing, it is one of the oldest inhabited places in Britain. Flint tools over 800,000 years old were unearthed here in 2010, making it one of a handful of Paleolithic sites in the UK.

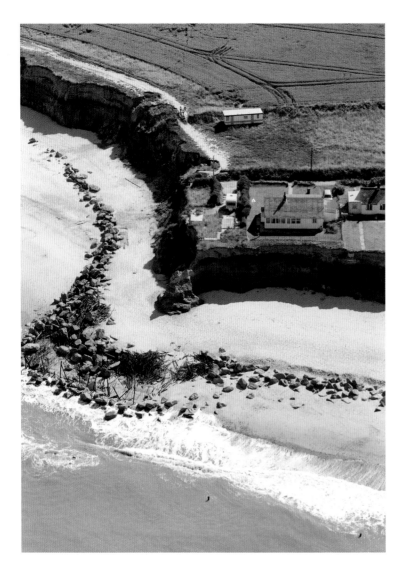

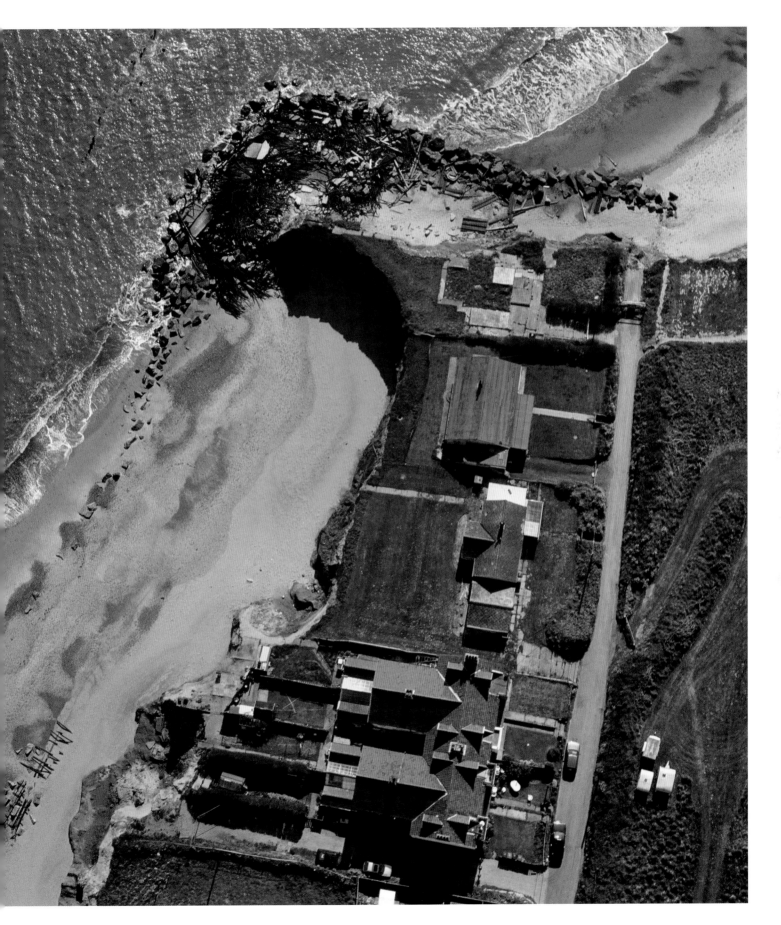

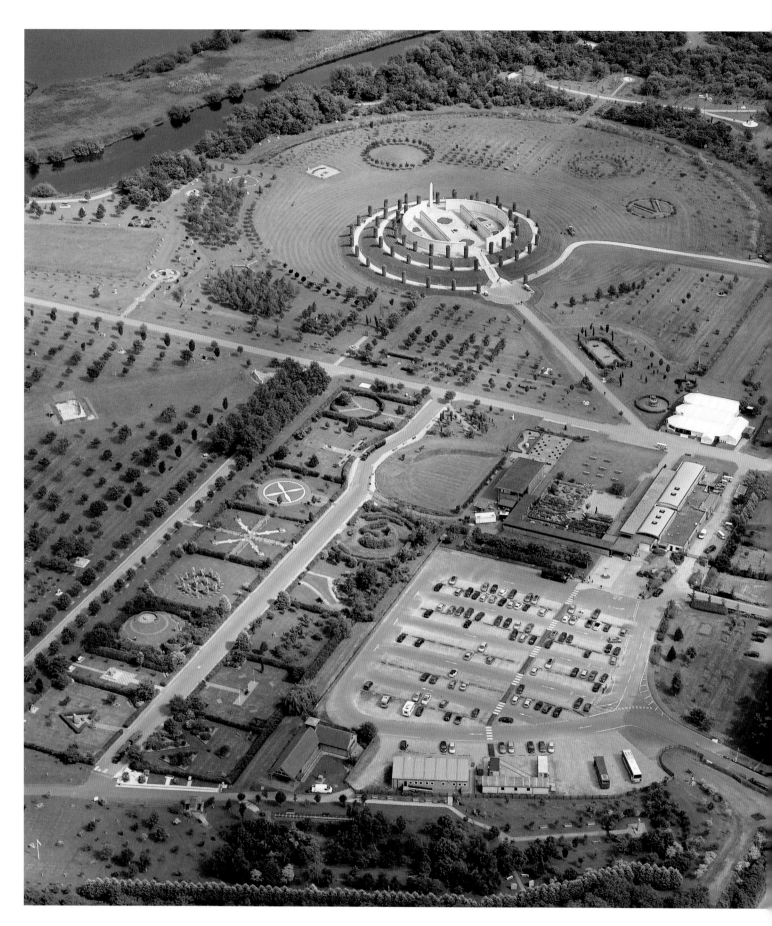

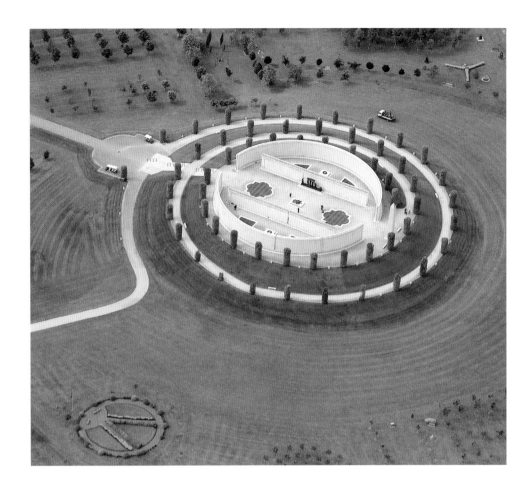

NATIONAL MEMORIAL ARBORETUM
2014

The National Memorial Arboretum at Arlewas, near Lichfield in Staffordshire, has been designed to provide an all-year-round memorial to honour those who have fallen in the service of our country and an attractive, peaceful environment in which they can be remembered. Developed on 61 hectares (150 acres) of old gravel workings at the western end of the National Forest, it was officially opened in May 2001.

In addition to the main Armed Forces Memorial, which is dedicated to over 16,000 service personnel who have lost their lives while serving their country since the end of the Second World War, the gardens contain over 250 individual memorials to various branches of the armed services, civilian organisations and voluntary bodies. Several of these were relocated to the National Arboretum when their original owners, including banks, building societies, and other corporate bodies, either ceased to exist, were unable to properly care for their memorials, or felt that they would be more widely appreciated when situated at this impressive facility.

The arboretum now contains over 50,000 trees, with more being planted as it continues to grow. Plans to develop the facility into a world-renowned centre for remembrance were announced in 2009. These include a pavilion to stage special events and a remembrance and learning centre for visitors, which will complement the existing visitor centre.

The National Memorial Arboretum is part of the Royal British Legion family of charities, and it currently welcomes around 300,000 visitors and stages over 200 special events each year.

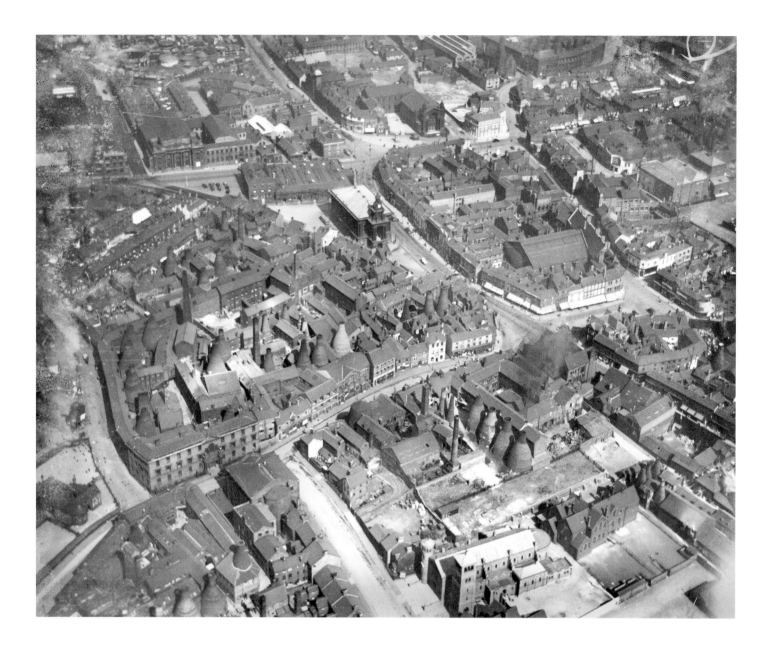

BURSLEM
1929 and 2014

An abundance of coal and clay made North Staffordshire an ideal location for earthenware production, and there were around 130 potteries in the present day area of Stoke-on-Trent by 1750. Most of these were small operations producing crude stoneware, but in 1765 one man changed English pottery forever. His name was Josiah Wedgewood.

Born into a family of potters, Wedgewood lost his leg to smallpox while still a boy. As he could no longer throw pots, he devoted his considerable energies to experimentation. In 1765 he unveiled a completely new form of cream earthenware. It so impressed Queen Charlotte that he was allowed to call it 'Queen's Ware' and this new crockery became a sensation.

In 1775, after four solid years of experiments and 3,000 failed samples, Wedgwood perfected another innovation: blue jasperware, which again was extraordinarily successful worldwide. Over the next two centuries, Wedgwood's descendants would help Stoke-on-Trent become the heart of England's globally successful pottery industry.

The 1929 photograph shows the cluster of active potteries with their distinctive bottle kilns around the Town Hall in Burslem, Wedgwood's home town. Although there was a general decline in the Potteries from the 1970s, Wedgwood still produces ceramics in the area and there are many successful specialist manufacturers.

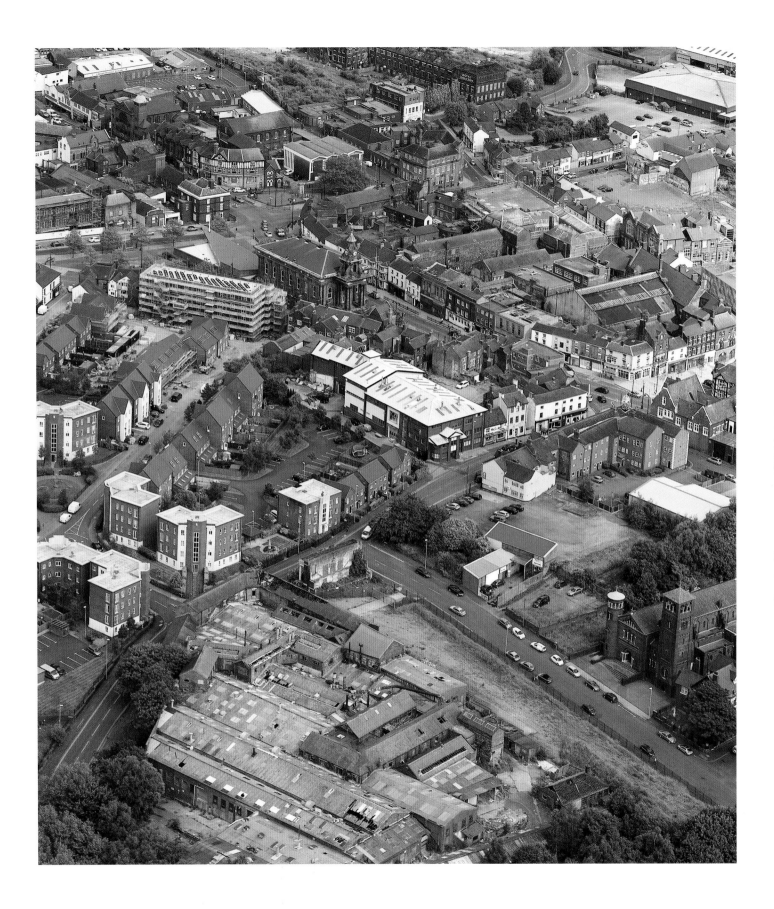

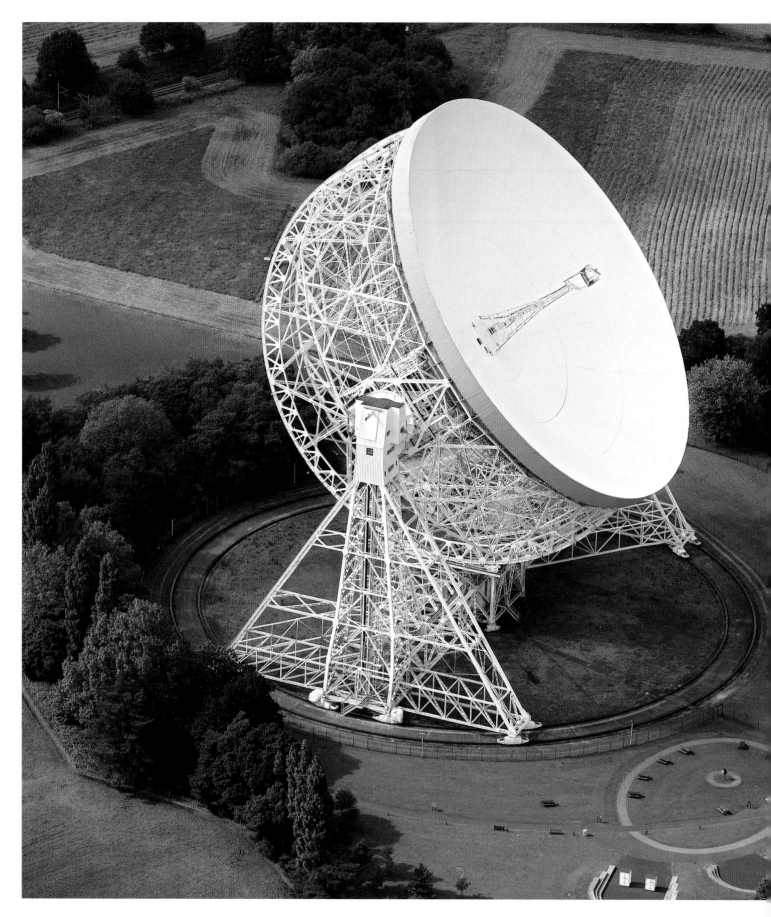

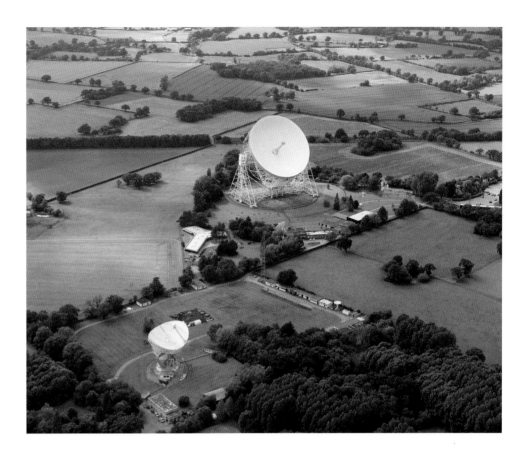

LOVELL RADIO TELESCOPE
2014

Sprouting 89 m (292 ft) out of the Cheshire fields is the Lovell Telescope at the Jodrell Bank Observatory. When completed in 1957 it was the largest steerable dish radio telescope in the world at 76.2 metres (250 ft) in diameter. The bowl has a surface area of 5270 sq metres (1.3 acres).

The bearings that change the telescope's altitude began life inside the battleships *HMS Revenge* and *Royal Sovereign*; they were gun turret bearings.

The telescope was switched on just in time to track *Sputnik 1*, the world's first artificial satellite, and in 1966 it listened in on the transmission of photographs from the USSR's unmanned moon lander *Luna 9*. This allowed British papers to publish pictures of the moon's surface before the Soviets.

To prevent damage by pigeon fouling the telescope has two pairs of resident peregrine falcons roosting in its metalwork.

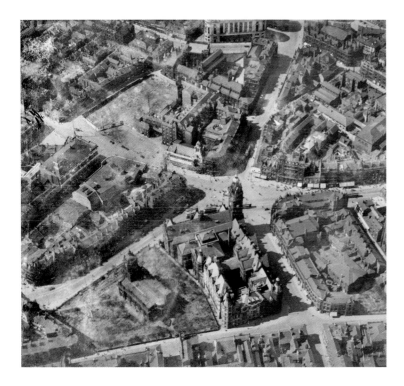

SHEFFIELD
1928 and 2009

In 1740 a Sheffield clockmaker trying to make better steel for watch springs perfected the crucible method of steel production. The city's production of steel rose from 200 tonnes per year to 80,000 tonnes – nearly half of Europe's total output – within a century. Further innovations followed, including the invention of stainless steel in 1912 by local metallurgist Harry Brearley, and Sheffield grew from a modest town to one of Europe's leading industrial cities by the mid-twentieth century.

Towards the bottom of the 1928 image is St Paul's Church. After local slums were cleared in the 1930s, its congregation dwindled and the building was demolished in 1938. Gardens were laid out on the site, known as the 'Peace Gardens', after the signing of the Munich Agreement in September of that year. The patch of bare ground towards the top left is the site of Sheffield City Hall, which opened in 1932.

Sheffield may have a long industrial pedigree, but within its boundaries there are 2 million trees, giving it the highest ratio of trees to people of any European city.

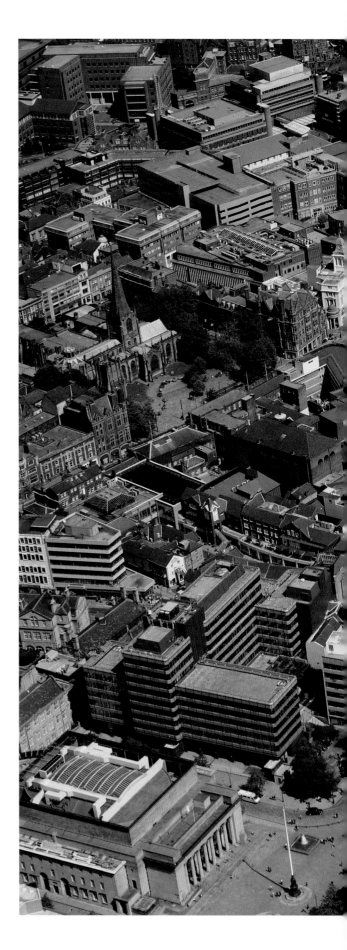

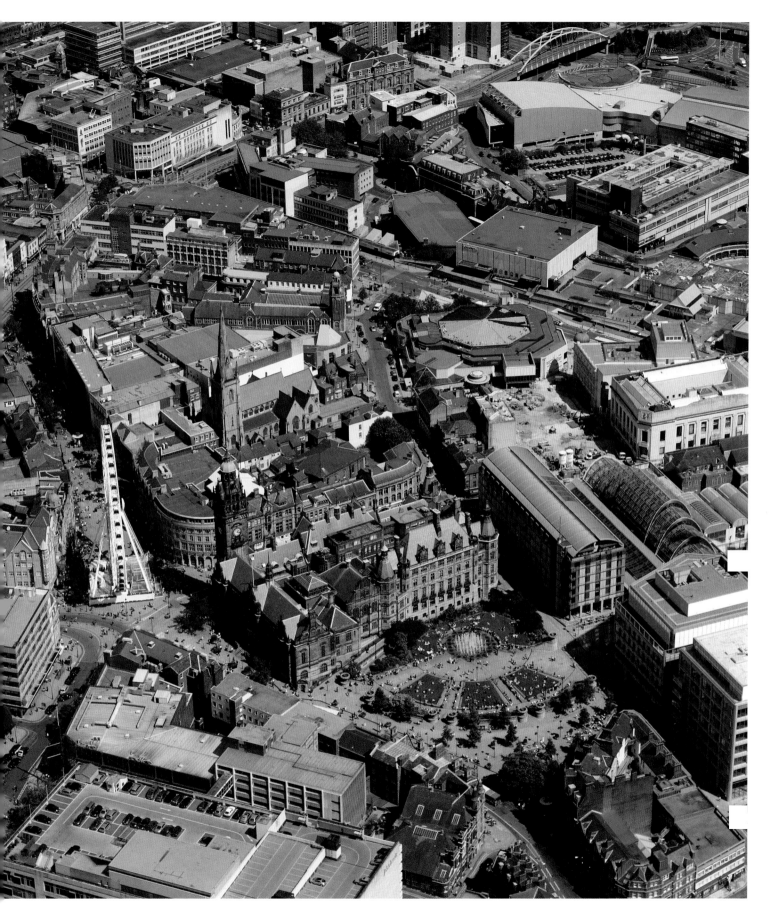

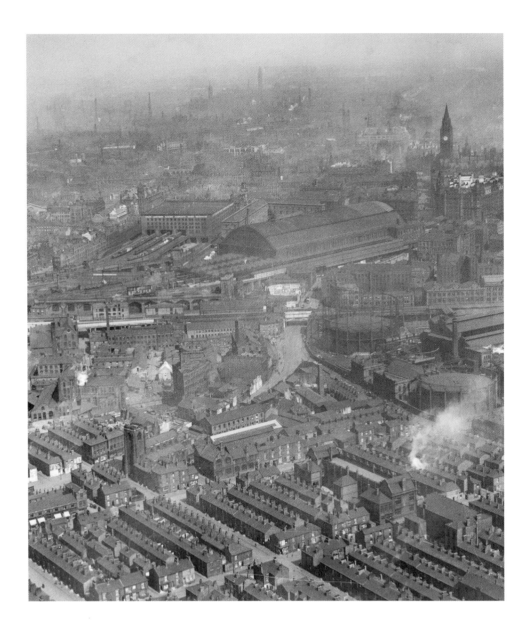

MANCHESTER
1921 and 2014

The city itself seems to be exhaling smoke in this 1921 photo: mist, industrial chimneys, household fires and puffing trains all add to the drifting miasma. The image captures an industrial heartland, grinding away at its daily business.

The modern city is busy in a different way and glass, metal and fresh brick have transformed its face into one of shining optimism. A few of the old landmarks seem unchanged, such as the clock tower of Manchester Town Hall. Others have been reborn – the sooty train shed of Manchester Central station is now an exhibition and conference centre. The Great Northern Warehouse goods station, in the centre of the modern picture, is now a cinema and leisure complex. A disused canal runs beneath its foundations.

Most striking of the city's new landmarks is the 47-storey Beetham Tower on Deansgate. At 168 metres (551 ft), this is the tallest building in Britain outside London and the fourth tallest residential building in Europe. It stands on the path of old freight lines and its slender footprint makes it one of the thinnest skyscrapers in the world. It is visible from ten English counties on a clear day. The northern end of Deansgate was badly damaged by the 1996 IRA bomb, and has been widely redeveloped.

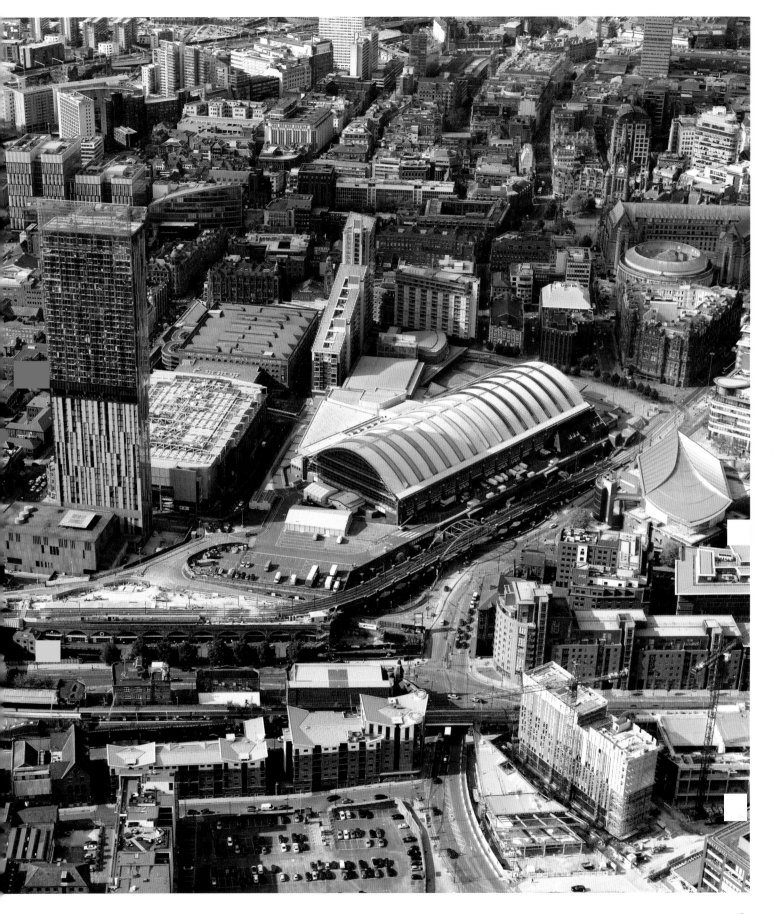

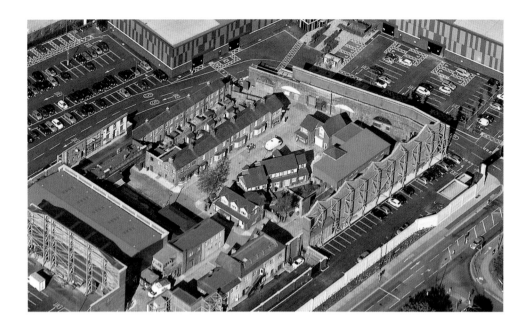

SALFORD
2014

Despite being around 64 km (40 miles) from the sea, the Port of Manchester grew to become Britain's third busiest port thanks to the Manchester Ship Canal, which when it opened in 1894, was the largest river navigation canal in the world. Two groups of docks were built at the Manchester end of the canal, the larger of which were at Salford, while the Pomona Docks were a little closer to the city centre. This enabled the ocean-going ships of the day to carry their cargoes of raw materials right into the heart of the city's thriving industrial area and then be loaded with manufactured goods for the return journey.

This trade was assisted by a specially formed shipping company: Manchester Liners, which was quick to adopt changing trends in sea transport. It pioneered regular sailings along the Manchester Ship Canal by ocean-going vessels, and the introduction of specially strengthened vessels which could navigate the ice-covered waterways leading to the Canadian Great Lakes in winter.

By 1968, it had taken delivery of the first British-built and operated container ship. Several more followed, each of which could carry 500 containers below decks. Two new, dedicated container terminals were built to speed up handling, one at Salford, the other at Montreal in Canada. However, by then the seeds of the Port of Manchester's demise had been sown.

The move to containerisation was so fast that by the early 1970's a new generation of container vessels were entering service, which were too big to pass through the ship canal. The decline of the port was surprisingly rapid. All the docks had closed by 1982, the port facilities lay derelict, and pollution of the canal waters had become an increasing problem. It was obvious that significant action was required.

Salford City Council acquired the docks from the canal company with the aid of a derelict land grant and the area was rebranded as Salford Quays. Since then an extensive redevelopment programme has transformed the area into an attractive destination for a variety of new uses, including waterfront residential, office and leisure developments. The complex in the centre of the larger photograph is Media City UK, which houses the BBC's new Salford Quays development; ITV Studios UK; ITV Granada, which has built a new Coronation Street set in the right foreground, and a number of independent production facilities. The Lowry Centre for Performing Arts occupies the building fronted by the circular façade on the end of the pier beyond, while the Imperial War Museum North lies just beyond the Coronation Street set on the near side of the canal.

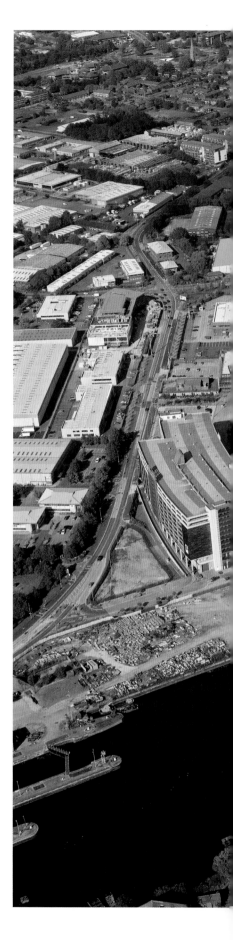

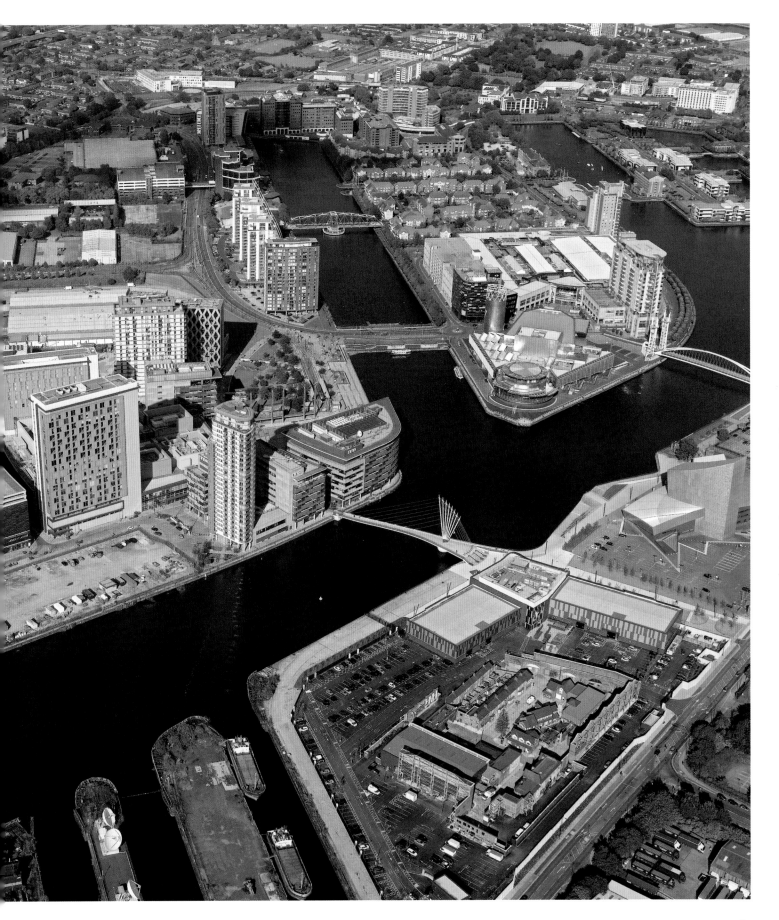

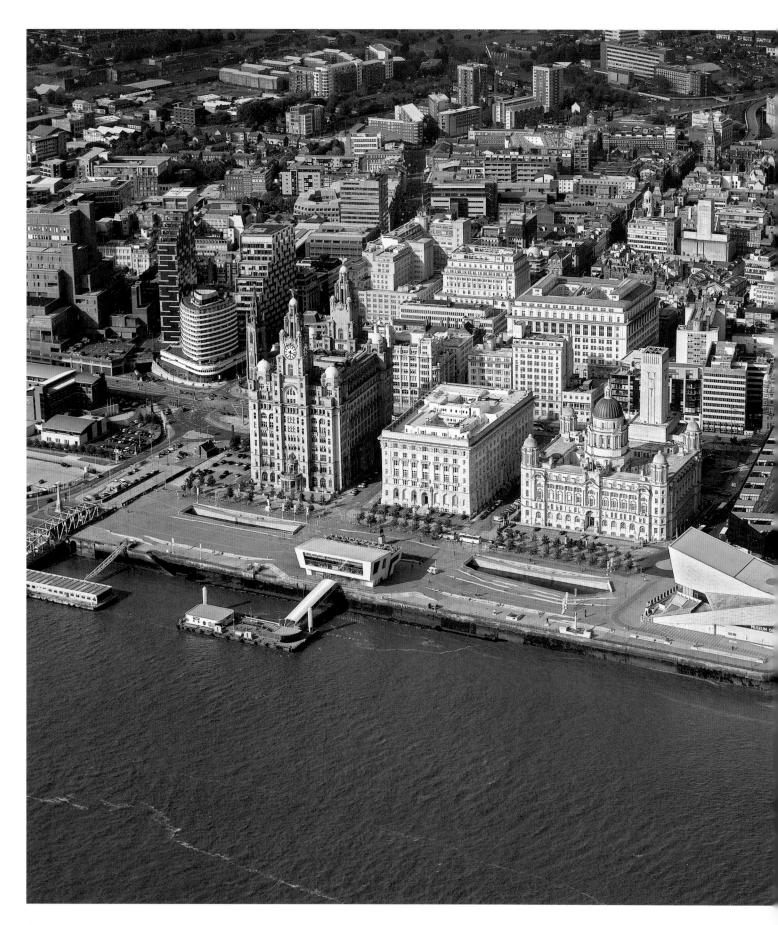

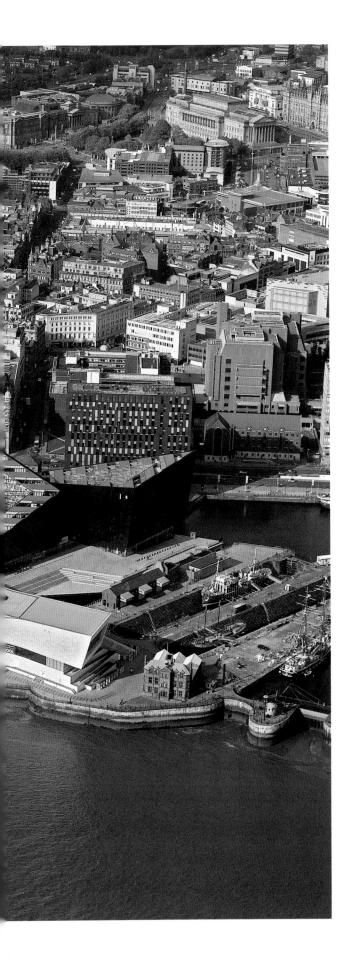

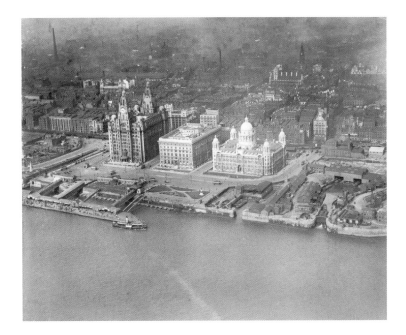

LIVERPOOL
1920 and 2014

In the nineteenth century, 40 per cent of world trade passed through Liverpool's docks and the city's Custom House became the single largest contributor to the British Exchequer. This wealth was expressed in many splendid buildings, the most famous of which are the Three Graces. Dominating the waterfront, they are seen here in 1920 just a few years after their completion.

The Liverpool Overhead Railway can be made out on the city side of the Graces. The world's first electric elevated railway, this was known as the "Dockers' Umbrella" and ran for 8 km (5 miles) along the waterfront until demolished in 1957. In 1897, the Lumière brothers filmed the world's first cinematic tracking shot from one of its trains.

Liverpool's docks were once all linked like beads on a chain. A connection to the Leeds and Liverpool Canal enabled boats to travel through the docks and inland. However, in order for the Three Graces to be built, George's Dock was filled in and the chain broken. Boats travelling from the north to south docks now had to go via the River Mersey. In December 2008 a new link reconnected the docks and canal. It is visible in the modern picture, recessed below street level in front of the Royal Liver and Port of Liverpool buildings.

The angular building in the bottom right is the Museum of Liverpool Museum, which opened in 2011 and tells the story of the city and its people.

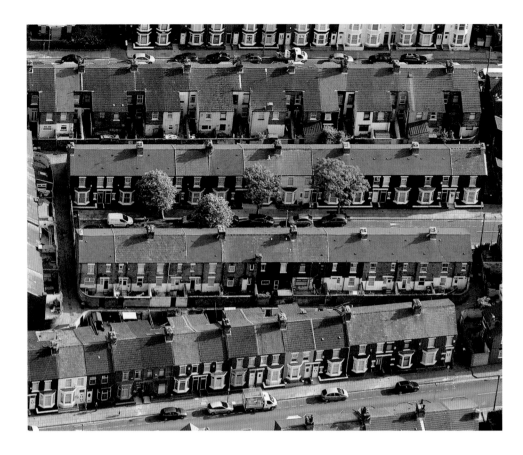

TERRACED HOUSING, LIVERPOOL
2014

Terraced housing was once the main form of building for residential purposes across many parts of Britain. This took many forms: from the grand Georgian terraces in the more desirable areas of cities such as London, Bath and in Edinburgh New Town; through the three, four and five-storey tenements of Scotland's inner cities; to the typical two-storey terraced developments, which were once uniform across many of England's industrial towns.

In the latter case, the terraced style was adopted to house the growing number of workers required to man the industries, which developed rapidly following the industrial revolution. At a time when workers usually had to be housed within easy walking distance of their workplace, the two-storey, terraced style was the usual form of high-density housing from the early Victorian period, right up to the Second World War, particularly in the textile, coalfield, metalworking and other industrial areas.

Although many of these neighborhoods have seen their terraced housing cleared away and replaced by tower blocks and other high-rise developments during the second half of the last century, recent research has shown that modernising and repairing a standard Victorian terraced house over a 30-year period is over 50 per cent cheaper than building and maintaining a newly-built house. This has led to re-thinking by many local authorities, and the wholesale demolition of structurally-sound terraced developments has been reduced in many areas.

These views show high-density terraced housing in the Walton area of Liverpool.

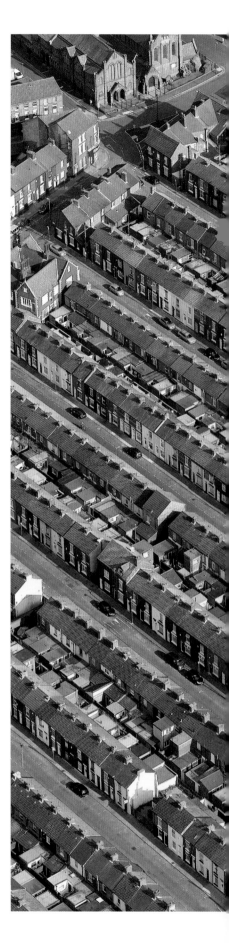

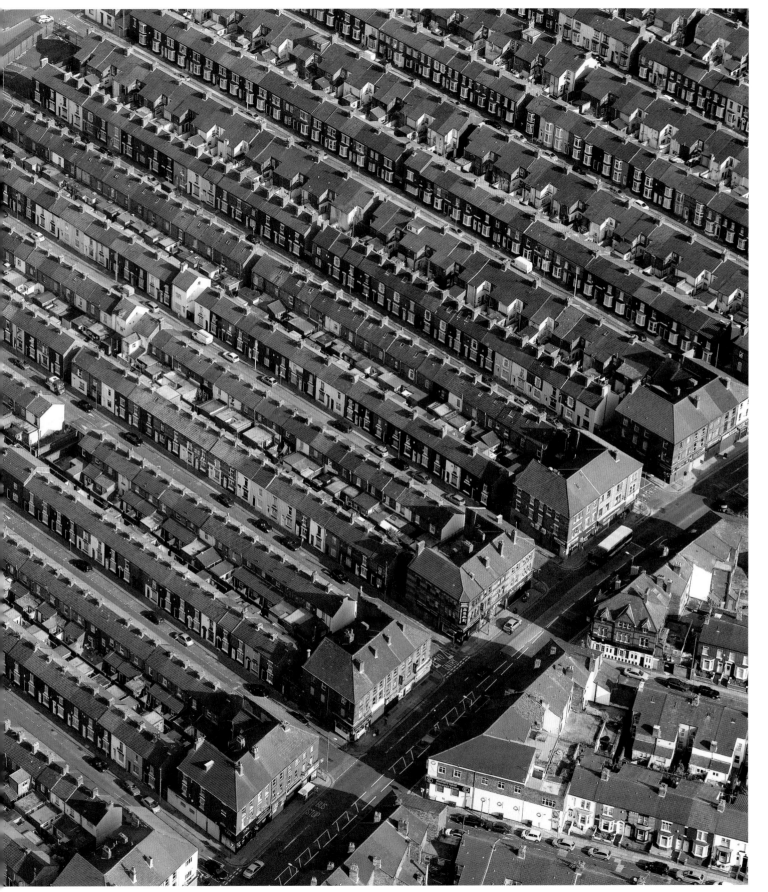

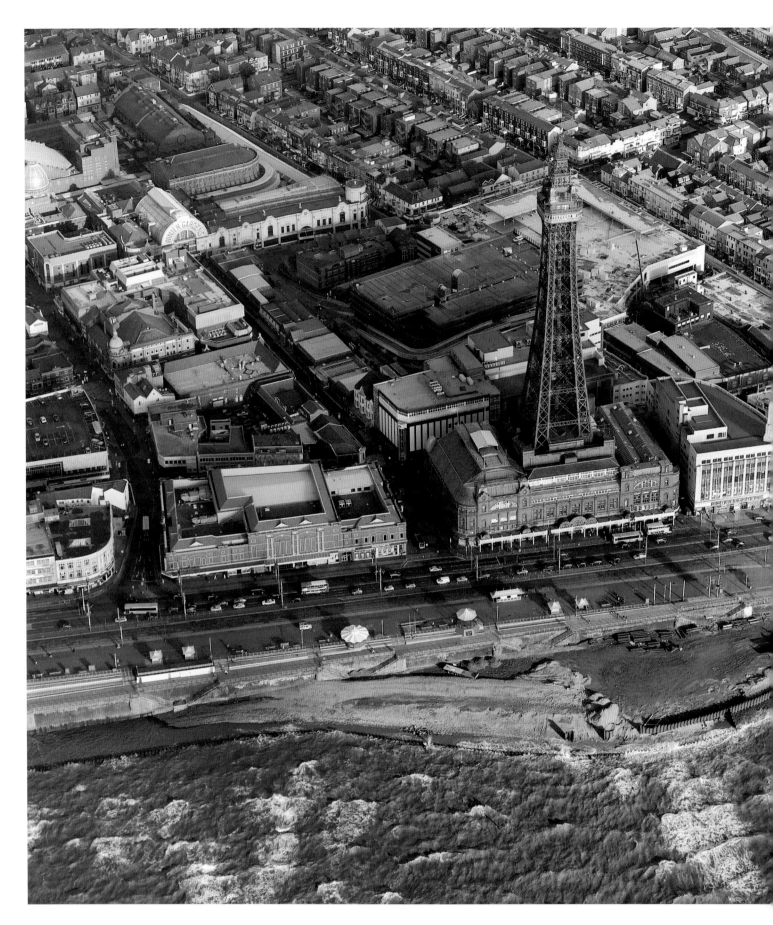

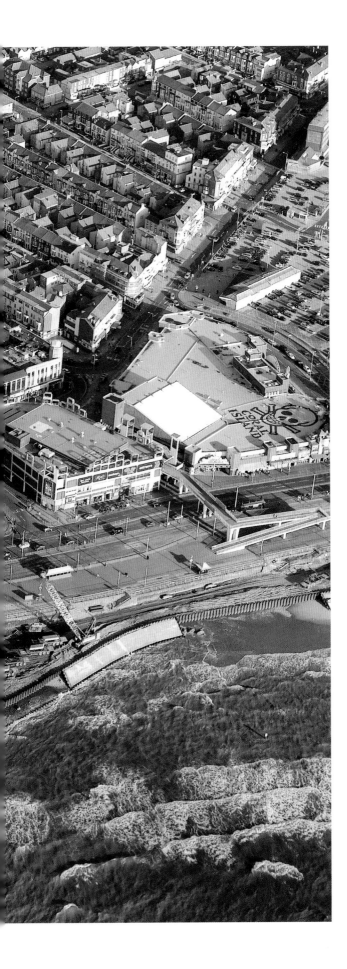

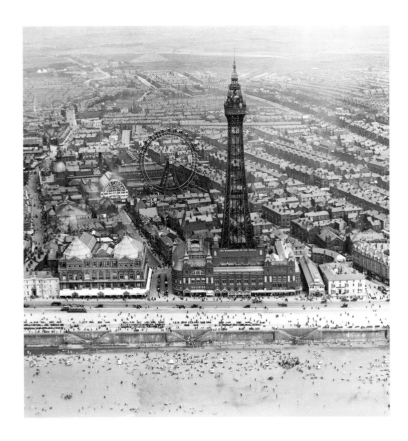

BLACKPOOL TOWER
1920 and 2007

In 1801 Blackpool was little more than a hamlet, with a population of 500. When the railway arrived in 1846, the workers of England's industrial north had rapid access to the town's 11 km (7 mile) long sandy beach. By 1901 there were 47,000 residents and Blackpool was the archetypal British seaside resort, with a promenade, tramway, three piers, amusements, fish-and-chip shops and theatres.

Its entrepreneurs had an eye for the future, and in 1879 Blackpool became the first municipality in the world to have electric street lighting. From 1894 it also had its own tower. Inspired by the Eiffel Tower, which had been completed just five years earlier, it soars 158 m (518 ft) above the prom. There is a time capsule buried beneath its foundations. The tower's 10,000 light bulbs are connected by 8 km (5 miles) of cables.

Blackpool is still the most popular seaside resort in the UK. It attracts 10 million visitors a year, down from its all-time peak of 17 million in 1992.

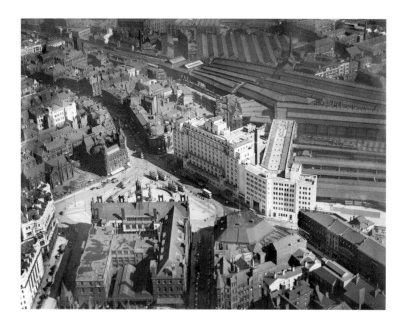

LEEDS
1938 and 2010

In 1650 Leeds was so insignificant it did not even have a Member of Parliament; nearby Otley had two. Over the next 300 years, first wool, then iron, engineering, printing and a hundred other trades would help it grow into the Britain's third largest city, with a population today of more than 750,000.

At its centre is City Square, and great change is visible in these two photographs, taken 72 years apart. The 1938 image was snapped within months of Queens Hotel being remodelled into its Art Deco magnificence, and Leeds City station had only just been created by the union of two older stations, New and Wellington. In 2002 Leeds City station was expanded from twelve to seventeen platforms, the most of any station in England outside London, and the 1967 metal canopy was replaced with a new glass roof. The River Aire runs underneath the station, and can just be seen towards the upper right hand edge of the modern picture, about to enter its tunnel.

In 1962 the high angled faces of City House rose to tower over the station. Poet Sir John Betjeman famously railed against the perceived ugliness of this building.

In the foreground of the 1938 photograph is the Old Post Office, which was converted into restaurants and apartments in 2006.

The tallest building in the modern square is the 20-storey hotel, completed in 1966. Its tiny neighbour to the north is the Mill Hill Unitarian Chapel.

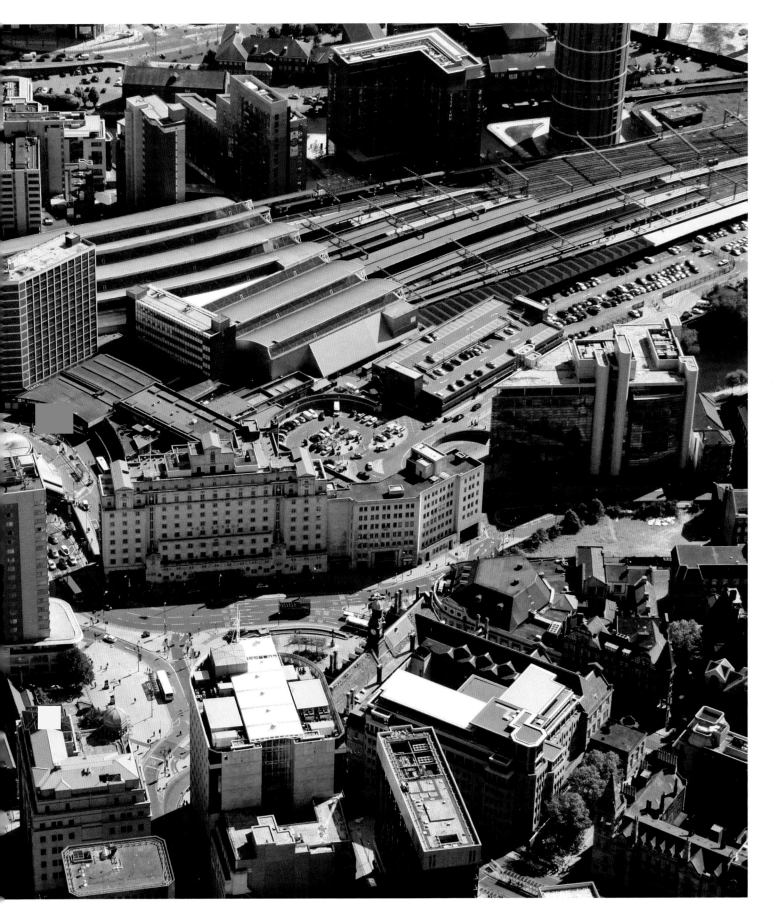

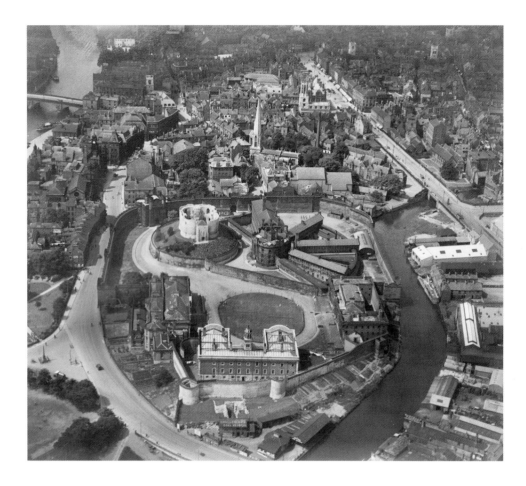

YORK CASTLE
1926 and 2013

Clifford's Tower now stands alone on its grassy mound, but this was once just the keep of a large castle complex in York. William the Conqueror's wooden motte-and-bailey fortification was destroyed by the Vikings and rebuilt in limestone in the thirteenth century.

The castle was being used as a gunpowder magazine in 1684 when an explosion obliterated the roof, floor and central pillar, leaving only the walls standing. The vulnerable castle became an administration centre, courthouse and jail. The 1926 picture shows it still in use as a military prison. This was torn down in 1935 and is now a car park.

The dark walls that loomed over neighbouring streets were also demolished, opening up views to the tower. The circular grass area, known as the Eye of York, has tennis courts in the old photo, most likely for the use of prison officers.

The eighteenth century Courthouse (at the bottom of the 1926 picture) is now York Crown Court. It still has holding cells and people are tried here, as they have been for almost 1,000 years. Although, thankfully, they are no longer executed and hung from the walls.

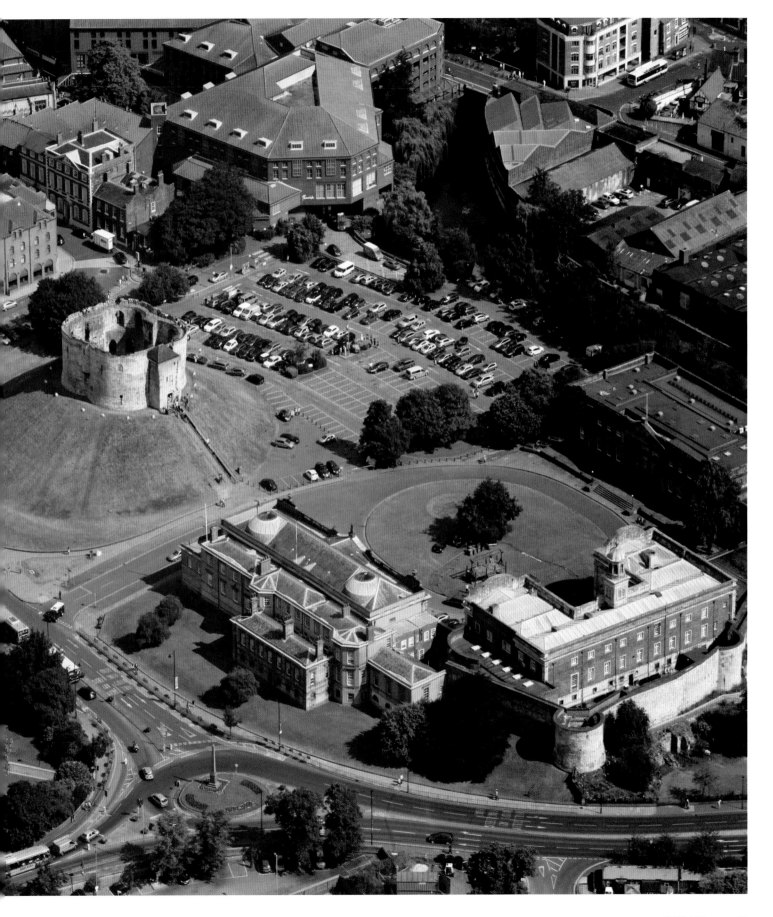

FOUNTAINS ABBEY

2014

Monks by name, millionaires by nature. In 1535 the Cistercian monastery of Fountains Abbey was the richest in England, with a vast income from its hundreds of acres of estates. The order also owned properties in several major market towns including York, Scarborough and Grimsby, which were used as trading bases, and further revenue came from milling, fishing, quarrying and iron-smelting.

The abbey had humble enough beginnings. After a ruckus in the Benedictine St Mary's Abbey in York, thirteen rebellious monks were expelled in 1132, eventually finding sanctuary on a little land in the valley of the River Skell. Here they built some modest wooden buildings and joined the Cistercian order to pursue a communal life of manual labour and self-sufficiency.

Their existence was a struggle for several decades, but a series of endowments from wealthy benefactors (often in return for prayers for their souls) gave the monks land, and therefore income from rents. They rebuilt their church in stone and added further buildings throughout the twelfth and thirteenth centuries. By this time the abbey precinct had expanded to cover an area of 28 ha (70 acres), and was surrounded by a 3.4 m (11 ft) wall.

When completed in the sixteenth century, the abbot's house was one of the largest in the country with wide bay windows, impressive fireplaces and a great hall around half the size of a football pitch at 52 x 21 m (171 x 69 ft). It was constructed on arches over the River Skell.

Henry VIII was so angered by the wealth and influence of the churches that in 1539 he passed the 'Dissolution of the Monasteries' act. Fountains Abbey was among hundreds of religious houses that had its land and property confiscated and sold.

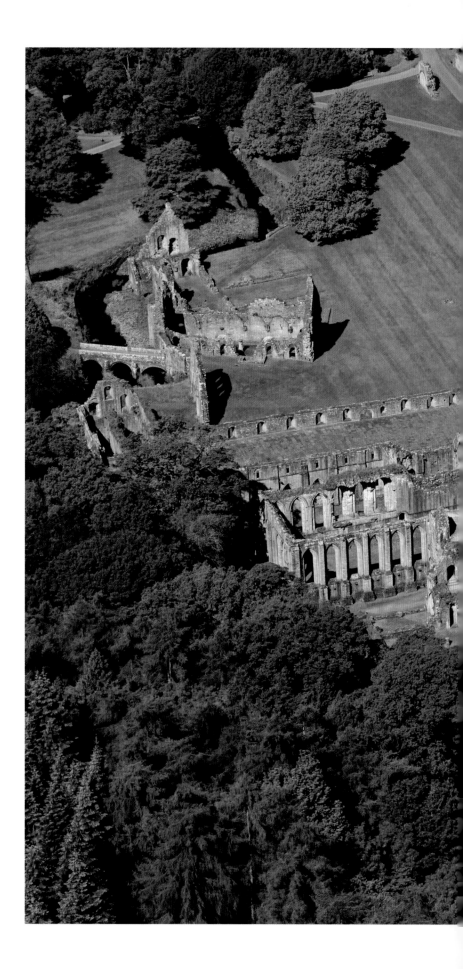

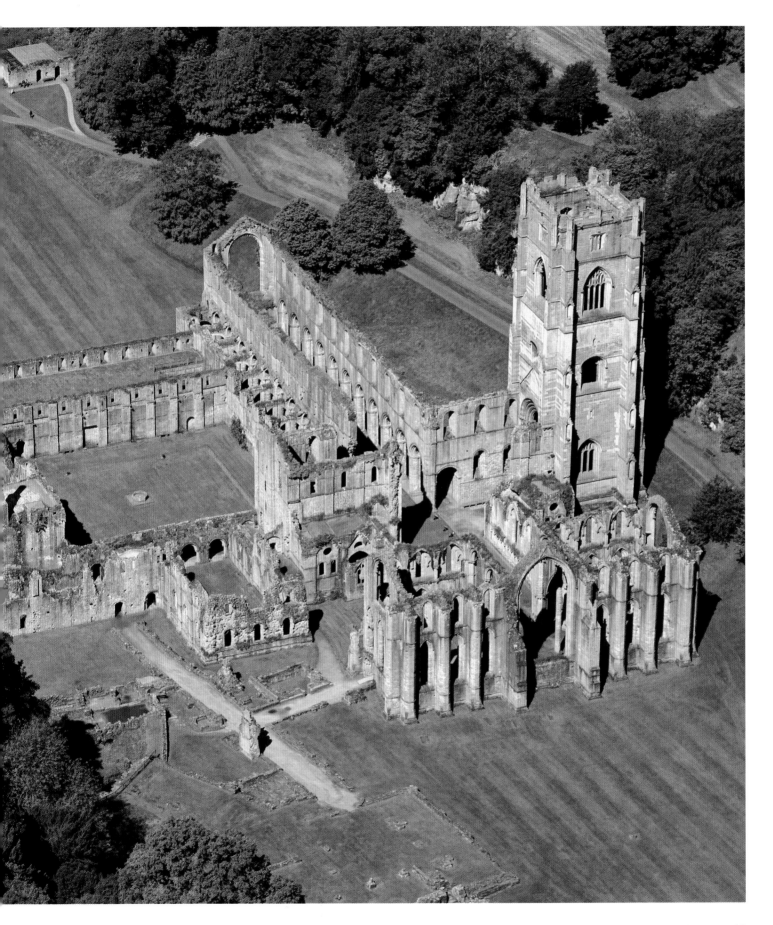

WHITBY
1932 and 2009

It was at Whitby that Count Dracula made landfall in England in the famous novel by Bram Stoker. Leaping from a storm-beached ship in the form of a great dog, he took refuge in the ruins of the Abbey, as tumbled then as they are today. When the mists roll in on a moonlit night and the waves smash on the shore, it's easy to see how Stoker's imagination was fired by this historic town on the border of moor and sea.

When *Dracula* was published in 1897, Whitby was the centre of English jet production, with its beautiful black jewellery being extremely fashionable. It has also long been an important fishing port. Catches of cod, haddock, salmon, lobster and crab are still brought into the quayside fishmarket.

In the late eighteenth century, Whitby was the third largest shipbuilding centre in England, after London and Newcastle, and a major whaling port. *HMS Endeavour*, the ship commanded by the explorer Captain James Cook on his voyage to Australia and New Zealand, was built in Whitby as a coal carrier. Cook himself was born in nearby Marton (now in Middlesbrough) in 1728 and learned his seafaring trade on Whitby coal boats. There is one local shipbuilder still making and repairing vessels today.

A monastery was first built on this fine site above the River Esk in AD 657 and thrived for two centuries until raided by the Vikings. After the Norman Conquest, a new Benedictine monastery was founded in 1078. This was destroyed in 1540 as part of Henry VIII's Dissolution of the Monasteries, and has remained a ruined, romantic landmark ever since.

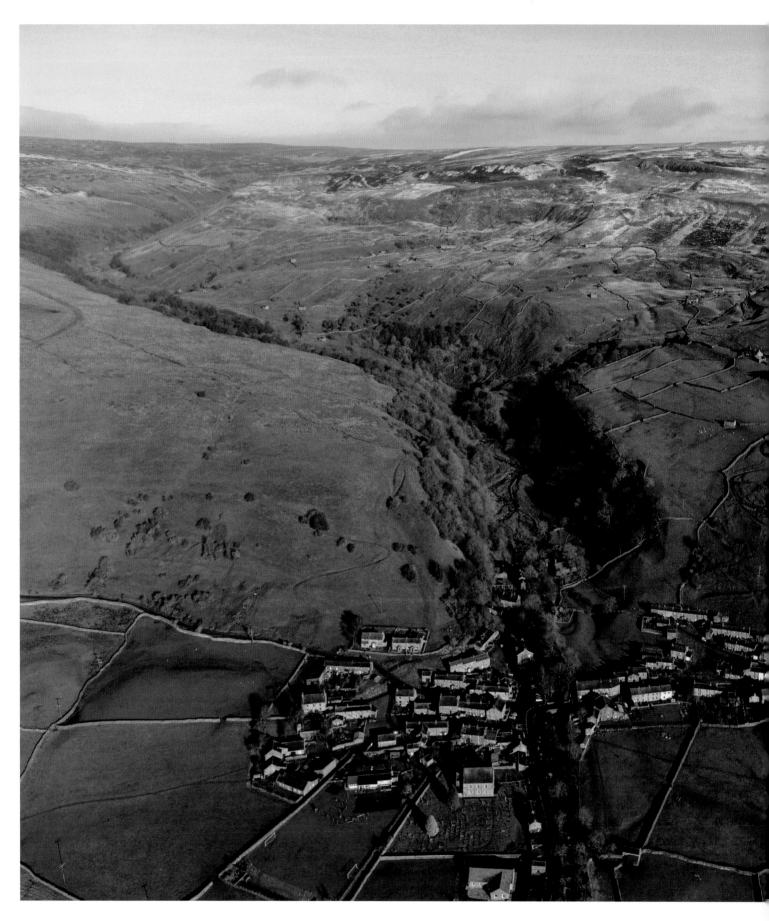

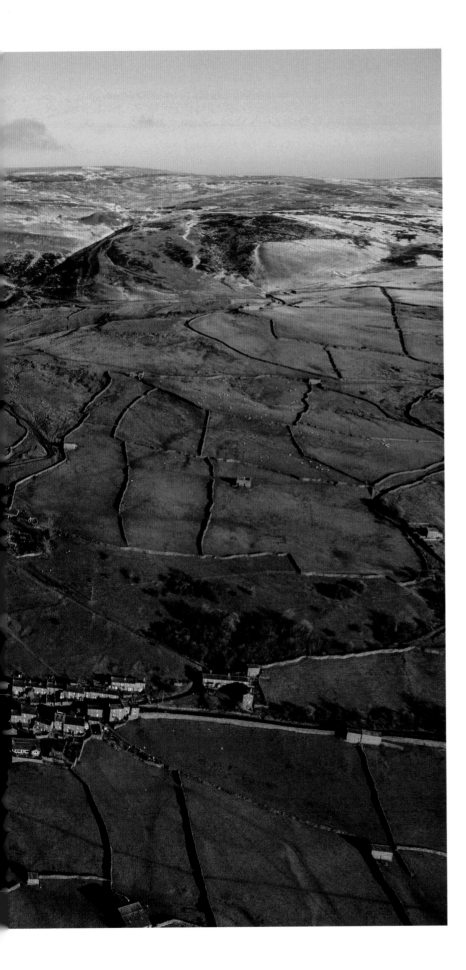

YORKSHIRE DALES
2014

A river, a ribbon of road, crumpled fields lined by moss-covered walls and high above it all the wilds of the moors – this is the quintessential image of a Yorkshire Dale.

Ice did much of the rough carving of this landscape. In the last ice age glaciers gouged great U-shaped troughs in the underlying limestone. Water was a finer chisel, deepening the Us into Vs, cutting cliffs into cataracts and boring Britain's longest caves – the Easegill system has 72 km (45 miles) of passageways.

The larger dales tend to run north to south, their rivers flowing out to the important market towns of Skipton, Harrogate and Ilkley. Further north, valleys such as Swaledale and Wensleydale are smaller and run from west to east.

Sheep farming has always been at the heart of life here, creating the patterns visible on the landscape today. Small, square fields are bound by dry stone walls; hay is cut only after wild plants have seeded, creating beautiful flower meadows; large limestone field barns still stand after centuries of use.

Swaledale has its own eponymous breed of round-horned sheep and several other dales have their own famed creations, such as Wensleydale cheese and Airedale terriers.

In the nineteenth century, the Dales were peppered with lead mines and scars of this industry are visible higher up on the hillsides. The spoil from the pits is often toxic to plants and created bare patches where it was dumped. Thankfully this mining has ceased and most signs of its existence are being slowly reclaimed by nature.

Today the beauty itself is more valuable: the winding valley paths and challenging ridgelines above are a honeypot for walkers and the high heather moorland makes for superb grouse shooting.

PIEL CASTLE

2010

The castle on Piel Island was built in the fourteenth century by the powerful monks of Furness Abbey to keep an eye on merchants using the local harbour, and as a refuge from raiding Scots. It was constructed largely using stones from the nearby beach.

It occupied the limelight of English history in 1487, when the pretender Lambert Simnel landed here at the head of an army intent on overthrowing Henry VII.

Simnel was a 10-year-old boy of humble stock, probably a baker's son, who had been coached by a priest in the ways of the court. He was then claimed as the rightful Earl of Warwick, and possible heir to the throne, by a faction of rebellious Yorkists. This uprising was crushed shortly after at the Battle of Stoke Field, the last conflict in the Wars of the Roses. Simnel was pardoned by Henry and sent to work as a spit-turner in the royal kitchen.

Today, the spectacularly sited castle enjoys a quieter life as a summer tourist attraction, reached by foot ferry.

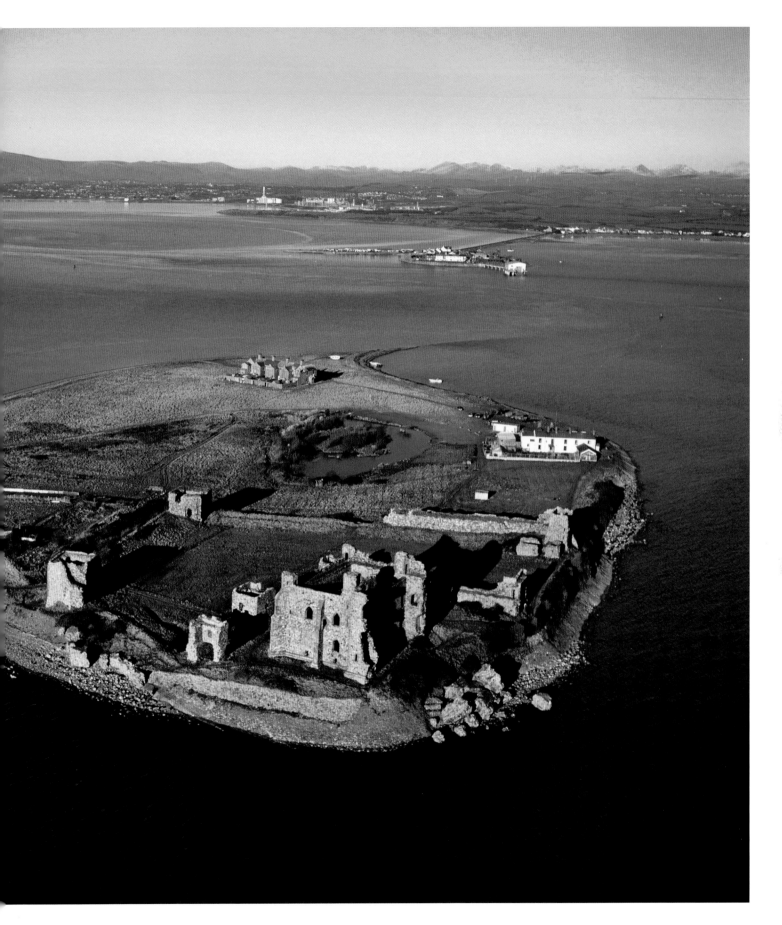

WASTWATER SCREES
2010

Tumbling 610 m (2,000 ft) from the heights of Illgill Head and Whin Rigg, these precipitous screes tumble into England's deepest lake, Wastwater. The lake cavity was gouged from the landscape by a glacier, and the lake bottom is 15 m (50 ft) below sea level.

This photo clearly shows how the huge, conical piles of rock debris have fallen from the weather-shattered cliffs above. The screes were formed when freezing water expanded within rock fissures, and by general erosion.

The vast sheet of fragments continues below the surface, reaching almost to the lake bottom, at 79 m (258 ft). The fell-side appears so steep and rough as to be almost impassable, but a ribbon-like path weaves round and over the boulders.

The lake is a 5 km (3 mile) finger pointing into a remote dale at the head of the Wasdale Valley. Here rise the mighty shoulders of Kirk Fell, Red Pike, Great Gable and Scafell Pike – England's highest mountain. It's an awe-inspiring setting, and Wastwater is often voted one of Britain's favourite views.

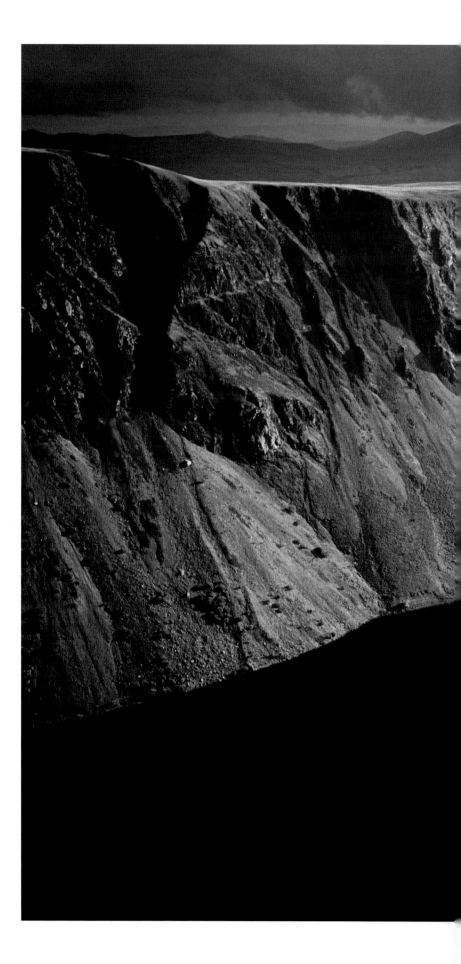

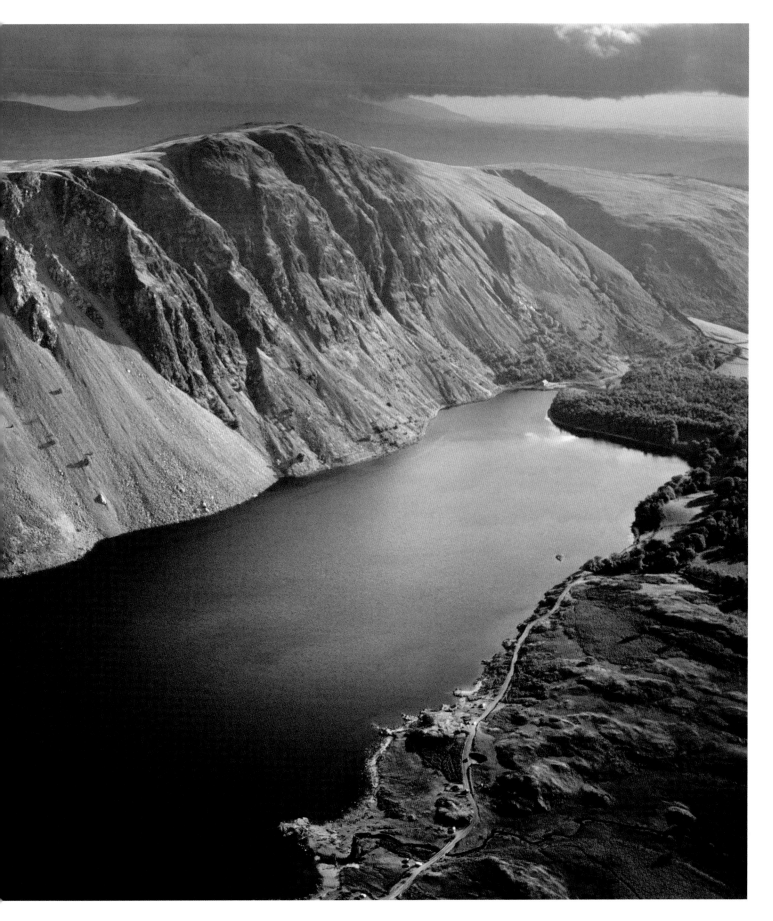

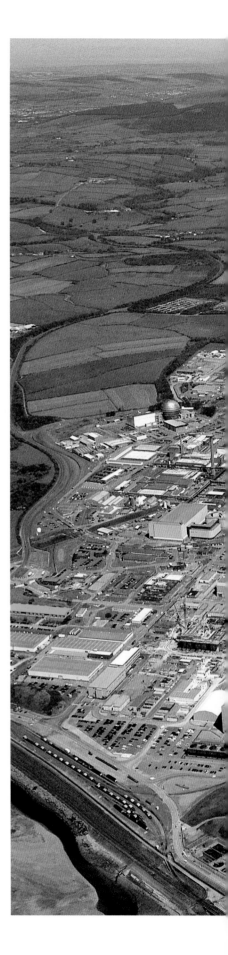

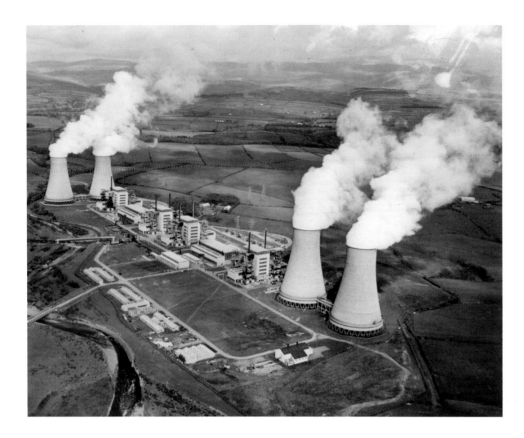

SELLAFIELD
1962 and 2007

Sellafield was the site of an explosives factory in World War II. In 1947 it was adapted to produce materials, mostly plutonium, for nuclear weapons. Two large atomic piles and a separation plant were built, and the site was renamed Windscale.

The commercial potential of atomic energy was then tapped with the building of Calder Hall nuclear power station nearby, which was opened by Queen Elizabeth II in October 1956. It was the world's first commercial nuclear plant.

Over the next forty years, a total of nineteen nuclear reactors were built in the UK. Production of nuclear power peaked in 1997, when 26 per cent of the nation's electricity was generated this way. Sizewell B was the last nuclear plant to be commissioned, in 1995.

There are currently nine active nuclear power stations in the UK. In 2013, it was announced that the first of a new generation of nuclear plants would be built at Hinkley Point in Somerset.

A second-generation reactor was built at Windscale in 1962, but all reactors at Windscale and Calder Hall have now been retired. When Calder Hall station closed on 31 March 2003, the first reactor had been in use for nearly 47 years.

Sellafield is still a major reprocessing site. It covers an area of approximately 3 sq km, and is one of the largest nuclear engineering centres in the world.

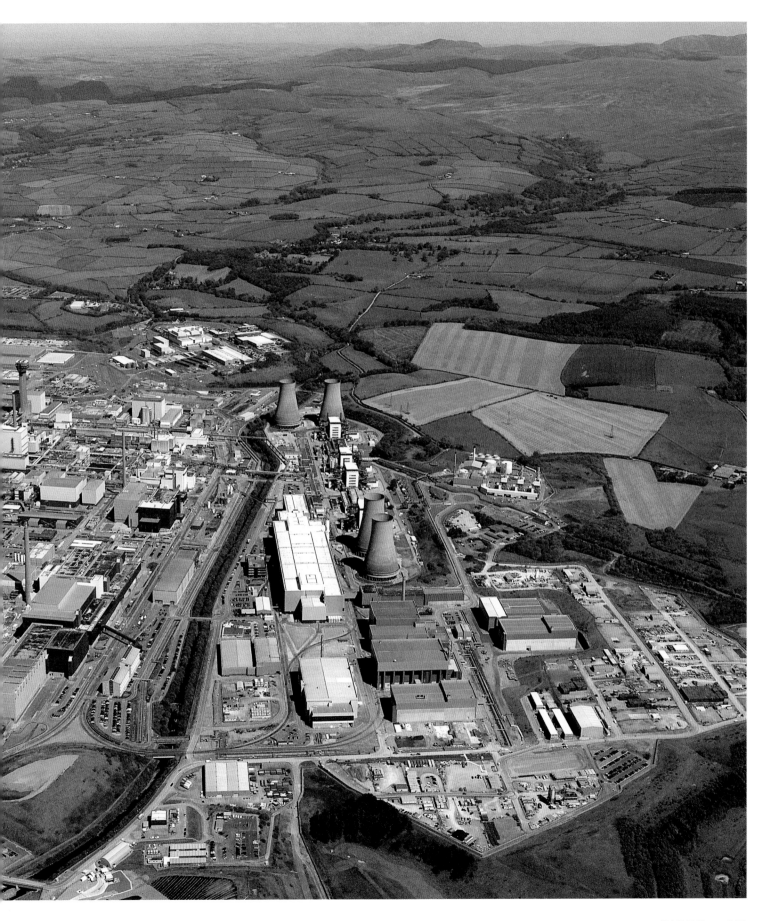

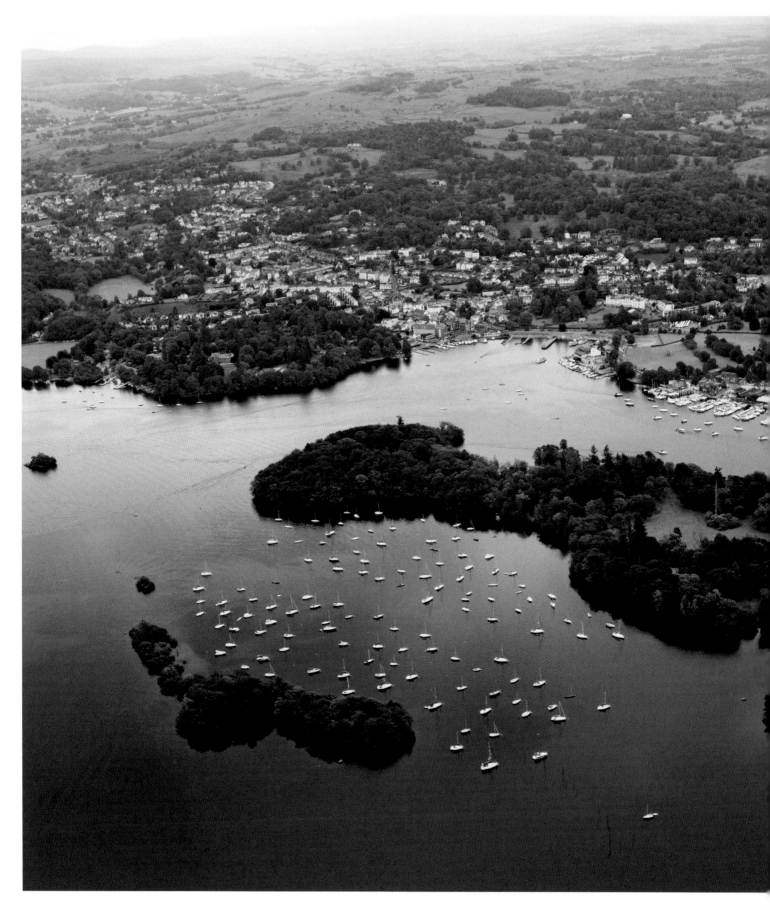

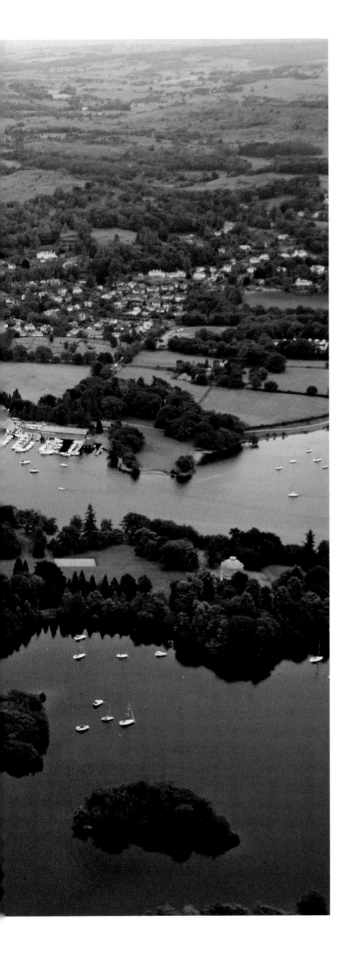

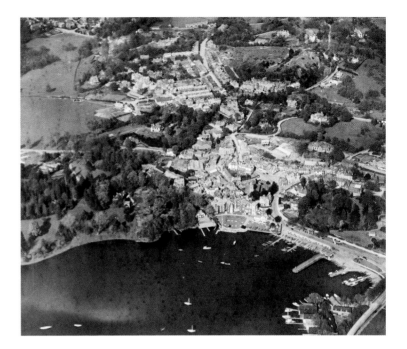

BOWNESS-ON-WINDERMERE
1929 and 2012

The romantic poetry of William Wordsworth, his sister Dorothy and friend Samuel Taylor Coleridge did much to popularize the beauties of the Lake District and throughout the nineteenth century this very rural part of England became increasingly popular with tourists.

When the railway arrived in 1847, the town of Bowness ceased life as a small fishing village and was reborn as the quintessential lakeside tourist destination. New trades servicing the visitors sprang up, with boat-building in particular flourishing here, and many hotels were built on the hills overlooking the water.

The inhabitants of Bowness opposed a station in their own town so the branch line's terminus was sited in Birthwaite, 1 km from the water, and the town renamed 'Windermere' after the lake.

One of the most vociferous opponents of the railway was William Wordsworth himself. In the last years of his life he undertook a sustained campaign against the line, writing many letters to the newspapers, often in verse, complaining that travellers would destroy the beauty they had come to enjoy.

The 1929 image shows the tourist trade in full swing with boats dotted on the water, jetties and hotels amid the trees. The year after this picture was taken the novel *Swallows and Amazons* was published and a whole new generation of holidaymakers were inspired to come to the Lakes for adventure.

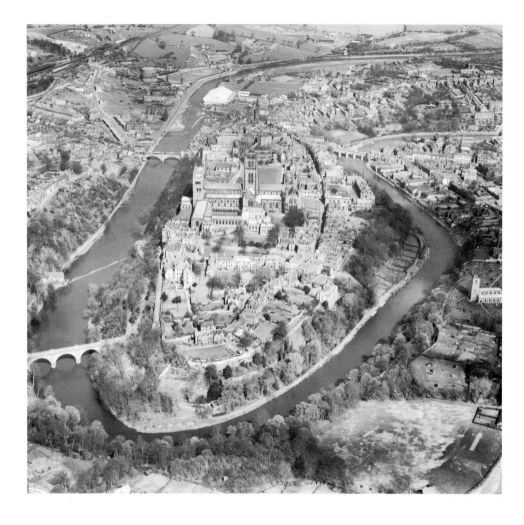

DURHAM
1948 and 2010

The peninsula at Durham is one of those few places that are remarkable for how little they have changed over time. The cathedral and castle have stood proud on this rocky outcrop overlooking the deep, wooded meander in the river Wear for nearly 1,000 years.

There are a few changes visible: the gas holder and greyhound track at the top middle of the 1948 photograph have gone and the Kingsgate Bridge to the right of the promontory in the modern picture was opened in 1966. The fulling mill that stands on the outer bank by its weir had closed by the time the 1948 photograph was taken. It is now an archaeological museum.

The cathedral was begun in AD 1093 and is the largest and most splendid example of Norman architecture in the country. The castle was also built by the Normans to consolidate their power in the north and for most of its life served as the palace of the bishops of Durham.

After the bishops moved to Auckland Castle in 1832, the then-dilapidated keep was gifted to University College and rebuilt. Today the castle is home to around 100 students, mostly in the keep itself – surely the most impregnable student residence in the country. The Great Hall, once the largest in Britain, serves as the refectory.

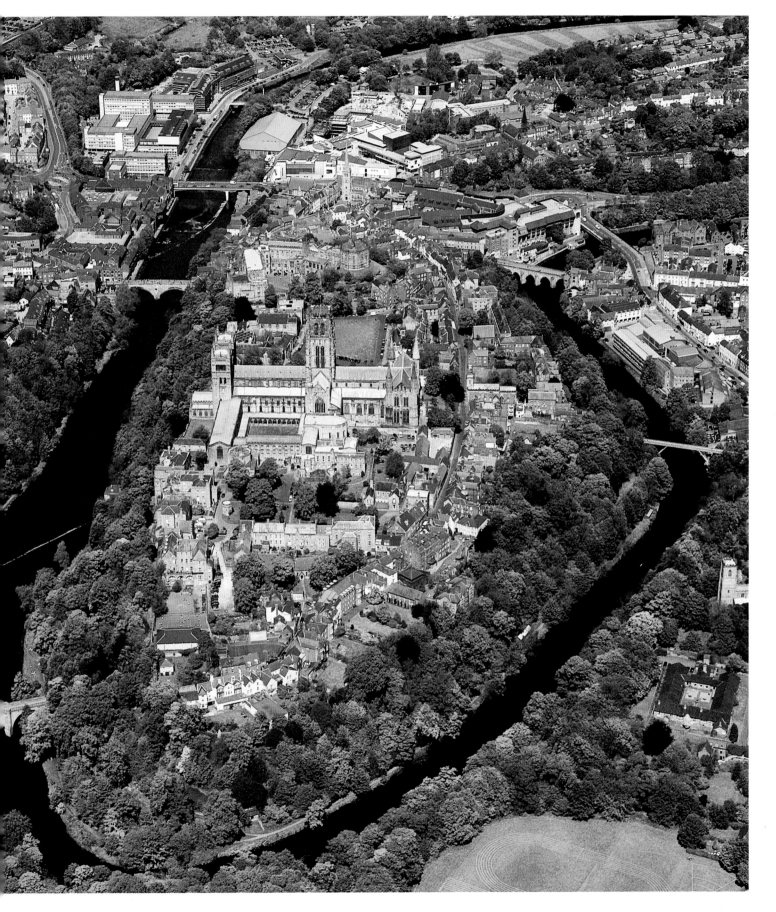

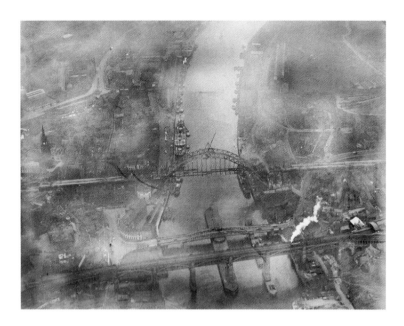

TYNE BRIDGES
1928 and 2007

There have been bridges at this vital location on the great road north since a Roman structure, Pons Aelius, was built around 122 AD.

The Swing Bridge of 1876 (the middle crossing) replaced a previous stone bridge that had been outgrown by the increasingly large ships of the time. The High Level Bridge (bottom of the old picture) was designed by railway pioneer Robert Stephenson, and completed in 1849. Its lower deck carries a roadway 26 m (85 ft) above the Tyne and its fog; the East Coast Main Line rides above that.

High tolls on this bridge fuelled demand for another Tyne crossing. Work finally started in 1925 to a design based on the Hell Gate Bridge in New York. It was completed three years later at a cost of £1.2 million. The bridge's hollow towers were built of Cornish granite and were intended to function as five-storey warehouses; this plan never came to fruition.

At that time Tyneside was one of the world's largest shipbuilding centres: an entire navy was built here for Japan. As in the rest of Britain, heavy industries were in serious decline by the 1980s. Recent regeneration is symbolised by the gleaming curves of the Sage Gateshead, a music, performance and conference venue.

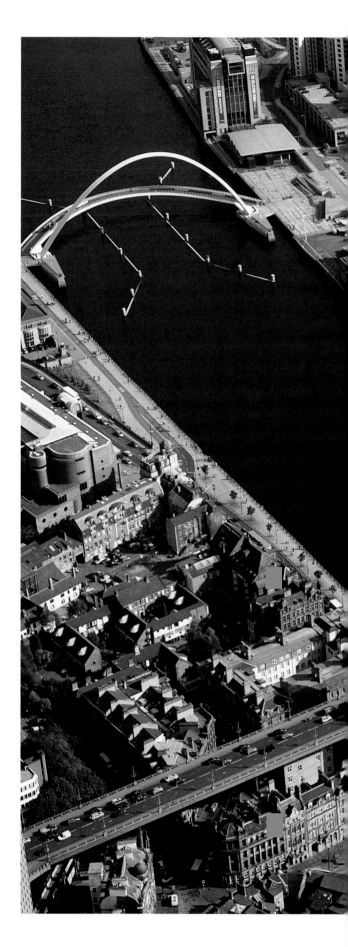

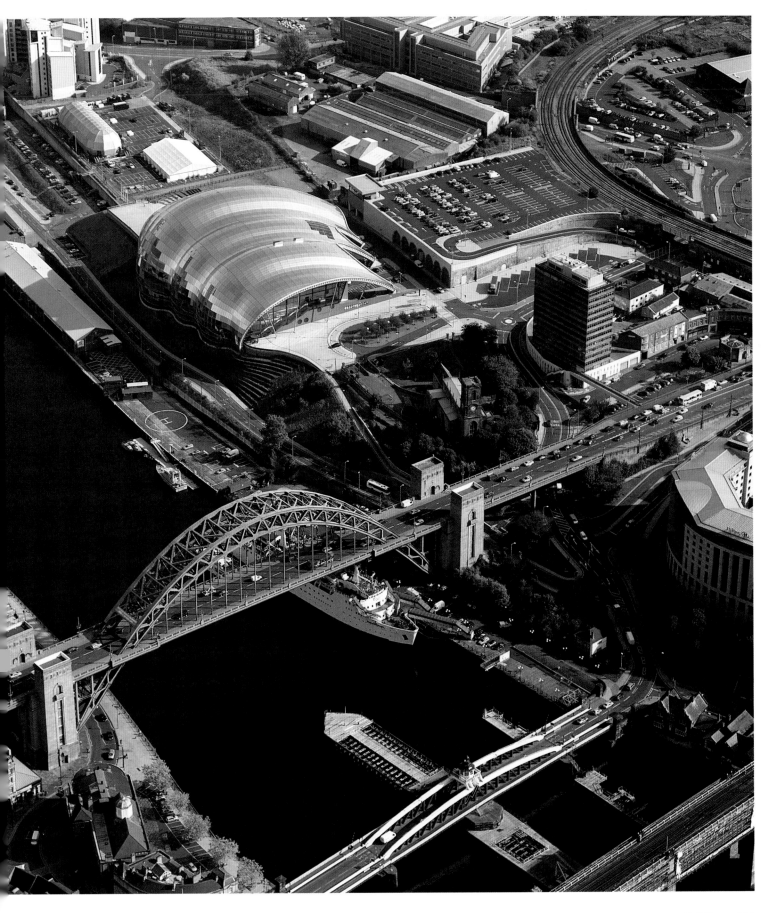

HADRIAN'S WALL
2007 (above) and 2010 (right)

Winding up and over crags, across rivers and round lakes, Hadrian's Wall marched unstoppably for 117 km (73 miles) from Wallsend on Tyneside to the shore of the Solway Firth.

Started around AD 122, when Hadrian had acceded to the throne and the Roman Empire was at its greatest geographical extent, his eponymous wall in a drizzly corner of England marked the northern limit of a realm that stretched unbroken to the baking-hot banks of the Euphrates in Syria, the shores of the Caspian sea and the fringes of the Sahara desert. Hadrian ruled over one-sixth and one-fourth of the world's total population

The Wall was not intended as an impassable barrier, but rather a way of controlling – and taxing – the every day cross-border movements between the Picts to the north and Romans. It would also have been an awesome reminder of just how powerful the Romans were – its walls stood up to 6 m (20 ft) high and would have been plastered and white-washed, creating a shining rampart visible for miles.

Regular milecastles guarded gateways in the wall, and larger forts such as this one at Housesteads provided a reserve force of cavalry in case of trouble with the 'barbarian' Picts. This is the most complete Roman fort in Britain, and it was home from home for around 800 soldiers and their horses.

For much of the time they were more concerned at keeping out the cold than any invaders – a letter found by archaeologists was from a soldier writing home asking for more woolly socks.

Built around AD 160, Arbeia Roman Fort (above) at South Shields once guarded the Roman port at the entrance to the River Tyne. Although situated four miles east of the known end of Hadrian's Wall, the Fort was originally built to house a garrison and soon gained several stone-built granaries as it evolved into a military supply base for the seventeen Forts along the Wall. The site is one of the most extensively excavated military supply base in the whole of the former Roman Empire. Today, the fort contains reconstructions of the West Gateway, a barracks and part of a commanding officer's house as well as an exhibition of some of the objects found during the excavations. Arbeia seems to have been abandoned by the Romans around AD 400 when the military units finally withdrew from Britain.

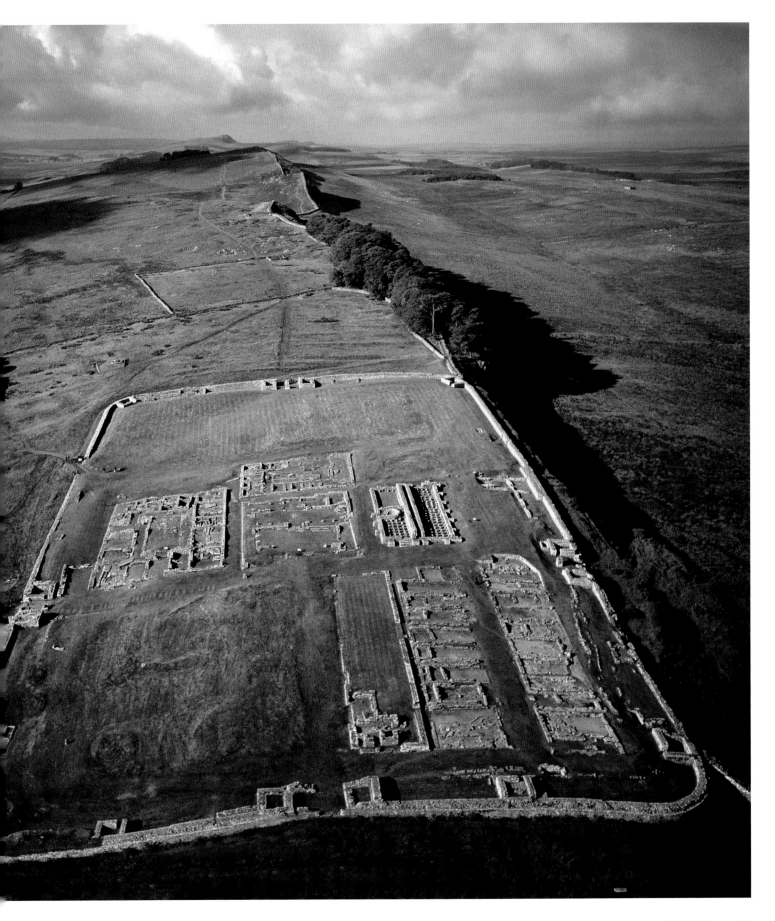

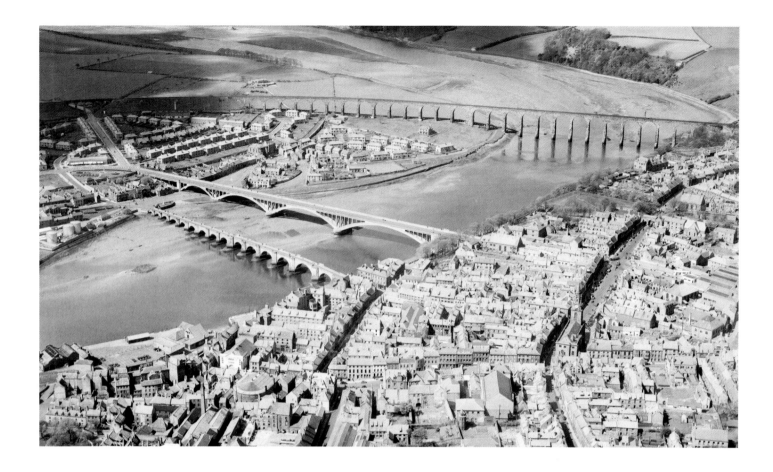

BERWICK-UPON-TWEED
1949 and 2014

As England's most northern town, sitting just 4 km (2.5 miles) from the Scottish border, Berwick-upon-Tweed has seen more than its fair share of skirmishes over the centuries. This territorial football changed nationalities many times in the four centuries from its foundation until it finally settled as English in 1482.

A robust defence was vital for such a border town, and Edward I built the first mighty set of walls in the early fourteenth century. These had crumbled by 1560, and a new fortification was constructed. Today these are the best-preserved Elizabethan ramparts in the country. Their innovative design is clearly visible in the lower modern image: ditches and walls are backed by large earthworks and augmented by five large bastions projecting from the main defences.

Berwick's Old Bridge was completed in 1624 and for 300 years carried the Great North Road coaching route that ran from London to Edinburgh. Just before the railways eclipsed coaching in the eighteenth century, this 660 km (410 mile) journey could be completed in 45 hours. In the 1920s the Royal Tweed Bridge was built to carry the newly designated A1, which now bypasses the town altogether, 2 km (1.2 miles) to the west. The twenty-eight spans of the Royal Border Bridge spectacularly carry the East Coast Main Line 37 metres (121 ft) above the River Tweed.

Berwick is so far north that its football team, Berwick Rangers, plays in the Scottish Leagues to limit the distance its fans have to travel.

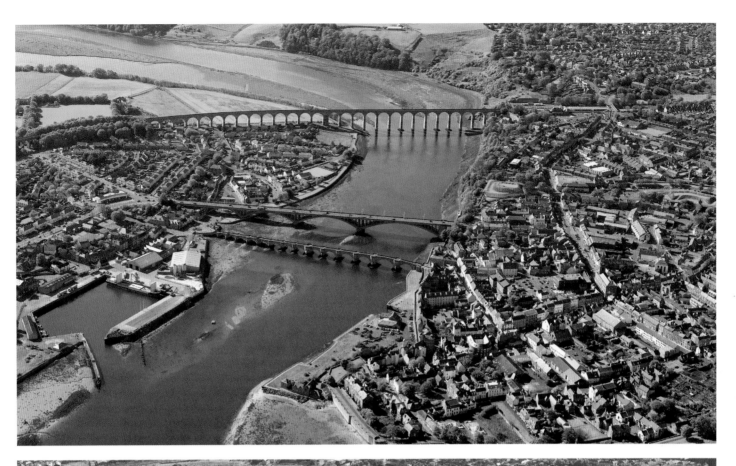

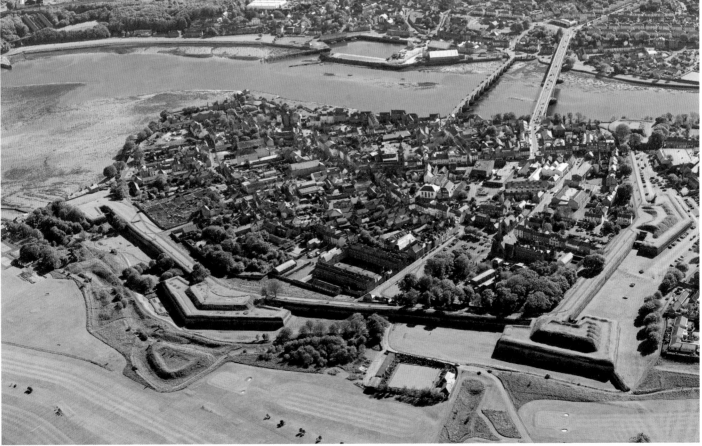

SCOTLAND

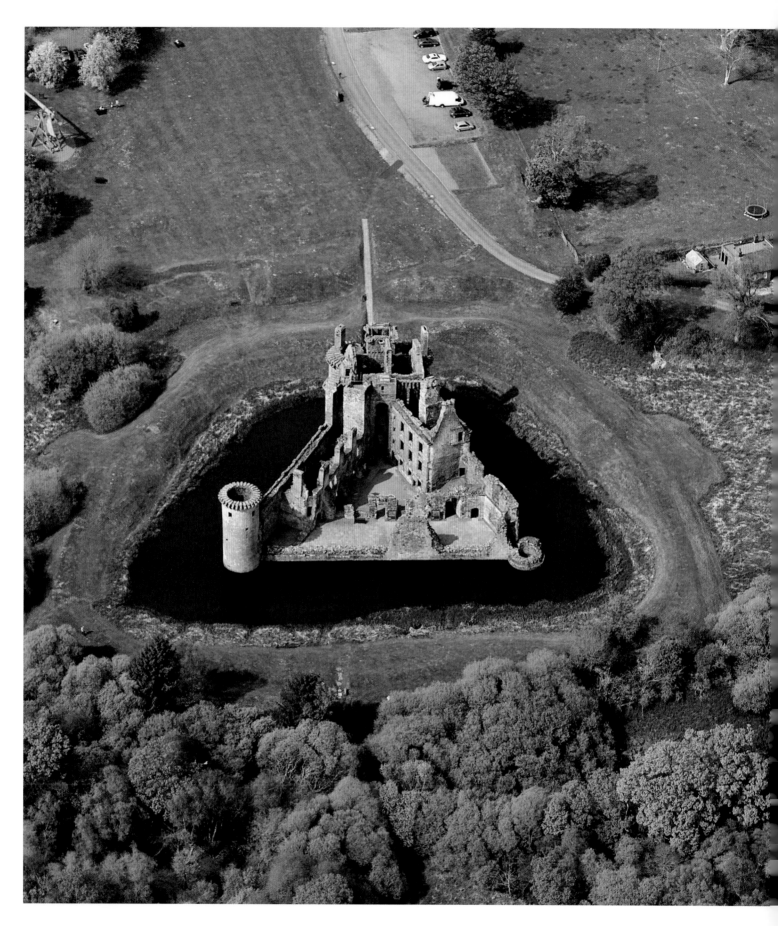

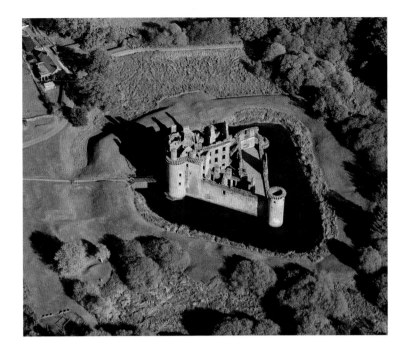

CAERLAVEROCK CASTLE
2007

Caerlaverock Castle is one of Scotland's most impressive and individual strongholds. Its triangular shape is totally unique among British fortifications, and it has a twin-towered gatehouse, imposing battlements and wide moat.

Its picturesque location near the Solway Firth is also in the skirmish zone around the Anglo-Scottish border and the castle has had a turbulent history.

Clan Maxwell built a square castle here around 1220 – one of the earliest stone fortresses in Scotland. But its shoreline location proved inadequate and they moved inland to build Caerlaverock on its current site in the late thirteenth century.

No one knows for certain why they chose a three-sided structure but it was certainly strong: a garrison of just sixty men kept out the much larger army of Edward I when he invaded Scotland in 1300. The castle last saw action in a thirteen-week siege in 1640, after which it was stripped of valuables and partly demolished.

Its name means 'fort of the skylark', *laverock* being the old Scots word for this bird. Many of them still sing high above the battlement walls.

GALASHIELS
1935 and 2014

With abundant natural supplies of fast-moving water and plenty of sheep on the hills, the Scottish border towns have a long history of textile production. Galashiels, on Gala Water just west of where it meets the River Tweed, had twenty-two mills by 1886 and sixteen further factories using hand looms.

Its secluded location in a narrow valley amid miles of hills meant that goods were best transported in and out by rail. The Waverley Line connected the town with Edinburgh and ran on south to Melrose and Hawick, even deeper in the hills, then across the border to Carlisle. A railway line also ran west to Peebles, and another branched east through Kelso to meet up with the East Coast Main Line at Berwick-upon-Tweed. All of these lines were closed in the 1960s and 1970s, in the face of particularly fierce opposition, leaving the whole Scottish Borders region without a connection to the national rail network.

Textiles declined significantly throughout the twentieth century, although there are still some smaller Borders mills producing wool, tweed and cashmere. Electronics factories arrived in the 1960s, and large supermarkets have now replaced the mills and marshalling yards visible in the 1935 picture.

In 2006 the decision was taken to reinstate 48 km (30 miles) of railway from Edinburgh to Tweedbank, just past Galashiels, the longest new railway to be constructed in Britain for over 100 years. Miles of the rural trackbed remained in place, and most of the superbly built bridges, tunnels and viaducts needed only cosmetic repair work. In the 2014 image, track laying is about to begin.

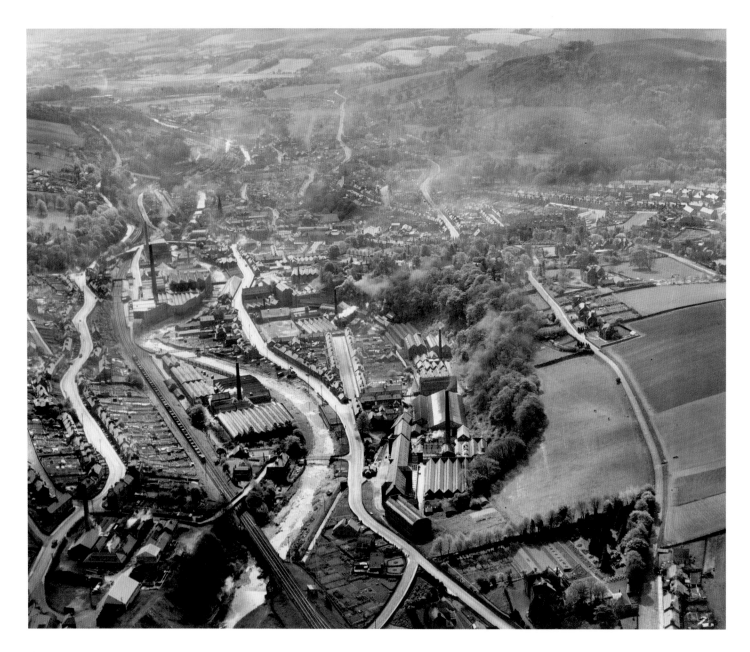

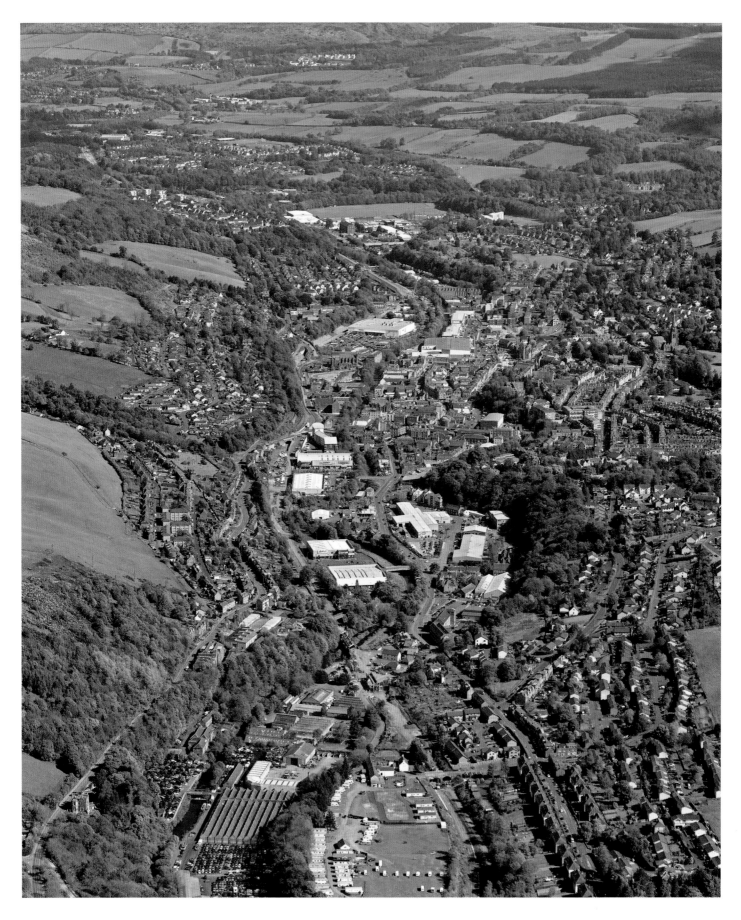

WHITELEE WINDFARM
2013

Whitelee Windfarm on Eaglesham Moor, to the south of East Kilbride, is currently the UK's largest on-shore windfarm. Its 215 wind turbines have the capacity to generate up to 539 megawatts (MW) of electricity, enough to power just under 300,000 average-sized homes.

Whitelee was developed and is operated by *Scottish Power Renewables*, which along with the rest of the *Scottish Power* operation in the UK, is owned by the Spanish energy giant *Iberdrola*. The windfarm was developed in three phases, with the first phase, which had a generating capacity of over 300 MW, supplying electricity to the national electricity grid from January 2008. The construction of Phase 2, which added a further 130 MW of capacity, was underway by 2009, and Phase 3, which added another 140 MW of generating capacity, was completed in 2012.

In an effort to boost its green credentials, Whitelee has entered the field of eco-tourism by opening a visitor centre containing an interactive exhibition, cafe, shop and education hub on site. This is managed and operated by the Glasgow Science Centre and offers a range of activities for educational and community groups. The visitor centre is also linked to a network of trails and paths for walkers, cyclists and horse riders, while the Whitelee Countryside Ranger Service works to promote and develop public access within the windfarm and the wider area.

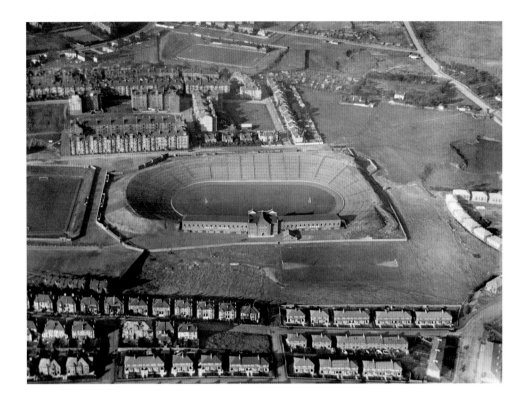

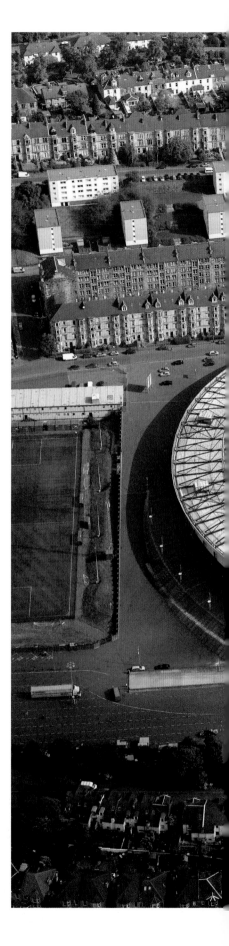

HAMPDEN
1927 and 2011

Hampden was the biggest stadium in the world when it opened in 1903. It could hold more than 100,000 fans but this was later increased. The official record attendance is 149,415, for a Scotland v England match in 1937. This is also the European record for an international football match. When Hampden opened, Glasgow had the three largest football stadia in the world, with Celtic Park and Ibrox.

Tighter safety regulations and subsequent renovations have reduced today's capacity to 52,063, but it is still a major venue. It is the home stadium of the Scottish national football team and the permanent home of the Scottish Football Museum. It also hosts the latter stages of the Scottish Cup and Scottish League Cup competitions.

Hampden was the venue for eight football matches during the 2012 Olympic Games, three of which were from the men's and five from the women's competitions. It was also selected as the venue for the Track and Field Athletics competitions and the Closing Ceremony of the 2014 Commonwealth Games. Several of the world's biggest names in music, including the Eagles, Bon Jovi, Robbie Williams and Bruce Springsteen have played to huge crowds at the stadium.

Curiously, this vast ground is also the home pitch of amateur league side Queen's Park. The club is the oldest in Scottish football and drew huge crowds in the early twentieth century.

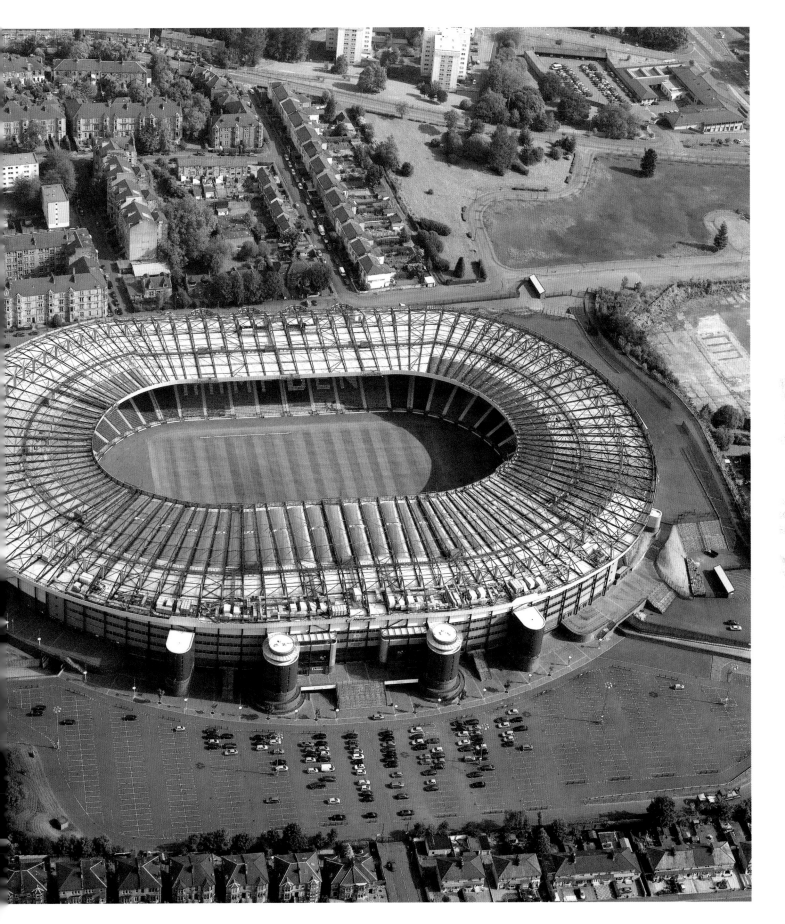

HMS QUEEN ELIZABETH
2013

Large ships used to be built from the keel up, but today they are usually built in sections that are then joined together. The aircraft carrier *HMS Queen Elizabeth* is the largest warship ever built for the Royal Navy and she was pieced together at Rosyth Royal Dockyard from nine large blocks built at six different UK shipyards.

In 2011, an 8,000-tonne section of hull built at BAE Systems' Govan shipyard was loaded on an ocean-going barge for a 970 km (600 miles) voyage round the north of Scotland. In 2012 an 11,300-tonne hull section left the same shipyard, but was forced by bad weather to take a longer route of 2,278 km (1,415 miles) round the south coast of England. Major sections were built at BAE Portsmouth, the flight decks came from Birkenhead, and other pieces were fabricated at Appledore, Hebburn and Rosyth itself.

The blocks were lifted into place by a specially commissioned Goliath crane, the largest in Britain. It stands 68 m (223 ft) high, spans 120 m (394 ft) and was made in China.

HMS Queen Elizabeth is 280 m (920 ft) long, displaces 65,000 tonnes, can carry 40 aircraft and provides a 16,000 sq m (4 acre) military operating base that can be deployed worldwide. She cost £3.1 billion.

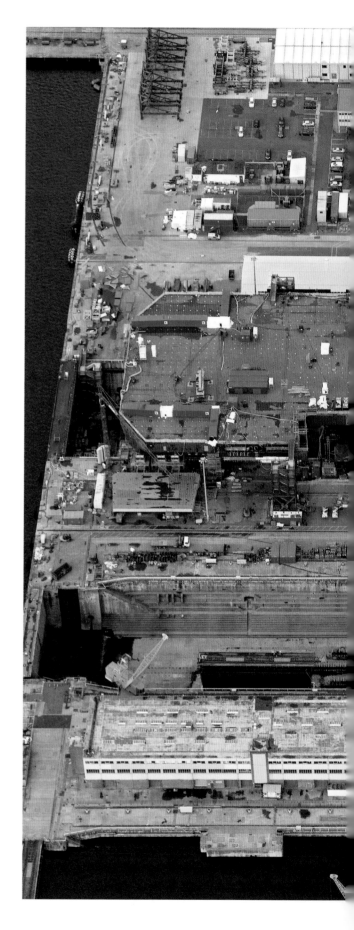

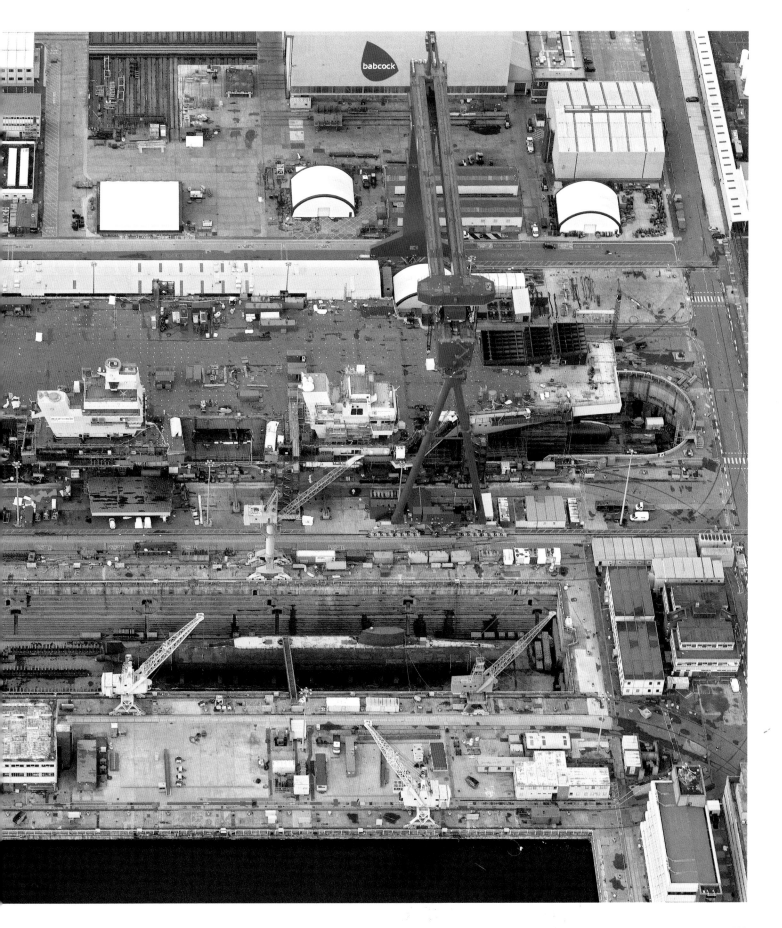

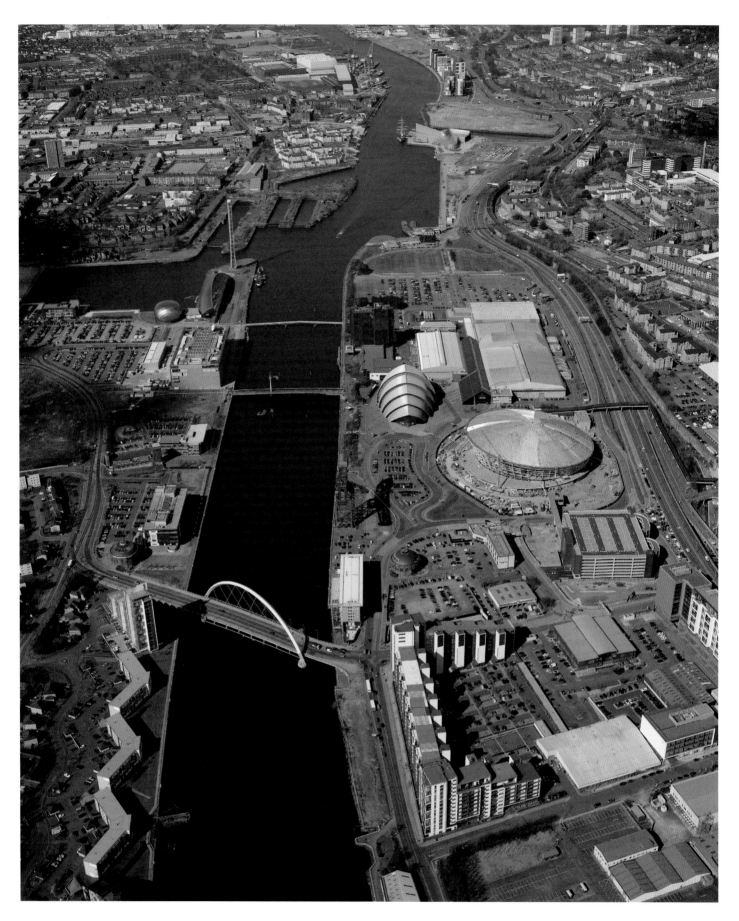

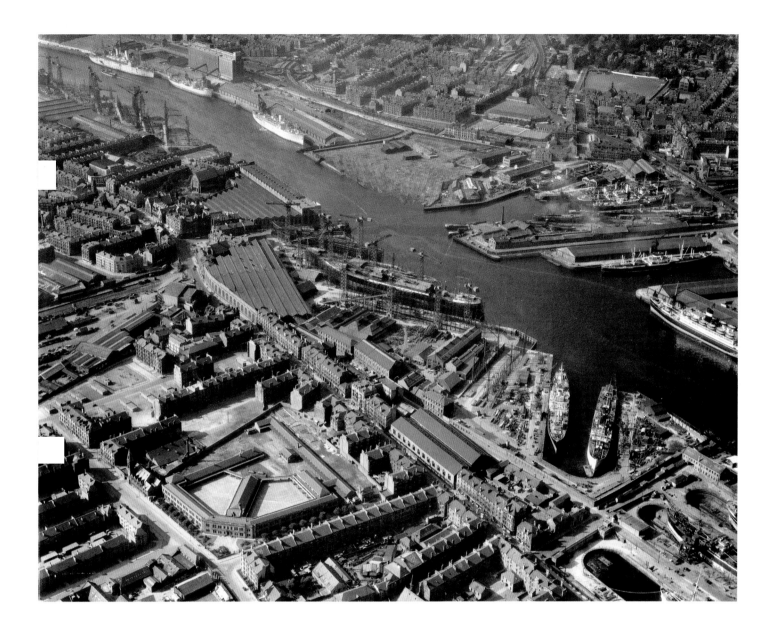

GLASGOW & THE CLYDE
1947 and 2013

Where bales of tobacco and sugar were once stacked high on the wharf, ships were built and spanking new locomotives were lowered into cargo holds, now rock stars sing their hits and children learn about science.

In the early eighteenth century, Glasgow enjoyed success importing tobacco and sugar, but its population was only 12,000. When the Clyde was deepened in the 1770s, the biggest ships could then berth in the heart of the city, and new canals put Lanarkshire's huge reserves of coal and iron within reach. Glasgow's industrial growth was stratospheric. The Upper Clyde yards shown here became the heart of the world's biggest shipbuilding centre, which launched 370 vessels a year at its peak. The city's population reached 1 million by 1910.

Overseas competition caused industrial decline in the twentieth century and by the 1960s, the shipyards began to close. Today only two yards remain on the Upper Clyde and these specialise in advanced warships for the Royal Navy.

Since the 1980s, the dock areas have been transformed. The Queen's Dock was in-filled for the building of the Scottish Exhibition and Conference Centre in 1984. This was followed by the Clyde Auditorium (known locally as 'The Armadillo') and the Scottish Hydro Arena. The popular Science Centre sits across the water and the Riverside transport museum was named European Museum of the Year in 2013. This half-mile stretch of river exemplifies industrial Glasgow's renaissance as a city of arts and culture.

GLASGOW CENTRE
1947 and 2013

When the 1947 photograph was taken, wartime bombs had damaged Glasgow's industry and slums made up much of the inner-city housing. The Bruce report recommended civic regeneration on an almost revolutionary scale. The M8 was to be part of a 'box' of motorways ringing the rejuvenated city centre. Swathes of slums and many then unfashionable Victorian buildings were cleared by 1968 to create the inner city section of the M8. This cut through the city from left to right, just below centre in the 1947 view, and its course just skirting the northern edge of the Port Dundas area can be followed on the lower view from 2013.

The communities of Charing Cross and Anderston were largely destroyed and their residents were relocated to new housing estates on the edges of the city.

Travel through the city was certainly easier, and the slums were gone, but protests at such a high level of demolition and upheaval led to the rest of the initiative being shelved. If the Bruce Report's plans had been fully implemented, Central Station, the Royal Infirmary, City Chambers, Kelvin Grove Art Gallery and Museum, and Charles Rennie Mackintosh's Glasgow School of Art would all have disappeared.

Buchanan Street railway station and the adjacent goods sheds, visible on the 1947 image, have all gone however, to be replaced by the modern buildings of the Cowcaddens and Buchanan Galleries areas shown to the left and in the distance on the upper view from 2013.

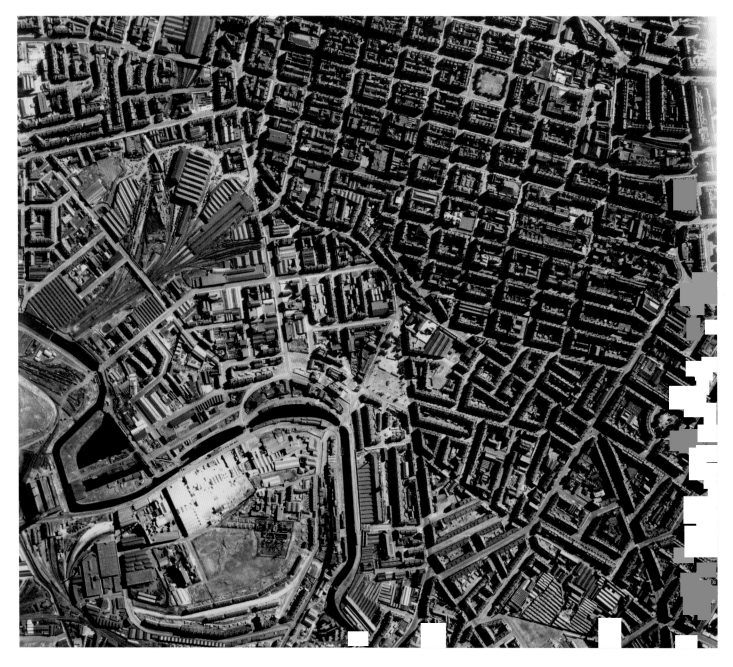

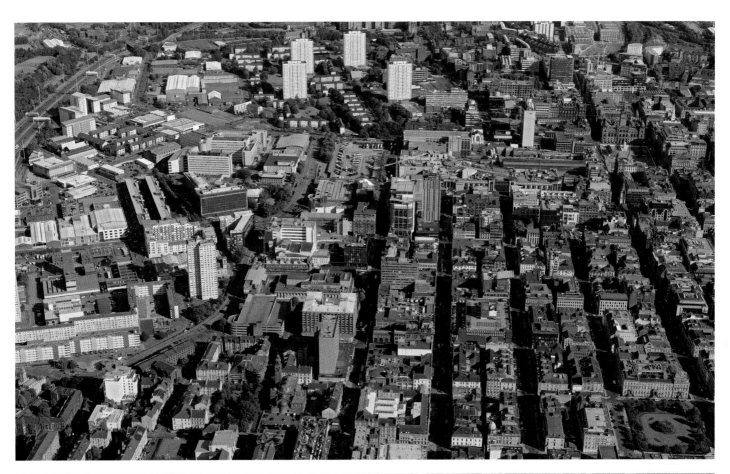

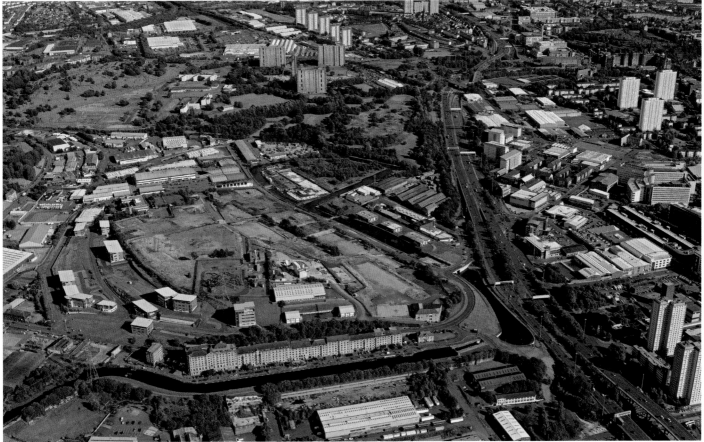

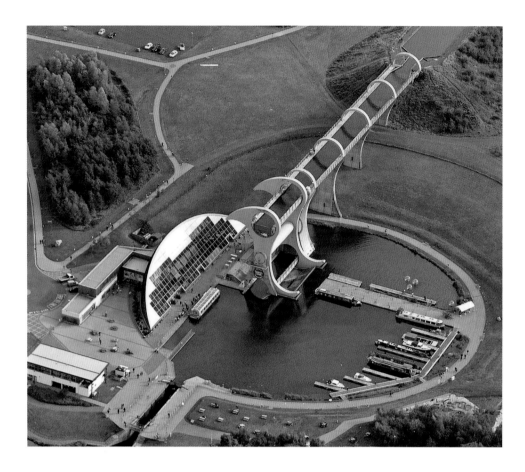

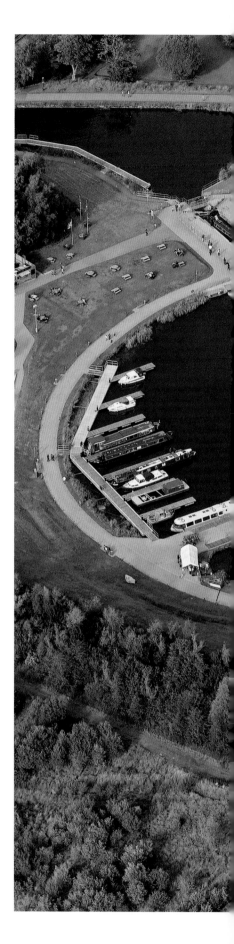

FALKIRK WHEEL
2013

In 1790 the seas on either side of Scotland were connected across the country's narrow waist by the 56 km (35 mile) Forth and Clyde canal. The Union canal later joined this around the belt buckle, adding a spur to the heart of the capital, Edinburgh. But the two canals were 34 m (112 ft) apart in height, and the connection required an 11-lock staircase. Each run through used 3,500 tonnes of water and took most of the day. When the canals fell into disuse in the 1930s, the locks were filled in.

The Millennium Project aimed to rejuvenate both canals, but a new link had to be created. Rather than reinstate the locks, designers decided to be bold and make a landmark as well as a conduit. Their answer was the Falkirk Wheel, the world's only rotating boat lift. Boats on the Union canal now continue past the start of the old locks along two new kilometres of waterway, through a tunnel under the Antonine Wall before sailing out into thin air on a viaduct. This terminates in a water-filled gondola. A gate is closed and the gondola, boat and water swing out into space, curving smoothly down into a basin on the Forth and Clyde canal below. The 23.7 m-long gondolas each weigh 50 tonnes, but rotating them only requires 1.5 kWh over 4 minutes – the same as boiling eight kettles. Since a boat displaces water exactly equal to its weight, the two gondolas are always perfectly balanced. The project architect worked out the gearing configuration that keeps the rotating gondolas upright by building a model with his daughter's Lego.

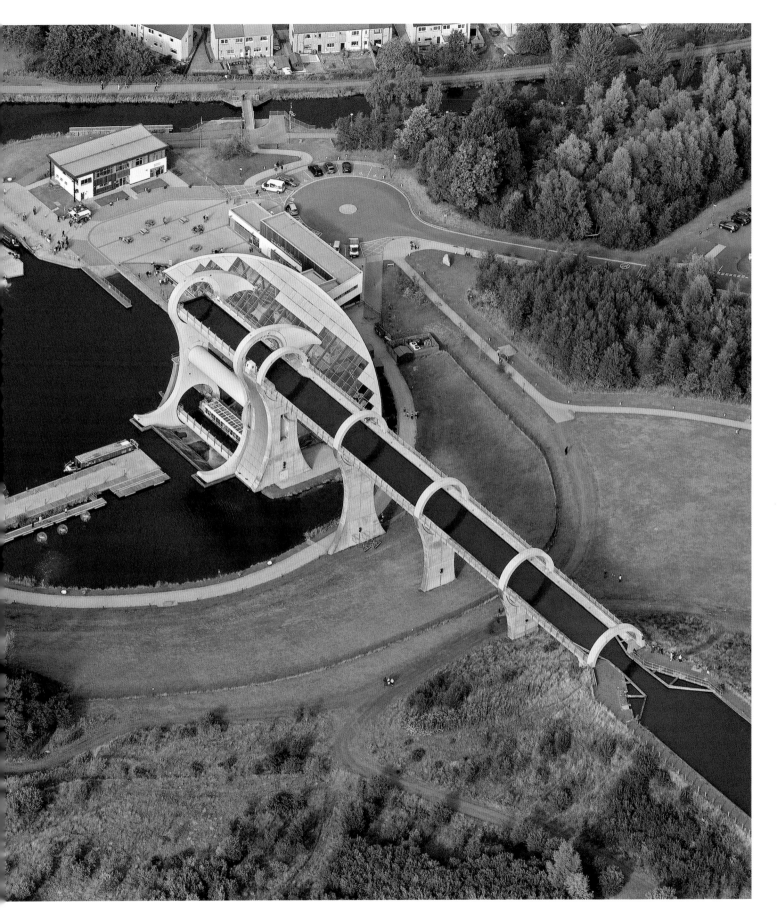

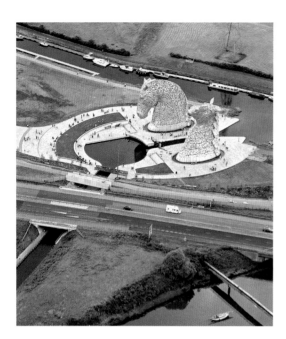

THE KELPIES
2014

The name Kelpies comes from the Lowland Scottish term for mythical water spirits, said to inhabit large bodies of water. Kelpies are usually said to appear in the form of a horse, but possessing the power and endurance of ten horses. Legend recounts that they can also adopt human form, and many traditional tales revolve around these mythical qualities.

The Kelpies name was chosen by Scottish Canals, when the plans for the redevelopment of the canal network and the associated Helix parkland were drawn up. Sculptor Andy Scott developed this theme to portray the important role the heavy horse played in Scottish agriculture and industry; pulling the ploughs, wagons, barges, iron and coal ships; nowhere more so than in the Falkirk area.

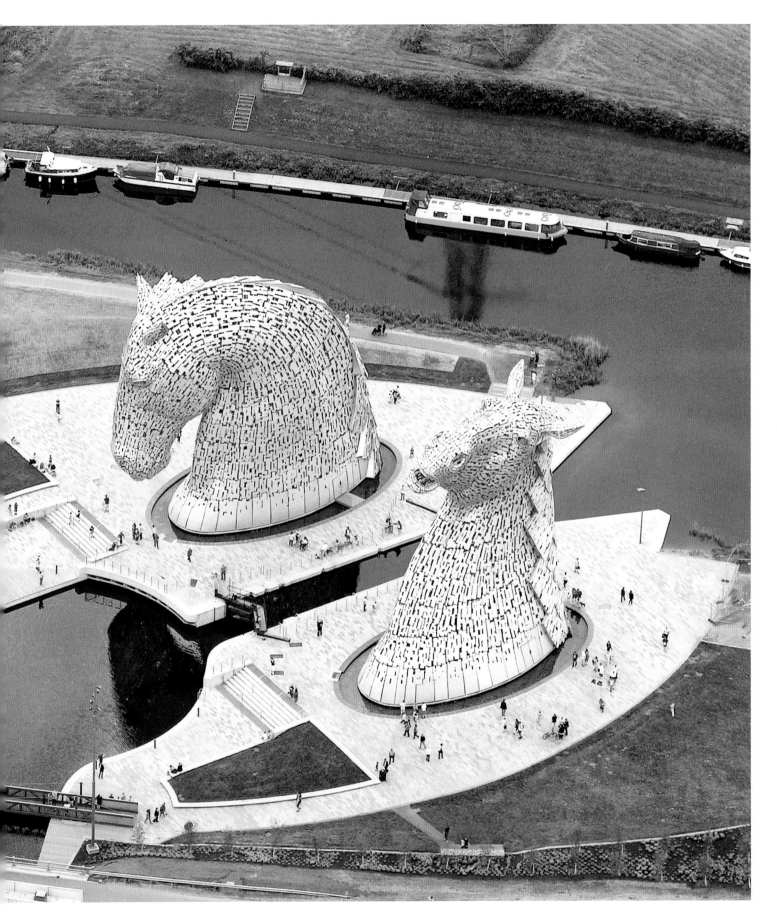

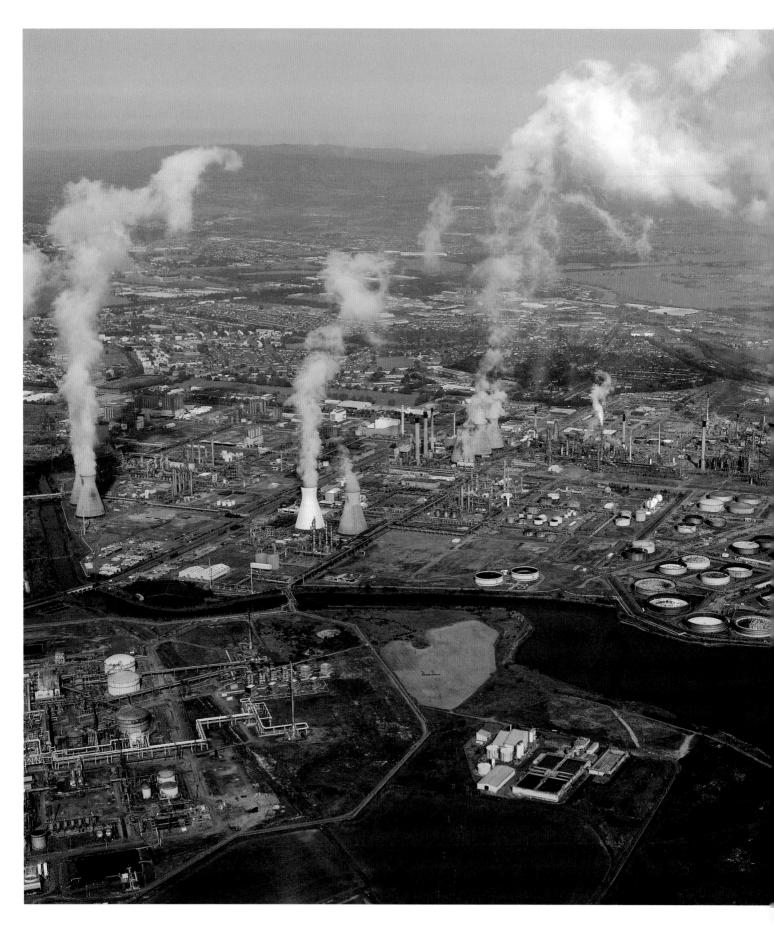

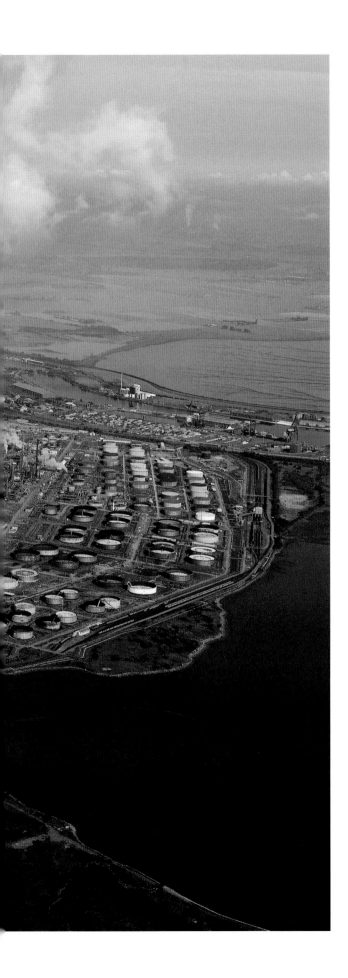

GRANGEMOUTH
1927 and 2012

The world's first oil works were opened in Scotland – at Bathgate in 1851. They refined oil from locally mined shale and were extremely successful: within a few decades the region was dotted with smoking refineries and looming shale bings.

But by the twentieth century, oil wells in the US and Arabia had made shale oil production uneconomic. In 1919 the six surviving Scottish shale companies united to become Scottish Oils. They built the country's first refinery to process imported crude oil on a flat site close to Grangemouth docks. The refinery is seen here just three years after it opened in 1924.

Grangemouth remained a simple refinery until 1939, processing 400,000 tonnes of crude oil a year, but after the Second World War it significantly expanded. A petrochemical plant was built adjacent to the refinery in 1951 and in 1975 oil flowed directly to the plant along a pipeline from North Sea fields.

Today the refinery complex sprawls over 700 hectares and is a major landmark, with its cooling towers and gas flares visible from land and sea. Its capacity is now 10 million tonnes of crude oil per year, making it one of the largest refineries in Europe.

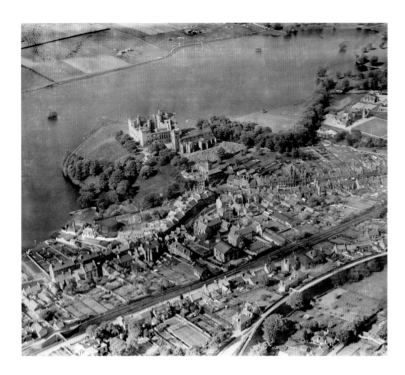

LINLITHGOW
1929 and 2012

Linlithgow Palace was conceived as an elegant royal pleasure palace by James I in 1424, after much of the old town burnt down. The site was ideally placed between Edinburgh and Stirling, with a peaceful, airy outlook and excellent hunting grounds nearby.

For the next 150 years it was a popular retreat for Scottish royalty. James III, James IV and James V all made their mark on the palace, adding new rooms and façades to create the formal courtyard structure. Its historical highlight came in 1542 when Mary Queen of Scots was born here. After the royal court moved to London in 1603, the palace deteriorated and was eventually gutted by fire in 1745.

The old burgh town has changed little in shape since the 1929 photo, but Linlithgow's distillery, paper mills, tanneries and explosives works have all disappeared. Bright white modern housing has replaced the dingy old gasworks by the shore of the loch.

The spiky aluminium 'crown of thorns' that adorns the fifteenth century St Michael's church by the palace was added in 1964. The M9 motorway cut its path along the north shore of the loch in 1968. The main Edinburgh-Glasgow railway line traverses the bottom of the image.

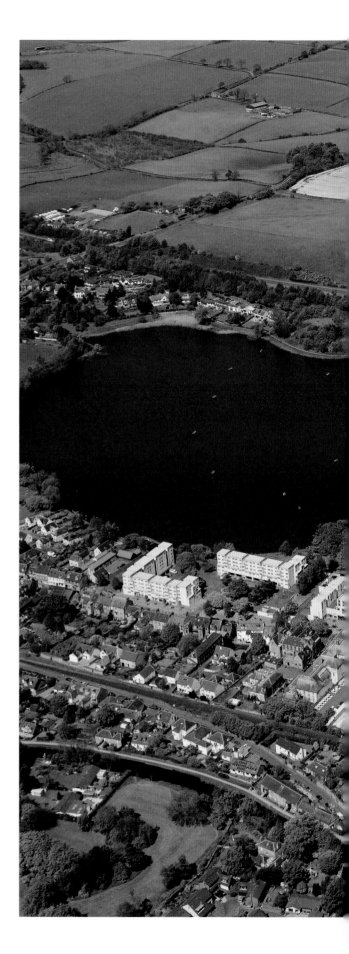

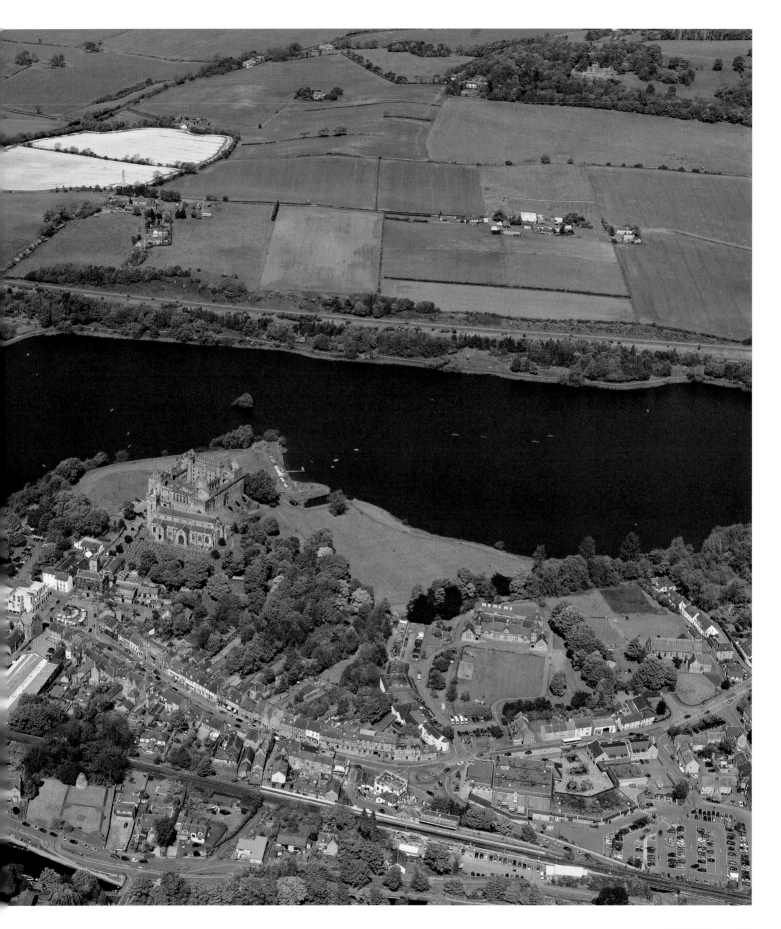

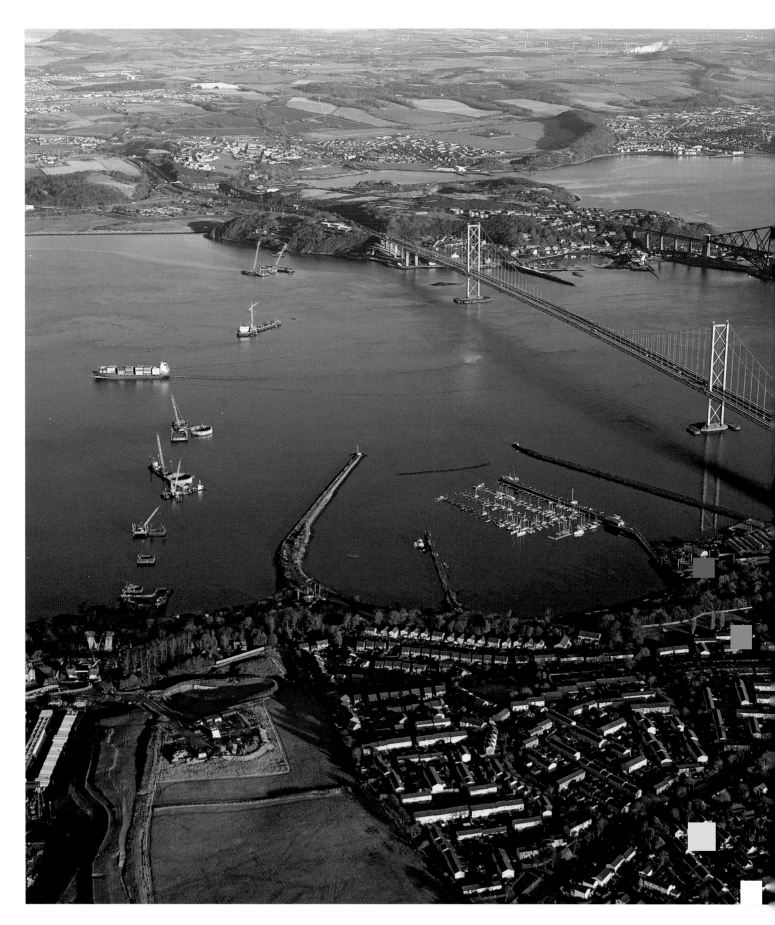

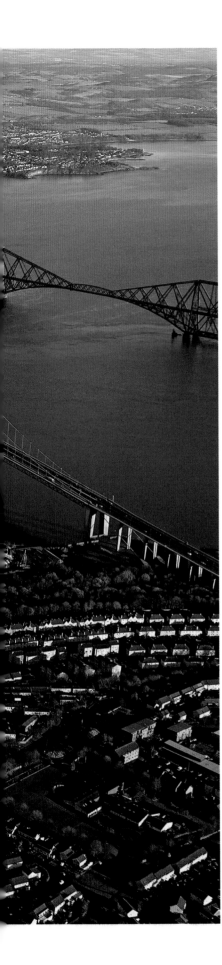

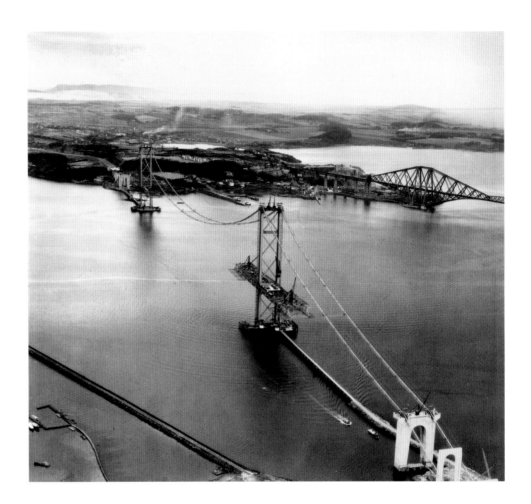

FORTH BRIDGES
1963 and 2013

The Forth Railway Bridge carries a double railway track soaring 46 m (151 ft) above the Firth of Forth, connecting Edinburgh with Fife.

After the catastrophic failure of the Tay Bridge in 1879, which killed 75 people, the Forth Bridge had to appear supremely strong. The cantilevered design was on a colossal scale. The bridge was completed in 1890 and was the first large steel structure in Britain. It used 64,800 tons of steel, ten times as much metal as its contemporary, the Eiffel Tower.

The idea that 'painting the Forth Bridge' is a never-ending task is erroneous. The last full repaint was completed in 2011 at a total cost of £130 million and will last for at least 25 years.

The Forth Road Bridge was completed in 1964 and then had the world's longest suspension bridge span outside the USA at 2,512 m (8,241 ft). It replaced a ferry service that had run for 800 years. Designed for 11 million vehicles per year, it was carrying twice this number by the turn of the century and in 2011 construction of a third crossing was approved.

The line of the new Queensferry Crossing, as it will be called, can be followed by the line of caissons extending across the Forth to the left of the existing Road Bridge. These have been sunk down to the bedrock beneath the Forth, and the piers and towers which will support the new cable-stayed bridge structure and its approach viaducts will rise from the concrete foundations constructed inside these watertight caissons. The new crossing is scheduled for completion in 2016 at a cost of £790 million.

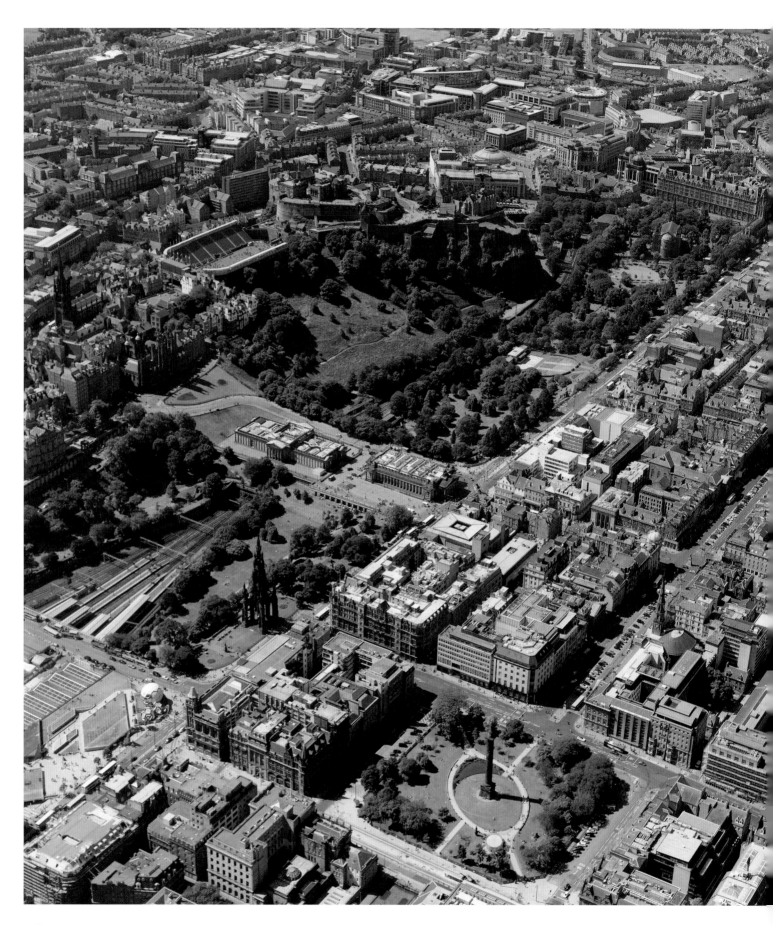

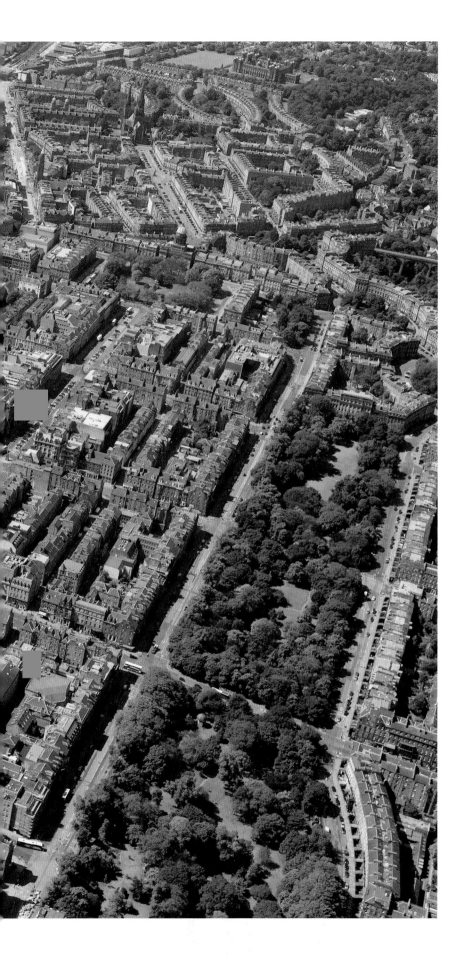

EDINBURGH NEW TOWN
2013

Edinburgh's New Town is roughly the same age as the United States of America, but it's still more juvenile than the medieval Old Town. In the eighteenth century the Scottish Enlightenment saw the city's merchants prosper and great thinkers such as Adam Smith and David Hume gain wide reputations. The old closes, where precarious tenements up to fourteen stories high towered over filthy gutters, were not suitable for such modern men.

In 1766, a competition was held to design a new, grander metropolis across the Nor Loch. The winning design was by James Craig, a mason who had no architectural training and was just 22 years old. Construction of this young man's grid-like masterplan began ten years later, with circuses, crescents and terraces added in several ever-grander waves until the 1830s.

The Nor Loch, by then a virtual sewer, was drained and landscaped as the pleasure grounds of Princes Street Gardens. The waste earth from the building works was tipped into a pile that formed The Mound, a link between the old and new halves of the city. Today, the remarkable preservation of most of this scheme makes Edinburgh the most complete and elegant of Georgian towns.

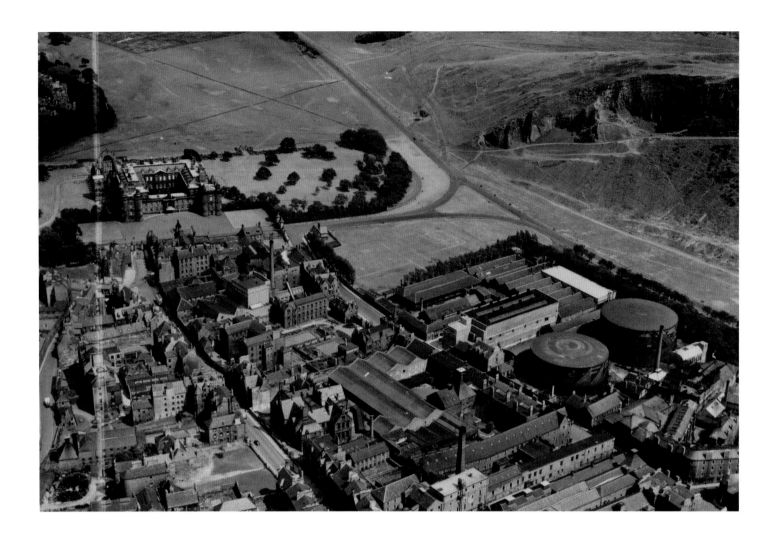

HOLYROOD
1949 and 2011

The Palace of Holyroodhouse in Edinburgh has been the monarch's official residence in Scotland since the sixteenth century. Mary Queen of Scots married both her husbands and witnessed the brutal murder of her secretary, David Rizzio, here. It abuts the ruined Holyrood Abbey, which dates to 1128. The surrounding park rambles over the rocks of an extinct volcano, and has 260 ha (650 acres) of lochs, glens, cliffs and wildlife.

The area is famous for the purity of its water, and by the twentieth century the city had 35 breweries, among them McEwans and Youngers (which produced a quarter of all beer quaffed in Scotland). The chimneys, warehouses and storage tanks in this 1949 photo show the vast sprawl of Youngers' brewery buildings in front of the royal residence. The brewery became part of the giant Scottish & Newcastle company, and after production moved elsewhere it closed in 1986.

A parcel of the brewery land was gifted to the nation for the site of the Scottish Parliament. This award-winning building houses an impressive debating chamber, offices for 129 MSPs, as well as 1,000 staff and civil servants. It was designed by Catalan architect Enric Miralles who died before its completion in 2004. The rest of the old brewery has been developed into housing, hotels, the new home of *The Scotsman* newspaper and the *Our Dynamic Earth* attraction.

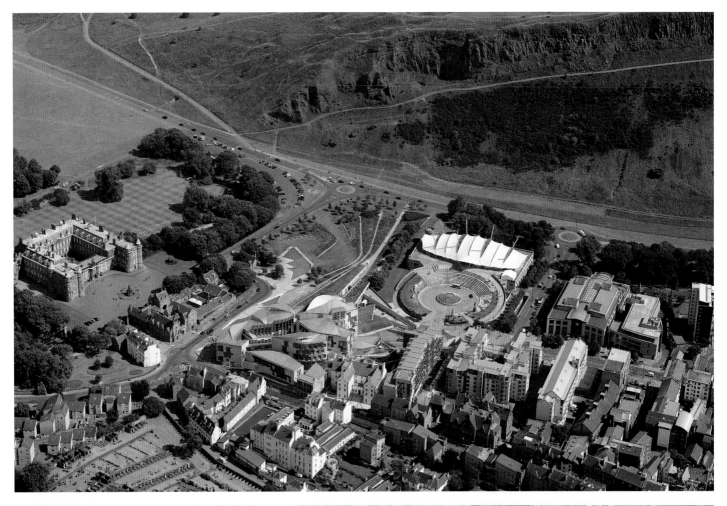

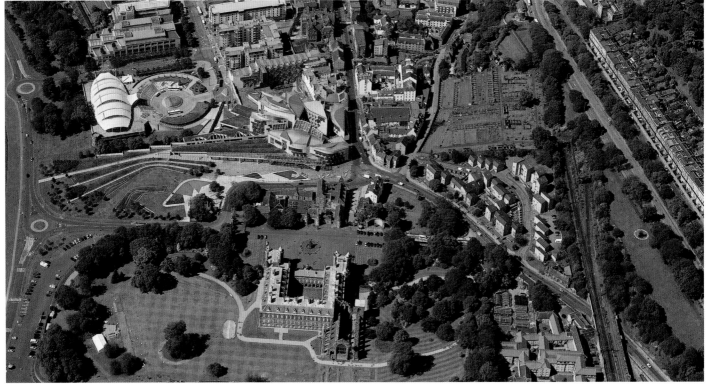

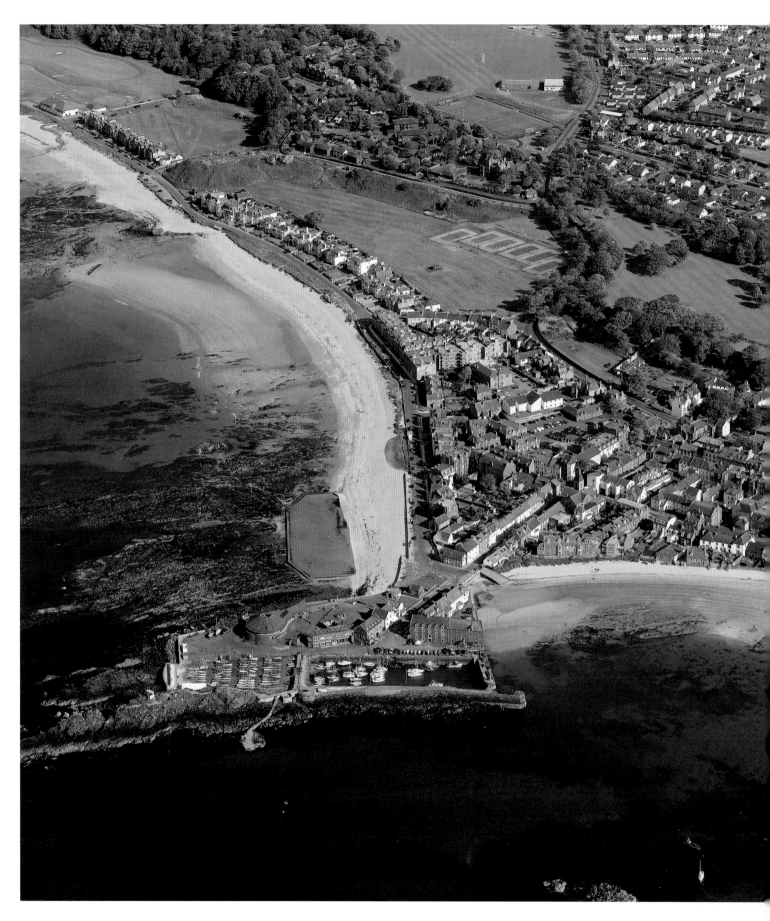

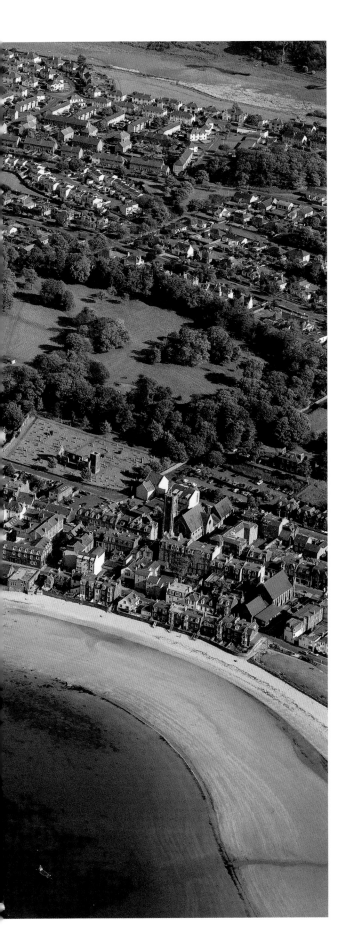

NORTH BERWICK
2014

In its nineteenth-century heyday as a fashionable watering hole and golfing centre, North Berwick was known as the 'Biarritz of the North'. Presumably by people who had never been to Biarritz. But after the arrival of the railway in 1850 its twin sandy beaches certainly drew the crowds. The town became hugely popular both as a resort and as a residence for Edinburgh's professional class, with its population doubling between 1880 and 1905.

The open-air pool was a popular Victorian addition, with diving shows and swimming galas attracting even more visitors. It was still open in the 1980s, but as more people could afford flights to the Spanish sun and warm indoor leisure pools sprung up at home, its days were numbered. It finally closed in 1996.

North Berwick harbour was built in the twelfth century and for 500 years a ferry took pilgrims bound for St Andrews over to Fife. It also flourished as a trading and fishing port, with eighteenth-century warehouses (now flats) clustering around the busy harbour.

North Berwick is still very popular with golfers, sailors and anglers, and the beaches are crowded in summer. Boat trips run from the harbour to the nearby Bass Rock, shown in the image below. Dinghies are now parked on the footprint of the old pool. The round-roofed Seabird Centre opened in 2000 and features live pictures of bird colonies on nearby islands, as well as any passing whales and dolphins.

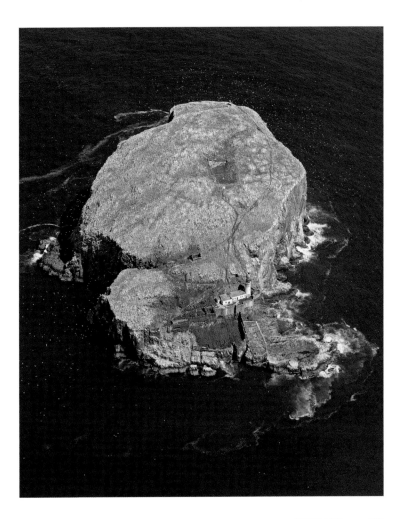

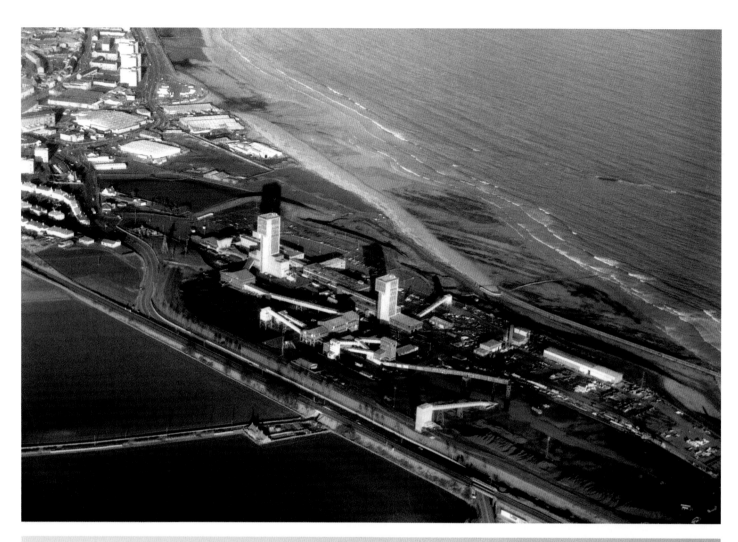

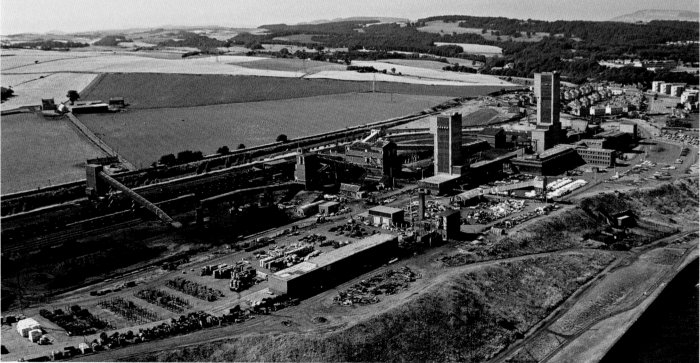

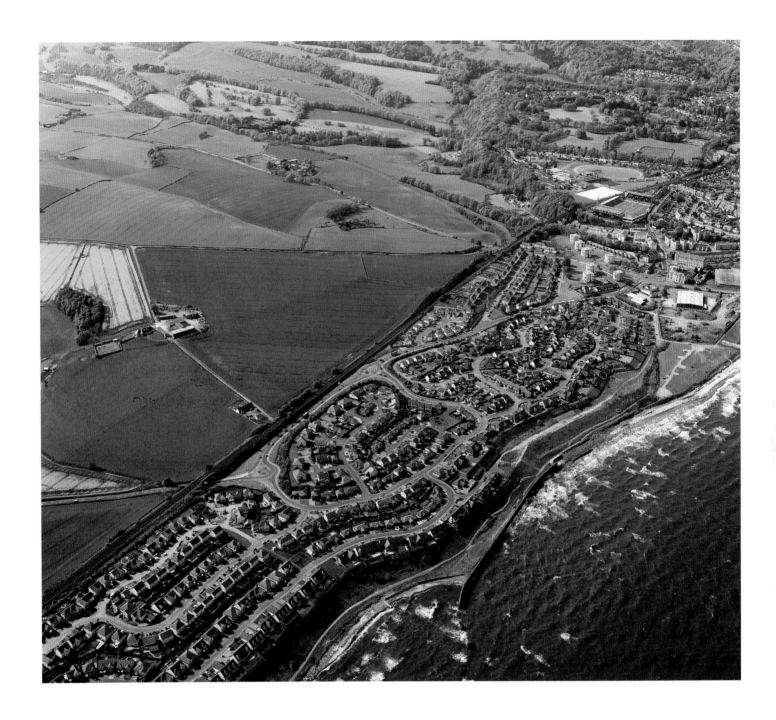

SEAFIELD COLLIERY
1960, 1983 and 2011

Far beneath this pleasant modern housing estate is the deepest hole in Scotland. Seafield Colliery, which opened in 1960, was one of five new Scottish 'super-pits'. It was forecast to have a life of 150 years, and in its 1970 heyday employed 2,466 people. Coal was hewn from faces 1,000 m (3,280 ft) below the surface of the Firth of Forth, making it the deepest mine in the country and one of the largest undersea mines in Europe.

The vertical shafts at Seafield were sunk to 600 m (1,968 ft), then steeply angled tunnels 2.4 km (1.5 miles) long descended a further 400 m (1,312 ft) out beneath the waters of Kirkcaldy Bay to the coal faces.

The undersea tunnels connected up with Seafield's sister mine, the Frances Colliery, which was sunk near Dysart over 5 km (3 miles) to the north past Kirkcaldy. Seafield survived the 1984 miners strike, but was closed four years later.

Seafield's most famous miner was Jocky Wilson, who would later become a darts world champion.

ST ANDREWS
1949 and 2010

Much of St Andrews has not changed in centuries: the layout of the famous Old Course, the ruined cathedral and the core of the ancient university. But around these inviolate sites, the rest of the town has expanded and altered a great deal in recent decades.

The little beach and tidal bathing pool at the bottom of the 1949 picture are today part of the St Andrews Aquarium. The Scores is the street with houses on once side and sea-worn cliffs on the other. At the end, alone in its grassy playground in the old photo, is the grand clubhouse of the Royal and Ancient Golf Club. Today it is joined by a golf museum and a large car park to the west.

At the top of the 1949 picture is the railway line that served the town from the junction at Leuchars until it was dismantled in 1969. It skirted right along the 17th hole of the Old Course, and the best line from the tee was over the corner of the engine sheds. A simulacrum of the sheds has been retained as part of the huge Old Course Hotel, which dominates the golf course. The old stationmaster's house is a pub. North Haugh, the empty grassy plain beyond the line, is now covered with new university buildings.

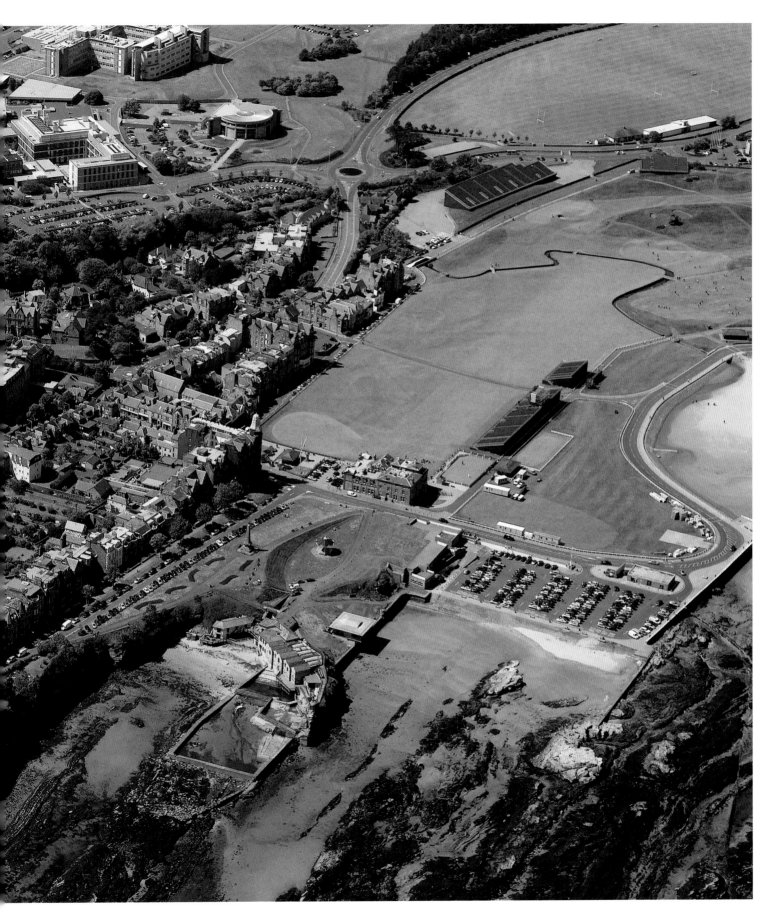

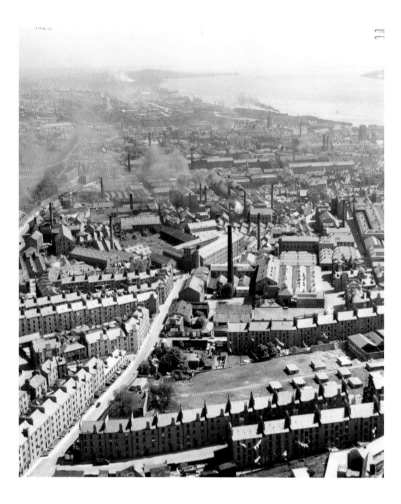

DUNDEE
1947 and 2008

When the Crimean and American Civil Wars interrupted cotton imports, Dundee's jute barons cashed in. Grown in India, this plant was imported and coated with whale oil (another major Dundee product) and its fibres spun into material for carpets, sacking, rope and hessian cloth. In the late nineteenth century the city had 62 jute mills, employing over 50,000 workers and the Camperdown Works was the world's largest, with almost 6,000 employees. The jute industry was still vibrant when the 1947 picture was taken, with eleven mills visible in this image alone. The last closed in the 1970s.

But Dundee has always been a versatile city, with accomplishments in many fields. It excelled as a shipbuilding centre, with 200 ships per year being launched from its yards in the 1870s. Famous Dundee vessels include the *RRS Discovery*, Robert Falcon Scott's Antarctic research vessel, which is now on display in the city. The last ship was launched into the Tay in 1981.

Journalism giant DC Thomson, publishers of The Sunday Post, The Dandy and The Beano, is still a major employer, but today the city's most promising achievements come from the biomedical and technological fields. Dundee accounts for 10 per cent of Britain's digital entertainment industry and Rockstar, maker of the world-famous Grand Theft Auto video game, was founded here.

The city is the home of marmalade, which was first produced by the Keiller family in 1795. The Keillers also pioneered Dundee Cake.

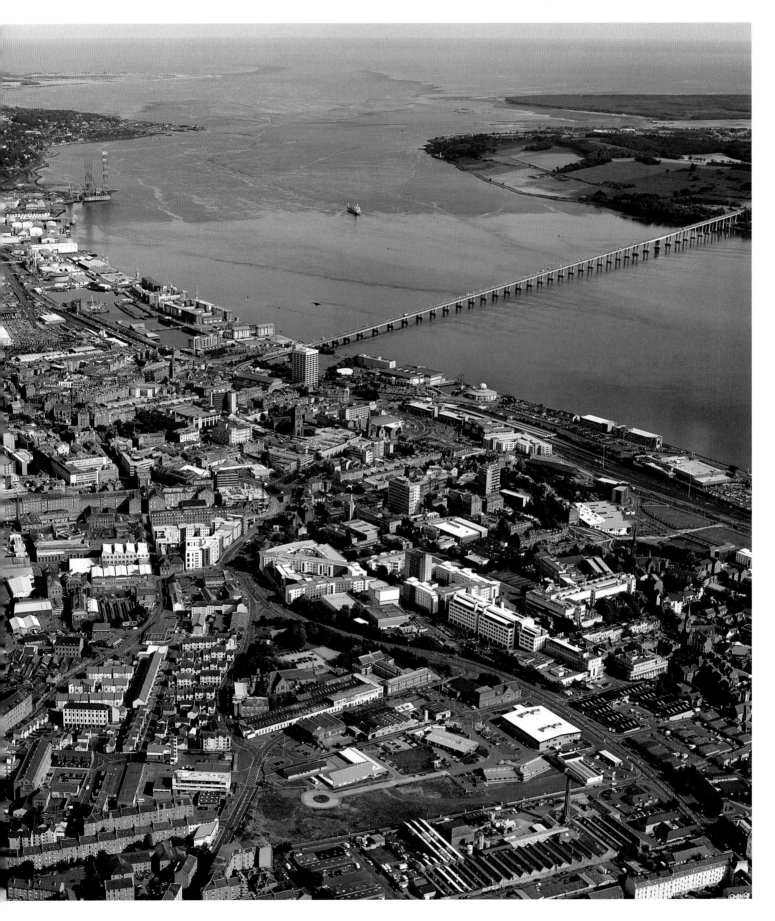

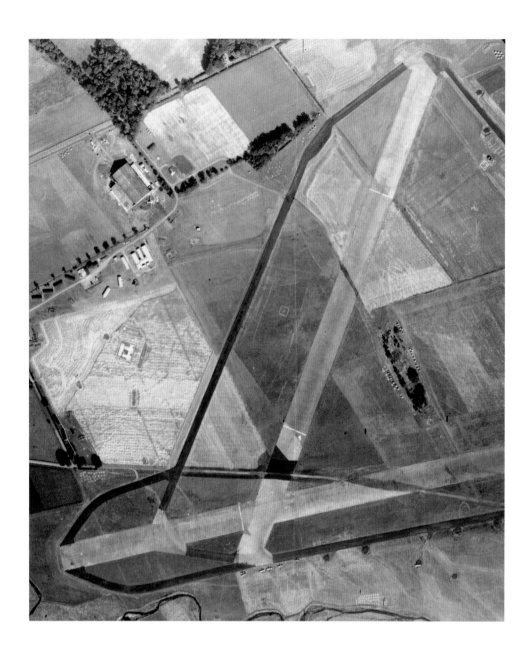

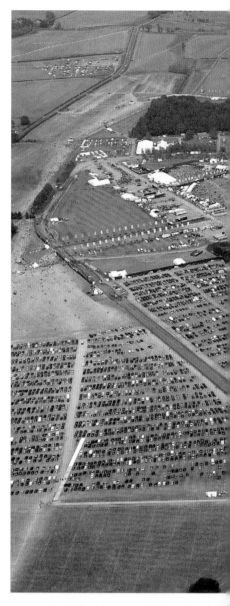

BALADO AIRFIELD
1943 and 2013

RAF Balado Bridge opened on 30 March 1942 as a satellite airfield to RAF Grangemouth. It was hoped that its better weather record would allow for increased flying training hours. After the war the airfield became an aircraft graveyard. McDonnell Aircraft of nearby Milnathort broke up many hundreds of surplus Fleet Air Arm aircraft here, including Harvards, Fulmars, Fireflies, Martinets, Barracudas, Expeditors and a rare Fairchild Cornell FT673. Airframes could still be seen in various stages of dismemberment as late as February 1952.

It was also used from 1946 for light aircraft and gliding until its decommissioning as an RAF station in 1957. During the Cold War the airfield was used as a NATO communications station, with aerials located inside a landmark 'golf-ball' structure.

From 1997 to 2014, the airfield hosted 'T in the Park', one of Britain's biggest music festivals. For three days in July, 85,000 revellers descended on the old airfield to enjoy more than 180 acts.

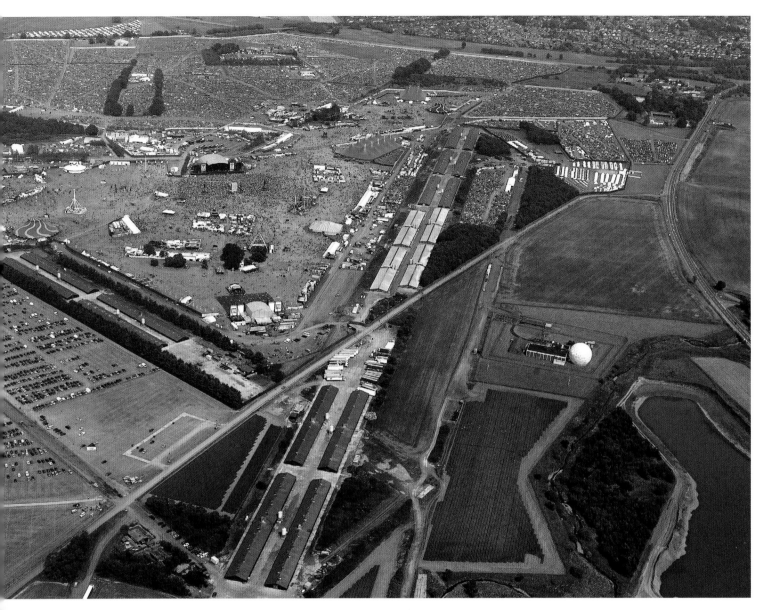

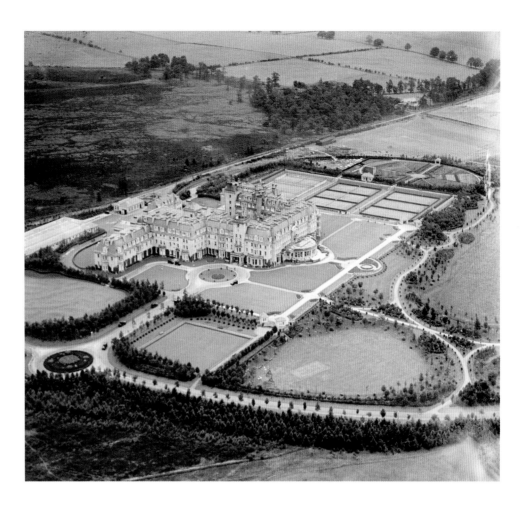

GLENEAGLES
1930 and 2010

The general manager of the Caledonian Railway was holidaying in Strathspey in 1910 when the magnificent scenery inspired a vision: a palatial highland hotel, golf courses, and rich guests who would use the company's trains to get there.

Fourteen years later his dream had taken shape as Gleneagles. The hotel was a grand building modelled on a French chateau, set in 850 acres of grounds with two golf courses designed by James Braid, the Tiger Woods of his day. It was unlike anything in the country at that time and was described as 'a Riviera in the Highlands'. Soon the hotel was shaping the lives of high society: after the London season it was yachting at Cowes, polo at Deauville and then golf and grouse shooting at Gleneagles.

The spoked wheel towards the top tight of the 1930 picture is an enormous vegetable patch, providing the ultimate in fresh and local produce. Curving round this is a train line, which carried goods right to the back door of the hotel. This closed in 1964 when the branch line it ran from was cut by the Beeching report. However, Gleneagles still has its own station on the mainline 1 km away.

Today the hotel maintains its high reputation: it hosted the 2005 G8 summit and was chosen as the venue for the 2014 Ryder Cup.

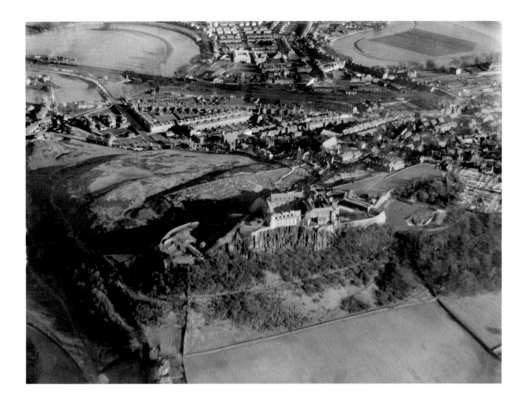

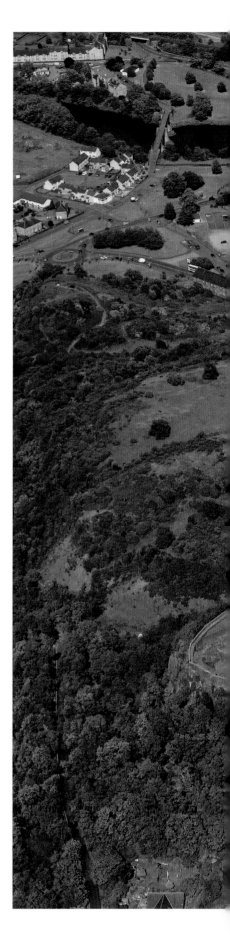

STIRLING CASTLE
1928 and 2010

Stirling Castle is perhaps the grandest and most historically important of all Scotland's castles. With near-perfect natural defences and a strategic position at a nexus of road and river routes through central Scotland, it was a royal power centre at least as early as the twelfth century.

The castle watched over two of the most important battles in Scotland's history: Stirling Bridge, where William Wallace's army defeated the English in 1297, and Bannockburn, where Robert the Bruce repeated the feat 17 years later. It also overlooks what was the furthest downstream crossing of the River Forth until the 1890s.

Most of the buildings we can see today were built from 1490–1600, during the castle's heyday as the royal residence of the Stewart kings James IV, James V and James VI. After the Union of the Crowns in 1603, the Scottish court relocated to London and the castle lost its royal influence.

The Great Hall was completed in 1503 and was by some distance the largest banqueting hall in Scotland, measuring 42 x 14.25 m (138 x 46.8 ft). Its soaring hammerbeam roof was removed in 1800 so that the hall could be divided up into barrack rooms. The army was still in residence when the 1928 picture was taken, finally leaving in 1965. An extensive restoration programme was completed in 1999, with the hammerbeam roof being rebuilt, period windows reinstated and, as can clearly be seen on the recent image, the outer walls limewashed.

The changes in Stirling itself can also be seen here. Towards the top of the 1928 picture, a swathe of railway sidings cuts in front of the meandering River Forth. Although Stirling's station today serves over 2 million passengers a year, these freight yards have now been replaced by a road and a large supermarket.

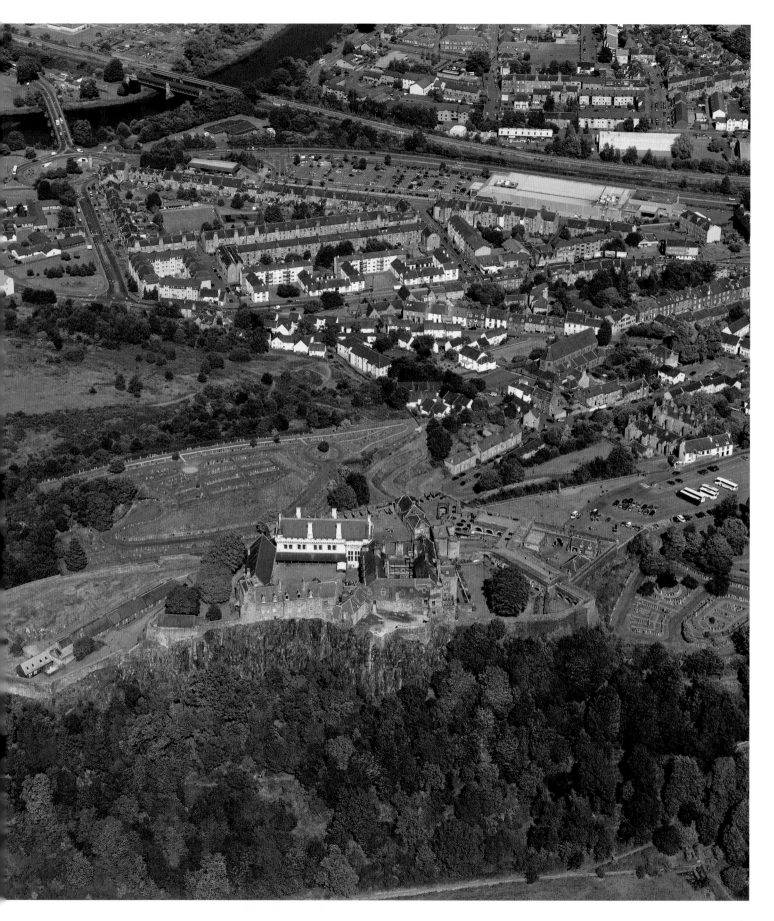

SCOTLAND **163**

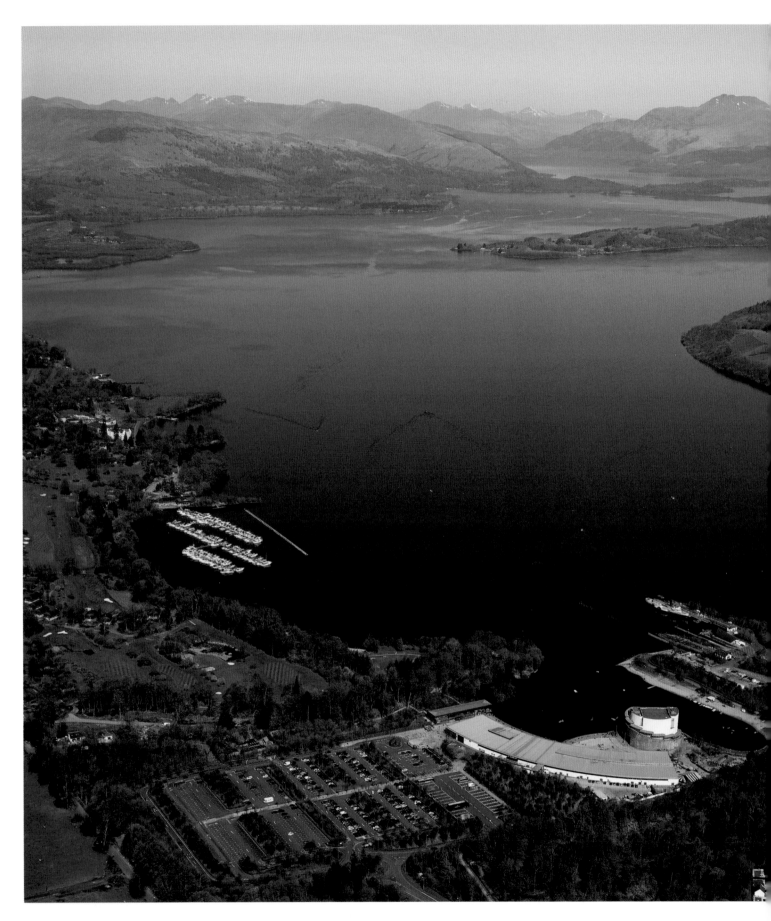

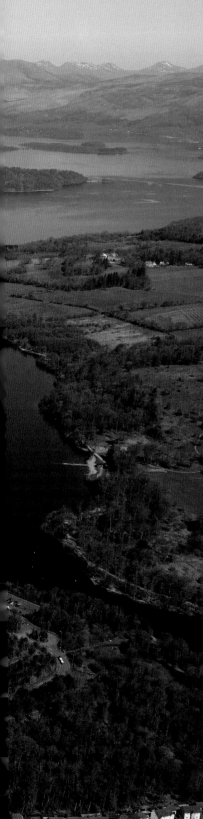

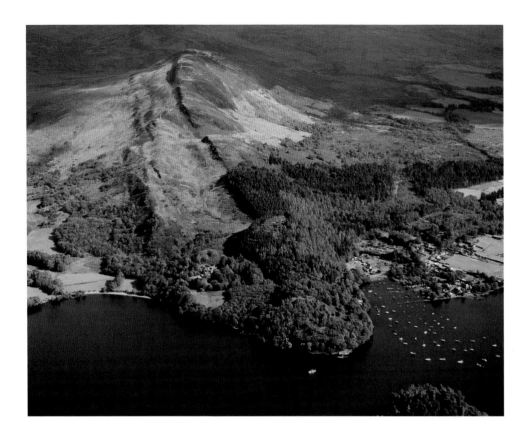

LOCH LOMOND
2011 (right) and 2014 (left)

At 39 km (24 miles) long, up to 8 km (5 miles) wide and 190 m (620 ft) deep, Loch Lomond is the largest body of water on the island of Great Britain by surface area. It is the second largest by water volume but the largest, Loch Ness, holds three times as much water.

Deep under the wakes of the jetskiers and sailors lies the Highland Boundary Fault, which traditionally marks where the wide straths and low, rounded hills of Central Scotland give way to the rugged peaks and steep-sided glens of the Highlands. The division is clearly visible in this image (left), with the green lowland fields in the foreground and the cluster of snowy mountains towards the north. Ben Lomond, the most southerly of Scotland's Munros (hills over 3,000 ft) stands sentinel over the loch on the far right of the image, opposite the jagged peaks of the 'Arrochar Alps'.

The loch's proximity to the lowlands, and Glasgow in particular, has always made it a popular recreation destination. The West Highland Way, Scotland's most-walked long-distance trail, runs along the eastern shore. There are several prestigious hotels and golf courses on the western side and a shopping complex to the south.

There are over thirty islands in the loch, several of which are crannogs – artificial islets built by prehistoric people as safe havens. These would have been accessed by stilted walkways. Somewhat incongruously, the island of Inchconnachan is home to a colony of wallabies, which were introduced there in the 1940s and seem to like their northern home.

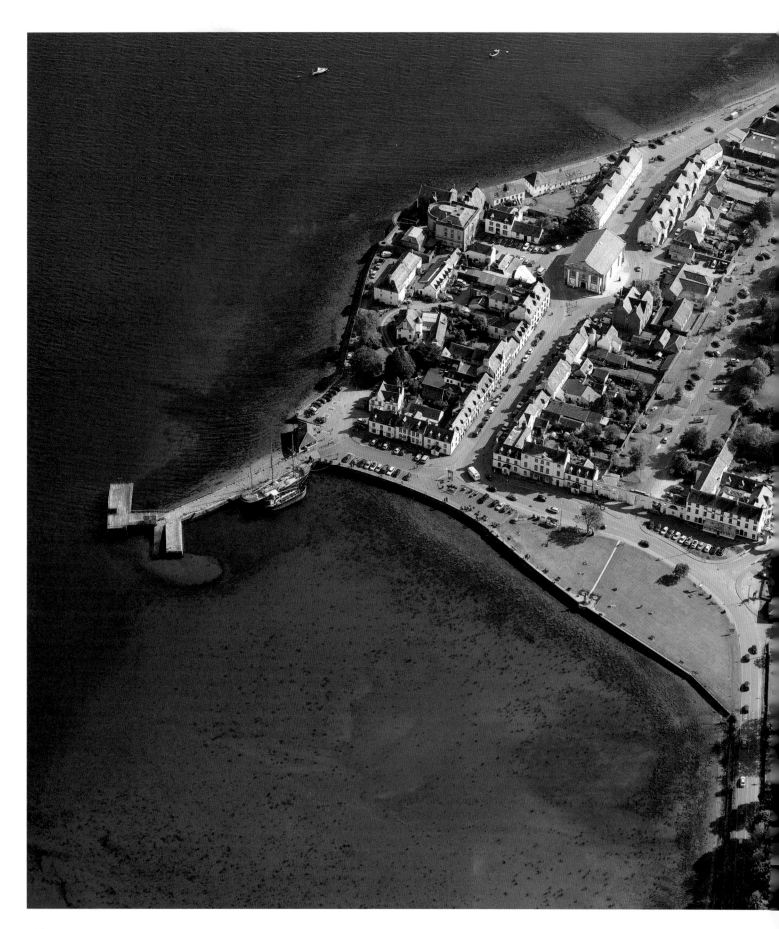

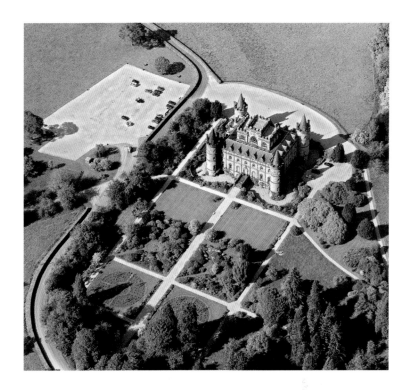

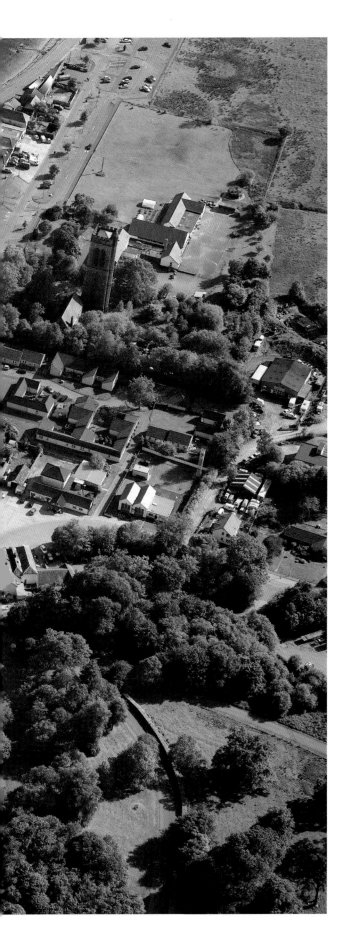

INVERARY
2014

When the third Duke of Argyll decided to demolish his existing castle at Inverary and build a new castellated mansion in the middle of the eighteenth century, the removal of the existing village of Inverary to create more parkland around his grand new family seat was part of the plan. Although plans for the new settlement at Inverary had certainly been drawn up by the celebrated Scottish architect, William Adam, much of the new village was the work of Robert Mylne, another famous architect of the period.

The new settlement is made up of attractive, white-harled buildings, which due to their size and grandeur often make Inveraray look much bigger than it is. Its famous Jail closed as a prison in 1889, but has since re-opened as an imaginative visitor centre and museum. Para Handy Cottage, which stands on the shore nearby, is the birthplace of Neil Munro, the author of the Para Handy stories.

Work began on the new castle in 1745, although it was not finished until 1789. The massive building is actually rectangular in shape, although it looks square from many angles. The 11th Duke carried out a major renovation of the castle following the Second World War and it has been open to the public since 1953.

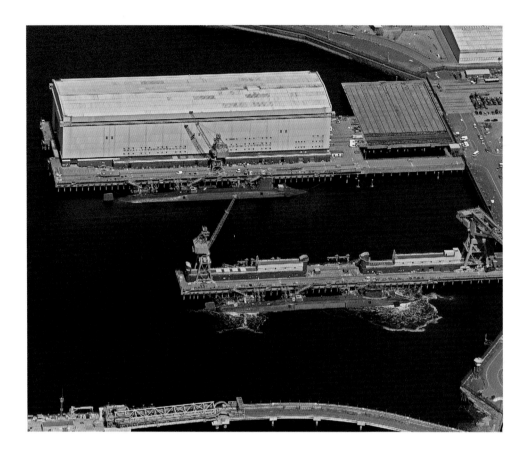

FASLANE
2013

Faslane Naval Base, on the Gare Loch to the north of the Clyde, is part of HM Naval Base Clyde, which also includes the RN Armaments Depot at Coulport on nearby Loch Long. Faslane is the sole base for *HMS Vanguard*, *HMS Victorious*, *HMS Vigilant* and *HMS Vengeance*, the four Vanguard-class submarines which carry the UK's Trident nuclear deterrent. Two of these 150 m-long vessels can be seen alongside the jetties in the image above.

Faslane is also the home base for the new Astute class, nuclear powered, hunter-killer submarines as they enter into service, and various mine countermeasures and patrol vessels. HMNB Clyde is the UK navy's main presence in Scotland and currently employs around 6,500 military personnel and civilian workers. Dicussions about a new generation of submarines and missiles to replace Trident at the end of its service are currently ongoing.

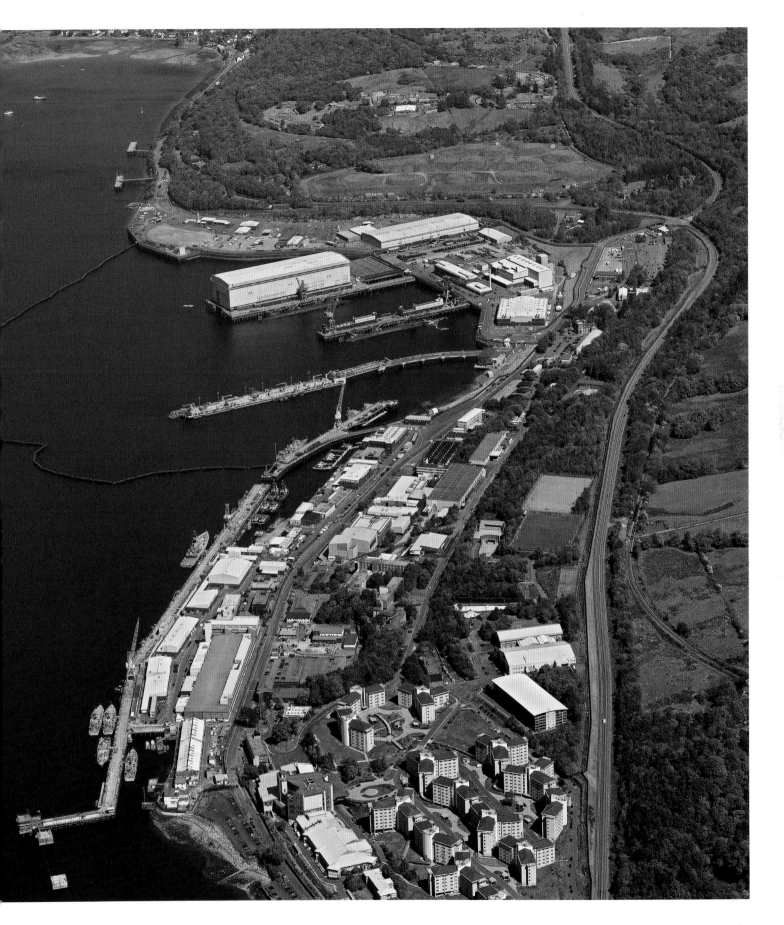

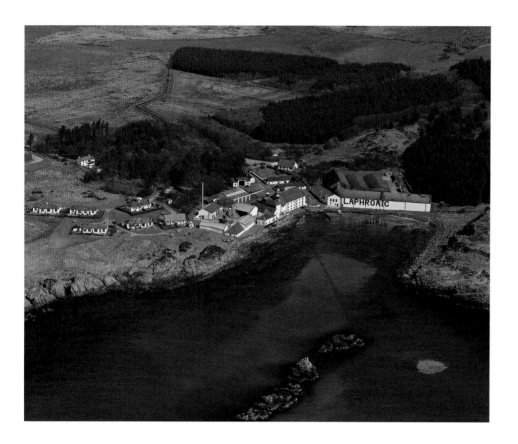

ISLAY WHISKY
2014

From illicit stills quenching the thirsts of local villagers to international centres of business, Scotland's whisky distilleries have come a long way in 200 years. The Excise Act of 1823 eased restrictions on licensed distilleries, creating the modern era of Scotch production. Output was still mostly for regional consumption until the *phylloxera* epidemic all but destroyed France's wine and cognac production in the 1880s, allowing whisky to fill the gap in the international spirit market.

The industry is currently enjoying its biggest boom in several generations, with exports now worth £4.3 billion per year, a figure that represents more than 25 per cent of the UK's entire food and drink overseas market.

Scotland has around 100 distilleries in five legally protected production areas: Islay, Speyside, Highlands, Campbeltown and Lowlands. Most distilleries are owned by multinational drinks businesses, but with increasing demand for high quality malt from emerging markets such as India, Brazil, China and Russia, and younger British drinkers, new distilleries are popping up all over the country.

Port Ellen distillery was opened in 1825 and there were once six other distilleries along a three-mile stretch of coastline immediately to the east; but today production in this part of Islay has been consolidated into three distilleries – Laphroaig, Lagavulin and Ardbeg. Port Ellen, shown to the right, is one of the two ferry ports on the island and has the only deepwater harbour.

At one time there were twenty-three different distilleries in operation on the island. Although only eight are now active, these include some of the most famous malt whisky brands in the world.

The word 'whisky' comes from the Gaelic *uisge beatha* meaning 'water of life'.

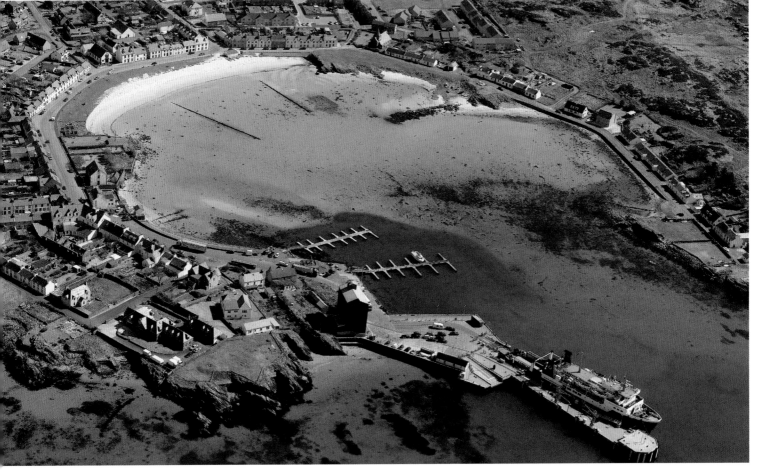

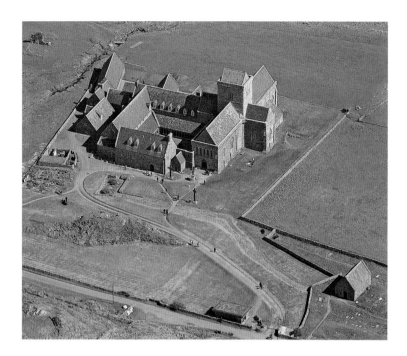

IONA
2012

Iona has a timeless spirituality and there has been a Christian church here since the sixth century. But despite their venerable tranquillity, the abbey buildings that we see today are mostly from the twentieth century.

In AD 563, the exiled Irish monk Columba fled his homeland with twelve loyal companions, and founded a monastery on Iona. This flourished as a seat of learning and became a hub for the spread of the Gospel to the local Picts and the Anglo-Saxons of the kingdom of Northumbria. Early Scottish kings were crowned at Iona and legend says that forty-eight monarchs, including kings from Ireland, Norway and France, are buried in the Abbey grounds. The Book of Kells, a sublimely beautiful illuminated manuscript now held in Trinity College, Dublin, was the work of Iona monks in the eighth century.

The Abbey was sacked and burned by the Vikings in the ninth century, and abandoned. A new Benedictine abbey was built on the site in 1203 and later expanded, but this monastery was left to crumble after the Scottish Reformation.

From 1938, an ecumenical Christian group, the Iona Community, began restoring the abbey and re-constructing the surrounding buildings. Now thousands of pilgrims come to Iona every year, for a brief visit or the peace of a longer retreat.

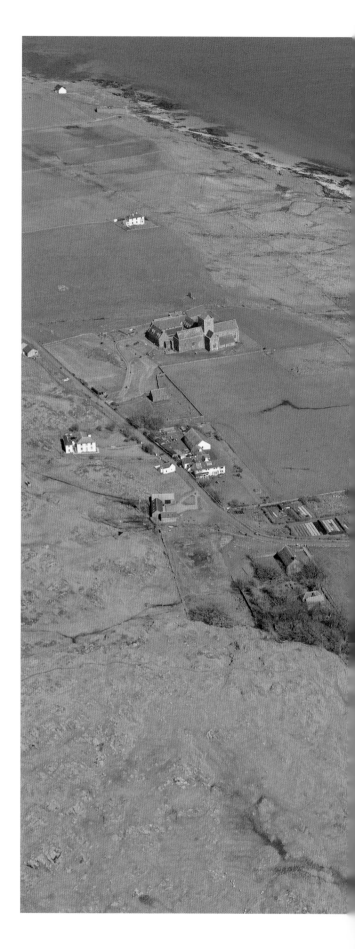

CORRYVRECKAN WHIRLPOOL
2014

The third largest whirlpool in the world forms in the Gulf of Corryvreckan, between the islands of Scarba and Jura. The underwater topography of the gulf is unique: the seabed is pitted with a 219-m-deep hole and studded with ridges and pinnacles, one of which rises like a pyramid from 70 m down to just 29 m below the surface.

As the flood tide enters the narrow strait it runs over this underwater obstacle course, causing violent effects on the surface. These can include a single mighty maelstrom, dozens of smaller whirlpools, a standing wave and a tidal race several miles long.

Tides, winds and pressure can combine to create waves at Corryvreckan of 9 m (30 ft) high, the roar of which can be heard 16 km (10 miles) away.

George Orwell wrote his classic novel 1984 in a remote cottage on Jura not far from Corryvreckan. Taking a break from his tale of a future dystopia, he sailed a small boat out into the gulf, but misread the tide tables and was driven into the whirlpool. The maelstrom sheared his boat's engine from its mounts, forcing Orwell to row to a rocky islet. He was rescued by a passing lobsterman.

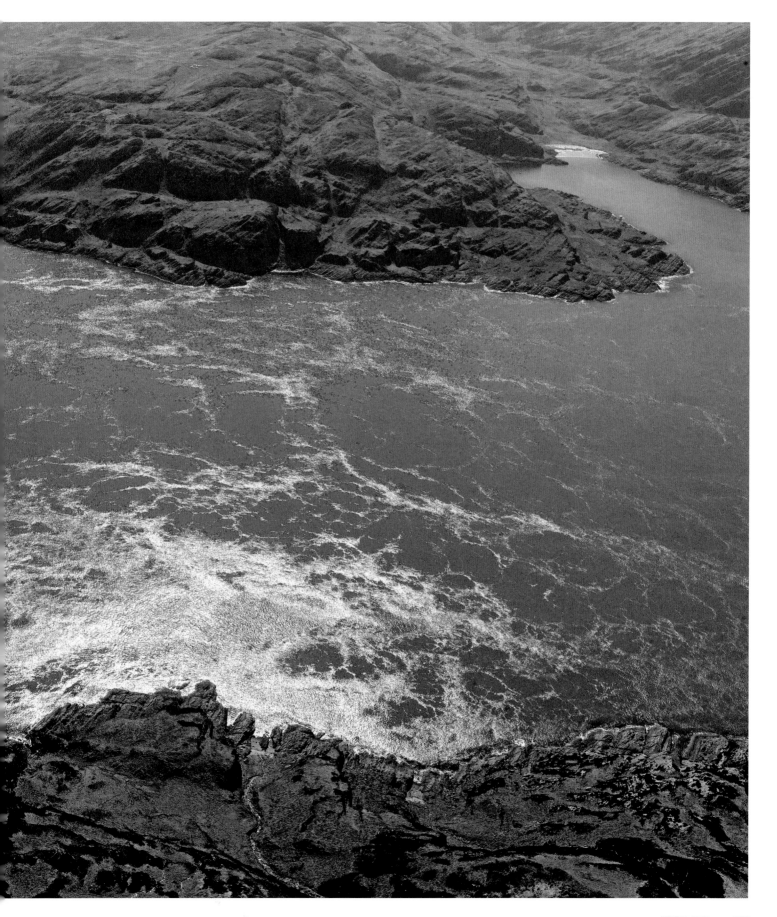

EASDALE
2014

Easdale is the island that once roofed the world. One of several slate islands in the Hebrides, Easdale had seven quarries and shipped its stone to places all across the British Empire, including Melbourne, Nova Scotia, Dunedin and Dublin. This photo shows the water-filled remains of the pits, which at their peak supported 500 workers.

Some of the diggings extended to 92 m (300 ft) below sea level, and the nearby island of Eilean-a-beithich was hollowed out entirely. Only a thin outer rim remained and this was breached by the sea one stormy night, leaving almost nothing of the island above the waves. Had the slate trade not fallen off in the 1950s, Easdale might have suffered the same fate.

Within a few years of the last slate boats departing, only four people lived on Easdale and it seemed that the settlement might pass into oblivion. But the community has rebuilt itself, with sixty residents on what is the smallest permanently inhabited island of the Inner Hebrides.

Today, the quarry pools are sanctuaries for a wide variety of flora and bird life. One of them also forms the perfect arena for the World Stone Skimming Championship. Every September entrants come from all over the world to skip a perfectly formed piece of Easdale slate as far as they can across the quarry's waters.

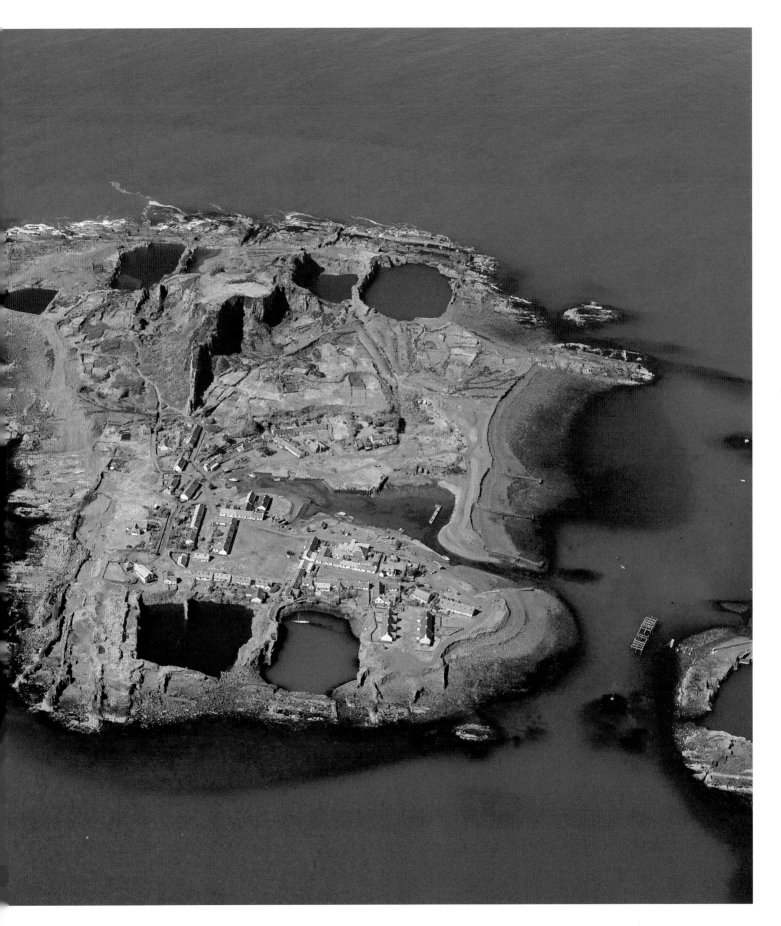

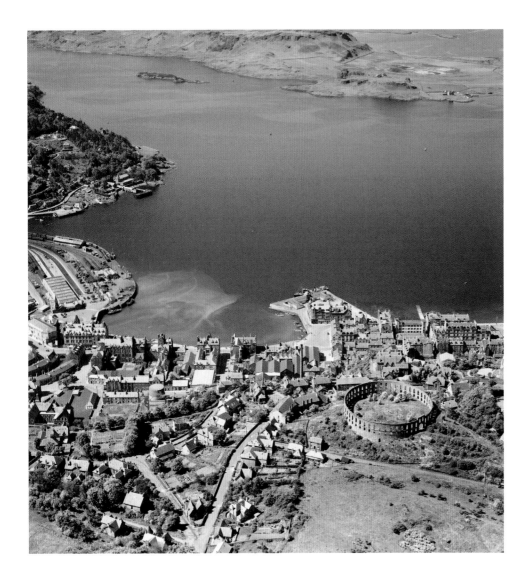

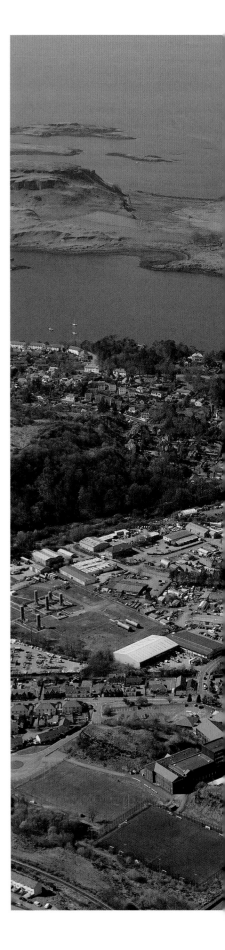

OBAN
1950 and 2014

Oban was little more than a distillery and a few scattered houses in the early nineteenth century. Then the boom in romantic Scottish landscapes fuelled by Sir Walter Scott's works, and the arrival of the railways in the 1880s, brought tourists and prosperity.

The old station building has been knocked down, but the beautiful West Highland Line from Glasgow still terminates here. The town gained a new ferry port in 2005, the busiest in the Caledonian MacBrayne network, which serves the islands of Lismore, Colonsay, Islay, Coll, Tiree, Mull, Barra and South Uist.

The arched stone circle standing high above the town is McCaig's Folly. Designed by a wealthy local banker as a monument to his family, and a means of employment for local masons, it was loosely based on the Colosseum in Rome. Building started in 1897, but when McCaig died in 1902 his plans for a museum, art gallery and a central tower inside the ring perished with him. Today it is a public park with fine views over the Firth of Lorne.

Oban was an unexpected communications hub in the Cold War: the first transatlantic telephone cable, which carried the Hot Line between the White House and the Kremlin, came ashore nearby.

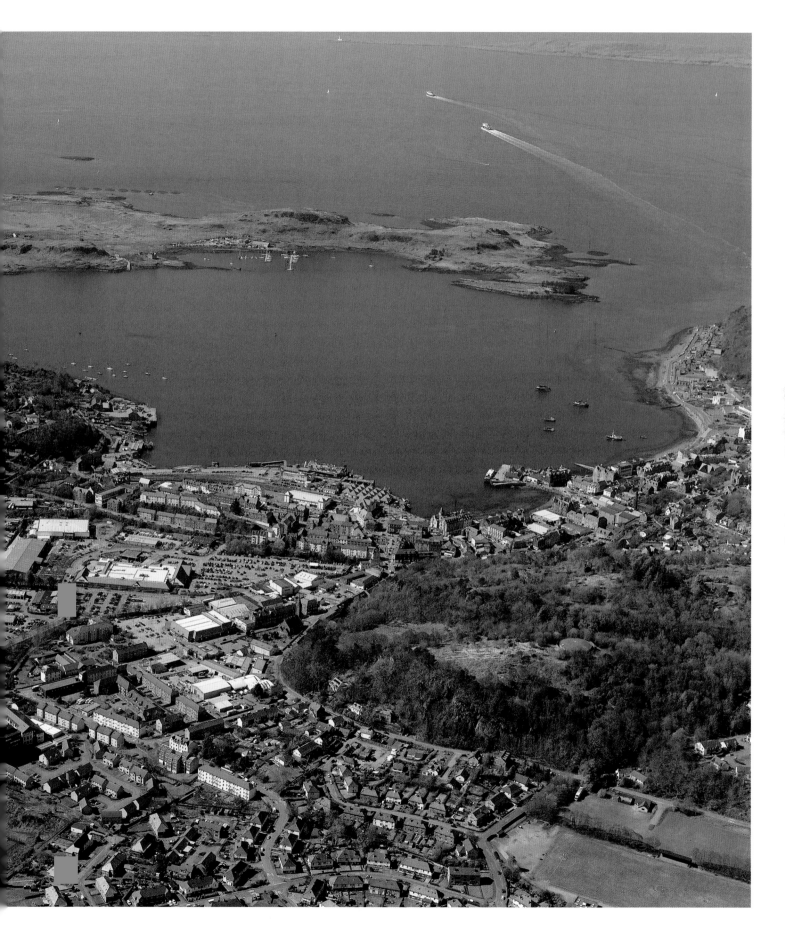

CRUACHAN DAM
2014

From 1943 to 1975, engineers conquered the geography and geology of Scotland to build 50 major dams and power stations, 300 km (186 miles) of tunnels, 640 km (398 miles) of roads and over 32,000 km (20,000 miles) of power lines. This ambitious series of hydroelectric schemes successfully brought renewable electricity to the majority of residents in the Highlands.

Completed in 1965, Cruachan power station is a particularly amazing achievement. A tunnel runs from the buildings at the bottom of the picture for a full kilometre inside the mountain, where a power station reminiscent of a villain's lair in a James Bond film has been built inside a hollowed out cavern large enough to house the Tower of London. Cruachan is the world's first reversible-pump hydro system and it acts as a huge battery. Water is stored behind the dam until times of peak electricity demand, for example at half-time in the cup final as millions of kettles are simultaneously switched on, when it is sent thundering down pipes to power four vast turbines. At quieter times it is then pumped back up the same pipes from the loch below ready to be used again.

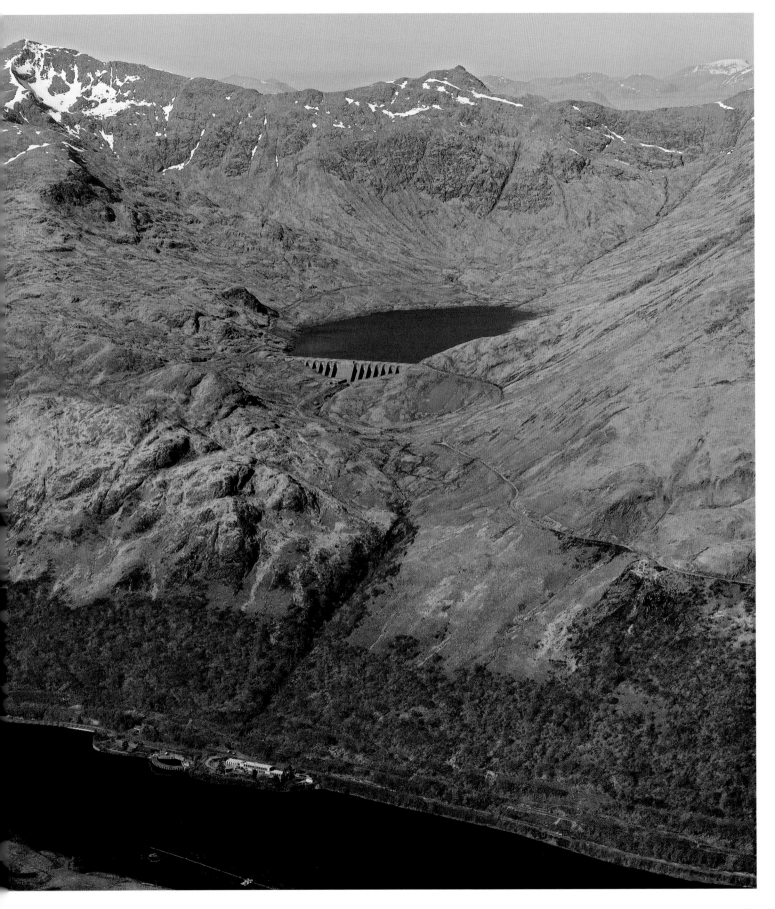

GLEN COE

Glen Coe is the heart of a supervolcano that blew its top 420 million years ago. The glen's sheer, looming sides and high corries were ground into their current shape by 600 m thick glaciers that departed 10,000 years ago.

Here, craggy peaks shelter hidden valleys; precipitous ridges shoot straight up from the glen floor; waterfalls crash into the tumbling river and a surprisingly placid loch reflects the sky. There is more rocky drama and scenic splendour packed into the 12 km (7.5 miles) of Glen Coe than perhaps any other glen in Scotland.

This has long been a honeypot for Scottish rock climbers and has some of the country's most distinctive mountains. Buachaille Etive Mòr's unique pyramid shape often adorns postcards and calendars, and the serrated knife-edge of the Aonach Eagach is one of Britain's finest ridge walks. Glen Coe also has one of Scotland's five downhill skiing centres.

Today, only a handful of people actually live within the glen itself, but in the seventeenth century hundreds of members of Clan MacDonald called this home. In 1692, they billeted the soldiers of the Earl of Argyll's regiment, under the command of Robert Campbell. After two weeks of hospitality the regiment slaughtered sseventy-eight of their MacDonald hosts for not pledging allegiance to the new monarchs, William and Mary, a massacre that is still considered a shameful betrayal.

To the east of Glen Coe lies the 130 sq km (50 sq miles) of marshy wilderness that is Rannoch Moor, one of Europe's largest peat bogs. Road and railway wind their way timidly over this spectacular emptiness and James Bond drove his Aston Martin past its gloomy acres towards Glen Coe in the film *Skyfall*.

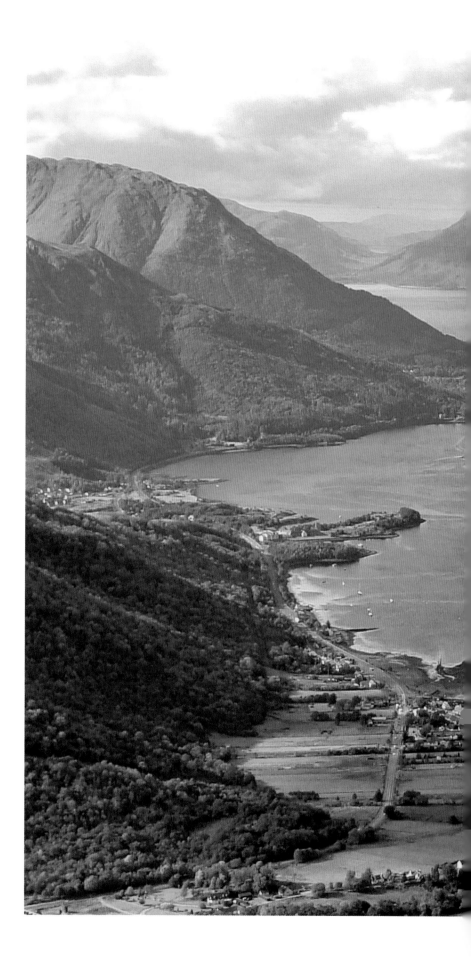

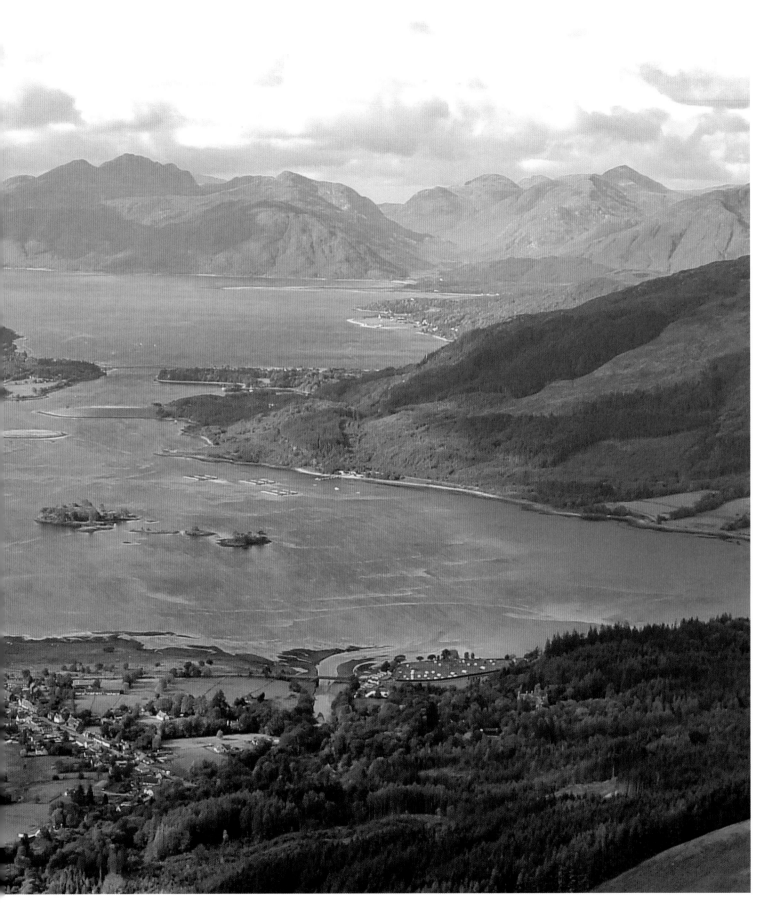

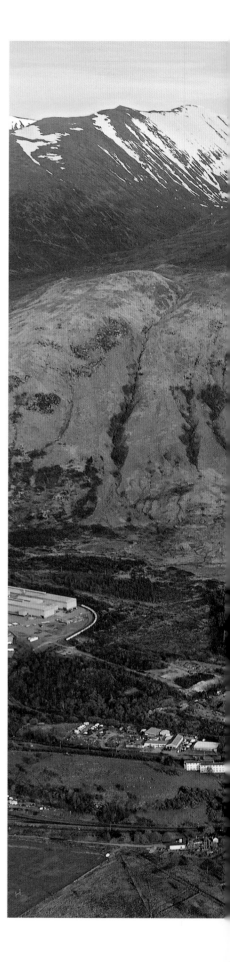

FORT WILLIAM
2007 (above) and 2014 (right)

After 200 years of battles and skirmishes, the Fort of Inverlochy was strengthened in 1690 with high stone walls, guns, barracks for a thousand men and it was renamed after the king, William of Orange.

Today the town is garrisoned with those ready to do battle with the great outdoors. Billed as adventure capital of Scotland, the town is famed for its hillwalking, climbing and skiing, and Fort William's epic downhill trails have hosted the Mountain Bike World Cup since 2001.

Glowering over the town is the mighty massif of Ben Nevis, the highest mountain in the British Isles, which rises to its 1,344 m (4,409 ft) almost from sea level. Most summiteers climb 'the Ben' via the 'tourist route' that rises up its rounded western rump, and so never see the savage north face. Here, the cliffs rise almost vertically for 700 m (2,300 ft) making them among the highest in the country. They are popular with climbers in summer and winter, but unfortunately claim several lives every year.

Its proximity to such high western hills makes Fort William the wettest town in Britain, with an average annual rainfall of 2,050 mm (81 in), almost four times that of London and 2.5 times that of Manchester.

In 1929 an aluminium smelter was built to tap into this free energy, and the longest water-carrying tunnel in the world, 5 m (16 ft) in diameter and 61 m (200 ft) below ground, was punched 24 km (15 miles) through the rock of the Ben Nevis massif from Loch Treig to just above Fort William. The water thundered down five massive pipes to generate 82,000 kW of power in the plant's turbines.

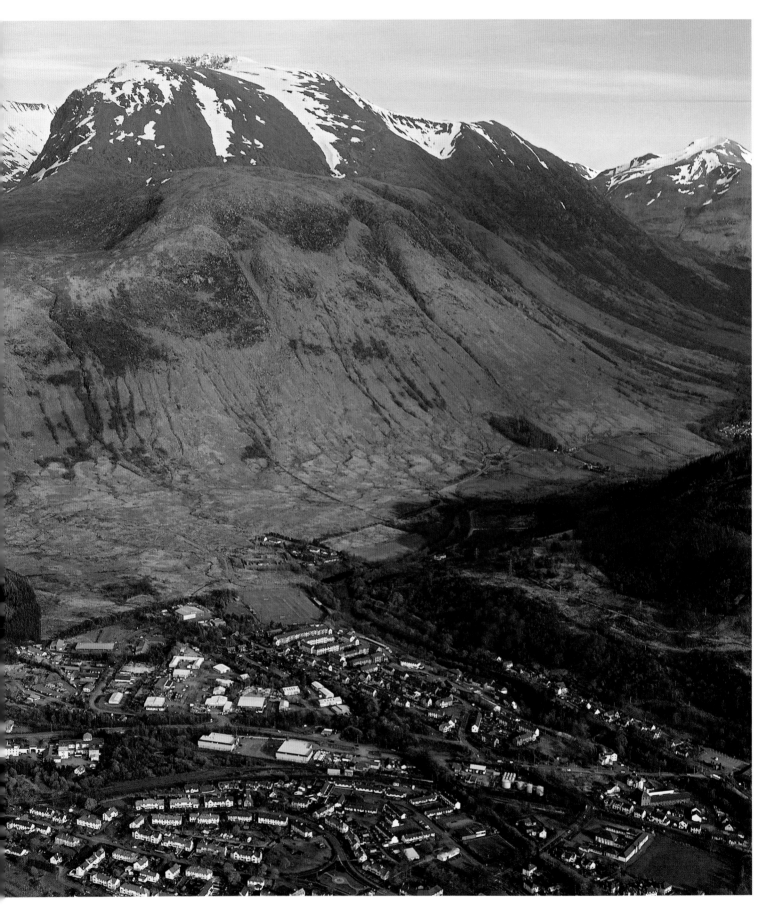

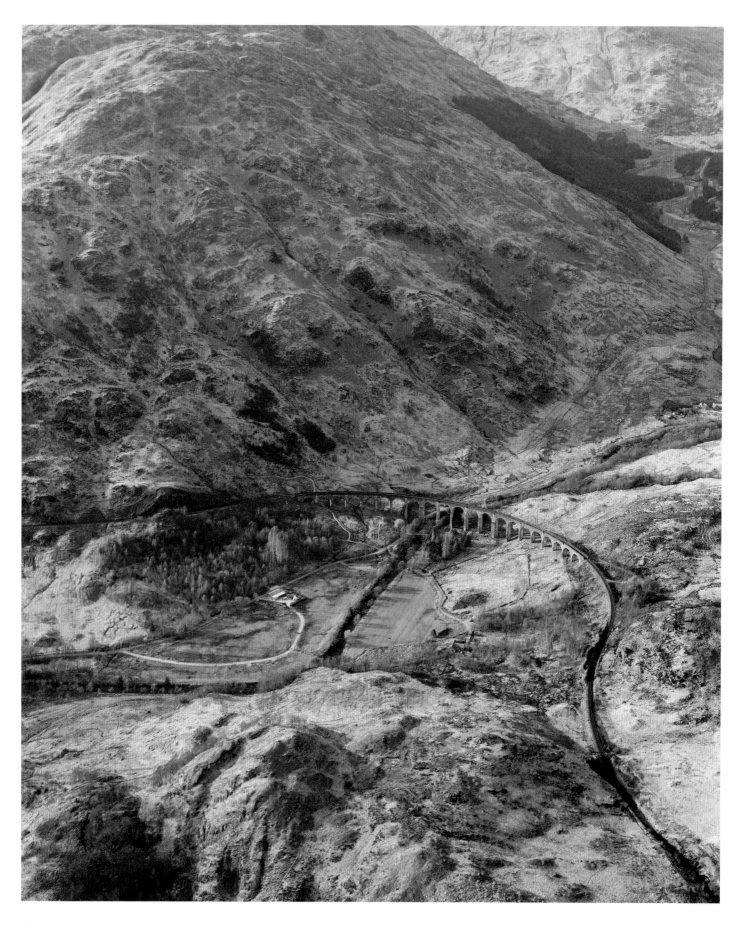

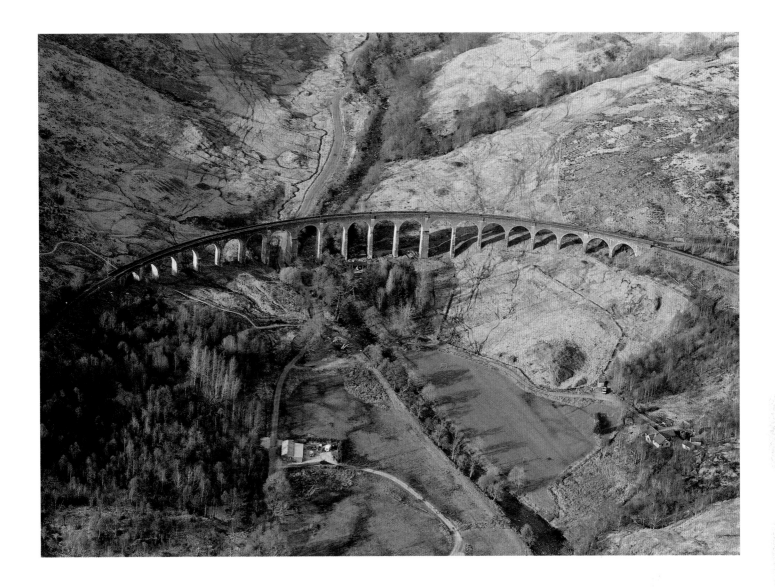

GLENFINNAN VIADUCT
2014

With views like this, it's easy to see why the West Highland Line is often voted one of the world's most scenic railway journeys. The Glenfinnan viaduct was constructed as part of the 'iron road to the Isles': the extension that took the line from Fort William to Mallaig.

Completed in 1898, this outstanding feat of engineering was the largest unreinforced concrete structure in Britain when built. It has twenty-one arches that carry the railway in a 380-m (1,247-ft) crescent up to 30 m (98 ft) above the River Finnan. The dramatic viaduct is a favourite with film directors and featured in three *Harry Potter* movies.

The slim pillar visible at the head of Loch Shiel is the Glenfinnan Monument. This marks the spot where Bonnie Prince Charlie raised his standard to formally claim the Scottish and English thrones in 1745. So began his ill-fated Jacobite Rising that would end in defeat eight months later at the Battle of Culloden.

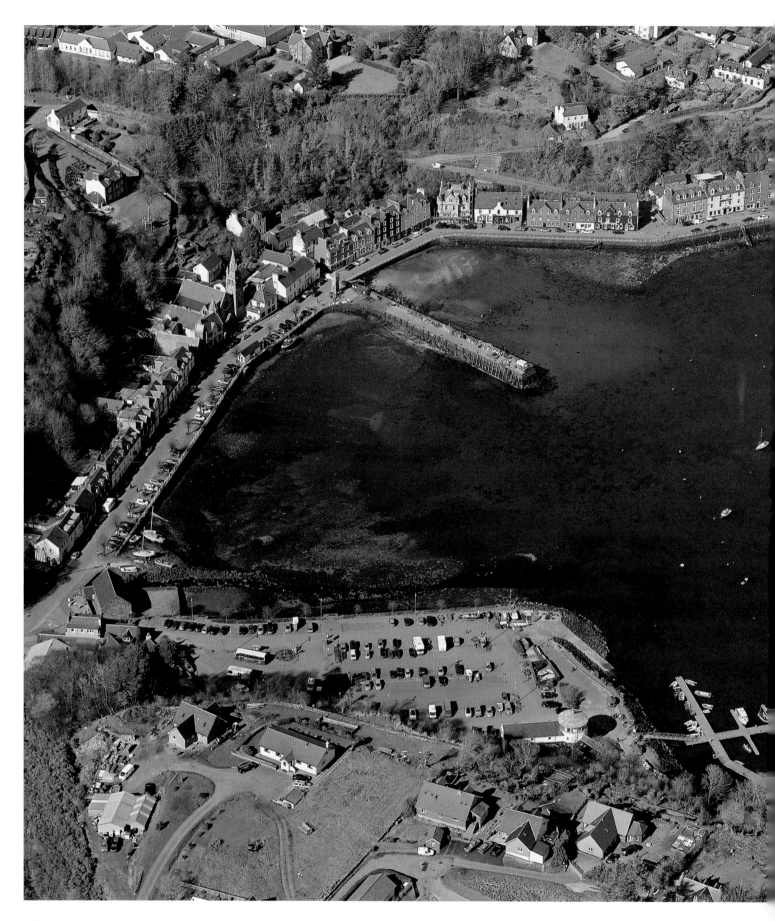

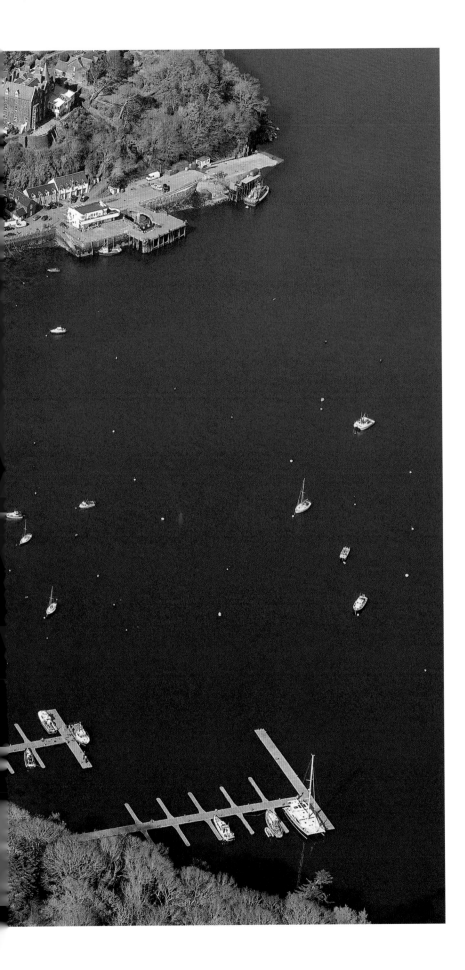

TOBERMORY
2014

Tobermory, on the Isle of Mull, was identified as a suitable site for a fishing port by the British Fisheries Society in the early 18th Century, due to its rich coastal waters, position near the herring migration routes and its fine natural harbour. Although its early growth was based on fishing, it is now mainly an attraction for tourists, wildlife and outdoor enthusiasts.

Today, it is the largest town on the island, with a permanent population of over 700. Its distinctive waterfront is regularly featured in magazines, calendars and promotional items and is usually recognised by the brightly coloured houses, shops and hotels, which extend around the bay.

This attractive waterfront, backed by picturesque hillsides and the spectacular scenery of the rugged interior, have attracted many film and TV crews, as well as tourists. Much of the filming for *When Eight Bells Toll*, based on an Alistair Maclean novel, was carried out on the island, and Tobermory was used as the setting for the popular BBC TV children's programme, *Balamory*, bringing many diminutive fans and their parents to the island. With its distinctive fauna, including white-tailed sea eagles, golden eagles and otters the island is regularly featured in wildlife documentaries.

Tobermory also has its own enduring tale of the wrecked *Spanish Galleon*, which is reputed to lie in the mud at the bottom of Tobermory Bay. This is thought to be one of the vessels from the Spanish Armada, which was driven off course by the storm that led to the loss of many of its fine ships. Having sailed around the north of Scotland in an attempt to get back to Spain, the galleon is said to have put into the bay to replenish essential supplies. Although accounts vary, legend has it that the vessel then blew up and sank with all hands.

ARDNAMURCHAN
2014

The most westerly point of the UK mainland is not Land's End, but Ardnamurchan. This craggy finger of land points out into the Atlantic just north of Mull, and at the end of the peninsula is a remarkable feature that draws geologists from all over the world. This rocky amphitheatre is 7 km (4.3 miles) across, and although it looks like a crater on the moon, it is really the worn stump of a volcano.

Greenland would have been visible from Ardnamurchan 65 million years ago. Then the American and Eurasian tectonic plates began to drift apart, and the north Atlantic began to open. A plume of molten material rose from deep within the earth and broached the surface, creating a chain of great volcanoes on the islands of Rum, Mull and Skye, and Ardnamurchan. These were fed by subterranean magma chambers and for 3 million years they spewed hot rock over this corner of the world. The Ardnamurchan magma chamber later blew its top and then collapsed, forming a caldera.

A mere 20,000 years ago, Ardnamurchan was gripped in an ice age. The harder rock of the caldera walls was resistant to the glaciers that scoured away much of the rest of the volcanic material, carving the land as we see it today.

BARRISDALE BAY
2014

Loch Hourn is a crooked finger of the Atlantic that pokes 22 km (14 miles) into the western flank of Scotland. Halfway along its southern shore is the sandy notch of Barrisdale Bay.

One of Scotland's most fjord-like lochs, the sculpting hand of the elements is clearly visible on this undisturbed landscape. Successive glaciations have gouged a steep-sided trough from hard, high hills. The flooded valley floor is a series of five long steps, dropping ever deeper as they near the open sea.

Rainfall here is high, and wind and water have cut gullies in the mountain slopes. The sands of Barrisdale Bay are carved into veins by the river coursing from the high hinterland. The flow deposits a little sediment then empties over the turquoise sill and into the black depths of Loch Hourn.

With Loch Nevis to the south, Loch Hourn bounds the Knoydart Peninsula, the remotest part of mainland Britain. This mountainous wilderness is only accessible by boat, or by a 26-km (16-mile) hike. The 11 km (7 miles) of local roads around the only village, Inverie, are not connected to the UK road system.

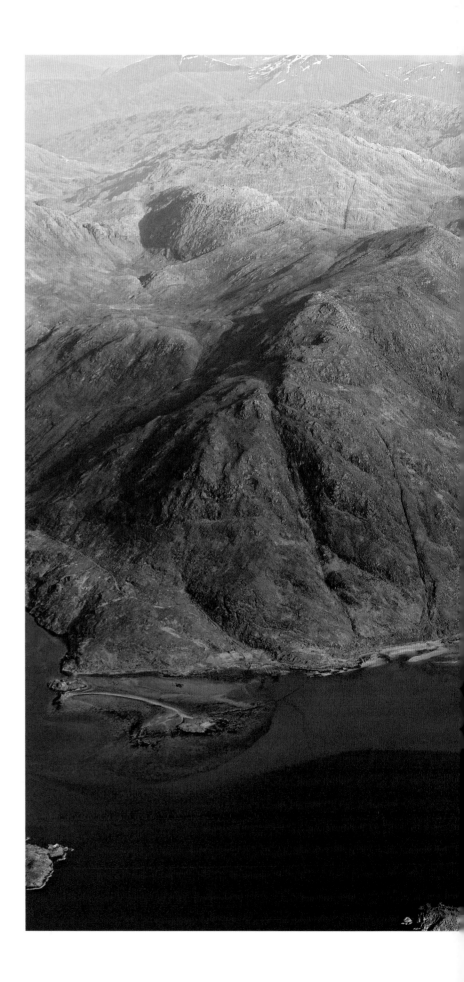

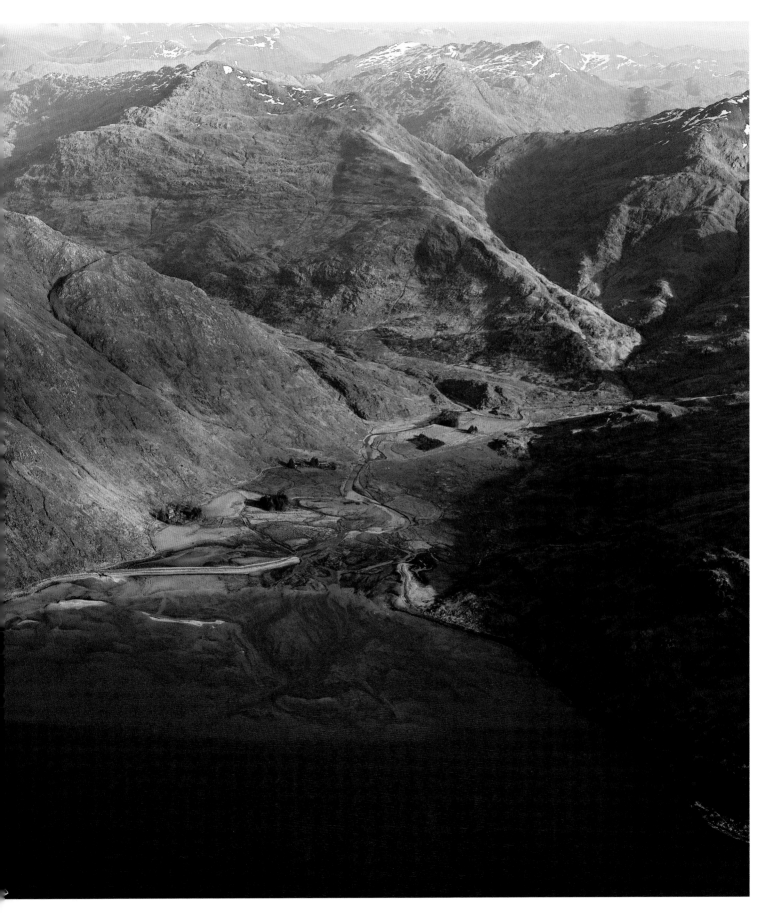

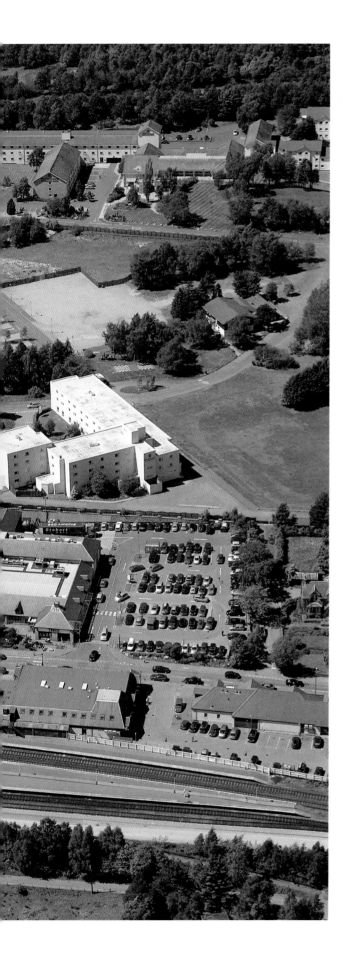

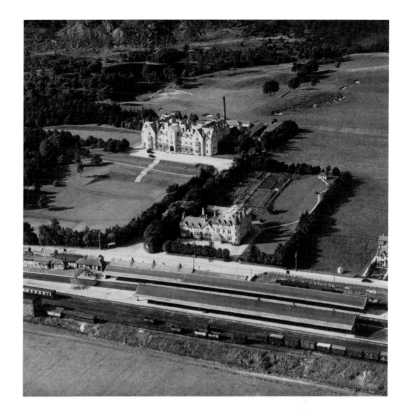

AVIEMORE
1932 and 2009

When the Highland Railway built the Aviemore Hotel (the largest building in the old image) in the late nineteenth century, it started the town's life as a holiday destination.

The hotel was destroyed by fire in 1950, but the town soon began a new phase of life. Developers were attracted by the range of 1,220-m (4,000-ft) mountains nearby, and the first ski chairlift was built in 1962. Four years later the Aviemore Centre, with its ice rink, cinema, bars and restaurants, was built on the site of the old hotel and its golf course.

The town doubled in size and, during the 1960s and 1970s, Aviemore had an undeniable aura of glamour. Prince Charles and Princess Anne danced till dawn at Royal Hunt Balls in the Aviemore Centre's Osprey Rooms and the BBC TV show 'It's A Knockout' was filmed there.

The A9 trunk road moved from the main street to bypass the town in 1980, and the Centre's concrete architecture began to look outdated and tatty. It was demolished in the late 1990s and the area redeveloped as an outdoor sports hub. Aviemore is now Britain's most-visited ski resort and a major mountain bike, walking and watersports venue.

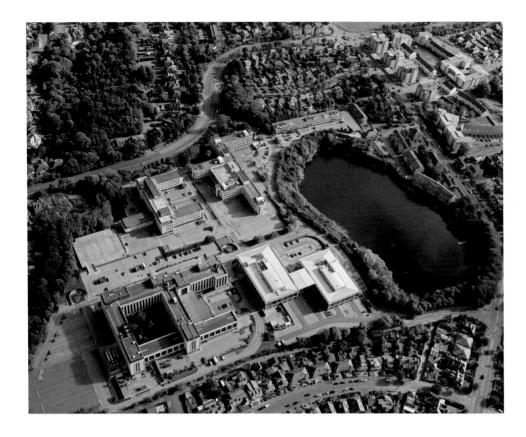

RUBISLAW QUARRY & CENTRAL ABERDEEN
2012

It may look like a puddle, but this is one of the deepest man-made holes in Europe, its bottom lying 142 m (466 ft) below the surface of the water. Most of the buildings in central Aberdeen came out of this hole in the ground – before it flooded, this was Rubislaw Quarry, source of the fine grey stone that built the 'Granite City'.

A quarry was first dug into the Hill of Rubislaw in 1740, but its stone was initially considered poor quality and the council sold it on to a local businessman for £13. He proved their judgement short-sighted as over the next 200 years around 6 million tonnes of high-quality granite were dug from the quarry. Appearing grey from a distance, the stone is flecked with mica that sparkles silver in the sun when seen close up.

It made a beautiful and durable construction material – unlike the sandstone in many other Scottish cities, Aberdeen's iconic buildings show few signs of weathering. Rubislaw granite was exported worldwide and was used in the nineteenth-century Waterloo Bridge, the Houses of Parliament and the Forth Rail Bridge. Marischal College on Broad Street is the second largest granite building in the world, after the Escorial in Madrid.

Several cranes, diggers and scoopers still lie at the bottom of the quarry – it was thought easier to leave them there than take them out when Rubislaw closed in 1971.

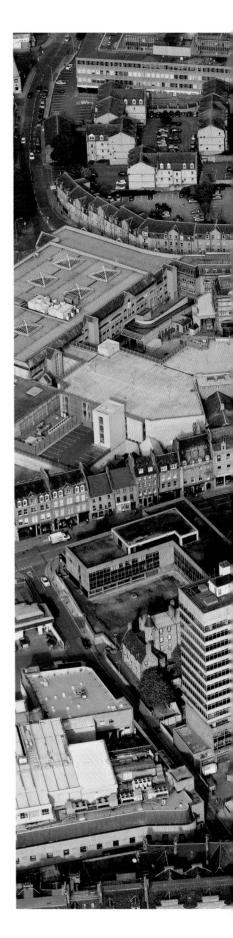

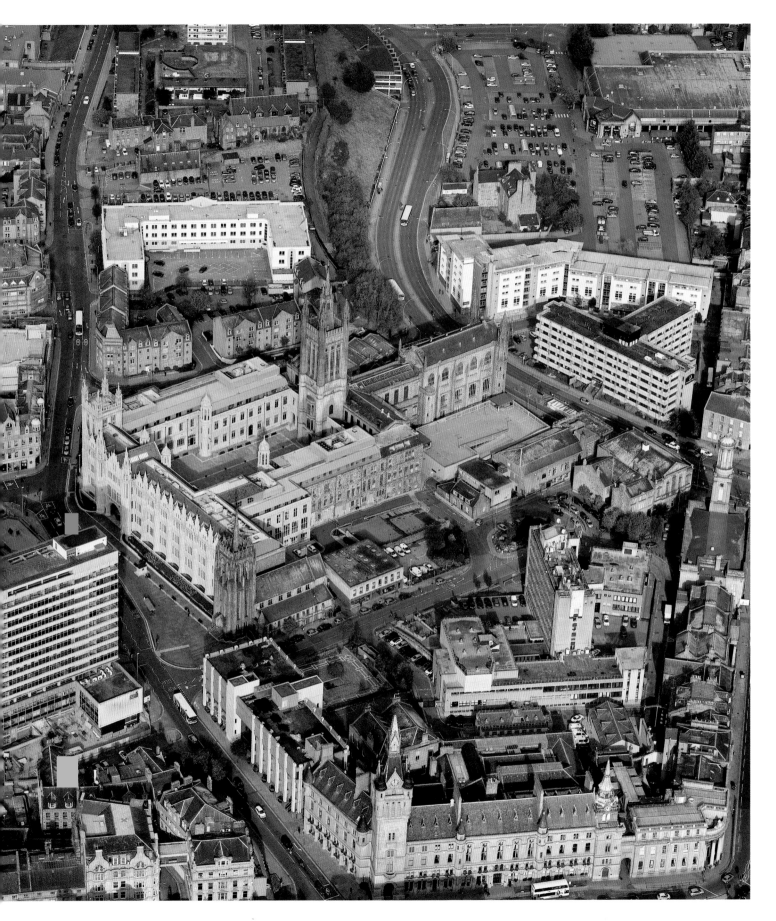

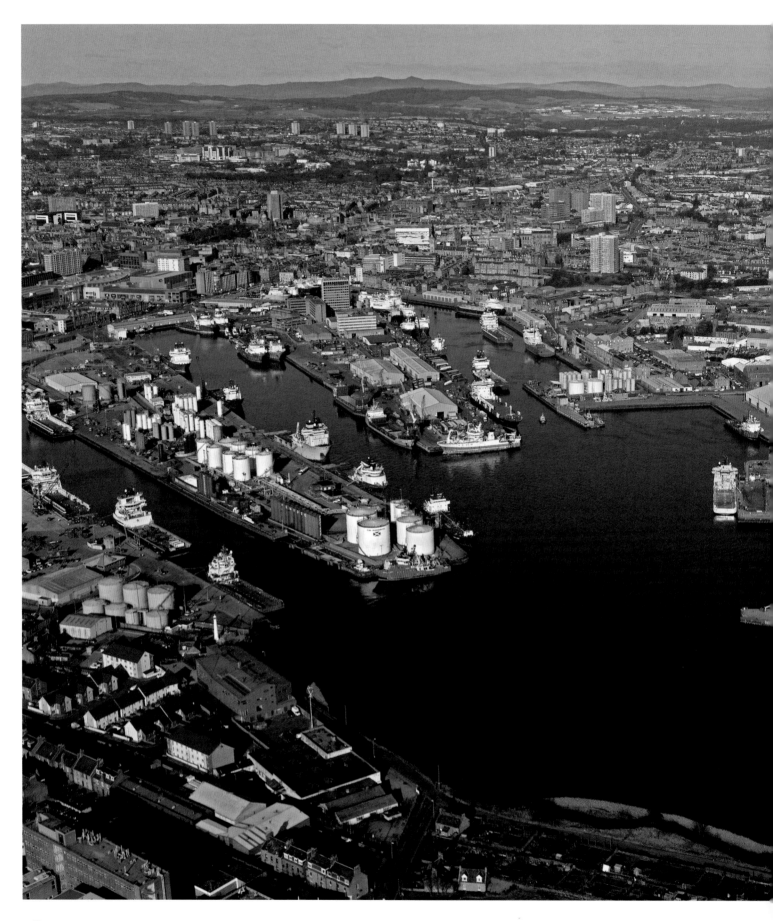

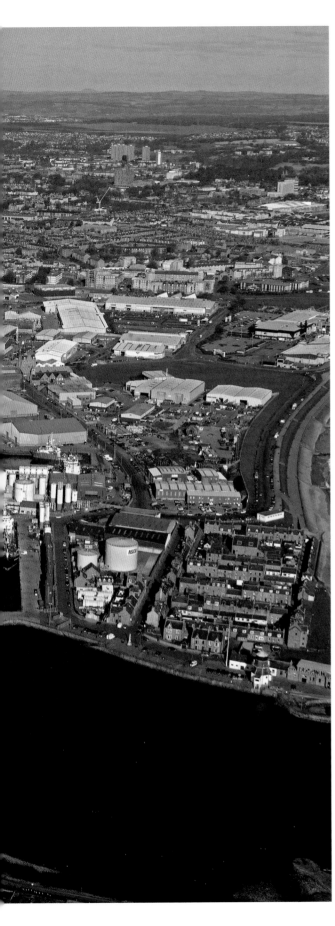

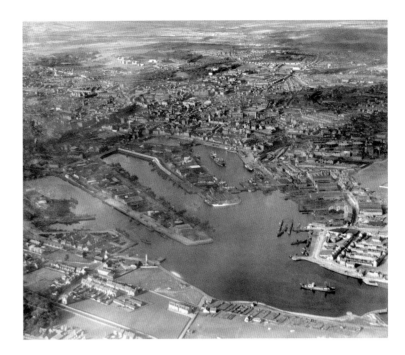

ABERDEEN HARBOUR
1938 and 2014

When the photograph above was taken in 1938, Aberdeen was Scotland's number one fishing port with 300 vessels bringing catches home and 3,000 men employed around the harbour. Within 35 years most of the trawlers had moved north to Peterhead and a new form of wealth from the ocean was keeping the docks busy: oil.

In December 1969, the first North Sea oil in UK waters was discovered: the Montrose Field, which lies about 217 km (135 miles) east of Aberdeen. The next year the Forties Oil Field, the largest in the North Sea, was found 180 km (110 miles) east-northeast of the city.

The black gold itself is piped directly to the refinery at Grangemouth, near Edinburgh, but Aberdeen thrives as a support centre for the industry. The harbour bustles with tugs, safety vessels and supply ships, which far outnumber the few fishing boats that berth here. The oil industry dominates the local economy, supporting at least 47,000 jobs. Aberdeen Heliport is one of the busiest commercial heliports in the world.

In 2011, Aberdeen had the highest rate of multimillionaires of any city in Britain, its tally of 52.97 per 100,000 people nudging London (51.63) into a poor second place.

URQUHART CASTLE, LOCH NESS
2011

Although Loch Morar is deeper and Loch Lomond is larger, Loch Ness's great length of 36.3 km (22.6 miles) and average depth of 132 m (433 ft) combine to make it Scotland's most voluminous loch. It contains more fresh water than all the lakes in England and Wales combined.

Urquhart Castle stands guard on a promontory near the middle of the loch and is one of the largest fortifications in Scotland by area. A fort was built here in the fifth century, but the ruins visible today are of the castle that was constructed in the thirteenth century and rebuilt in the sixteenth. In 1692, this was largely blown up by soldiers to prevent it falling into Jacobite hands, and it has lain in its crumbled, but very picturesque, state ever since.

A glance at a map will show that Loch Ness lies along a geological dividing line in the Highlands. This is the Great Glen Fault, in a weakness in the underlying rocks turned into a great glacial gouge and then inundated by lochs Ness, Lochy and Oich. In 1822 the Caledonian Canal was built by Thomas Telford to link these bodies of water, and so connect Fort William with Inverness.

Legend says that St Columba repelled a water beast nearby in the sixth century, and it may be that this ancient miracle is the piece of grit on which the pearly tale of the Loch Ness Monster grew. Despite several scientific surveys, no concrete proof of Nessie's existence has ever been found. The 1934 photograph that sparked modern 'Nessie-mania' has been shown to be a fake but every year the romantic allure of the legend still draws thousands of visitors to watch the waters for themselves, hoping to spot a tell-tale wake…

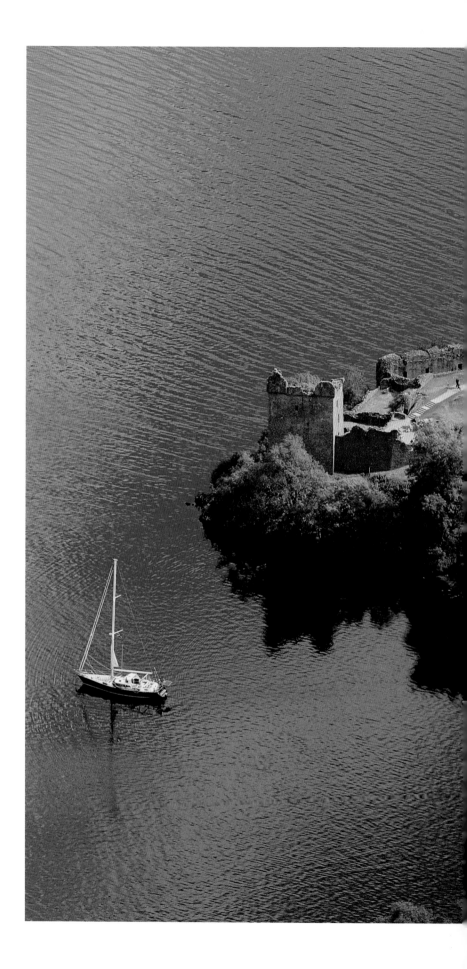

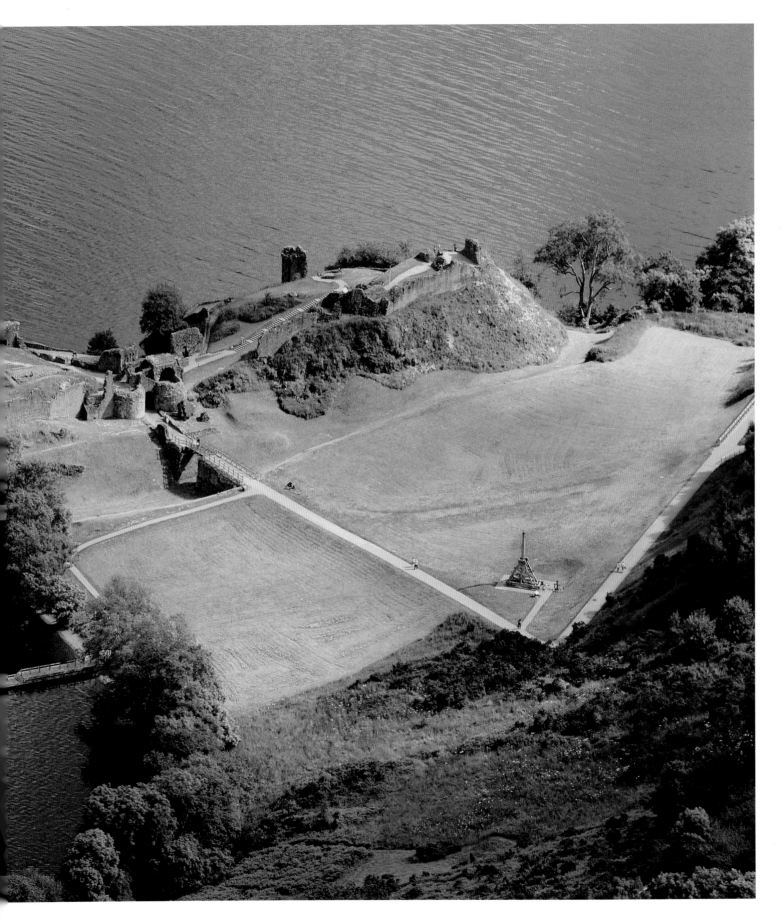

INVERNESS

Britain's northernmost city is bordered by the Ness River, the Caledonian Canal and the Beauly Firth, and bridges have defined its development.

For centuries the main crossing point was the Ness Bridge, beside Inverness castle. Flooding or battles destroyed every bridge built here until 1855, when an asymmetrical suspension bridge solved the problem of river piers being washed away by not having any. However, It was considered a traffic bottleneck and demolished in 1961 to be replaced with a four-lane concrete bridge.

Beyond it is the Greig Street pedestrian suspension bridge from 1881. A familiar postcard image of the city, it wobbles when several people cross it at once. The empty river bend in the old image is now crossed by the city's main road crossing – the Friars Bridge, opened in 1987. Beyond that is the Waterloo Bridge, built in 1896.

The five stone arches of the last river bridge, the Ness Viaduct, collapsed in a flood in 1989, severing the only rail connection with the far north of Scotland and stranding all the locomotives in the Inverness depot. One locomotive was put on a flatbed truck, driven over Waterloo Bridge and set on the rails to serve the north. A new steel bridge was swiftly erected.

At the top of the picture is the Kessock Bridge, which carries the A9 trunk road to the Black Isle. Because Inverness lies at the end of the Great Glen Fault, the Kessock Bridge has 3m-long seismic buffers built into its north abutment. Opened in 1982, this put Inverness within easy reach of the residents of the far north, helping it to become one of Europe's fastest growing cities.

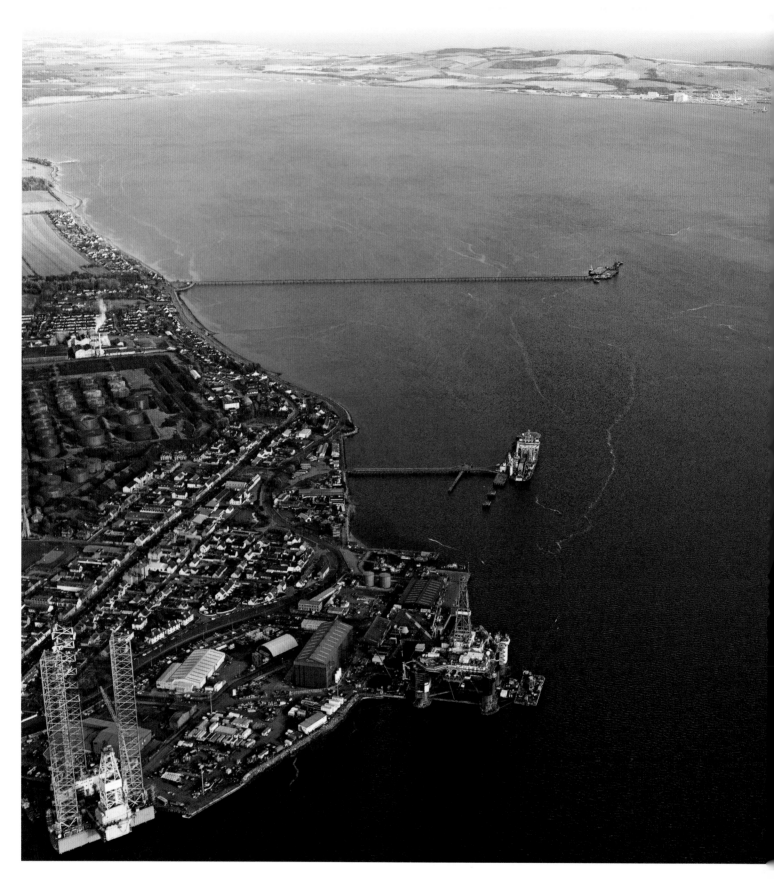

OIL RIGS, CROMARTY FIRTH
1957 and 2012

Long, deep, wide and protected by twin headlands, the Cromarty Firth has been a vital haven for centuries. The Royal Navy based the Home Fleet here for many years and it was a permanent naval base from 1912–1993. This photograph from 1957 shows the fleet aircraft carriers *Ark Royal*, *Albion* and *Ocean* steaming through the Moray Firth to welcome the Queen and Prince Phillip in the *Royal Yacht*, *Britannia*, on their return from an official visit to Denmark, before escorting them back to the Cromarty Firth as guests of the Home Fleet.

Following the discovery of oil under the North Sea, a fabrication yard was opened at Nigg, just inside the Cromarty Firth, in 1972 to construct oil platforms. This can just be seen to the left of the entrance to the firth in the 2012 view. The abundant construction work attracted many workers from Glasgow's troubled shipyards, and Glasgow accents are very common in this relatively remote corner of northeast Scotland. Platforms and production vessels are still serviced at Nigg, and the yard also constructs wind turbines and other renewable energy equipment.

Cruise ships often berth at Invergordon, farther up the firth, bringing overseas visitors directly into the Scottish Highlands. Invergordon also services and repairs oil rigs and acts as a base for other oil-related vessels. Note the jack-up and semi-submersible rigs visible at the port and offshore, in the 2012 view.

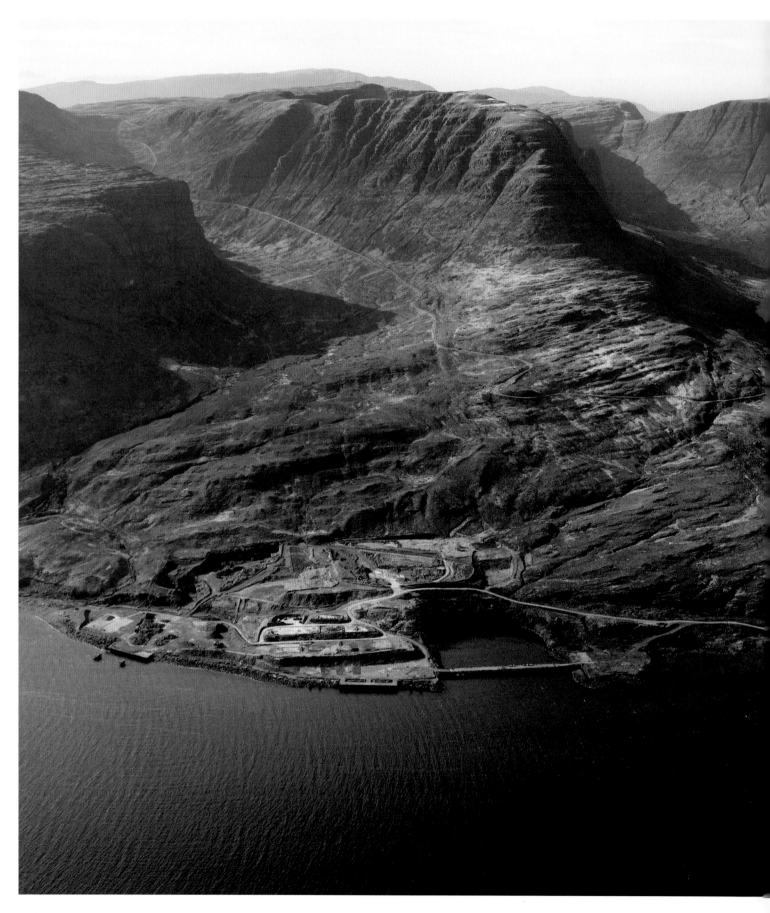

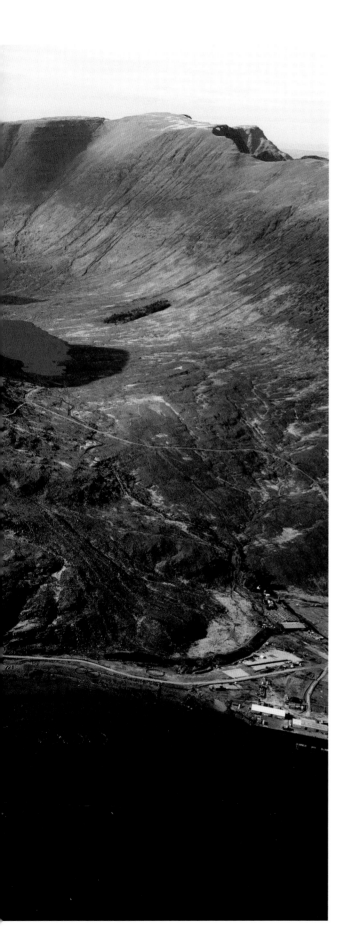

KISHORN & THE BEALACH NA BA
2014

The wilderness around Loch Kishorn was mostly known for its fine seafood, venison and hillwalking until 1975. Then it was realised that the loch would make an ideal location for an oil platform fabrication yard: it was deep at 61 m (200 ft), sheltered and remote, yet still had a nearby link to the rail network at Stromeferry. A vast construction plant was built on the north side of the loch, and by 1977 over 3,000 people were working here in an almost self-contained community.

The large dry dock you can see in the photo was used to build the Ninian Central Platform. When complete in 1978, this platform weighed 600,000 tonnes and was the largest moveable object ever created. Seven tugs were needed to tow it to its position in the North Sea, where it was sunk and secured to the ocean floor.

The yard was closed in 1987, but the dock was used in 1992 to build the bases of the Skye Bridge. Today it operates as a port, mostly handling timber products and fish farm supplies.

The ribbon of road that threads its way up the mountains behind the yard is the Bealach na Ba. Its hair-rising hairpin bends take it over the 626-m (2,054-ft) pass to Applecross, making it the greatest ascent of any road climb in the UK.

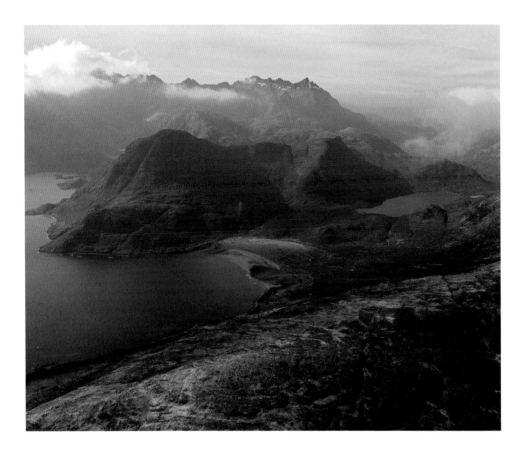

SKYE
2014

Skye is the largest and most northerly island of the Inner Hebrides and consists primarily of a series of rugged headlands and peninsulas, which radiate out from a central mountainous core.

For raw mountain beauty, it's hard to beat Skye. As well as having Britain's finest ridge – that of the Cuillin Range, the island has an eye-popping variety of cliffs, glens and peaks. The photograph above looks across the northern edge of Loch Scavaig, to the high peaks of the Cuillins, partly shrouded in mist and cloud beyond. The mountains seem to rise almost vertically out of the sea in some parts of this area.

Portree is the main settlement on the island. Situated on the northern shore of Loch Portree on the east coast, it has a fine anchorage, sheltered from the Atlantic storms by high ground to the west, and to the east by the Isle of Raasay, which lies just offshore.

As in many island settlements, the centre of activity often tends to be the harbour, around which the older part of the town is clustered. The main part of the town and the more recent developments, including supermarkets and secondary school, occupy the land above and beyond the harbour area.

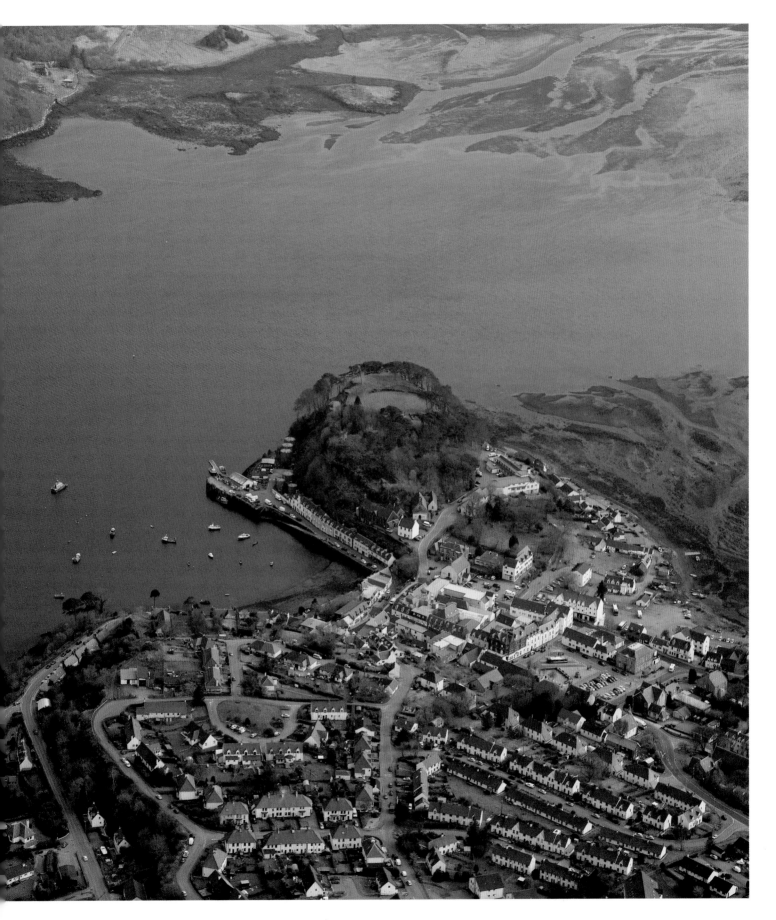

SUILVEN

Suilven is an extraordinary peak that rises almost sheer from a vast wilderness of boggy moorland. From its western end it resembles a single dome, but it is really a slender ridge 2 km (1.2 miles) long. Its name comes from the Norse for 'Pillar Mountain', which is how it would have appeared from a longship sailing by to the west.

Although the contrast between the steep peak and the flat land around makes it look precipitous, Suilven is not a Munro (one of Scotland's 284 peaks over 914 m or 3,000 ft). It is a relatively modest 731 m (2,398 ft) high, but its steepness, knife-thin ridge and wildly remote situation make it one of the finest mountains in Britain.

Suilven is an 'inselberg', or island mountain, made of sandstone compressed under mighty lakes and rivers when this part of Scotland was a tropical landscape that lay near the Equator, a billion years ago.

More recently, a series of ice ages scoured away the relatively soft sandstone, with glaciers grinding round Suilven to create the symmetrical ridge. Over several million years the landscape was stripped back to the harder underlying Lewisian Gneiss – a metamorphic rock that is the oldest in Europe and among the oldest in the world. In places this is 3 billion years old, two-thirds the age of the Earth itself.

The Suilven we see today was only revealed 12,000 years ago when the last ice sheets retreated.

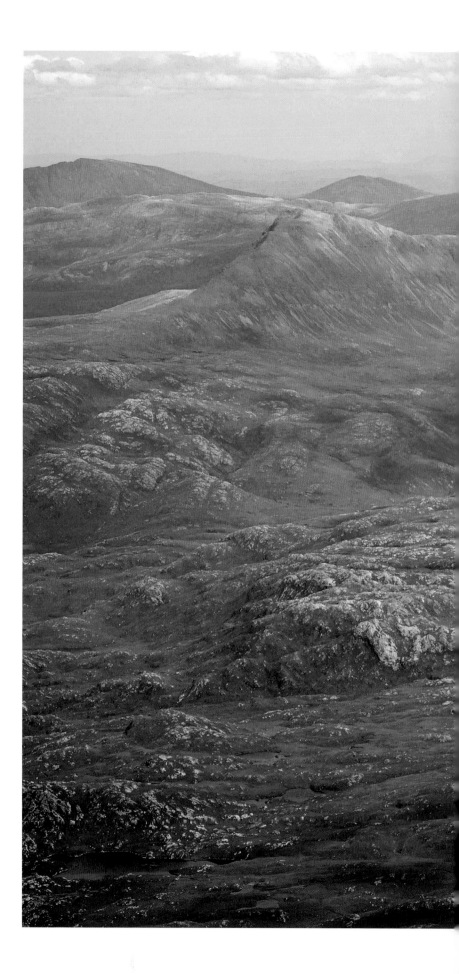

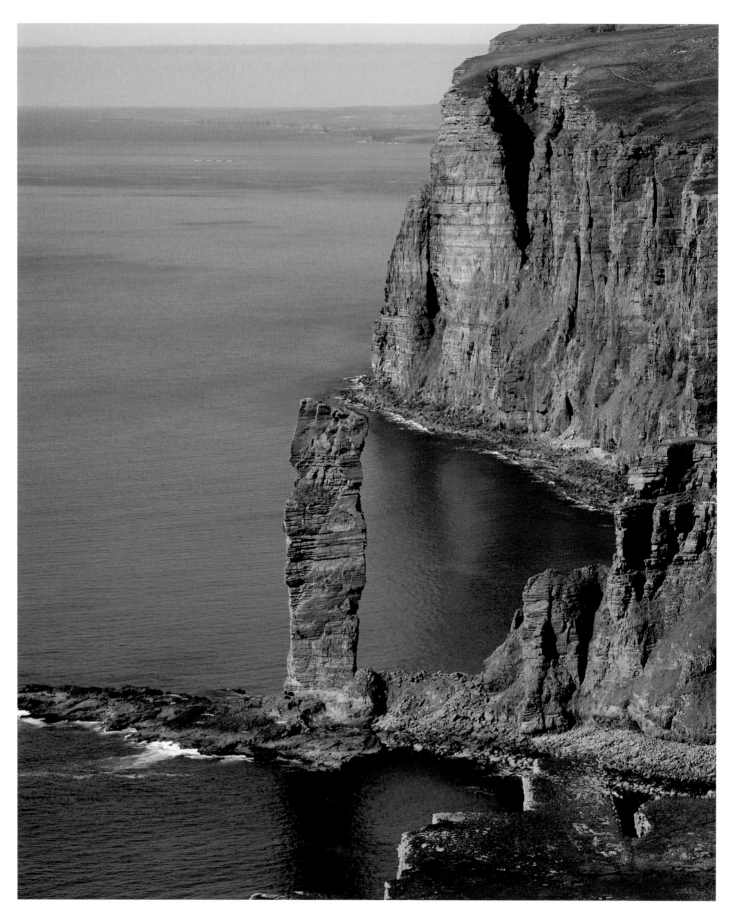

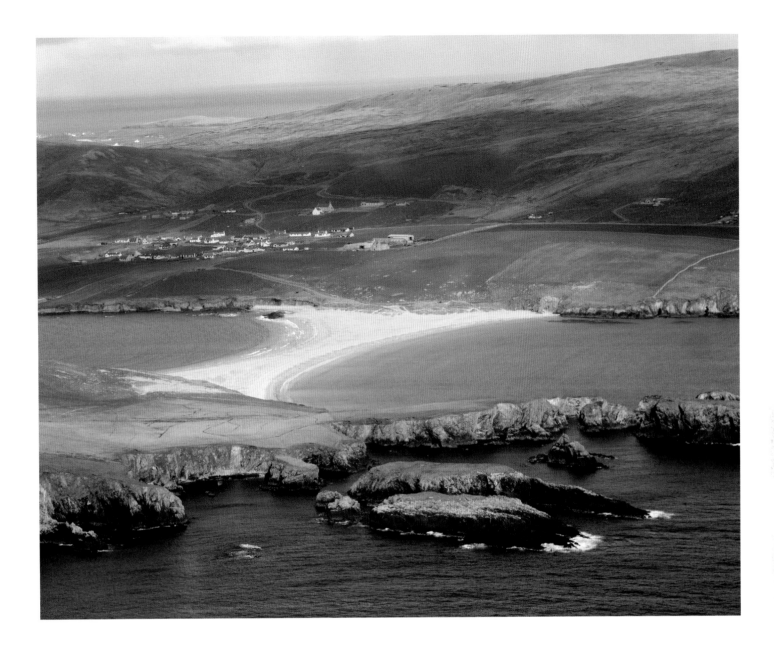

OLD MAN OF HOY & ST NINIAN'S TOMBOLO
2010 (right) and 2011 (left)

It may be known as the Old Man of Hoy, however, Britain's tallest sea stack is geologically very young indeed. A map of Hoy from 1750 shows the area around the stack as a headland. By 1819, wind and wave had bitten through the neck of land to leave a high column with a low arch at its base. Within a few years the arch was also consumed by the sea, leaving just the stack.

Today it stands 60 m (200 ft) out from the mainland across a rubble-strewn chasm and is 137 m (449 ft) tall, although there is a large crack near the summit and it will inevitably be felled by erosion. The Old Man was first climbed in 1966 and BASE jumpers leapt from the top in 2008.

With beautiful, near-perfect symmetry, St Ninian's Tombola connects St Ninian's Isle to Shetland Mainland. It is the largest active tombolo in Britain, stretching for 500 m (1,640 ft).

St Ninian's Isle has been uninhabited since 1796, but the ruins of a twelfth century chapel can be found just beyond the end of the tombolo. In 1958 a local schoolboy helping out some visiting archaeologists unearthed a superb hoard of eighth century silver in the chapel grounds. The treasure trove included bowls, brooches and sword decorations.

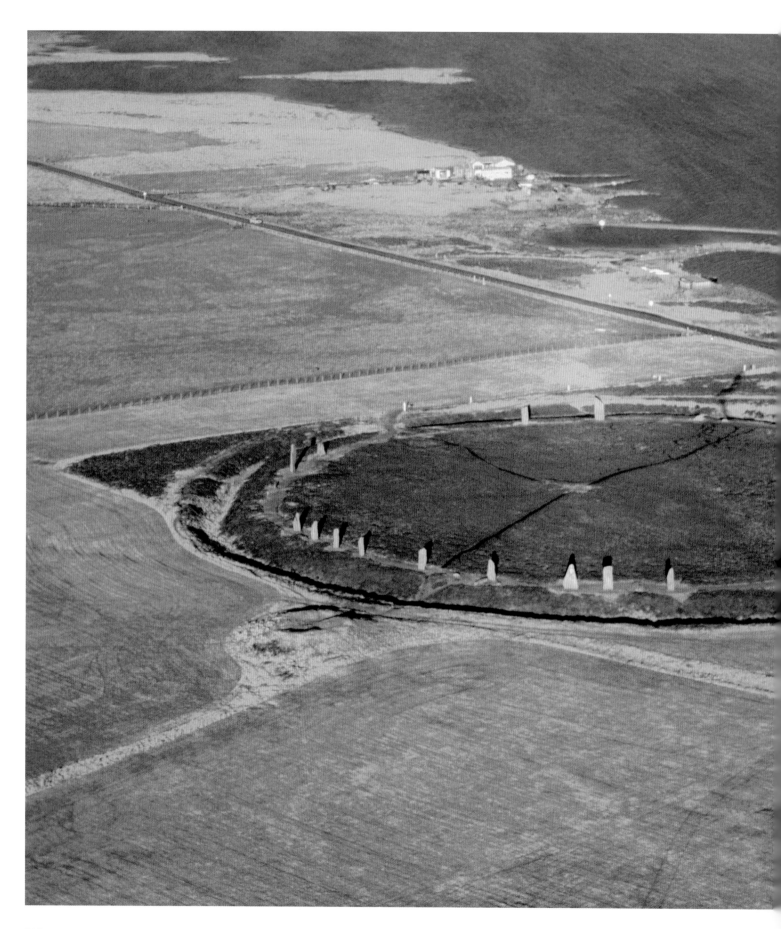

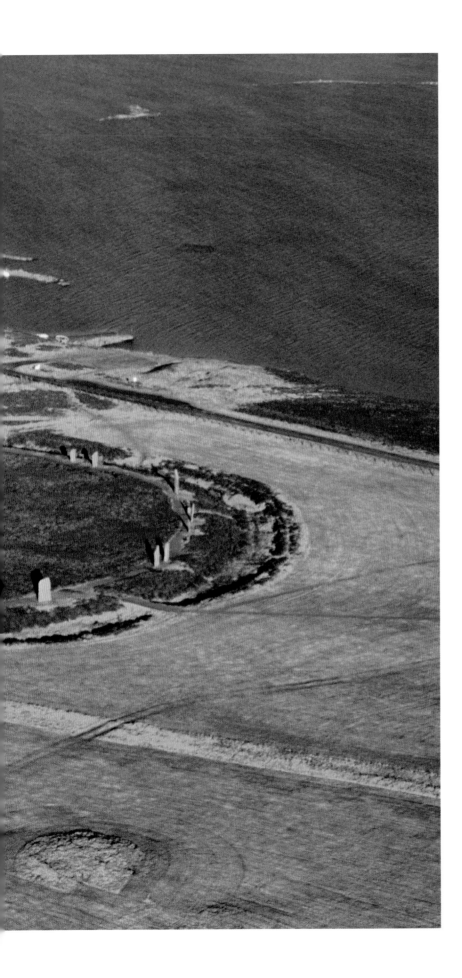

RING OF BRODGAR

On a narrow finger of land between two lochs stands Britain's most mysterious stone circle: the Ring Of Brodgar. The inside of the ring has never been fully excavated and the stones keep almost all their secrets clutched to their ancient heart. It is certainly 4,000 years old, perhaps more.

Our ancestors transformed this whole area into a ritual landscape with Brodgar as its centrepiece. Within a couple of kilometres there are two other major stone circles, four chambered tombs, many single standing stones, barrows, cairns, and mounds.

The circle's construction was an endeavour of almost unfathomable magnitude for the Neolithic people. Sixty stones up to 4.7 m (15ft 3in) tall and weighing several tonnes were erected inside a circular ditch broader than a football pitch is long. The ditch itself was cut into solid sandstone to a depth of 7.5 m (24 ft).

However, it is the circle's sublime setting, delicately poised where bleak land meets wild sea, that makes it so truly magical.

WALES

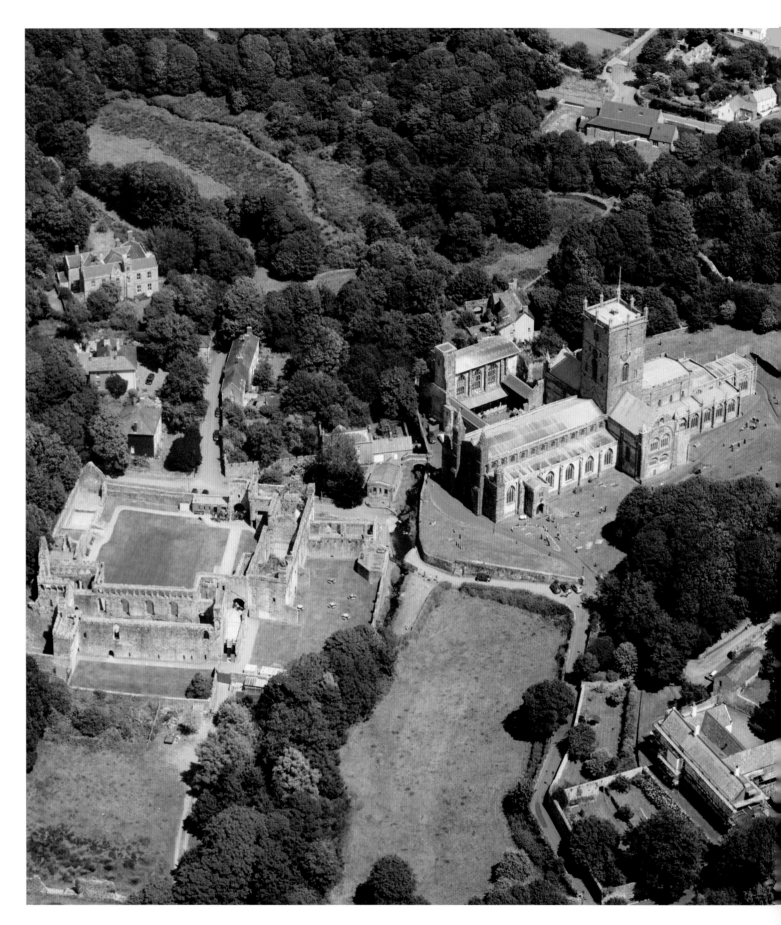

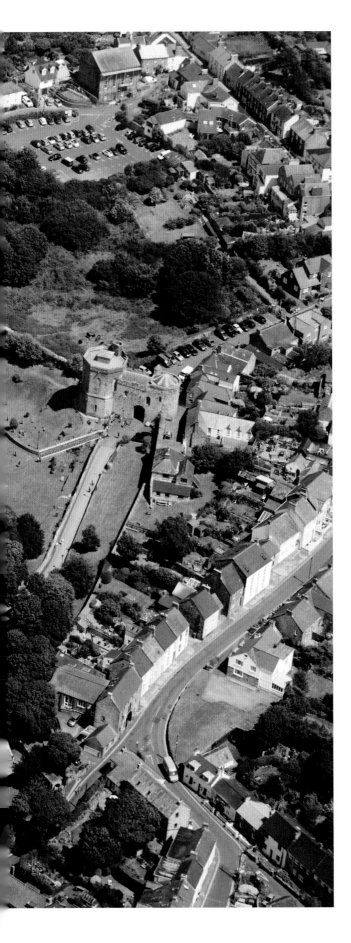

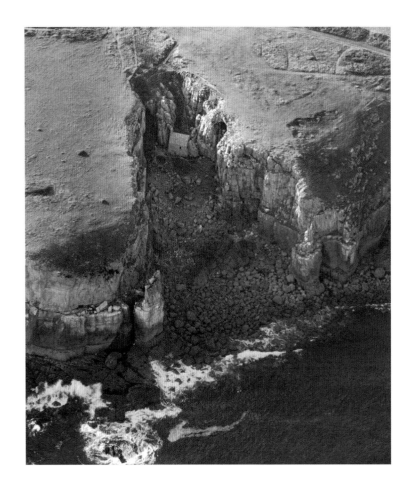

ST DAVID'S & ST GOVAN'S
2007 and 2013

With just 1,797 inhabitants, and only covering an area the size of a modern shopping centre, St David's is Britain's smallest city.

David was a sixth-century Pembrokeshire preacher who founded a monastic community on the remote, rugged promontory that forms the most westerly part of Wales. He achieved cult-like adoration after his death and is Wales' patron saint. The cathedral marks his final resting place and is the largest and holiest cathedral in Wales. Its precinct is one of the finest in Britain.

The original church burned down in AD 645 and later the Vikings raided the site for its gold and silver. An eleventh-century visitor found St David's shrine lost amid ruins and undergrowth. But it became a revered place of pilgrimage, and its holy fame was sealed in 1120 when the Pope declared two visits to St David's equal to one pilgrimage to Rome.

In 1181, work on the cathedral we see today was begun, and throughout the medieval period large numbers of pilgrims trekked here, bringing with them great wealth for the resident churchmen. The Bishop's Palace may now be roofless, but it still exudes grandeur, making it easy to imagine the sumptuous lifestyle once enjoyed by the bishops within.

A much simpler existence was sought, and achieved, by David's contemporary, the Irish monk St Govan. Legend says this hermit built his tiny cell in this rocky notch in the sea cliffs south of Pembroke. The building in the picture above occupies the same lonely spot but dates to the thirteenth century.

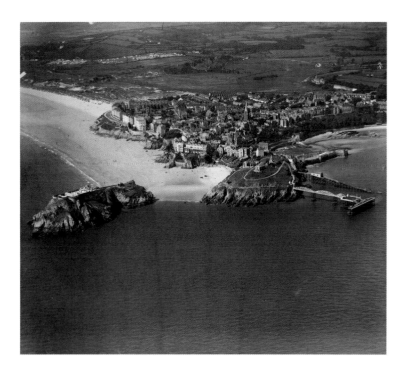

TENBY
1929 and 2014

War shaped the seaside town of Tenby. This easily defendable rocky promontory was an early Welsh stronghold, and then a Norman fortified town. Parts of its medieval walls survive to this day.

In 1802, the eruption of war with Napoleon meant that rich English holidaymakers could no longer travel abroad so easily. Local politician, Sir William Paxton, was quick to spot an opportunity. He conceived a vision of Tenby as a resort to rival continental spas. Paxton bought property in the then virtually ruined old town and built baths, an inn, a theatre and houses. He introduced fresh piped water and constructed a new road into the town. With its new facilities and 4 km (2.5 miles) of sandy beaches, Tenby soon evolved into one of the prettiest resort towns in Wales.

St Catherine's Island, which is linked to the town at low tide, has the remains of a Palmerston Fort. Many of these strongholds were built in the 1860s as part of a scheme to protect Britain's coastline from a potential landing force.

Ferries sail from Tenby's harbour to scenic Caldey Island, 3.5 km (2.2 miles) offshore to the south, which is owned by monks of The Cistercian Order and still has an active monastery.

The 1929 picture shows The Royal Victoria Pier running out from Castle Hill. This served coastal steamers, but was removed in the late 1960s. Beside it is Tenby's first RNLI lifeboat station, with boathouse and launching ramp, which was built in 1905. A new one, with silver roof, was built in 2008 and can be seen in the modern image.

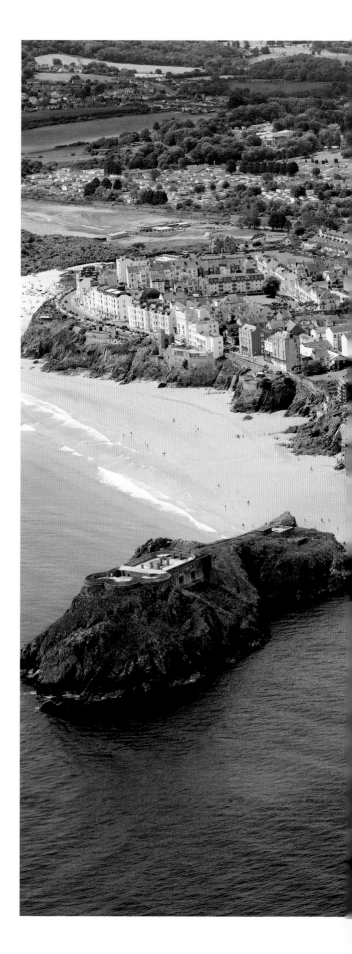

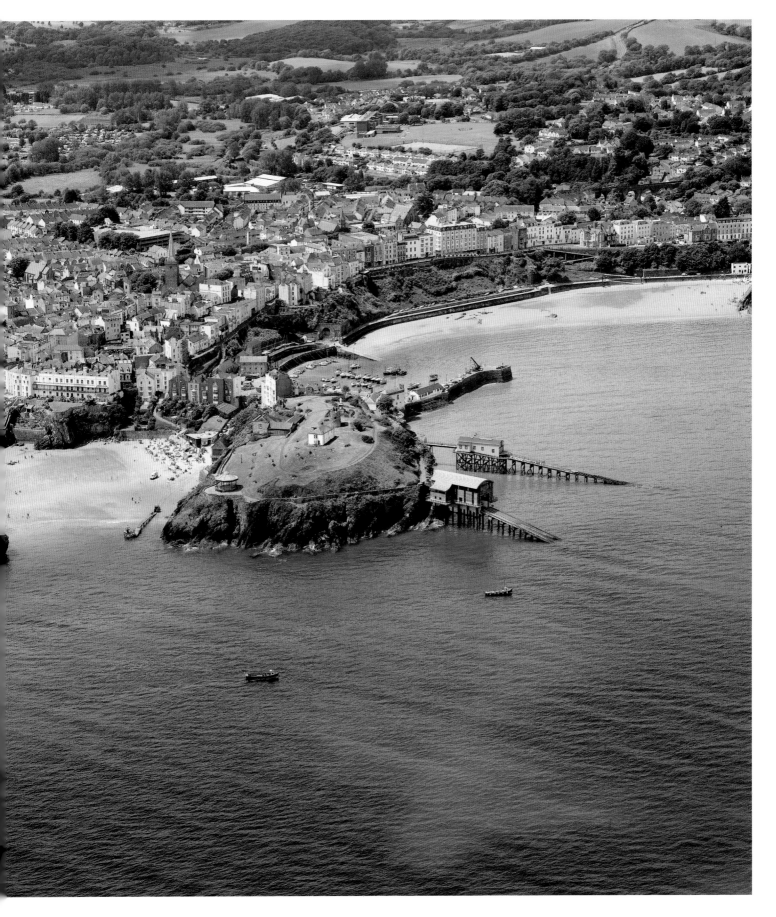

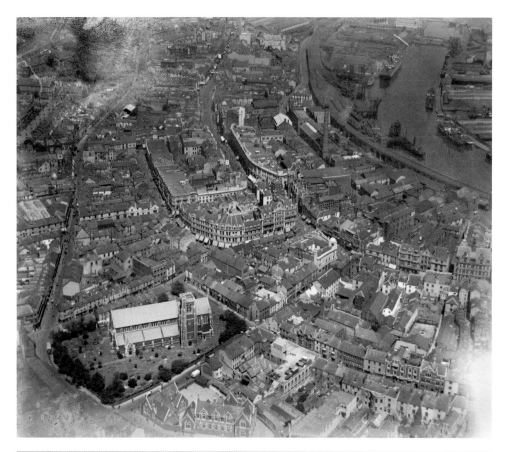

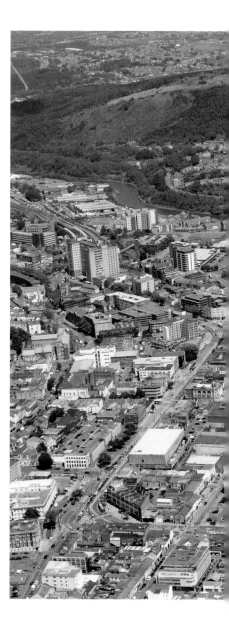

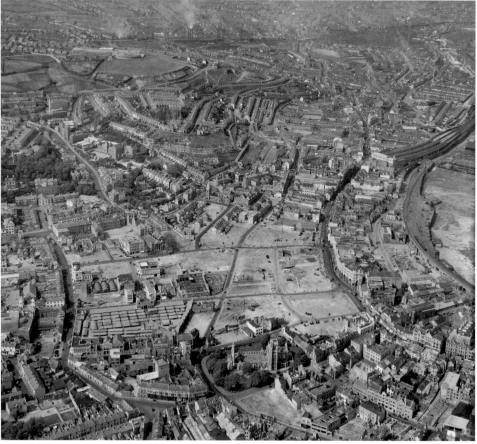

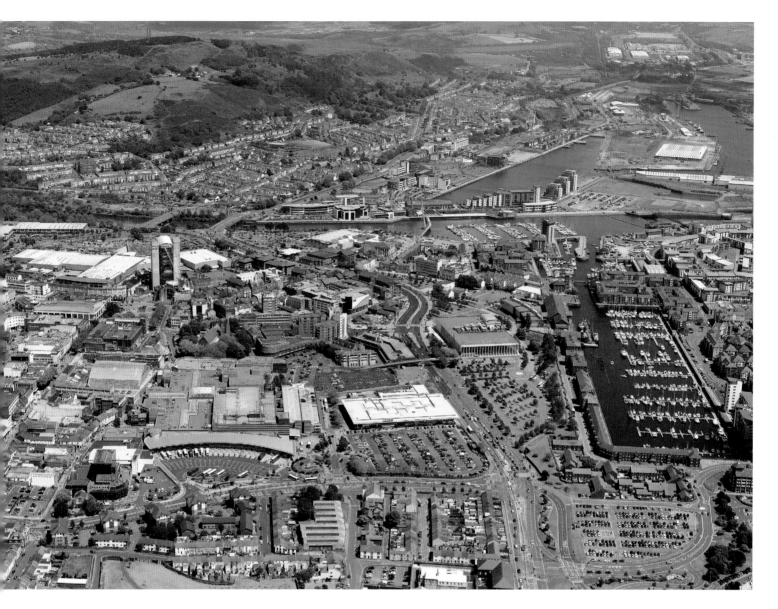

SWANSEA
1923 (top left), 1949 (bottom left) and 2014

Britain had eighteen copperworks in the mid-nineteenth century, and seventeen of them were in Swansea. A local abundance of high-grade coal made it a perfect smelting centre, and as well as 60 per cent of the world's copper, other metals including lead, zinc, tin, nickel, silver, and even gold were processed here.

To get the metals out of Wales, the River Tawe was diverted into a new cut and the old course was turned into the North Dock in 1852. The South Dock opened seven years later.

The success of its metallurgical industries attracted the bombs of the Luftwaffe like a magnet. Much of central Swansea was flattened in the 'Three Nights Blitz' from 19–21 February 1941.

New, larger docks were built on the east bank of the Tawe, (the far side of the river in the 2014 photograph) around the turn of the twentieth century.

These made the old North Dock redundant and it closed in 1930. It had been filled in by the time the 1949 picture was taken; a solitary crane stands landlocked on what was a wharf to the right, below the station. This area is now covered by the Parc Tawe retail development, clearly visible as the white-roofed complex to the left of centre in the modern image. The South Dock didn't close until 1971, but it was then redeveloped as a marina and centrepiece of Swansea's Maritime Quarter.

Towards the lower left of the 1949 picture are rows of covered market stalls. Swansea's covered market was destroyed in the blitz, and not rebuilt until 1961. St Mary's Church, in the foreground of both older images, was hit by bombs, but remained standing. It still stands today, and is just visible amidst the trees, just below and to the left of centre in the modern view.

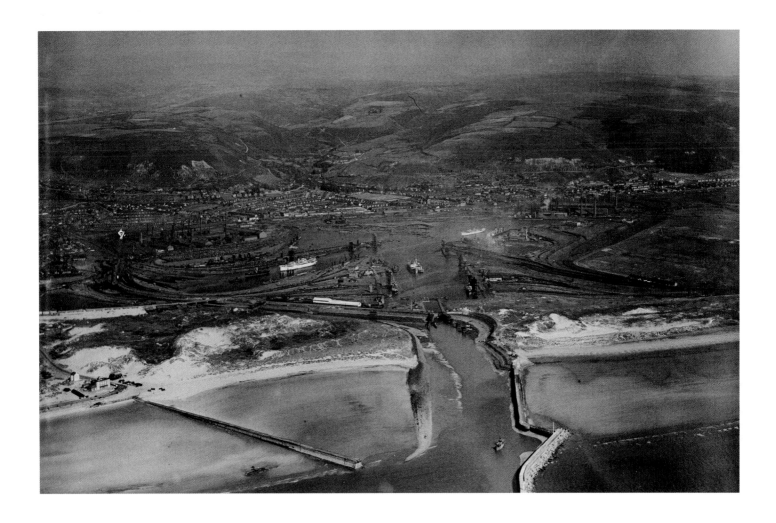

PORT TALBOT
1933 and 2014

In the eighteenth century there was only a natural harbour at the mouth of the River Afan, and its modest wharf would have been lined with sheep and a little coal, destined for Bristol and the West Country.

In 1836, the river was diverted into a new channel and the first major docks in South Wales were constructed. Coal output rose significantly in the nineteenth century, and in 1902 the first steelworks were founded at Port Talbot. Steel production required iron ore, which was imported in huge quantities. When this 1933 photo was taken, 275,000 tonnes of iron ore were being landed here every year. By 1960, it was 2,750,000 tonnes.

In 1951 the Abbey steelworks was opened to the south of the old docks. By the 1960s they were Europe's largest steelworks and the biggest employer in Wales, with a labour force of 18,000. Today it is still the largest of the UK's three major steel plants, with an annual output of up to 5 million tonnes.

The old docks could only accept ships up to 10,000 tonnes – too small for the vast new plant. A new Tidal Harbour was built to the southwest in 1970, and this could handle vessels up to 100,000 tonnes. This is shown in the modern photograph to the right. The old dock complex was closed to shipping in 1959, but, in a rare example of industrial rebirth, it was reopened in 1998. It currently handles around 9 million tonnes of cargo a year.

The huge Abbey steelworks is an integrated plant, in which both iron and steel is produced by a continuous process. Iron ore is smelted in blast furnaces, using coal as a fuel and limestone as a flux to collect the impurities. The iron is then moved to the steel furnaces, where it is further processed and may have different materials added to produce a variety of different types of steel. Finally the hot steel, usually in the form of ingots or bars, is taken to the steel mill. It is then pressed, or rolled into plates, girders, bars or continuous steel strip, which can be rolled out and coiled like rolls of paper according to customer requirements.

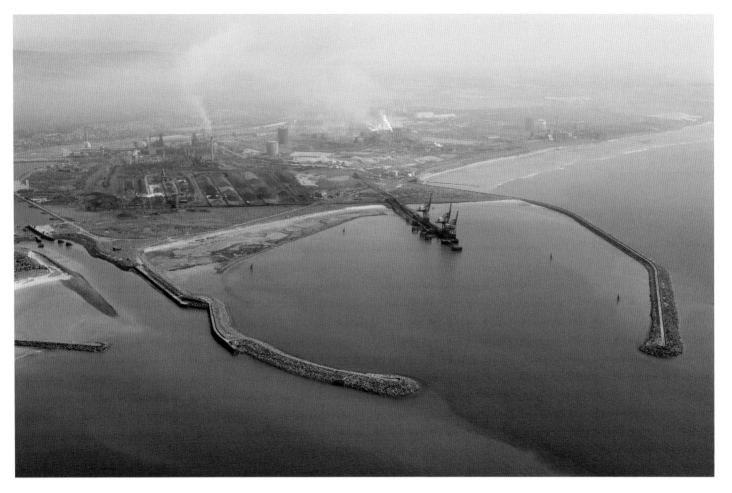

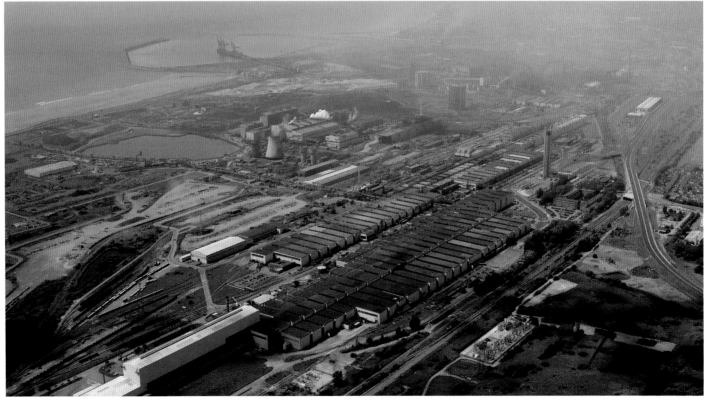

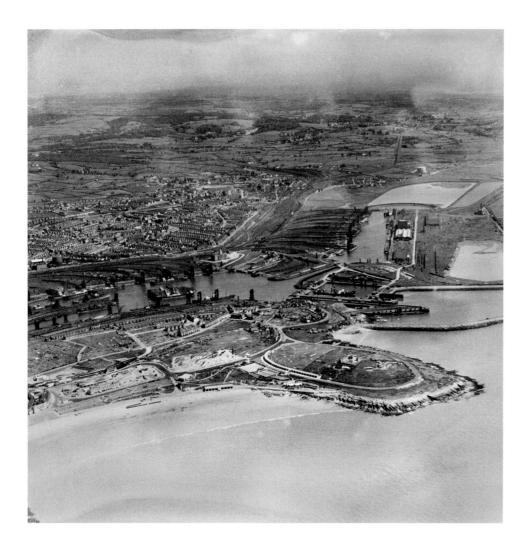

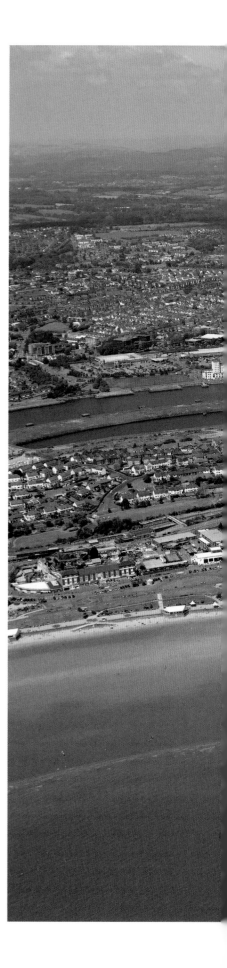

BARRY ISLAND
1933 and 2014

Visitors once crossed mudflats and stepping stones at low tide to stroll on the sands of Barry Island. In the 1880s, docks were built at Barry to break the virtual monopoly on coal exports then held by Cardiff. These made the island a peninsula, and in 1896, a railway made it even easier for sightseers to visit.

Visitor attractions were built on the island, including a small fairground with carousels, swing-boats and a playground. Paddle steamers brought trippers from Bristol, Clevedon and Weston-super-Mare, and the resort bloomed. By 1934, the fairground drew 400,000 visitors during the August Bank Holiday week.

Meanwhile, mere yards away, the docks were becoming the largest coal exporting port in the world. Barry was a unique amalgam of industrial powerhouse and tourist hotspot.

By the late 1970's the docks were in serious decline as the coal industry struggled. The Geest Company's banana imports brought a stay of execution, but by the 1980s the docks were largely derelict.

They have recently been successfully redeveloped and are a popular location for film and television shoots. The funfair and beach still draw strolling holidaymakers.

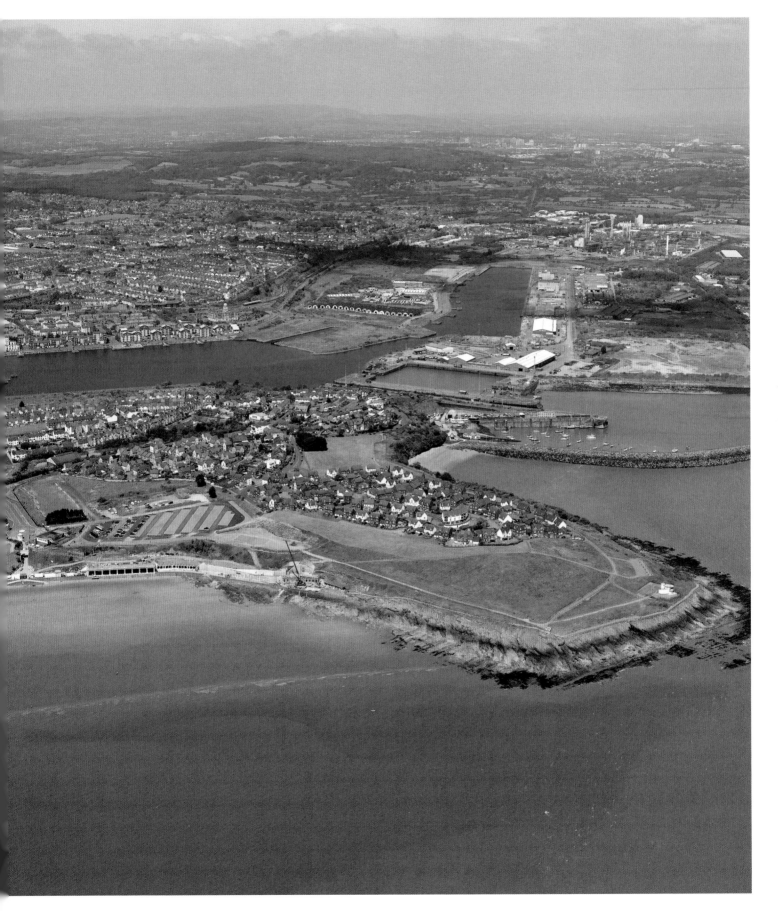

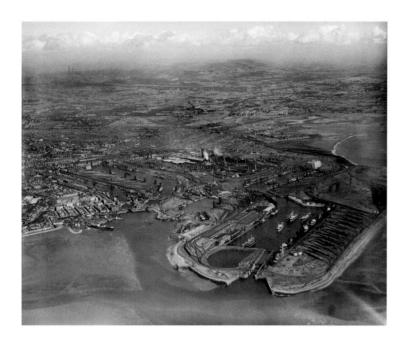

CARDIFF DOCKS
1937 and 2014

At the dawn of the nineteenth century, Cardiff was the twenty-fifth largest town in Wales, with a population of just 1,870. Much of the area was owned by John Crichton-Stuart, second Marquess of Bute, and when surveys in 1823 reported vast coal seams on his land, he enacted a vision of staggering ambition. He built Cardiff Docks virtually from scratch, and although the project was heavily over budget when it opened in 1837, and the Marquess was mortgaged to the hilt, his foresight would pay off.

As the wheels of Britain's industrial development moved up the gears, Cardiff became the main coal port for the Cynon, Rhondda, and Rhymney valleys. The city grew at a rate of 80 per cent each decade between 1840 and 1870. When the third Marquess came of age in 1868, he received an annual income of £300,000, making him the richest man in the world. He embarked on several hugely ambitious architectural schemes, restoring Cardiff Castle and Castell Coch as well as Falkland Palace and Mount Stuart in Scotland.

Cardiff Docks were eclipsed by those at Barry during the early twentieth century, and they were in near-terminal decline after the Second World War. Since the 1990s they have enjoyed a spectacular rebirth. Amid extensive office, leisure, cultural and administrative facilities are the Wales Millennium Centre and the Senedd Welsh Assembly.

The dock area's Victorian nickname of Tiger Bay probably came from the behaviour of the merchant seamen, who would arrive with the tide, enjoy the local recreational facilities with a rather feral sort of gusto, and then sail out with another tide.

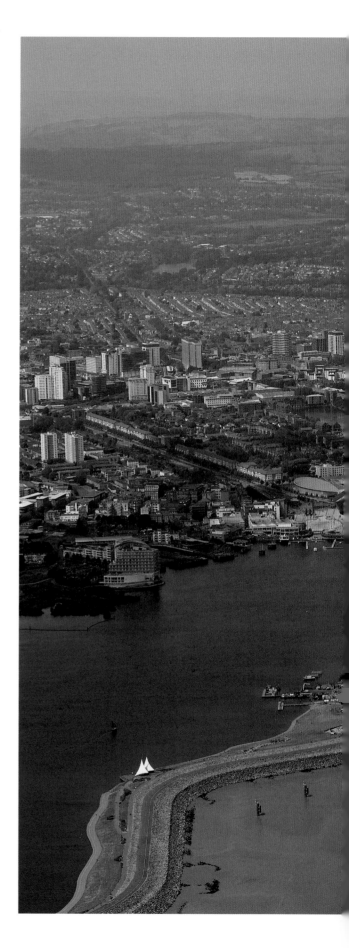

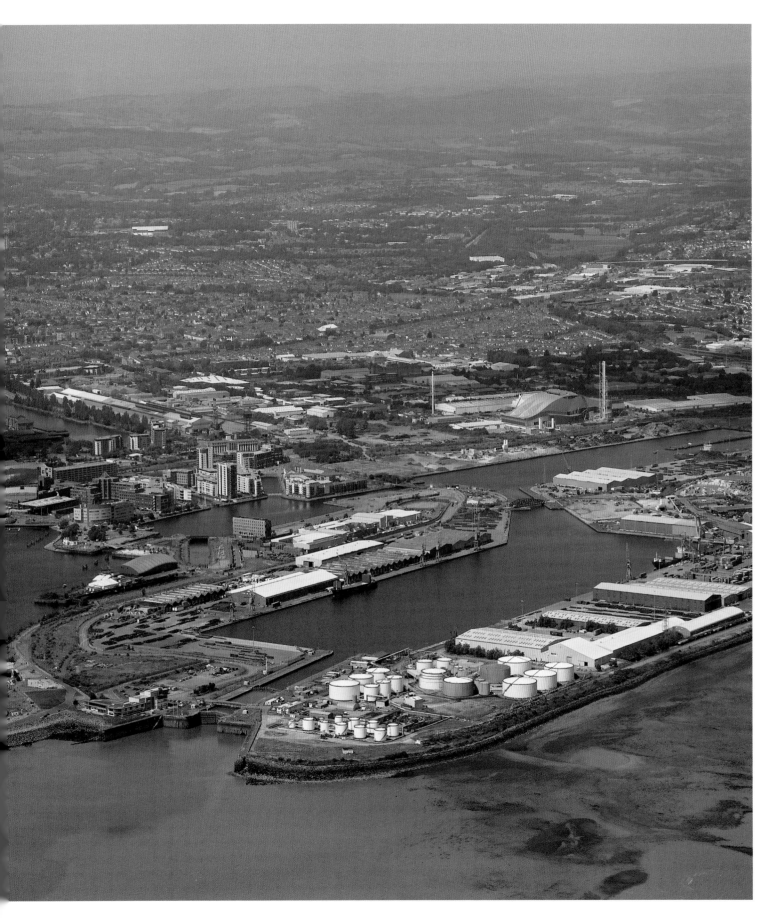

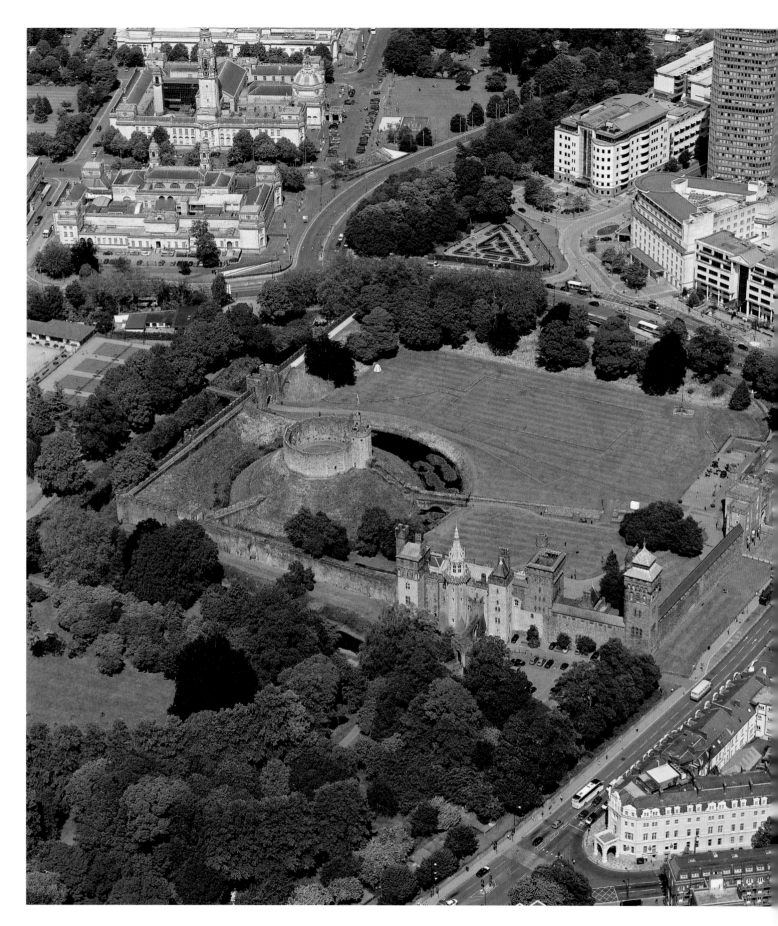

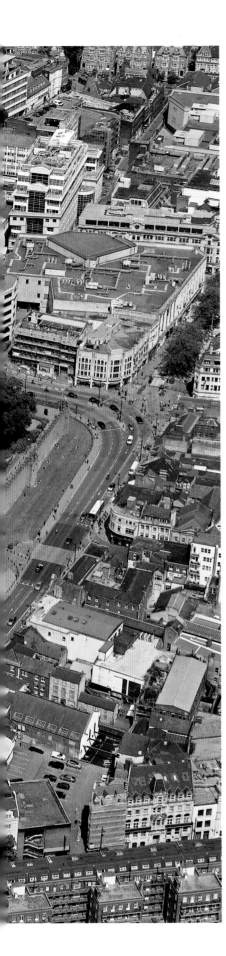

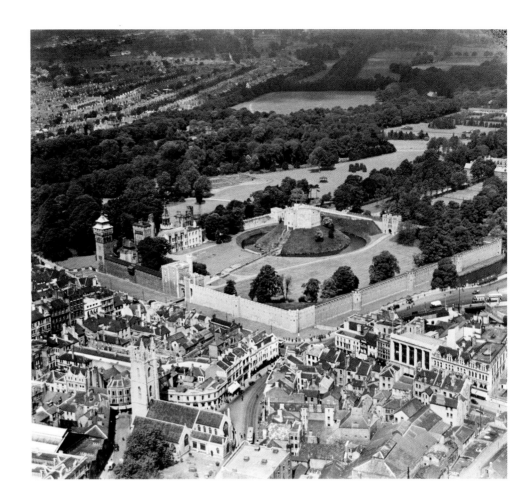

CARDIFF CASTLE
1933 and 2014

Right in the centre of Wales' twenty-first-century capital city beats a medieval heart. The basic rectangle of Cardiff Castle was established as a fourth-century Roman fort. Robert Fitzhamon, Earl of Gloucester, then built the first true castle in the northwest corner in 1091, with the same moat-encircled, steep-sided motte that is visible today. A stone keep soon replaced the original wooden palisade and an outer ward with ditch and earth bank was added onto the Roman outline.

The towered buildings at the southwest were domestic apartments built in the fifteenth and sixteenth centuries, but extensively remodelled from 1868–1927 by the Marquesses of Bute. They unearthed the Roman walls and gates and rebuilt them, a storey too high, to create the Victorian Gothic fantasy version of medieval battlements that we see today.

As the inner motte is ringed with a moat, so the outer ward was very nearly encircled by a canal. The Glamorgan Canal was built in 1794 to link the iron works of Merthyr Tydfil with the docks at Cardiff, and the castle's ditch was used in its route. The canal ran along the north of the castle then part way along the east wall on its way to Bute West dock. Another arm reached down the west side. When the 1933 picture was taken it was still an active waterway, but it finally closed to traffic in 1951. Although it has been largely built over, it still runs through central Cardiff, albeit unseen below Churchill Way.

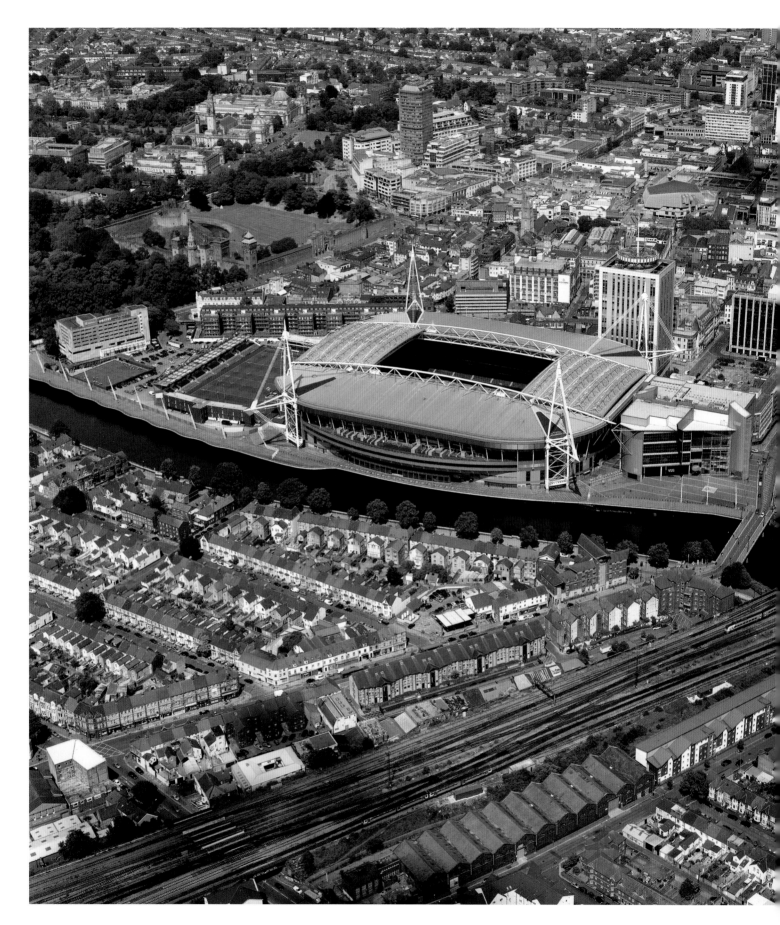

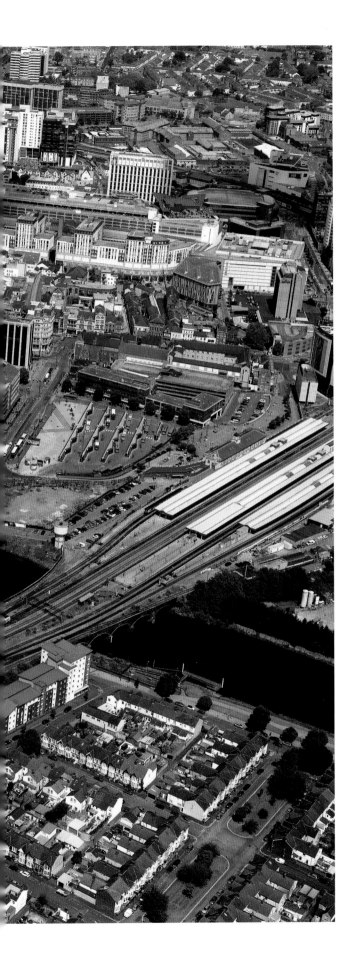

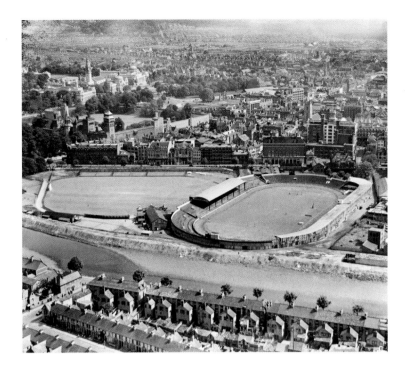

CARDIFF ARMS PARK
1933 and 2014

When a swampy meadow became a popular sporting venue in the nineteenth century, it took the name of the nearest refreshment spot – the Cardiff Arms Hotel. This was demolished in 1878, but 'Cardiff Arms Park' stuck.

The park had bowling greens, tennis courts, a cricket ground to the north and a rugby union ground to the south. Stands and terraces were built as rugby's popularity surged. A greyhound track was added in 1927, visible on the 1933 photograph; this was used until 1977.

Until 1969, Cardiff RFC and Wales shared the rugby pitch. To create a new international stadium the cricket club moved elsewhere, and a stadium for Cardiff RFC was built on the cricket ground. The old rugby pitch was redeveloped into the National Stadium, opened in 1984.

However, just 13 years later, its 53,000 capacity was dwarfed by its peers, Murrayfield (67,000) and Twickenham (75,000). With the World Cup coming to Wales in 1999 it was rebuilt again. To increase space, buildings around the site were purchased and the pitch rotated through 90 degrees.

The new Millennium Stadium can seat 74,500 and is the second largest stadium in the world with a fully retractable roof. It has 124 hospitality suites, 22 bars, 7 restaurants and its own hawk, employed to scare away seagulls and pigeons.

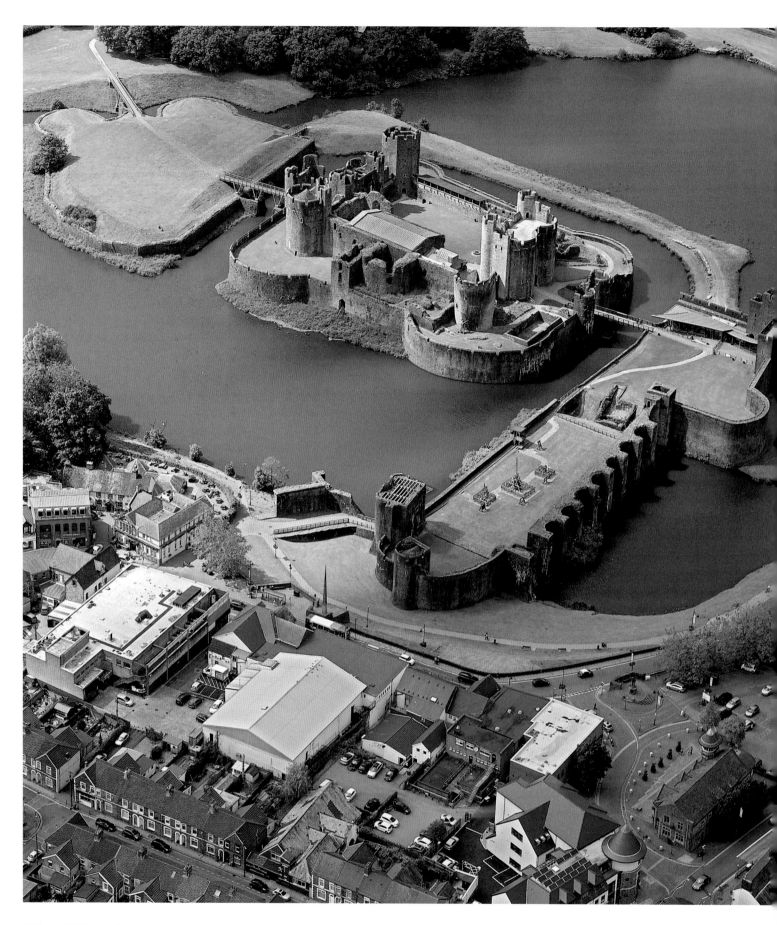

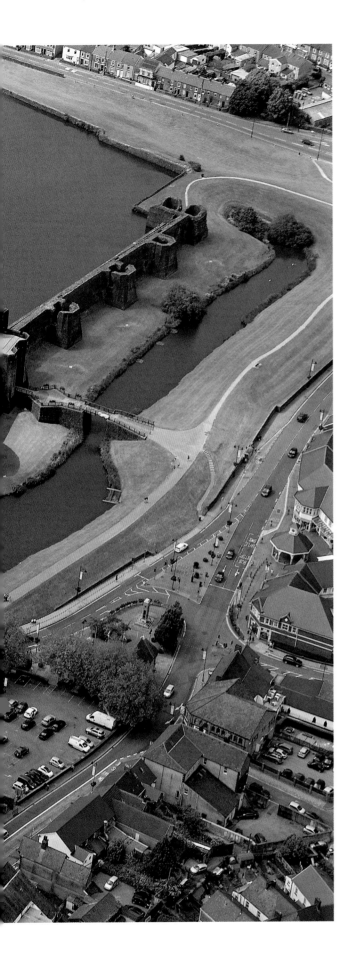

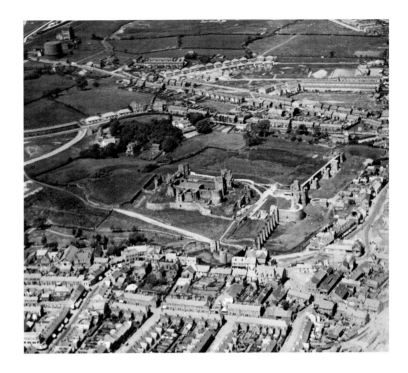

CAERPHILLY CASTLE
1930 and 2014

Caerphilly Castle was a revolutionary masterpiece of military planning. Built between 1268 and 1271 by Gilbert 'the Red' de Clare, as part of a Norman attempt to conquer Wales, it introduced concentric castle building to Britain. It has a high, turreted inner structure nested within a larger, but lower, curtain wall. A series of moats and watery islands add further protection.

Caerphilly is immense. It covers 1.2 hectares, and stands as the largest castle in Wales and one of the great medieval fortresses of western Europe.

Unusually, the contemporary picture shows the castle looking more like it was in its medieval heyday than the 1930 shot. Its owners, the Marquesses of Bute, spent nearly 200 years restoring the property, buying back houses that had encroached on its walls and repairing the stonework. The fifth marquess gave the castle to the nation in 1950 and the restoration was soon completed, with the lakes being reflooded to create the spectacular fortification on show today.

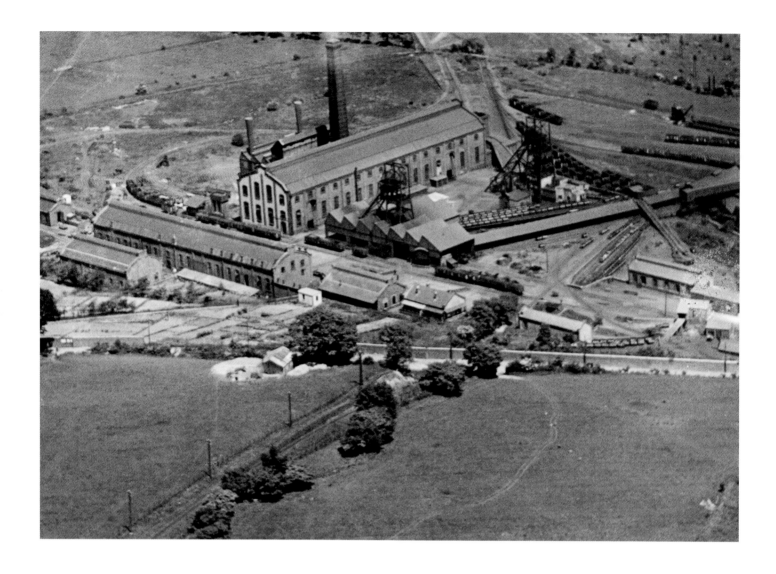

PENALLTA COLLIERY & SULTAN PIT PONY
1930 and 2014

When the two shafts of the Penallta Colliery were sunk in 1906 they were the deepest in the South Wales coalfield, at 690 m (2264 ft) and 716m (2349 ft). The first coal was raised three years later, to fuel an industrial Britain that was still a dominant power, with the largest empire the world had ever seen. When Penallta reached its peak production during the 1930s, it employed more than 3,200 men. In 1930 the mine produced 975,603 tons of coal, and five years later it produced more coal in a single 24-hour period than any other pit in Europe. Output fell to 210,000 tons a year in the 1970s, and although the pit survived the 1984–85 miners' strike it closed in 1991.

As part of the redevelopment of the area, thousands of tons of waste coal shale have been transformed into this remarkable sculpture by Welsh artist Mick Petts. At 200 m (655 ft) long, it is the largest of its type in the UK, and is affectionately nicknamed 'Sultan' after a well-loved ponythat worked underground in the Penallta pit.

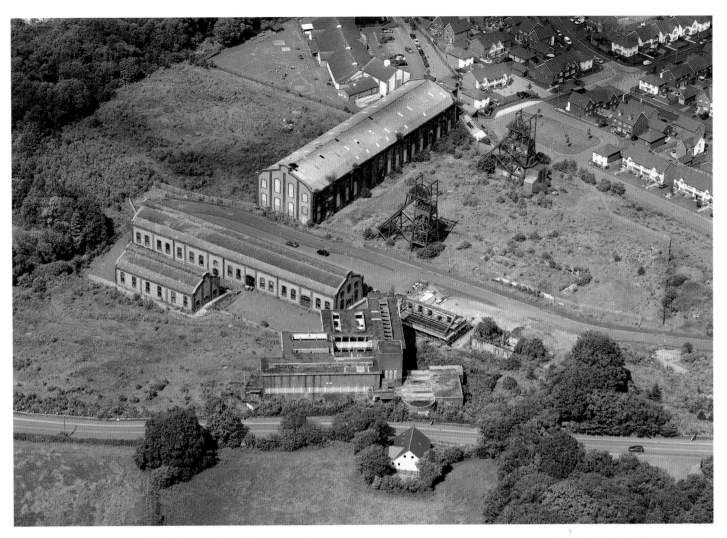

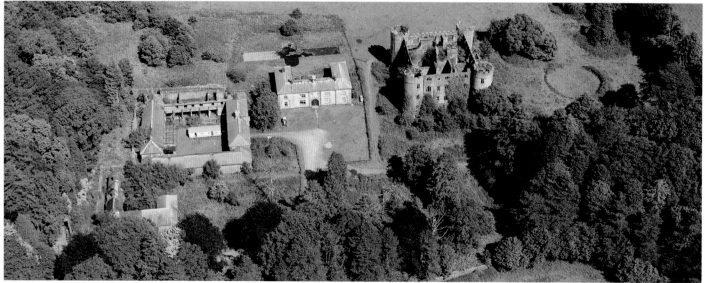

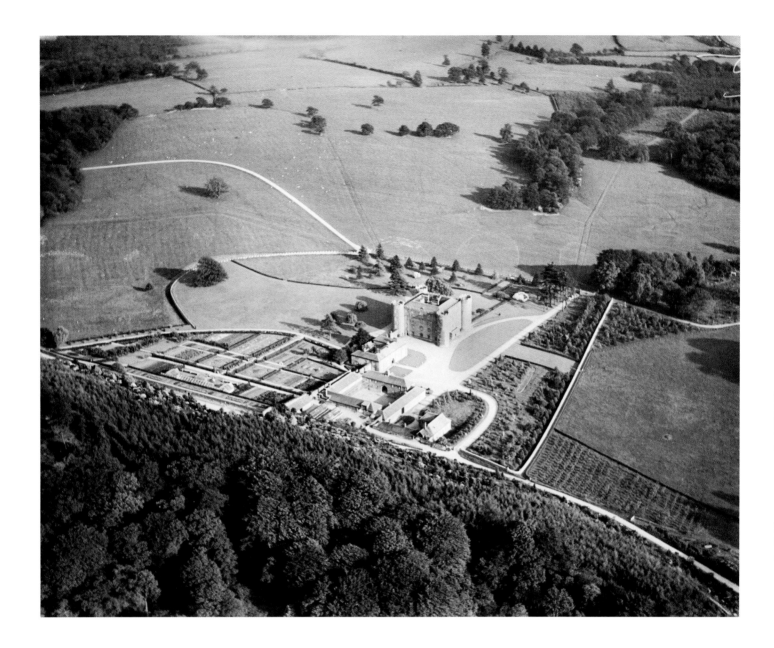

RUPERRA CASTLE
1930 and 2014

Where once Jacobean courtiers dined at walnut tables amid fine paintings, now young sycamore trees spread their branches. Ruperra Castle was built in 1626 by Major-General Sir Thomas Morgan as an early example of the 'mock' castle – a country house that superficially resembles a fortification. King Charles I sought solace under Ruperra's roof for two nights in 1645 after his forces had been trounced at the Battle of Naseby.

The house was destroyed by fire in 1785, but was rebuilt. It was being improved even in the early twentieth century, when its owner, Courtenay Morgan, First Viscount Tredegar, built a new stable block, reservoir and staff accommodation.

Ruperra was still in the Morgan family when this picture was taken, in 1930, but was only used as a weekend hunting lodge and the 1,200 ha (3,000 acre) estate was soon put up for sale. When the Second World War broke out, Ruperra was one of many large houses requisitioned by the army. Unfortunately, fire broke out on their watch, in 1941. Finding money for repairs was certainly not a priority then, so the house fell into decay.

After the war the estate was sold simply as farm land. Recent attempts to develop the house into flats have failed, and it remains a romantic ruin.

CAERLEON AMPHITHEATRE
2014

The clang of gladiatorial swords and the shouts of 6,000 spectators once rose high above this grassy oval on the outskirts of what is now Newport. The Caerleon Roman amphitheatre was built around AD 75 to give the men of the Second Augustan Legion something to keep them occupied during their long, cold days at the extremity of the empire.

The remains of around seventy-five amphitheatres have been found across the Roman Empire, and Caerleon is the best-preserved example in Britain. However, it was only revealed as an amphitheatre during excavations in 1926, during which 27,000 tonnes of soil were removed. Before that it was a sunken hollow with a raised earth rim known locally as King Arthur's Round Table.

The amphitheatre was part of the legion's fortress headquarters, known as Isca Augusta, which was in use until around AD 300. As well as the amphitheatre, Caerleon today has the remains of baths, barracks and the fortress wall, although many of the wall's stones were used to build local houses. Further excavations in 2011 uncovered more buildings outside the fortress walls, and a Roman harbour by the River Usk.

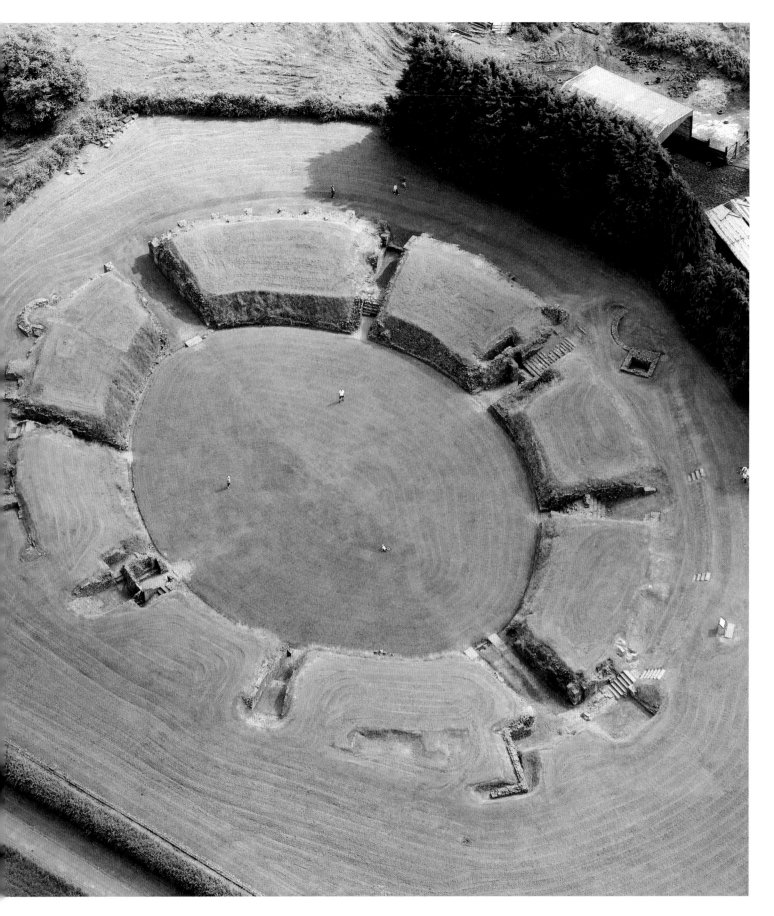

SEVERN CROSSING
2010 and 2013

Before 1966, drivers travelling from England to South Wales could either take the Aust Ferry or make a 92-km (57-mile) detour via Gloucester. The ferry had carried cars since 1934, but it was a relic of this past age: it could hold just seventeen vehicles and was unable to sail at low or very high tides, making its timetable rather idiosyncratic.

Construction of the four-lane Severn Bridge started in 1961. Two years later, Her Majesty the Queen opened the bridge and it proved immediately popular, with 100,000 cars crossing within the first few days – most of them for the pure fun of the trip. Within eighteen years, the annual volume of traffic using the bridge had tripled and a second crossing was begun in 1992.

A high tide can deepen the Severn Estuary by up to 14.5 m (48 ft), the second highest tidal range in the world, and tricky currents rip across the mud flats. So engineers built most of the bridge off-site, and then moved the pre-fabricated pieces into place with barges at high tide.

The Second Severn Crossing carries six lanes of the M4 for 5.1 km (3.2 miles) over the estuary, clearing the water by 37 m (121 ft) to allow ships to pass underneath. Over 80,000 vehicles now use the crossings every day.

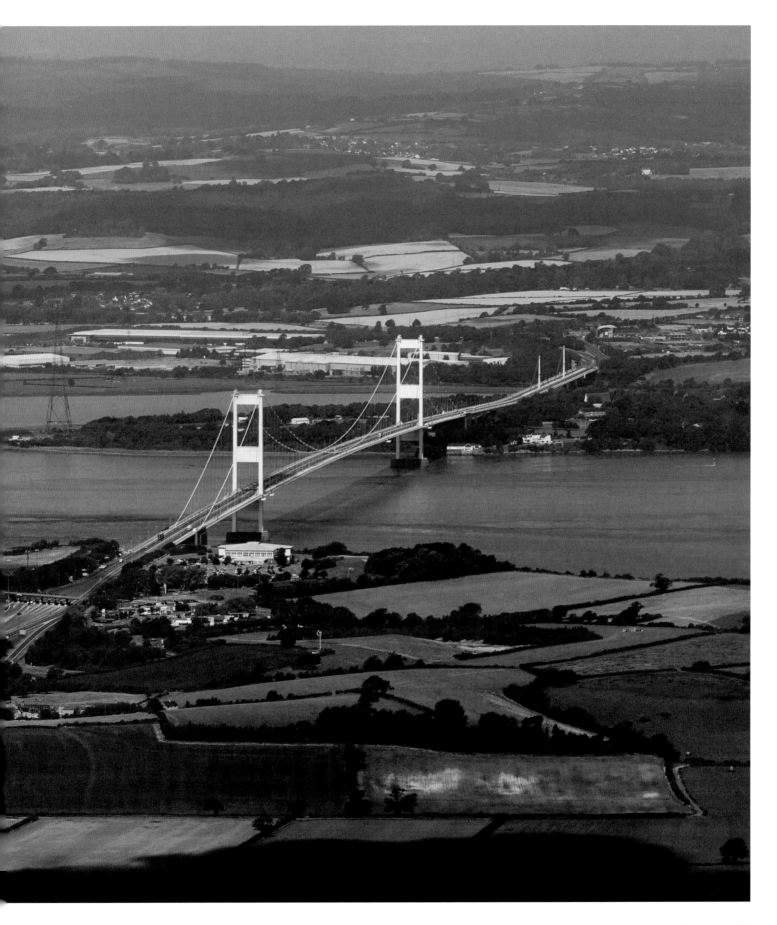

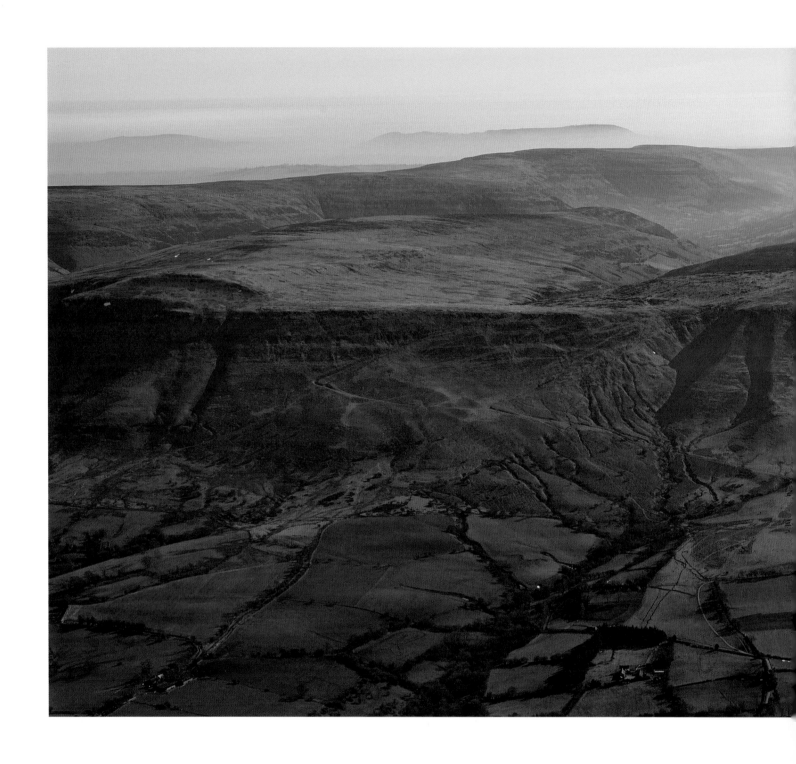

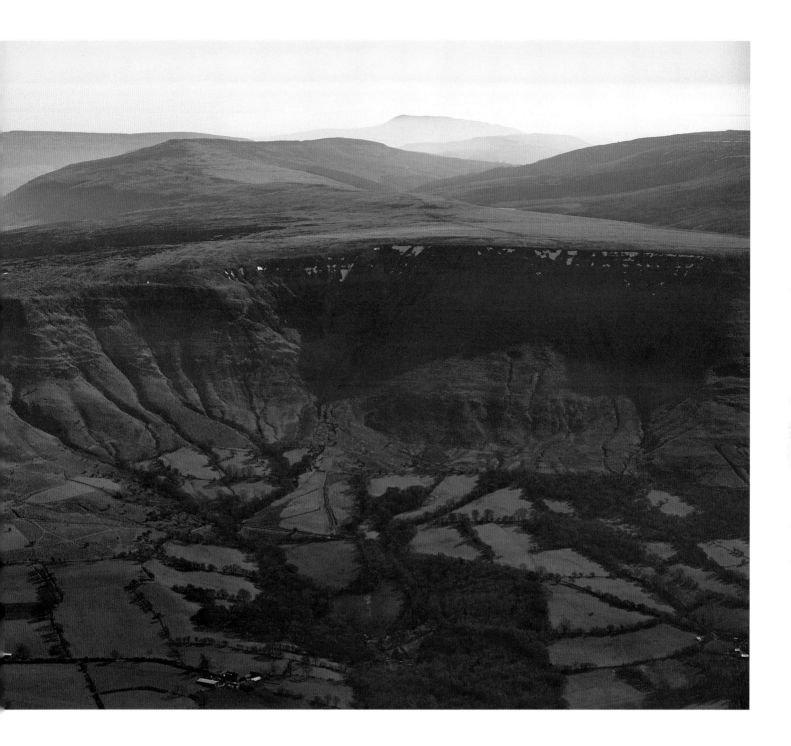

BRECON BEACONS
2013

For the Bronze Age residents of the Brecon Beacons area, the hill-tops were places to bury their dead. In the Iron Age, the summits were used defensively, and the remains of dozens of hill forts are still visible today, many of them very large. This often harsh but very beautiful area is beloved of walkers, climbers and nature-lovers, and has been protected as a National Park since 1957.

The rugged and remote corners of the Brecon Beacons are favoured training grounds for the UK's armed forces. Would-be members of the SAS and other Special Forces often have to show their mettle on Pen Y Fan, the highest mountain in South Wales. Carrying an 18-kg backpack, rifle and water bottle, candidates must climb up the 886-m (2,907-ft) peak, down to the other side, then turn around and come back again. This exercise is 24 km (15 miles) long and must be done in less than 4 hours 15 minutes, and is affectionately known as the 'Fan Dance'.

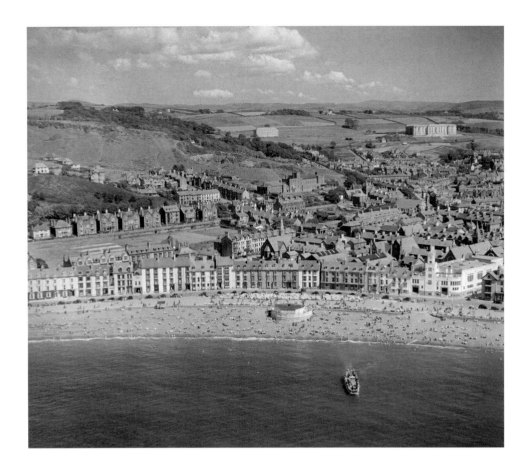

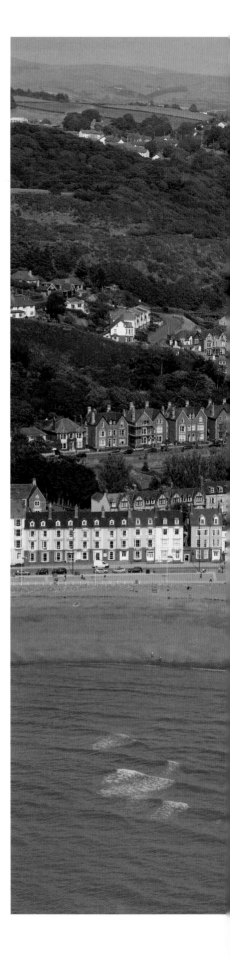

ABERYSTWYTH
1947 and 2014

Rationing might still be keeping belts tight, and the memory of war may be painfully fresh, but nothing can stop the crowds enjoying sun and sand on a hot Aberystwyth Sunday in July 1947.

In the top right of the image above from 1947 stands the National Library of Wales, which was established here in 1907 after a tussle with Cardiff for the honour. This is one of six legal deposit libraries in the United Kingdom and Ireland, which are automatically entitled to request a copy of every book published in the UK. It holds more than 4 million printed volumes, including the first book printed in Welsh, from 1546, and the first Welsh translation of the complete Bible.

The main building was completed in 1916 and here stands in proud isolation amid the fields behind the town. In the modern image it has been enveloped by the buildings of Aberystwyth University's Penglais campus. Established in 1872 as University College Wales with just 26 undergraduates, today the university has 15,000 students.

Aberystwyth's other jewel, its seafront, looks very similar to the way it did in 1947, with Victorian townhouses looking out over pier, promenade and sandy beach. The historic Bathrock Shelter, erected on the promenade in 1924, was heavily damaged in the storms of January 2014.

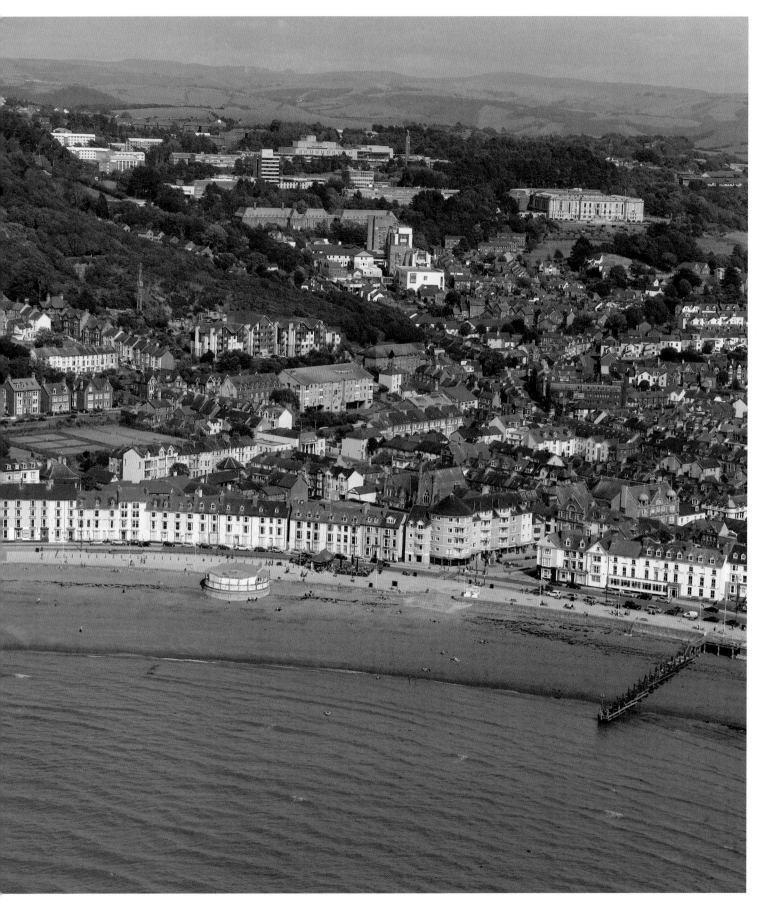

CEFN MAWR VIADUCT & PONTCYSYLLTE AQUEDUCT
2014

Just south of the town of Cefn Mawr the River Dee has carved a very beautiful, but rather inconvenient, 60-m (197-ft) gouge in the Welsh countryside.

The Ellesmere Canal was planned in 1791 to link the Mersey with the Severn, but much of its planned northern section was never built. This left its central part short of water, which was taken from the River Dee west of Llangollen. So what is now the Llangollen Canal was more a water supply for the Ellesmere Canal than a navigable waterway in its own right. The water had to flow high over the Dee Valley, a problem solved in 1805 by Thomas Telford with his Pontcysyllte Aqueduct, shown above and in the lower right image. This cast iron trough stretches for 307 m (1,007 ft) across nineteen hollow masonry piers that stand 38 m (126 ft) above the river. It is the longest and highest aqueduct in Britain and a UNESCO World Heritage Site.

Forty years later, as railways superseded canals, a group of industrialists wanted to extend the Chester to Ruabon railway to Shrewsbury, linking the Port of Liverpool with England's industrial Midlands. They appointed one of England's most prolific railway engineers to the job, Thomas Brassey. He took this line over the Dee Valley on the Cefn Mawr Viaduct, completed in 1848 and shown in the upper right photograph.

Brassey went on to construct major railways in Canada, Australia, South America and India, and was responsible for three-quarters of the lines in France.

The Cefn Mawr viaduct is visible in the upper right of the photograph above, with the bridge which carries the A5, London to Holyhead road across the deep valley of the River Dee, just visible to the right of top centre.

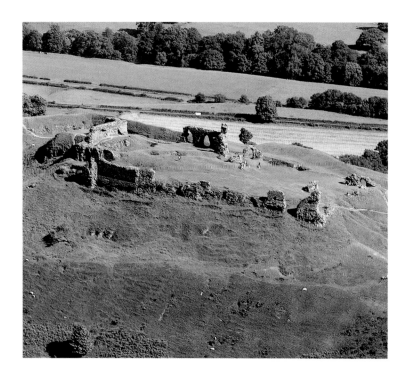

CASTELL DINAS BRAN
2014

'Castle of the City of Crows' is the literal translation of Castell Dinas Bran and it seems an apt name for this lofty eyrie.

The first defensive structure on this ideal hill near Llangollen was an Iron Age fort built around 600 BC. The remains of its earthen rampart and deep ditch can still be seen ringing the summit. A wooden palisade on the rampart would have protected a village of roundhouses.

The stone buildings visible today are the remains of a castle built by Gruffydd II ap Madog, a prince of Powys, around 1260. It was in his sons' hands when Edward I of England invaded Wales in 1276, and after a minor skirmish and some wise peace-making in the face of the mighty invading army, it was in English hands by 1282. Dinas Bran was subsequently abandoned as its English owners decided to build a new castle at Holt.

Today almost all that remains are the walls of the keep, the gatehouse and the tower that held the kitchens. Two windows in the southern wall, of what was once a sumptuous great hall, still look out over the valley. Within the outer wall there would also have been stables, workshops, storage buildings and a chapel in the castle's thirteenth century heyday.

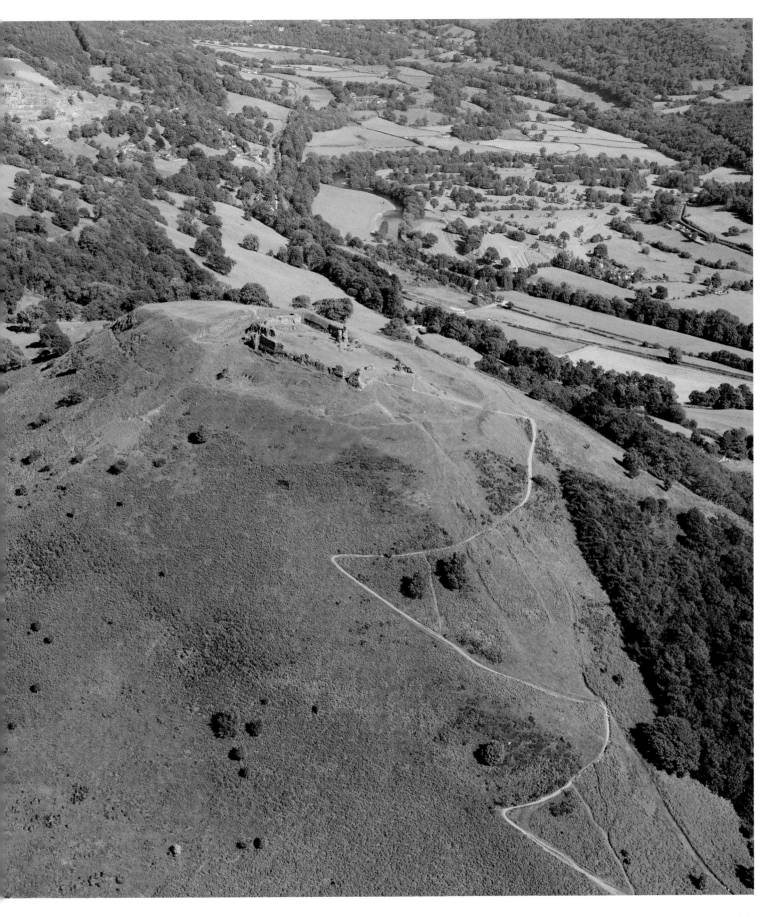

LLANGOLLEN
2014

An eisteddfod is a Welsh cultural festival that features music, dance and literature. Llangollen has held its own International Musical Eisteddfod every summer since 1947. Each year more than 5,000 performers from dozens of countries come to entertain crowds by the banks of the River Dee. Many world-famous musical names have taken part and Luciano Pavarotti first came here in 1955, winning top prize with his father's choir. This success inspired the 19-year-old to sing professionally.

In 1992 the 4,000-seat Royal International Pavilion was opened to replace the temporary canvas structure erected every year.

In 1969, the railway line through Llangollen was lifted following the Beeching cuts. However, the route's potential as a tourist attraction was quickly spotted, and the station reopened in 1975. The line has been extending westwards ever since, and currently runs for 16 km (10 miles) to Corwen, making it the longest preserved standard gauge railway in Wales. Llangollen Station occupies the area to the left of the bridge of the far side of the river.

The Llangollen Canal closed to traffic in 1944, but was still in use as a water supply in 1957. In the second half of the twentieth century canal boating surged in popularity and this canal, which twists past beautiful welsh hills, over aqueducts and through tunnels, became one of Britain's most popular waterways. The 32-berth marina, visible to the left of the Eisteddfod Pavilion in the above photograph, opened in 2004 to cope with the rise in boat traffic. The canal is also visible running across the upper left of the photograph to the right.

The Llangollen Canal became a UNESCO World Heritage site in 2009.

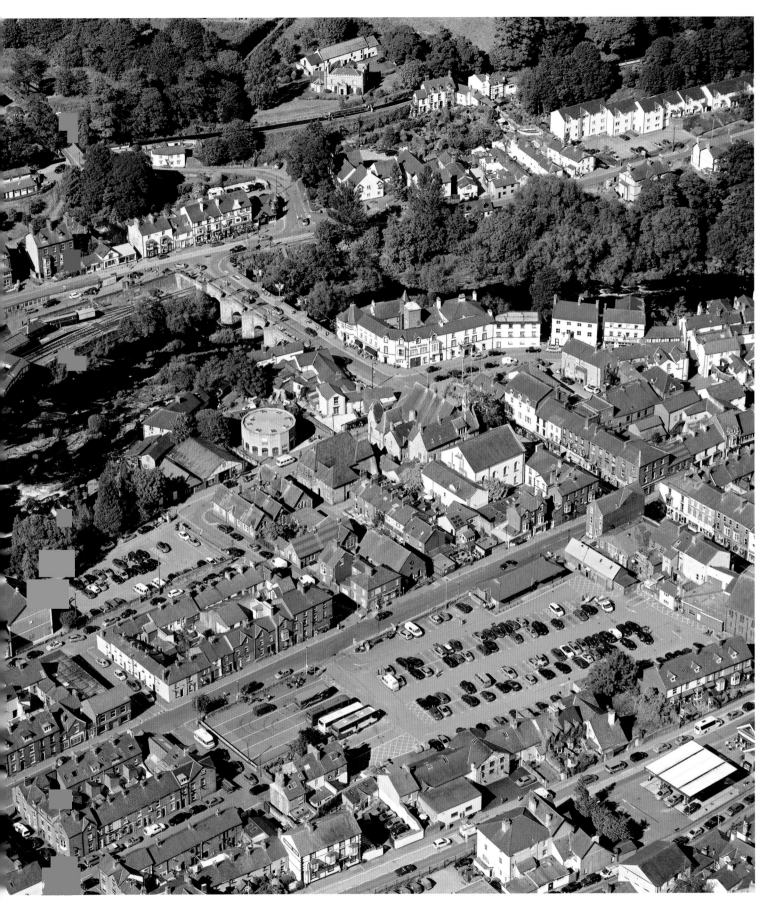

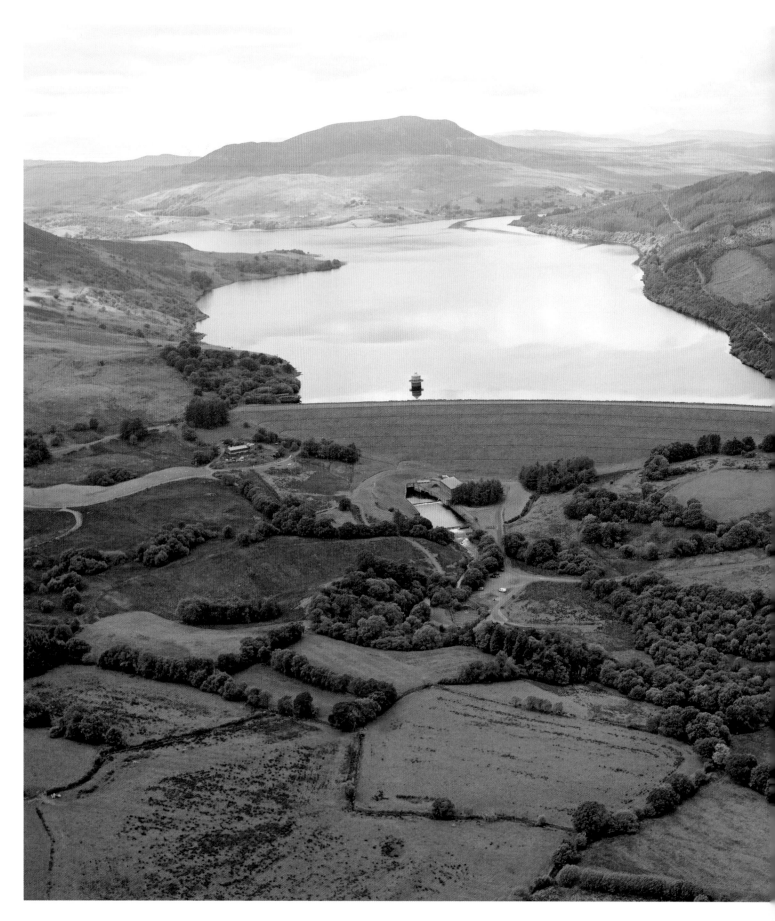

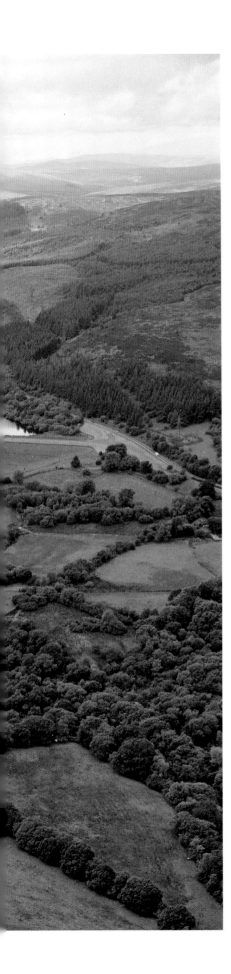

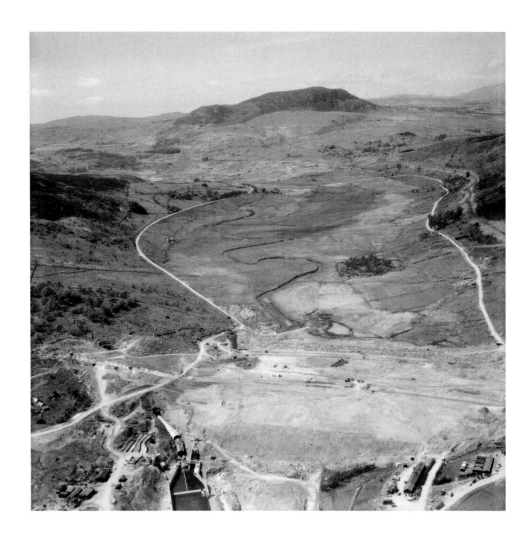

LLYN CELYN
1963 and 2014

The village of Capel Celyn was drowned so that Liverpool could drink. The lake is used to regulate the flow of the River Dee, allowing more water to be drawn off at Chester for the Wirral and Liverpool. The decision to flood the Tryweryn Valley and create the reservoir of Llyn Celyn was a controversial plan that stirred strong feelings in Wales.

The legislation for the scheme was opposed by thirty-five out of thirty-six Welsh MPs (the thirty-sixth did not vote) but passed anyway – which boosted support for Plaid Cymru, the Welsh nationalist party.

This 1963 image shows construction of the huge earth dam that would hold back the waters of the Afon Tryweryn. It dwarfs the diggers, dumptrucks and workers' housing in the foreground. The pale construction road on the left of the photograph is the trackbed of the former Bala and Ffestiniog Railway. This closed in 1960 to enable the scheme to proceed.

In 1965 the valley was flooded, drowning twelve farms and the village of Capel Celyn, buildings of which can be seen towards the right of the 1963 image.

Today Llyn Celyn delivers hydroelectric energy to the National Grid, and its run-off waters are often used for international-standard canoeing competitions.

PORTMEIRION
2014

There is a corner of Wales that is forever Italy – Portmeirion. This extraordinary village was created by architect Sir Clough Williams-Ellis, who poured his time and resources into recreating the essence of a Mediterranean town in a scenic nook by the River Dwyryd. His goal was to create a place that could be enjoyed for its own sake, and to show how a naturally beautiful site could be developed without spoiling it. It took him fifty years, from 1925 to 1975.

Portmeirion is set amid 70 acres of sub-tropical woodlands and features flower-lined plazas, ornamental terraces and brightly coloured buildings in a variety of styles. The village is a popular tourist destination and guests can stay in most of its buildings. Its serenity and playful eccentricity have inspired many famous visitors including Noël Coward, who wrote *Blithe Spirit* while staying in a suite here. Portmeirion itself played a starring role in the surreal 1960s spy drama *The Prisoner*, as 'The Village' where Patrick McGoohan is incarcerated.

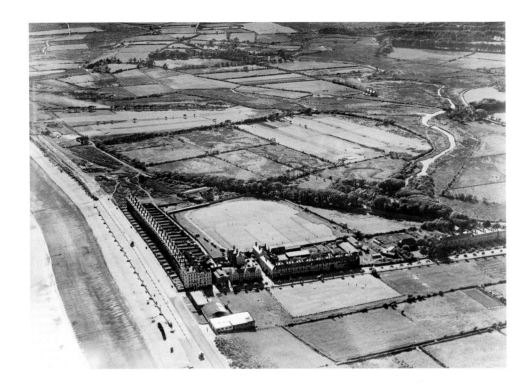

PWLLHELI
1934 and 2014

For many generations of holidaymakers Pwllheli was little more than the train station nearest to Butlins holiday camp. However, the town has a proud history that far predates its summer resort status.

Pwllheli received its charter from Edward, the Black Prince, in 1355 and for the next six centuries fulfilled its role as the main market town of the Llyn peninsula. It was developed as a seaside resort in the late nineteenth century, but despite its large influx of summer visitors, 81 per cent of its 3,861 inhabitants speak Welsh. Even more significantly, it was in Pwllheli that Plaid Cymru was founded. This party was formed with the goal of Welsh independence in 1925 and won its first seat in 1966. Today Plaid Cymru has 18 per cent of seats in the Welsh Assembly.

Pwllheli's Wednesday market is still a magnet for residents of the remoter parts of this far northwest tip of Wales, while its neat harbour attracts sailing and motor-boat enthusiasts from even further afield.

The famous Butlins holiday camp, which actually lies some 5 km (3 miles) to the east of Pwllheli had a rather unusual origin. During the Second World War, the Admiralty, who had already taken over Billy Butlins camp at Filey in Yorkshire, commissioned him to build two new camps, one in North Wales and one in Scotland. After the war, Butlin regained ownership of the camp he had built near Pwllheli, and after some refurbishment this opened as another of Butlin's popular holiday facilities, with all the usual attractions.

As the twentieth century drew to a close, the appeal of such facilities had faded when compared to cheap package tours to warmer climes. Butlins was taken over by the Rank Group, who also owned Haven Holidays. The camp then became part of Haven, during an internal group reorganization in 1999. Both Haven and Butlins were then sold to Bourne Leisure, who still operate the holiday park, now renamed Hafan y Môr (Sea Haven), under the Haven brand. In this view, taken in 2014, most of the chalet accommodation has been replaced by modern, static caravans; many of the traditional Butlins attractions have been removed, and the facility looks more like a well-equipped static caravan park.

PORTH DINLLAEN
2014

At the far western end of a 5-km (3-mile) swoop of sandy bay, Porth Dinllaen nestles in the protective arm of a grassy promontory. This tiny village is only reachable by boat, on foot across the golf course or along the strand itself when the tide allows.

Porth Dinllaen faces out into the Irish Sea, and as railway lines stretched ever further across nineteenth-century Britain, it almost became the main point of embarkation for Ireland. But Thomas Telford bridged the Menai Strait and Holyhead on Anglesey became the main ferry port.

The village's handful of houses have been owned by the National Trust since 1994. At the centre of the village is the Ty Coch Inn. In 2013, this pub was voted the third best beach bar in the world. It began life more sedately in 1823, as a vicarage before being converted to an inn to quench the thirsts of shipbuilders from the nearby harbour.

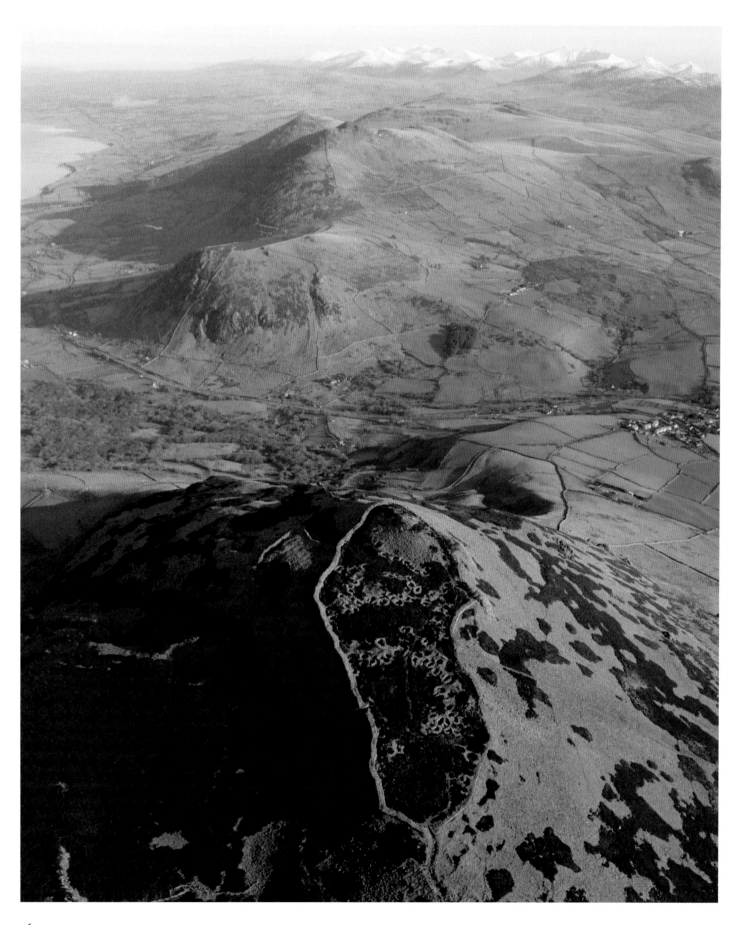

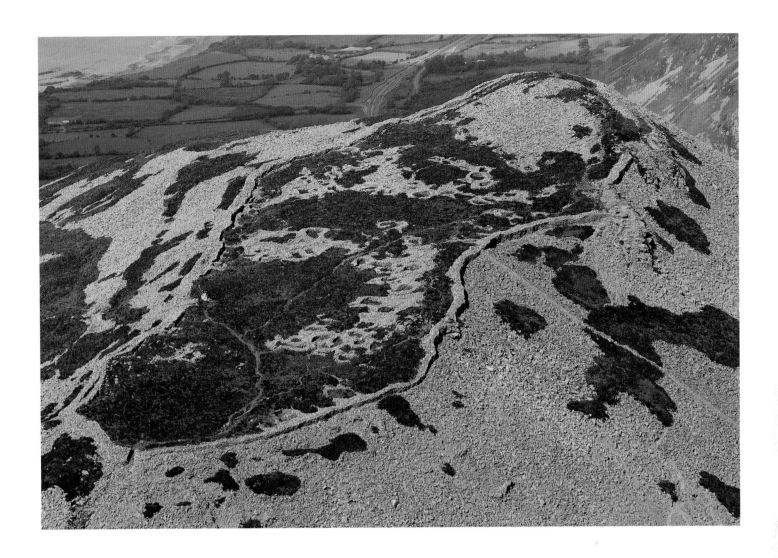

TRE'R CEIRI HILLFORT
2007 (left) and 2014 (right)

Tre'r Ceiri means 'Town of the Giants' and they certainly picked an impressive place to call home. The hillfort perches like an eyrie 450 m (1,476 ft) above sea level on one of the three peaks of Yr Eifl on the Llyn Peninsula.

This has to be one of the most beautifully situated hillforts in Britain, with the ocean on three sides and glorious views to Anglesey, the mountains of Snowdonia and, on the far west horizon, Ireland. Tre'r Ceiri is also one of the best preserved. It is still entirely ringed by ramparts, which stand up to 4 m (13 ft) high in places, and inside the remains of 150 stone houses are clearly discernible.

The fort started as a simple stone wall around an early Bronze Age cairn. A second wall was built outside this rudimentary enclosure in the Iron Age, when the fort housed around 100 people in 20 houses. It covers an area of 2.5 ha (6 acres) with additional oval enclosures built around the fort to hold animals and to cultivate crops. Fresh water came from a natural spring just outside the walls. The fort had its heyday when the Romans were in Wales when there were probably 400 people living here.

SNOWDON
2010 and 2013

When the mists smoke and roil around Snowdon's cliffs it's easy to believe that the summit is the tomb of Rhitta Gawr, a fearsome giant slain by King Arthur.

At 1,085 m (3,560 ft), Snowdon is the highest peak in Wales and in Britain outside Scotland. Its famously wide views can encompass Ireland, Scotland, England, the Isle of Man, twenty-four counties, twenty-nine lakes and seventeen islands.

When first approached by railway builders in 1869, the local landowner refused to allow the building of a line to the summit, for fear it would spoil the scenery. But he eventually relented and the Snowdon Mountain Railway opened in 1896. It climbs 7.6 km (4.7 miles) from Llanberis to within just a few metres of the top.

In 1935, a summit station designed by Sir Clough Williams-Ellis, creator of Portmeirion, was built. By the 1990s this had become a famous eyesore and the 'highest slum in Wales' according to Prince Charles. Hafod Eryri, a new visitor centre built from weather-resistant granite, opened in 2009.

The vast majority of Snowdon's summitteers may hitch a ride to the top, but for outdoor enthusiasts the mountain offers some very serious rock climbs. Edmund Hillary came here to train before his ascent of Mount Everest in 1953.

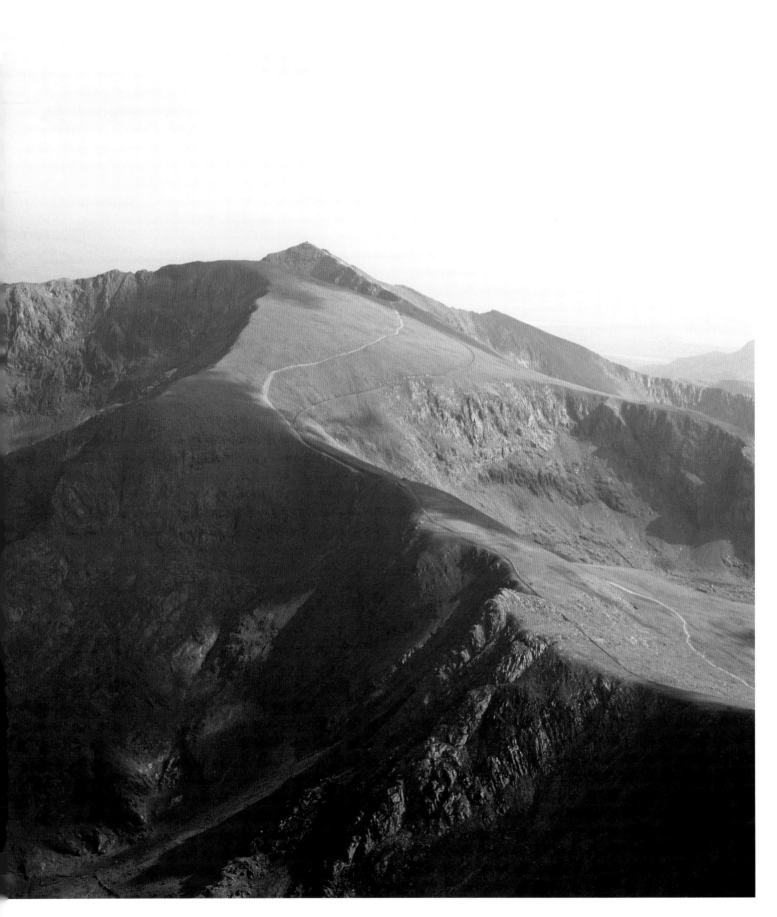

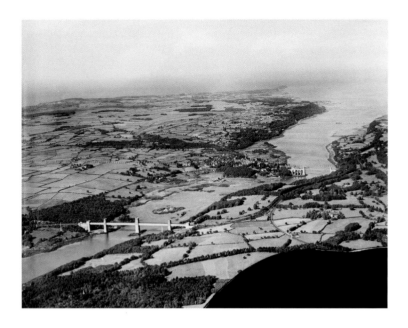

MENAI STRAIT
1934 and 2014

Before 1826, cattle raised on Anglesey had to be swum across the Menai Strait to market. After the Act of Union with Ireland in 1800, a good road linking London with Ireland was imperative and the strait had to be bridged.

Thomas Telford's elegant solution, the Menai Suspension Bridge (furthest away in both photographs), was the world's first modern suspension bridge. Telford's route cut nine hours off the journey time from London to Holyhead, from thirty-six to twenty-seven hours.

When train travel took off in the coming decades, Robert Stephenson, son of railway pioneer George, designed a tubular rail bridge of wrought iron – the Britannia Bridge. Another engineering triumph, its two main spans were 140 m (460 ft) long. Previously the longest wrought iron span was 9.6 m (31 ft).

Boys accidentally set fire to the tar-covered wooden roof of the tubes in 1970, gutting the Britannia Bridge. It was reborn ten years later as an arched steel truss bridge with a road deck above the railway lines. The difference between the old and the new structures can be readily appreciated by comparing the two photographs.

The island to the left of the Britannia Bridge is Ynys Gorad Goch. The high tidal range of the straits made it ideal for use as a site for fishing traps. The tidal range means the size of the island ranges from 2,000 – 15,000 m² (0.5 – 3.7 acres).

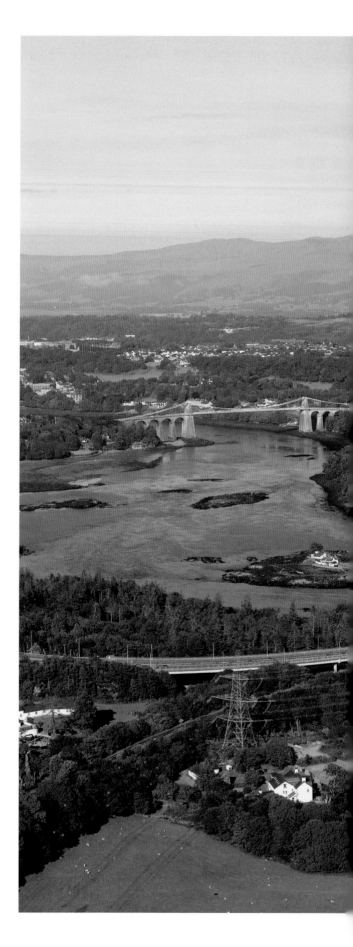

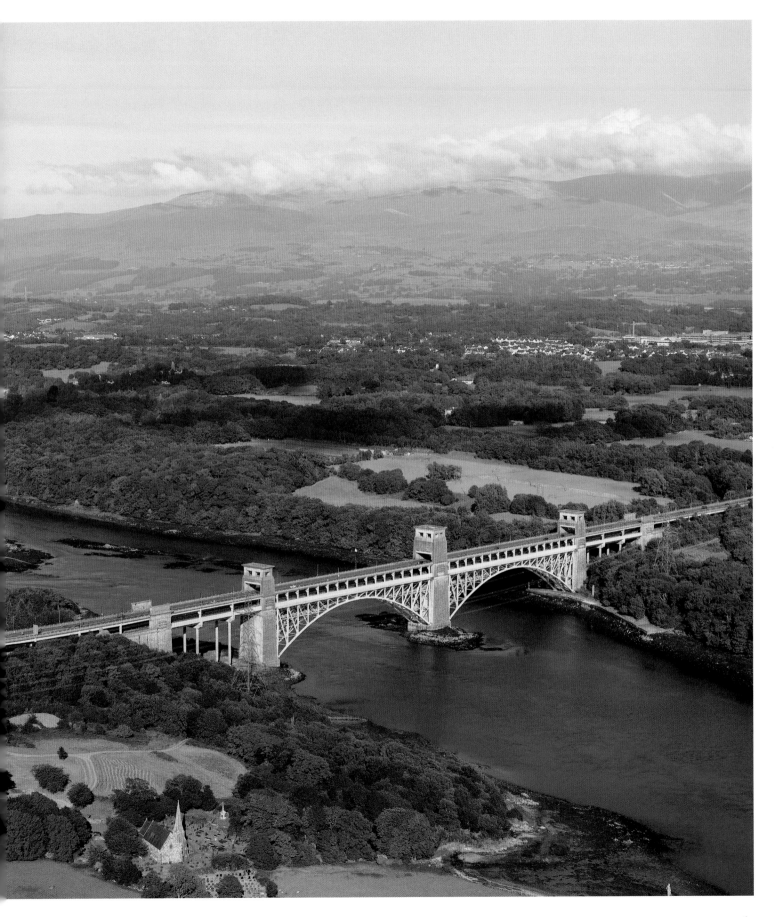

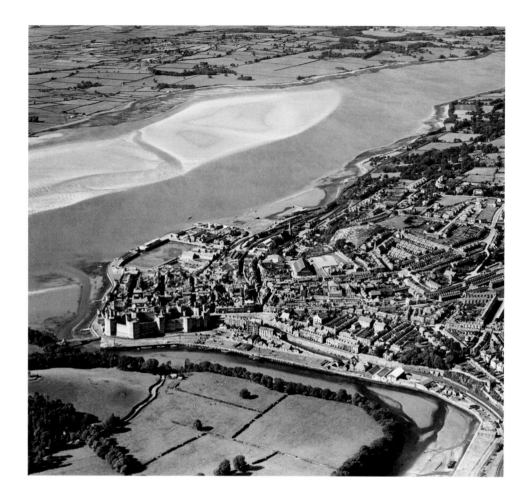

CAERNARFON
1934 and 2014

After Edward I, King of England, completed his conquest of northern Wales in 1283 he replaced the wooden fortification at Caernarfon with a mighty stone castle, complete with town walls and a new quay: a power centre from which he could control the area. The castle's history as a symbol of foreign domination influences the town's culture today.

More people speak Welsh in Caernarfon than anywhere else in Wales – 86.1 per cent of the general population and 97.7 per cent of 10–14-year-olds. In 1911 the Royal Family deliberately chose the castle as the venue for the investiture of the future King Edward VIII as Prince of Wales. The current Prince was similarly honoured there in 1969.

Doc Fictoria (Victoria Dock), to the north of the castle, opened in the 1870s to berth ships transporting slate mined from nearby Snowdonia. Warehouses, an abattoir and oil storage tanks (visible in the 1934 image) were later added. Following the decline of the slate industry, the dock has been redeveloped as a marina, with housing and an arts centre.

Entering the top right of the 1934 image is the railway line from Bangor. A tunnel took it under the main square of Y Maes to connect with another railway. Its track runs out towards the bottom right of the picture along the curve of the Afon Seiont with the two branches running to Afon Wen and Llanberis. All these lines were culled as part of the Beeching cuts in the 1960s, but the first part of the southern line was resurrected in 1997 within the narrow gauge Welsh Highland Railway to Porthmadog.

This pair of pictures also show how the sand banks in the Menai Strait shift their shape and position over time.

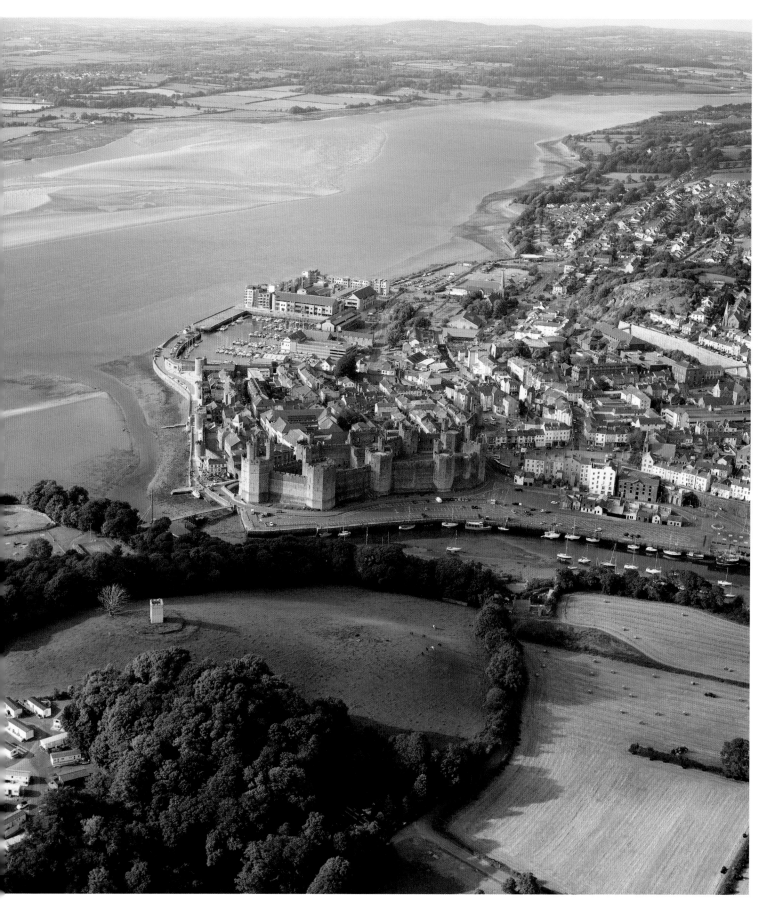

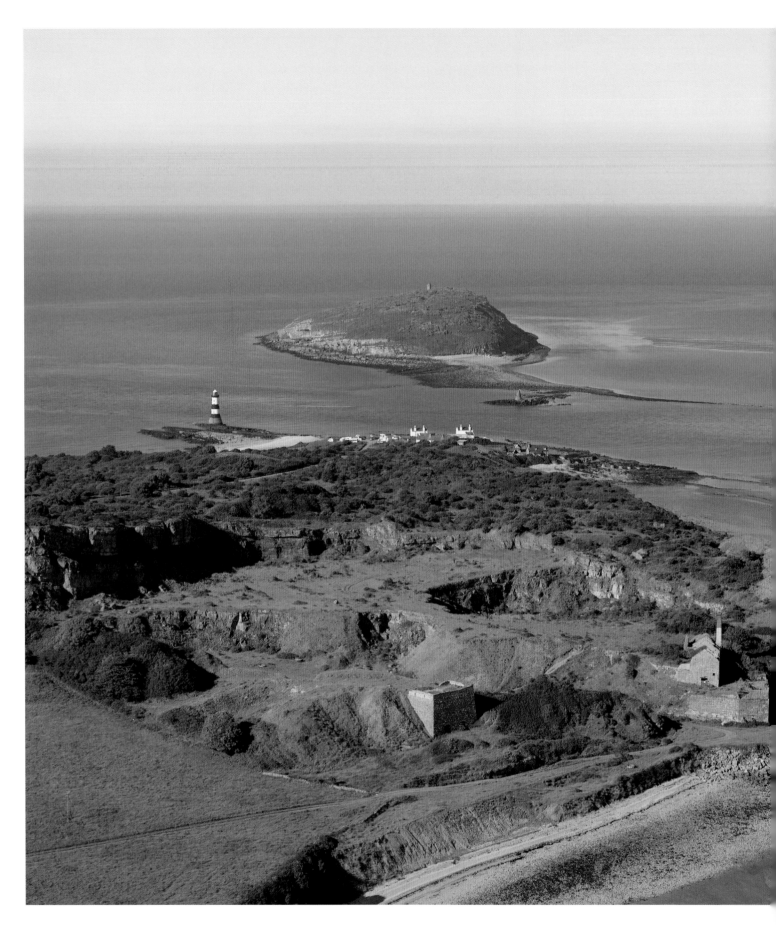

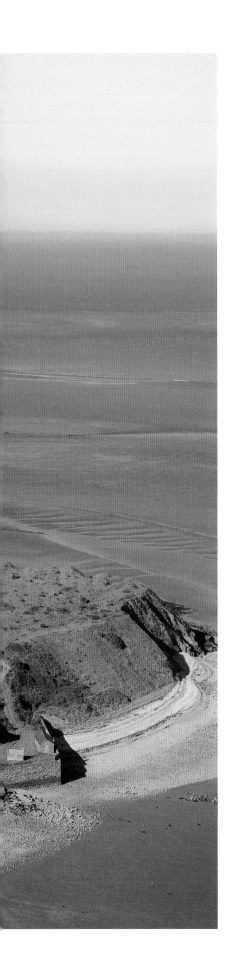

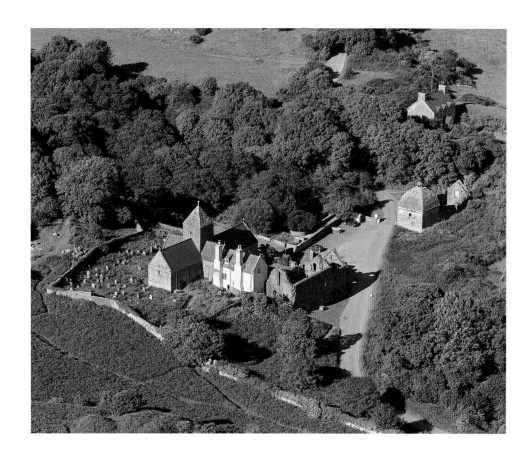

PENMON PRIORY & PUFFIN ISLAND
2014

There has been a place of Christian worship in this tranquil spot on Anglesey overlooking Menai Strait since the sixth century. After the original simple structure was ravaged by the Vikings an abbey church was built in the twelfth century, and managed to survive English King Edward I's conquest of Wales. However, it was later undone in a quieter manner when Henry VIII took his dissatisfactions with religion out on the monastic houses of England and Wales in 1538.

A local family, the Bulkeleys of Beaumaris, then took over ownership of the site and devoted much time and money to its improvement. There is a large dovecote and the priory church remains open for worship.

Quarries in the area were also famous for their fine quality marble, and Penmon stone was used to build Birmingham Town Hall and the bridges over the Menai Strait.

The lighthouse at Penmon Point was built after a number of shipwrecks in this area, which lies at the northern entrance to the Menai Strait. In one such tragedy, the paddle steamer, *Rothesay Castle*, was driven on to a sandbank while on a day trip from Liverpool to Beaumaris in 1831. As conditions worsened, the ship was wrecked and 117 people drowned, most of whom were day trippers.

Puffin Island, as its names suggests, used to be home to a colony of puffins. Although the puffins no longer inhabit the island, this area is still rich in wildlife.

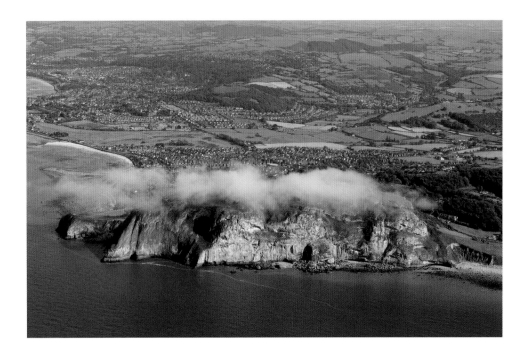

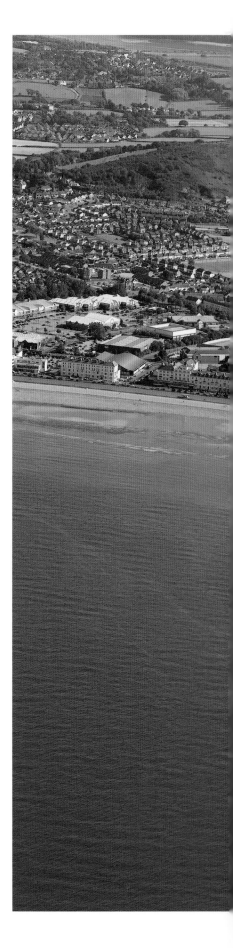

LLANDUDNO
2014

Llandudno is the largest holiday resort in Wales, yet it has retained the charm and character of its Victorian origins to such an extent that, even today, it is easy to see why it was referred to as 'Queen of the Welsh Resorts' in the society advertising of that time.

This is almost certainly due to the foresight and influence of one man, Lord Mostyn, who owned large tracts of land in the area. He enthusiastically took up the idea of developing part of his substantial coastal estate into a purpose-built holiday resort, after being presented with a plan by a prominent architect and surveyor of the day.

The curving stretch of sand and shingle beach, between the prominent rocky headlands of the Great Orme and the Little Orme, was ideal for the purpose and the resort soon took shape. A wide promenade was built to run along the entire length of the beach, separated from the road by a strip of garden for much of its length. Blocks of elegant, terraced hotels faced out to sea, while shops and other amenities were situated a short distance inland, lining the aptly-named Mostyn Street, which runs parallel to the shoreline. A pier was built out from the western end of the promenade, at the foot of the Great Orme, and a tramway was built to take visitors the 207 metres (679 ft) to the top. Mostyn and his agents were always careful to ensure that each new development complimented the rest, and this principle still seems to be followed today.

Cloud nestles on the top of the Liitle Orme in the photograph above, while the view to the right shows part of the resort's unspoiled frontage today.

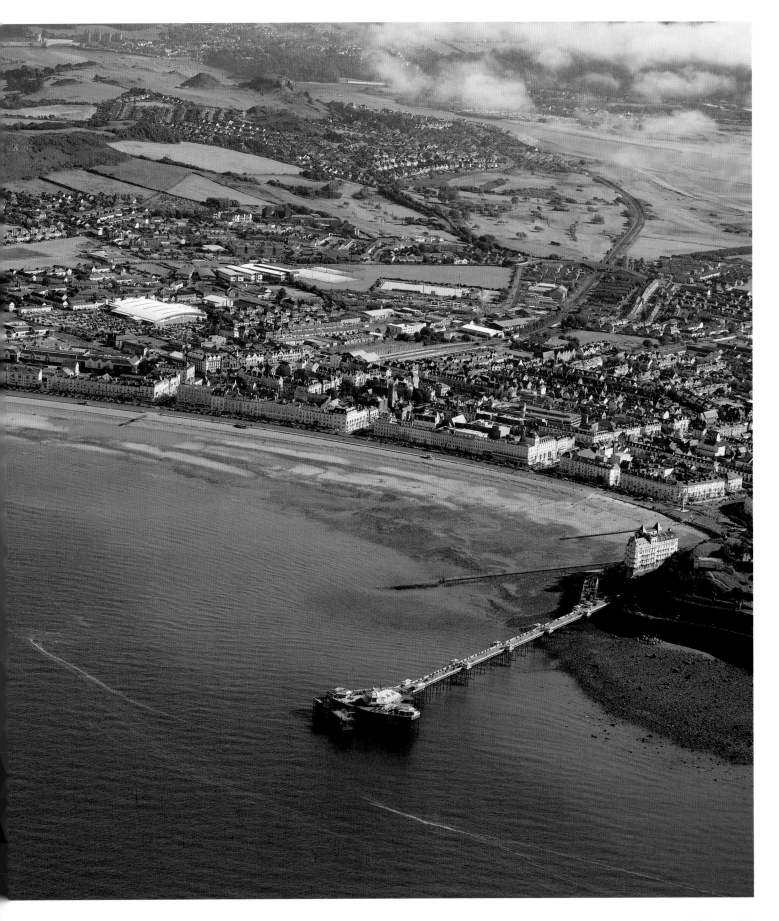

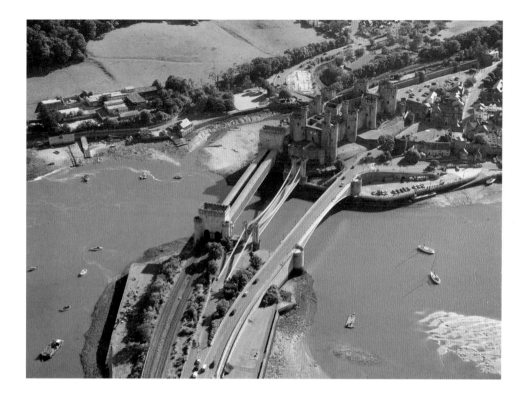

CONWY
2014

Rampaging armies, market-bound farmers and caravans heading for the coast – the river at Conwy has been a headache for them all. In 1283 the invading English king, Edward I, realised the importance of this narrow tidal neck of water on Wales' north coast. He built the castle and garrison town walls that stand today, then offered English settlers incentives to move here.

For centuries a ferry was the only way to cross the river, for local traffic and long-distance travellers heading for Ireland alike. Then in 1826, a suspension bridge designed by Thomas Telford was completed. One of the first road suspension bridges in the world, it required the demolition of part of the castle. But Telford was sensitive enough to design the bridge towers as castellated echoes of the castle's turrets. It is now used solely by pedestrians.

The tubular railway bridge, which is similarly adorned with mock battlements, was built by Robert Stephenson in 1849, and this still carries the main line to the ferry port of Holyhead today. The tight bend at the castle end of Telford's suspension bridge is unsuitable for modern road traffic, so a new road bridge has been built to serve the needs of the town and other local communities.

Conwy's medieval street plan is unsuitable for large volumes of traffic, and as the large photograph shows, the castle walls, which still surround the old town, prevent wholesale reconstruction. A tunnel was therefore built to carry the A55 trunk road under the River Conwy a short distance downriver, which enables this very busy road to by-pass the town altogether.

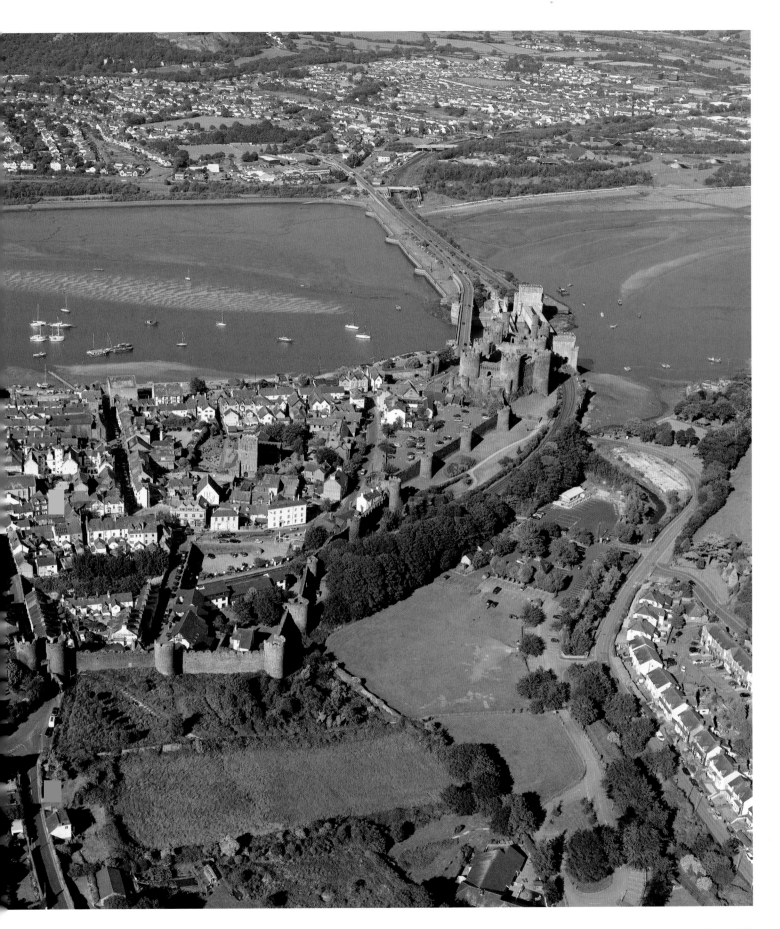

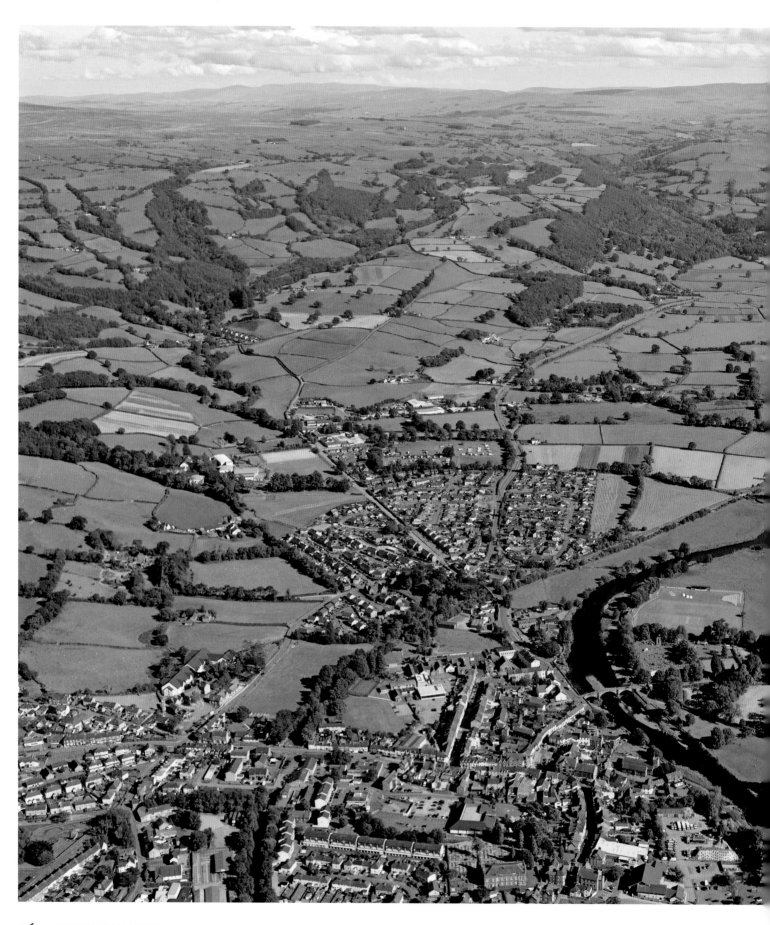

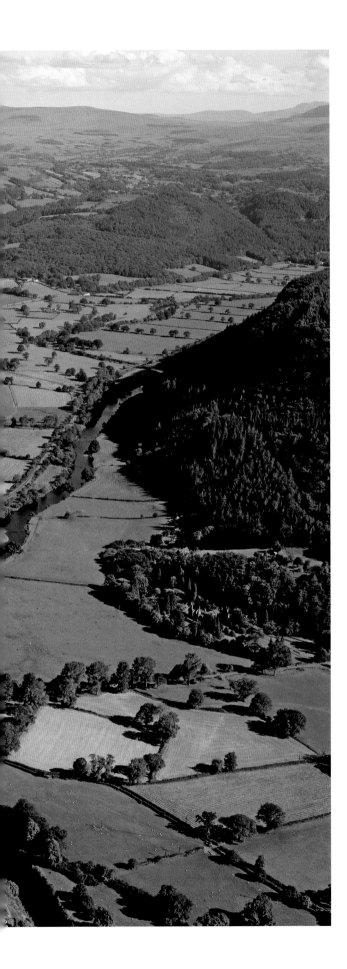

LLANRWST
2014

Llanwrst is an attractive town in the Conwy valley with an interesting history. As the influential Cistercian monks of Aberconwy Abbey owned much of the land in the area, it is perhaps not surprising that the town's early growth and development was largely dependent of the wool trade. For many years, the price of wool over a large area of Britain was set in Llanwrst, and wool was the country's main trading commodity at that time.

Aberconwy had close connections with the Welsh Princes, who ruled this part of Wales for many years, and who were regularly involved in skirmishes with English armies, particularly when Edward I was trying to extend his authority throughout Wales in the 13th century.

Edward's plan involved building a network of great castles at strategic points around Wales and encouraging influential English people to move to the settlements, which were growing up around them. When Edward issued an edict prohibiting any Welshman from trading within 10 miles (16 km) of Conwy to further his plans, this was a boost to Llanwrst, which was just outside that area.

In 1276, the Welsh Prince Llywelyn ap Gruffudd, seized Llanwrst and declared it a 'free borough'. As this would mean that Llanwrst would be independent of the diocese of Llanelwy, the Bishop sought the help of the Pope to overturn this, but Llywelyn used his close family ties with Aberconwy Abbey to plead his case and the Bishop's pleas fell on deaf ears. Further pleas by the Bishop also failed, even after Llywellyn's death.

As Conwy expanded, the monks at Aberconwy moved to a new site near Llanwrst, and as the town continued to grow a new coat of arms and flag appeared, bearing the legend 'Cymru Lloegr a Llanwrst' (Wales, England and Llanwrst) to assert the towns supposed independence. This phrase is still used as a good natured toast by the locals and a local band have a song with the same title.

Records also show that in 1947 Llanwrst Town Council made an application to the United Nations for a seat on the Security Council on the basis that Lanwrst was an independent state within Wales. Needless to say, this was unsuccessful.

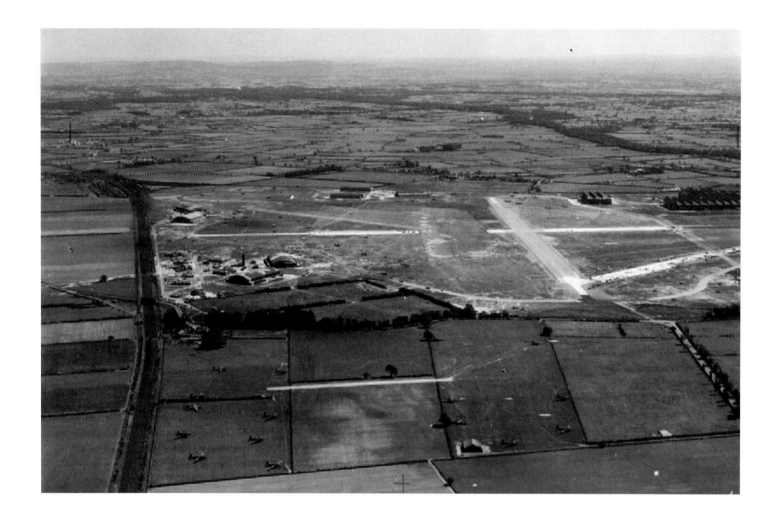

HAWARDEN AIRPORT
1941 and 2014

As Europe stumbled towards war in the late 1930s, the government funded a series of 'shadow factories' which could produce aircraft should a conflict erupt. RAF Hawarden in Flintshire was one of them, and during the war it produced 5,540 Wellington and 235 Lancaster bombers. This image shows the shadow factory towards the top right with completed aircraft parked nearby. More planes have been put in the fields in the foreground while work goes on to enlarge the runways.

After the war the factory made prefab bungalows and then more aircraft for several manufacturers, including de Havilland, Hawker Siddeley and British Aerospace.

Today the facility is owned by Airbus, and its 5,000 workers specialise in making aircraft wings. These are transported to a plant in Toulouse, where aircraft are assembled from its collected components. This image shows a huge Airbus Beluga cargo plane arriving to pick up a set of wings.

However, the wings for the Airbus A380, the world's largest passenger airliner, are too large even for the Beluga. They are loaded onto a barge on the nearby River Dee, then floated down to Mostyn docks to catch a ship bound for France.

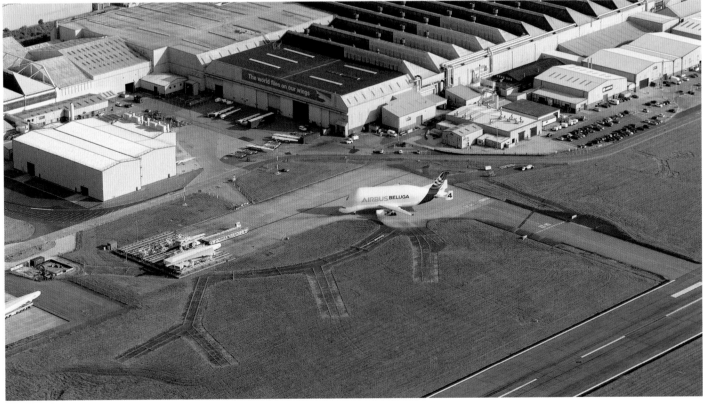

NORTHERN IRELAND

MOURNE MOUNTAINS

A magical land of rough snow-capped peaks, wild valleys and a sapphire sea sits right on the edge of civilization and yet also seems a million miles away from it. The Mourne Mountains inspired the land of Narnia in the famous children's book *The Lion, The Witch and The Wardrobe*, by C.S. Lewis. The Belfast-born author used to roam here as a boy and he wrote that the landscape made him 'feel that at any moment a giant might raise his head over the next ridge'.

The Mourne Mountains are the highest in Northern Ireland, with seven peaks over 700 m (2,297 ft). Together they form an area of outstanding natural beauty and are a honeypot for walkers and climbers. The tallest of them is Slieve Donard, at 850 m (2,790 ft). In 1826, a group of Royal Engineers camped on its summit from July to November as part of the first complete triangulation of the British Isles. Their measurements were used as the baseline for mapping Ireland.

Running over the summits of fifteen hills is the Mourne Wall. This dry-stone barrier runs for 35 km (22 miles) to enclose an area of 36 sq km (8,900 acres) purchased by the Belfast Water Commissioners. It took 18 years to build and was completed in 1922.

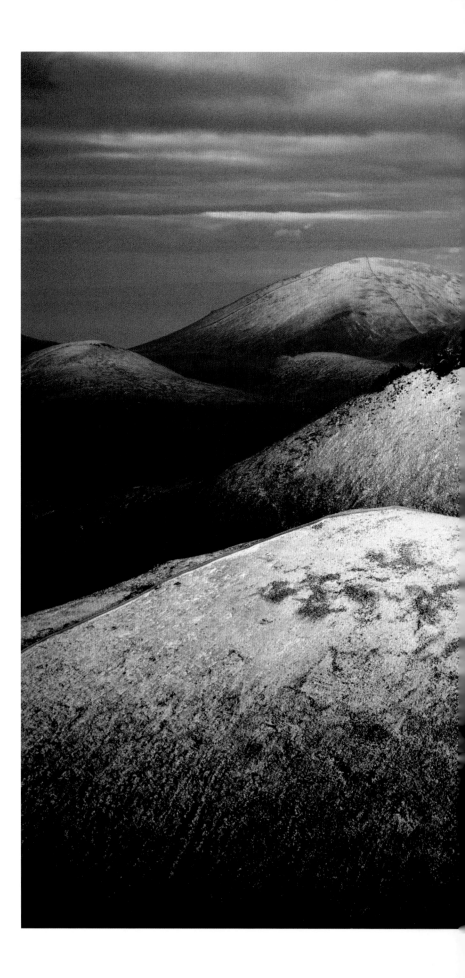

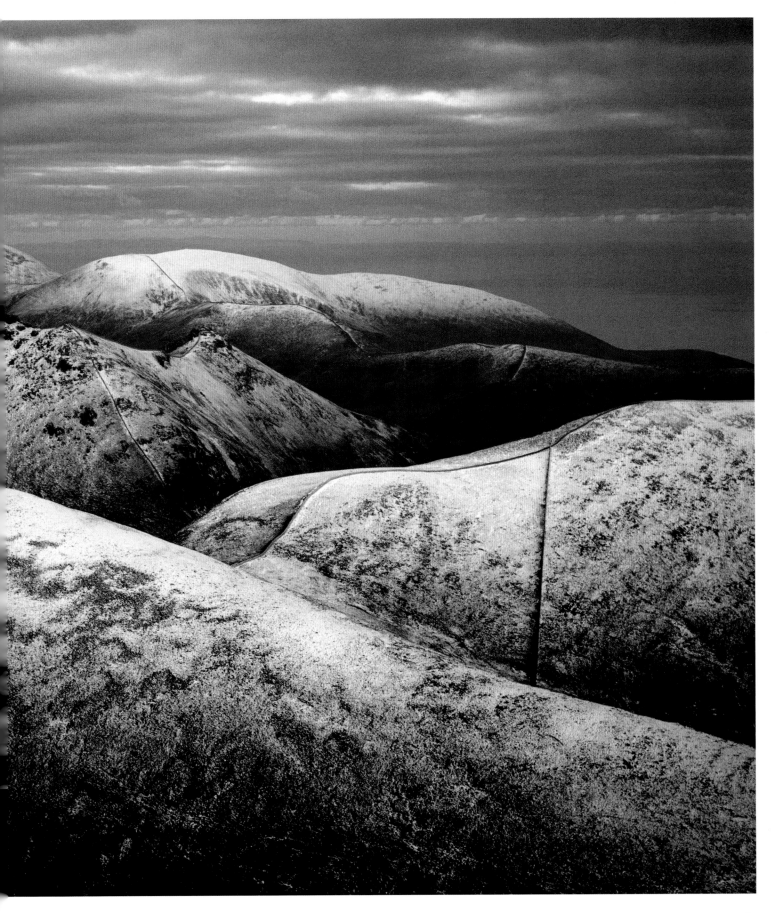

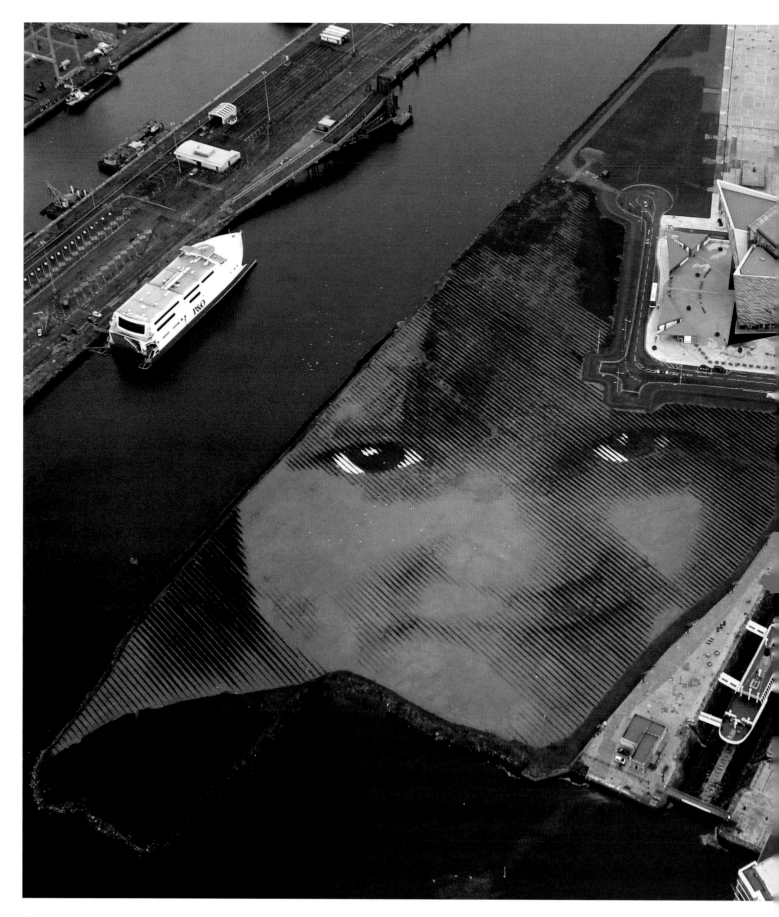

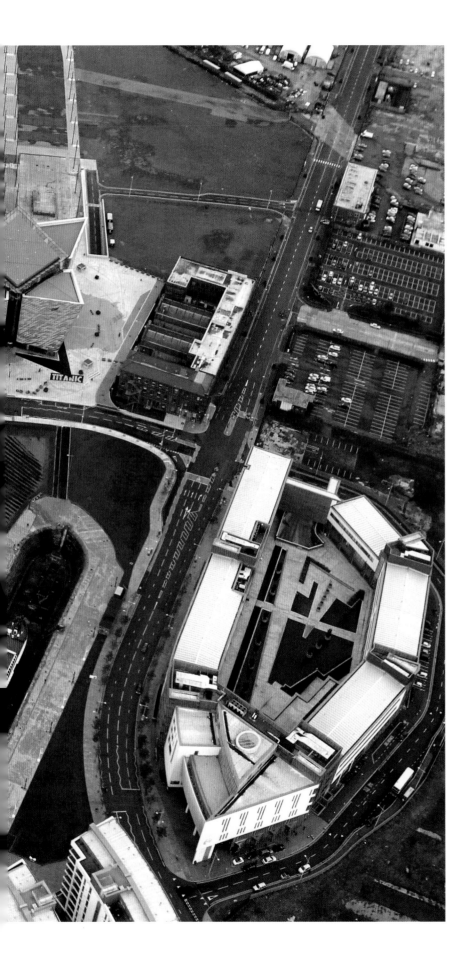

BELFAST'S WISH
2013

Covering 11 acres of old quayside is Britain's largest portrait. It is situated in Belfast's Titanic Quarter, the regenerated dock area that was once the world's biggest shipbuilding yard and that now features a museum devoted to its most famous creation, *RMS Titanic*.

Local businesses donated 2,000 tonnes of soil, 2,000 tonnes of sand, and thousands of tonnes of limestone and gravel. Cuban-American artist Jorge Rodriguez-Gerada, with a team of helpers, then laid the materials out in a design marked with 30,000 pegs.

From the ground the work appeared to be a huge series of neat, but random, lines. But from the air it created the image of an anonymous local child.

The artwork was unveiled – with the help of satellite imagery – in October 2013 as part of the Ulster Bank Belfast Festival, an 11-day celebration of arts and culture in the city. It is titled *WISH*.

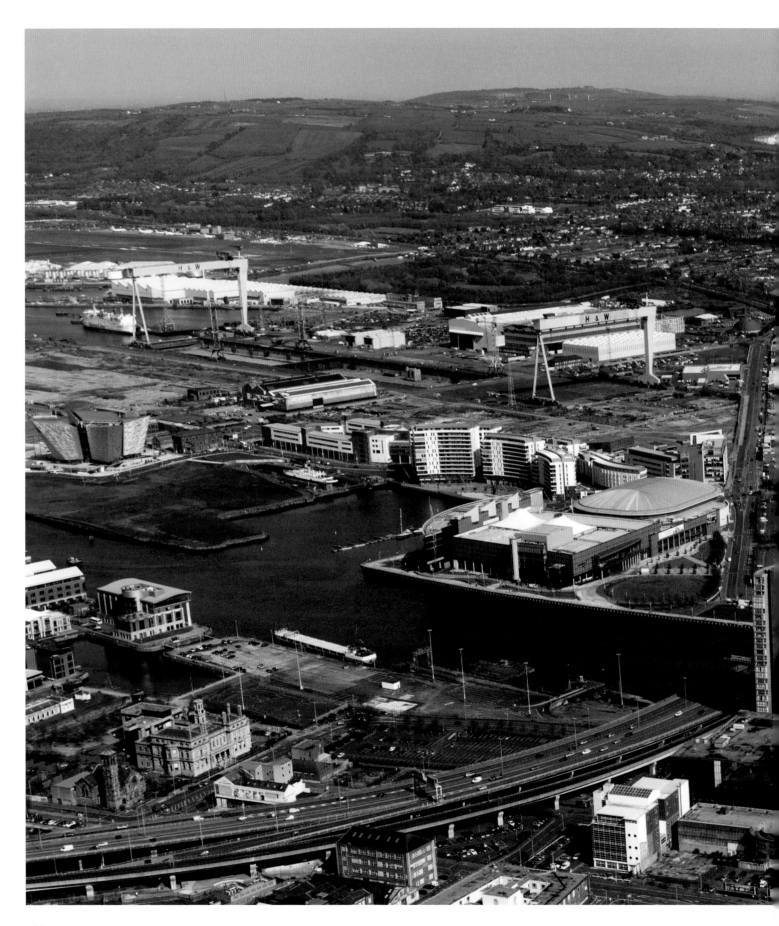

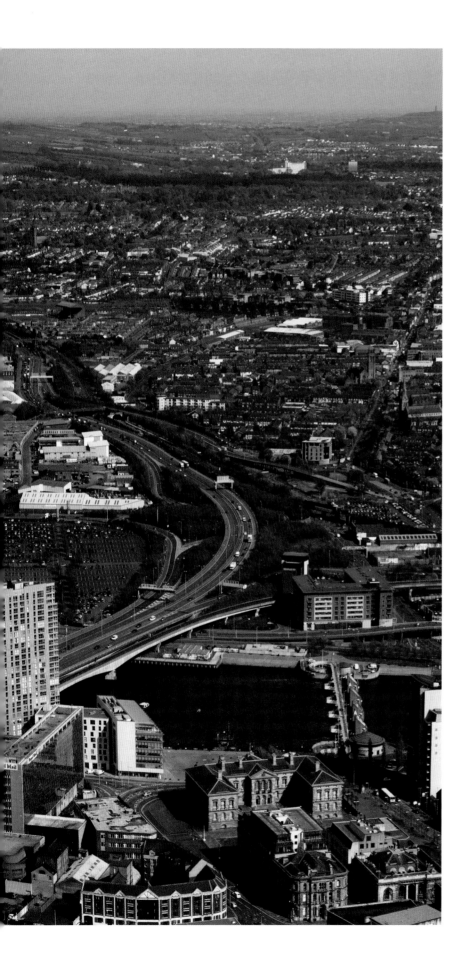

SAMSON & GOLIATH
2012

The twin gantry cranes Samson and Goliath are Belfast's most famous landmarks, towering over the city's traditional buildings. Goliath stands 96 m (315 ft) high – the same as the Big Ben clock tower – and was built in 1969. His younger brother Samson is even taller at 106 m (348 ft) and was built further inland in 1974. At that time Harland & Wolff was one of the world's biggest shipyards; the cranes straddle what is still the world's largest dry dock (556 m x 93 m). Together they can lift over 1,600 tonnes, making them among the strongest cranes in the world.

The yard made its last ship in 2003, and since then it has focused on ship repair, structural engineering, offshore platforms and the manufacture of renewable energy devices. In 1995 Samson and Goliath were officially scheduled as historic monuments.

STORMONT
2005

Northern Ireland's Parliament Building is usually referred to simply as Stormont as it is situated in the area of Belfast known as Stormont Estate.

When a new parliament building for Northern Ireland was needed, following the passing of the Government of Ireland Act in 1920, the original plans envisaged a large central domed building with wings on either side to house the three branches of Government, legislative, executive and judicial. However, a simpler plan designed by Sir Arnold Thornley in the Greek classical style was eventually adopted, and the building was fronted in Portland stone, like many government buildings of the period.

The new building was officially opened in 1932, by the then Prince of Wales, and was used by the Parliament of Northern Ireland until 1972, when Direct Rule from England was imposed during the troubles. After interim use by the short-lived Sunningdale power-sharing executive and as the seat of the rolling-devolution assembly, it is now the official home of the Northern Ireland Assembly, which was established following the Belfast (Good Friday) Agreement of 1998.

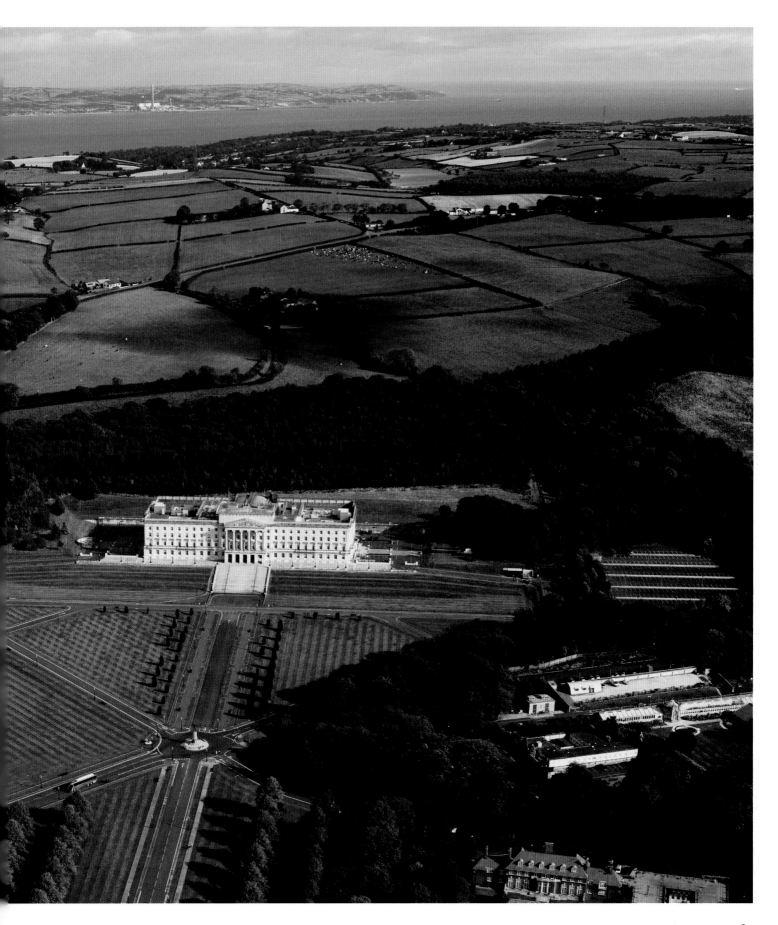

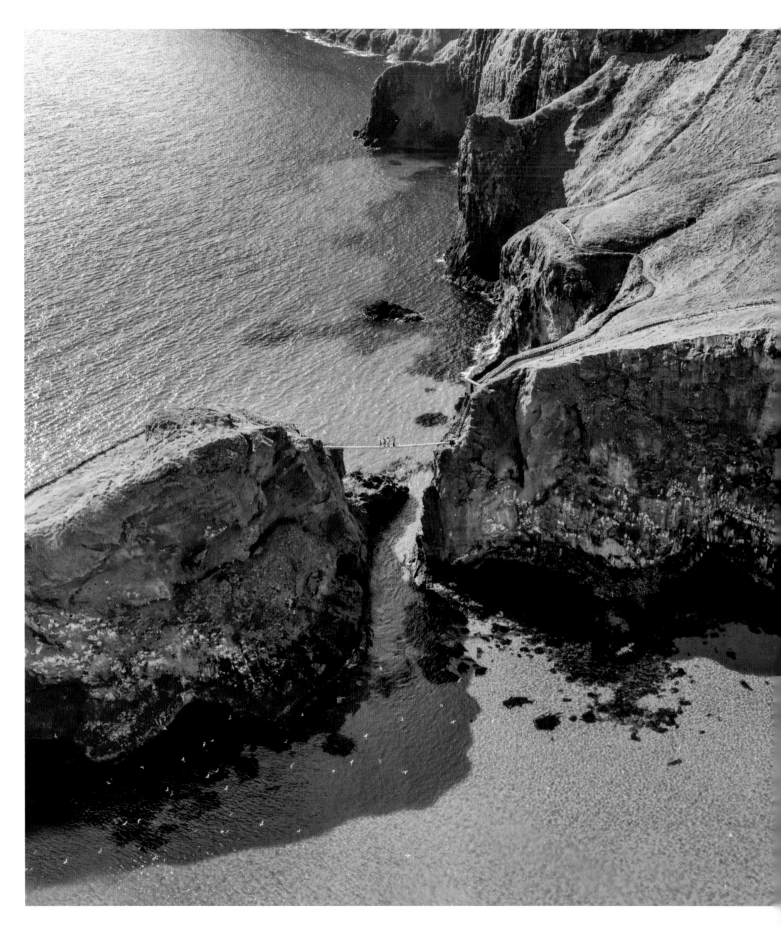

CARRICK-A-REDE
2013

In the seventeenth century the fishermen of Ballintoy in County Antrim built the first nerve-jangling rope bridge over to Carrick-a-Rede island. Their quarry was the Atlantic salmon that swim past the rocky bluff on their way to spawning grounds in the River Bann and River Bush.

As recently as the 1960s, 300 fish a day were being caught here, but by 2002 only 300 were landed in a whole season. Today the bridge serves as a tourist attraction and a rite of passage for local youngsters.

Carrick-a-Rede Is from the Irish *Carraig a' Ráid*, meaning 'rock of the casting'. It stretches for 20 m (66 ft) between mainland and island and is 30 m (98 ft) above the rocks below.

Carrick-a-Rede island is the finest example of a volcanic plug in Northern Ireland, and erosion by wind and wave has cut a section through the neck of this old volcano. Below the craggy island summit are several caves, once used by boat builders and as shelter during stormy weather.

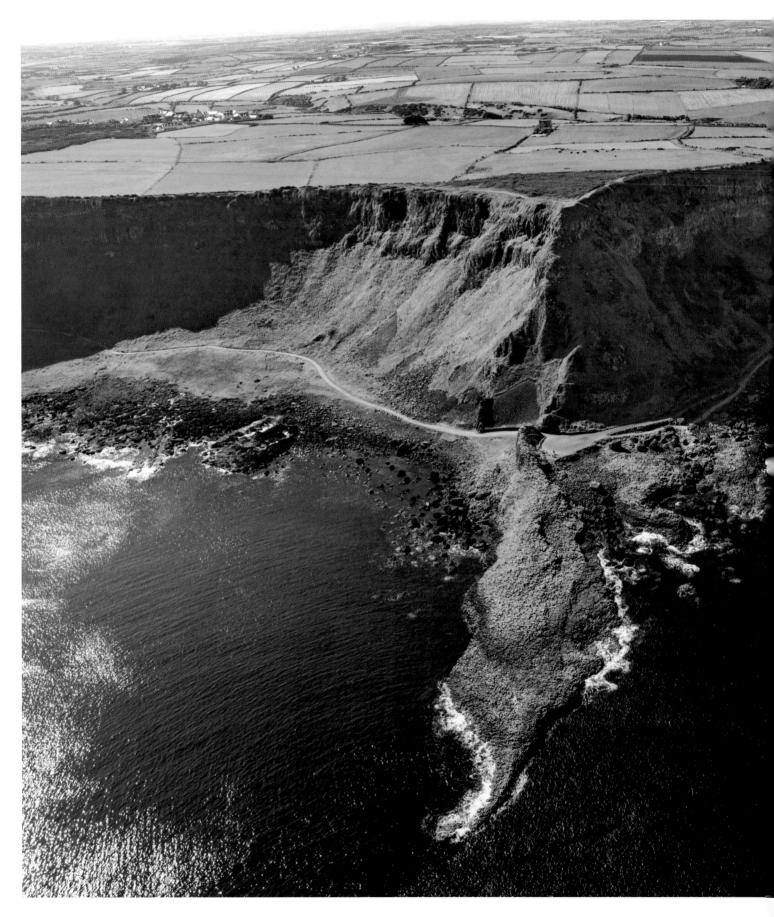

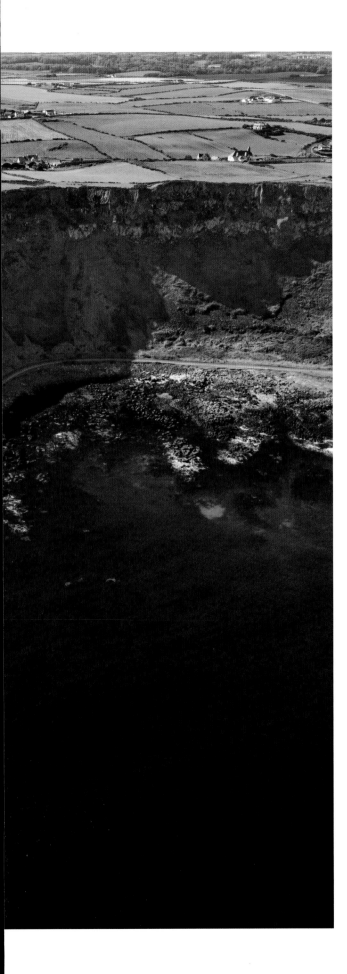

GIANT'S CAUSEWAY
2013

A picture taken here 65 million years ago would have shown a sub-tropical sea and an erupting volcano. At that time, the tectonic plate that Northern Ireland lies on was at the latitude of Spain and was joined to what is now the eastern seaboard of America. As the plate moved, magma welled up from inside the Earth and spilled out across the surface as lava.

The lava flowed into a river valley and then slowly cooled and crystallized, producing the 40,000 interlocking basalt columns that we see today. Most of the columns are hexagonal, although there are also some with four, five, seven or eight sides. The size and shape of each basalt column is determined by the rate at which the lava cooled and dried: the slower the cooling the larger the basalt columns. The same column formations can be seen at Staffa in Scotland (Fingal's Cave).

Legend has it that the columns are the remains of a causeway built by the Irish giant Finn MacCool so that he could fight the Scottish giant Benandonner.

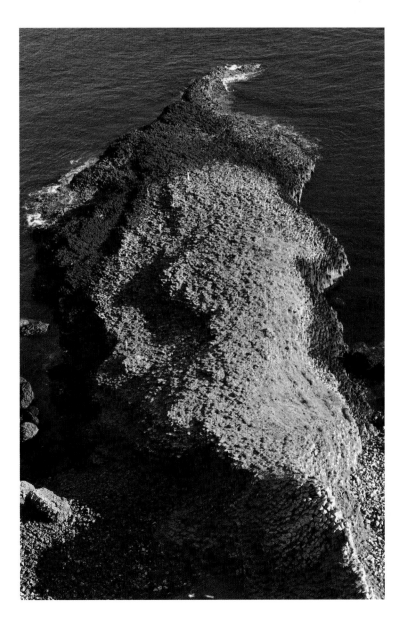

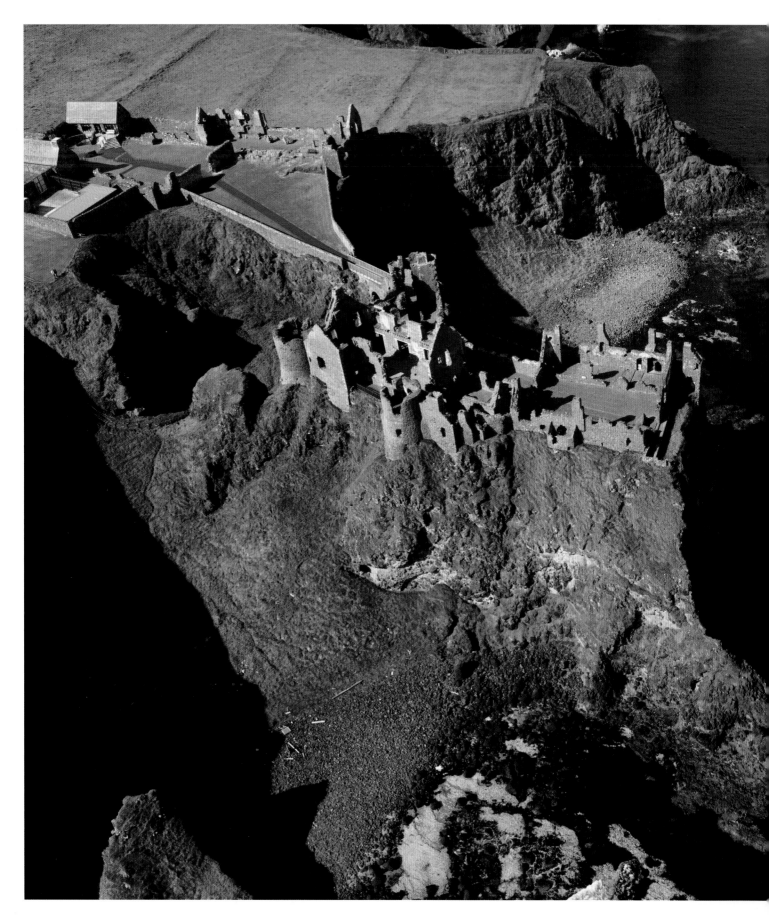

DUNLUCE CASTLE
2006

With its crumbling stone walls rising sheer above dizzying drops on three sides, Dunluce Castle seems to grow from the very rock on which it stands. Its dramatic location was both a strength and a weakness: it offered local clans a near impregnable refuge, but in 1639 a powerful storm pulled part of the walls into the sea. The ruined fortress was abandoned.

In 1588, many ships of the fleeing Spanish Armada were wrecked off the coasts of Ireland and Scotland. One vessel, the *Girona*, foundered on the rocks by Dunluce. The ship's cannon were recovered and mounted in the castle's gatehouses. The *Girona's* cargo was sold, with the money being used to restore the castle.

Author C.S. Lewis was a frequent visitor here in his youth, and the walls and giddy towers of Dunluce are thought to have inspired the Narnian castle of Cair Paravel.

MUSSENDEN TEMPLE
2013

Perching perilously close to the clifftop near Castlerock is the Temple of Mussenden. This neat rotunda was built in 1785 by Frederick Hervey, Bishop of Derry, as a library and ecumenical chapel. It was modelled on the Temple of Vesta in Rome and was dedicated to the memory of Hervey's young cousin, Frideswide Mussenden.

The Temple offers grand views over the Atlantic Ocean towards the islands off Scotland's west coast. It was originally set further back from the precipice, but erosion has edged it ever closer to the drop.

Hervey was a popular, if eccentric, bishop. A self-confessed agnostic, he spent much of his energy and family fortune on philanthropic ventures and on building a grand country house and verdant estate on this bleak headland. His 'Bishop's Palace', just inland from the temple, is today a roofless ruin, but it was once one of the most celebrated houses in Ireland. It was inhabited until 1939, but fell into decline after the Second World War.

The Belfast to Derry/Londonderry railway line runs at the base of the cliffs, passing under the temple itself in a tunnel.

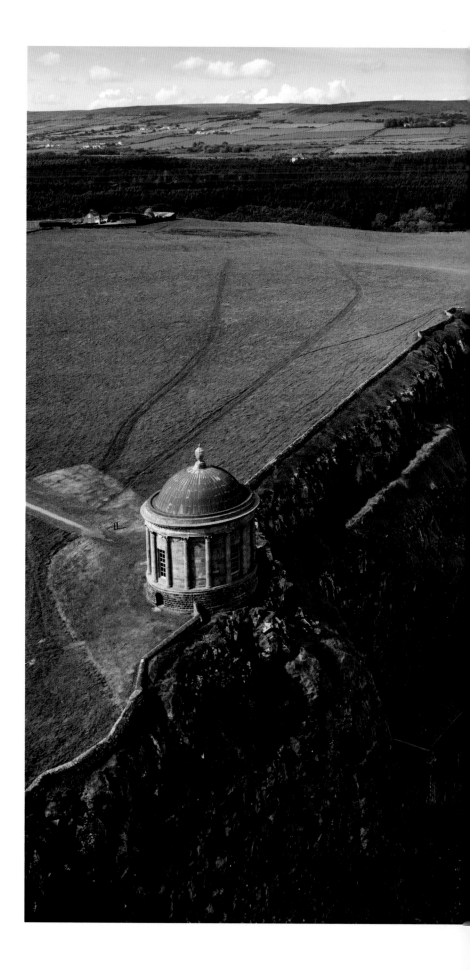

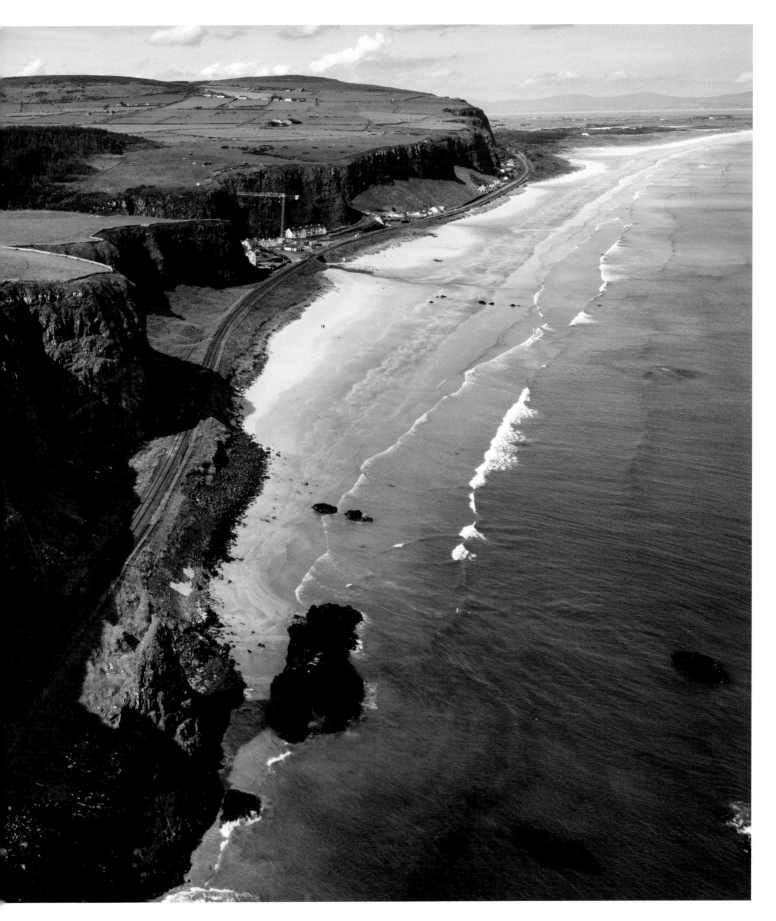

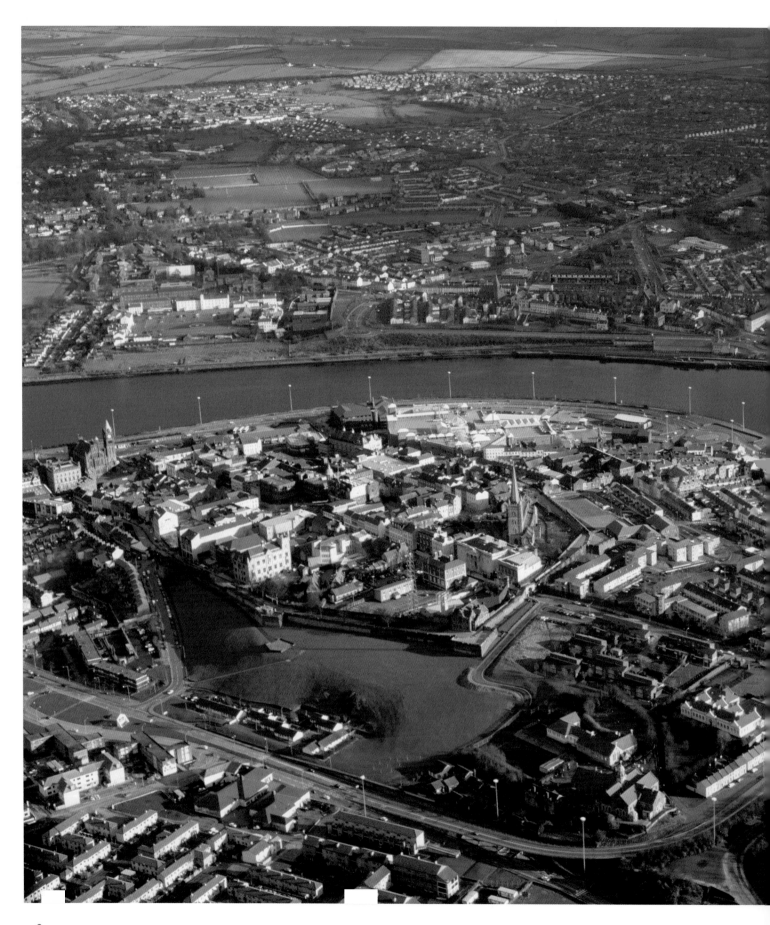

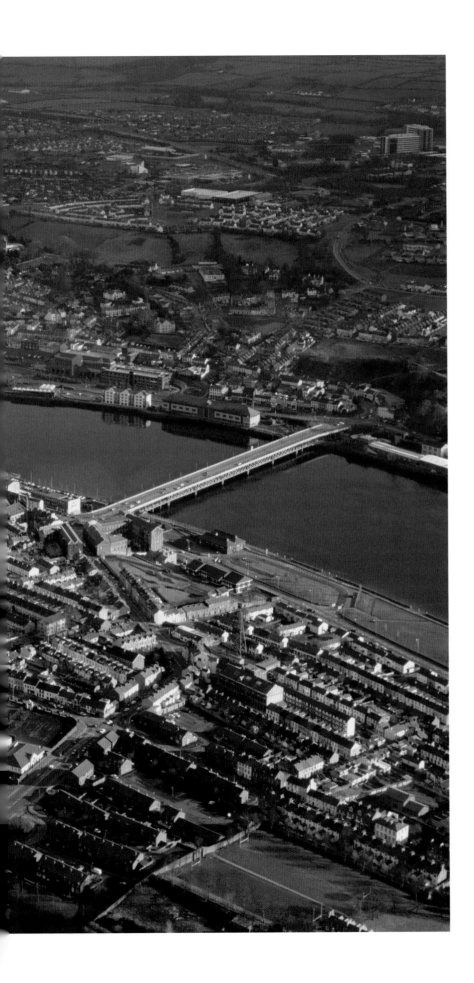

DERRY/LONDONDERRY
2010

Derry/Londonderry is the second largest city in Northern Ireland and one of the finest examples of a walled city anywhere in the world. Its formidable fortifications were built from 1613–1619 to protect settlers who had arrived from Scotland and England. This made it the last town in Europe to have a complete set of city walls built. The walls create an aerial promenade around the inner city that runs unbroken for 1.5 km (1 mile) and varies in height from 4–12 m (13–39 ft).

Ingress to the walled city was through four impressive gates, which still stand today: Bishop's Gate, Ferryquay Gate, Butcher Gate and Shipquay Gate. Three more gates were later added: Magazine Gate, Castle Gate and New Gate. The Gothic cathedral of St Columb was built inside the walls in 1633.

The walls stand completely intact 300 years after their construction, and the city is one of the few in Europe that never saw its fortifications breached, despite being besieged several times. The last assault started in 1689 and the defences remained unpenetrated for 105 days, earning Derry the nickname, The Maiden City.

The politically correct title of 'Derry/Londonderry' has led to its affectionate nickname of 'Stroke City'.

INDEX

Project Manager: Craig Balfour Alistair Coats
Designer: Kevin Robbins
Layout: Gordon MacGlip Text written by Richard Happer

Image Credits